GIOVANNI
BELLINI

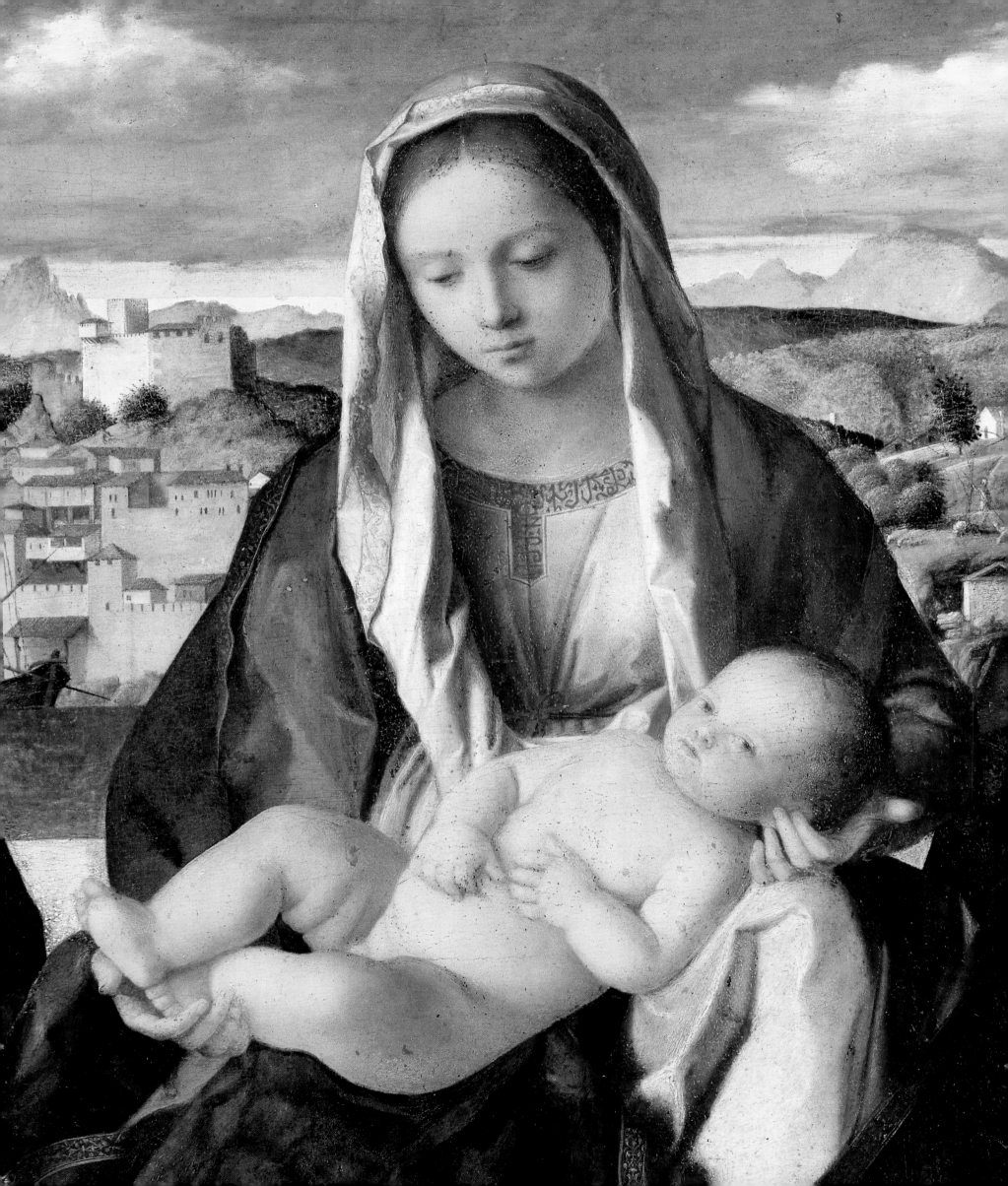

GIOVANNI BELLINI

ANCHISE TEMPESTINI

Translated from the Italian by
ALEXANDRA BONFANTE-WARREN AND JAY HYAMS

ABBEVILLE PRESS PUBLISHERS
NEW YORK LONDON PARIS

Jacket front: Saint Francis in Ecstasy.
See page 112.

Jacket back: Portrait of Doge Leonardo Loredan.
See page 158.

Frontispiece: Giovanelli Sacra Conversazione.
See catalog 104.

FOR THE ENGLISH-LANGUAGE EDITION
Editor: Abigail Asher
Typographic Design: Barbara Sturman
Jacket Design: Patricia Fabricant
Production Manager: Lou Bilka

FOR THE ORIGINAL EDITION
Editor: Paula Billingsley
Design: Marco Zung
Layout: Elena Pozzi

Library of Congress Cataloging-in-Publication Data
Tempestini, Anchise.
[Giovanni Bellini. English.]
Giovanni Bellini / by Anchise Tempestini ; translated from the
Italian by Alexandra Bonfante-Warren and Jay Hyams.
p. cm.
ISBN 0-7892-0433-9
1. Bellini, Giovanni, d. 1516.—Catalogues raisonnés. I. Title.
ND623.B39A4 1999
759.5—dc21 98-47449

CONTENTS

Preface 11

THE LIFE AND WORK OF GIOVANNI BELLINI 15

PLATES 87

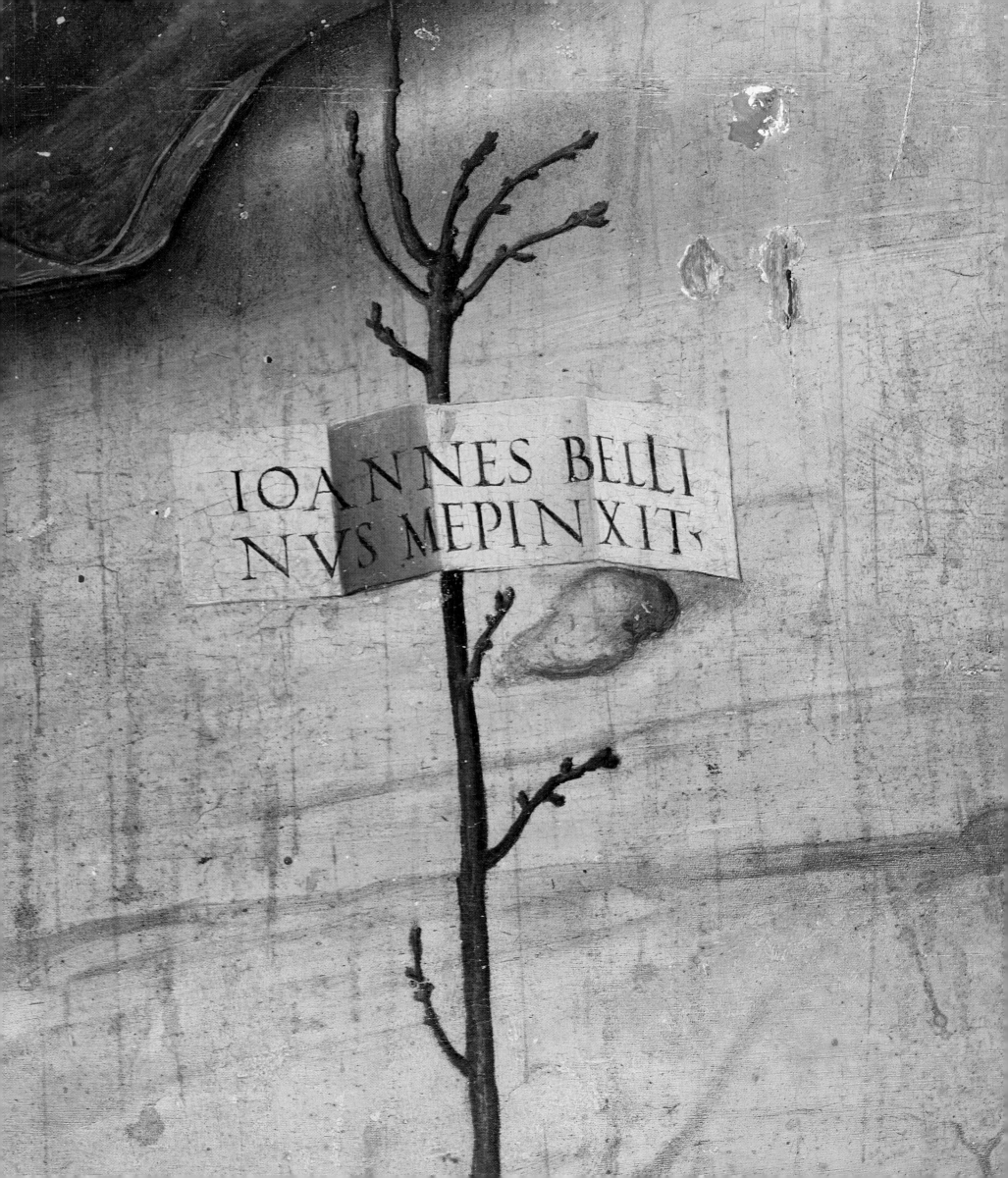

TO MY WIFE, ORTENSIA

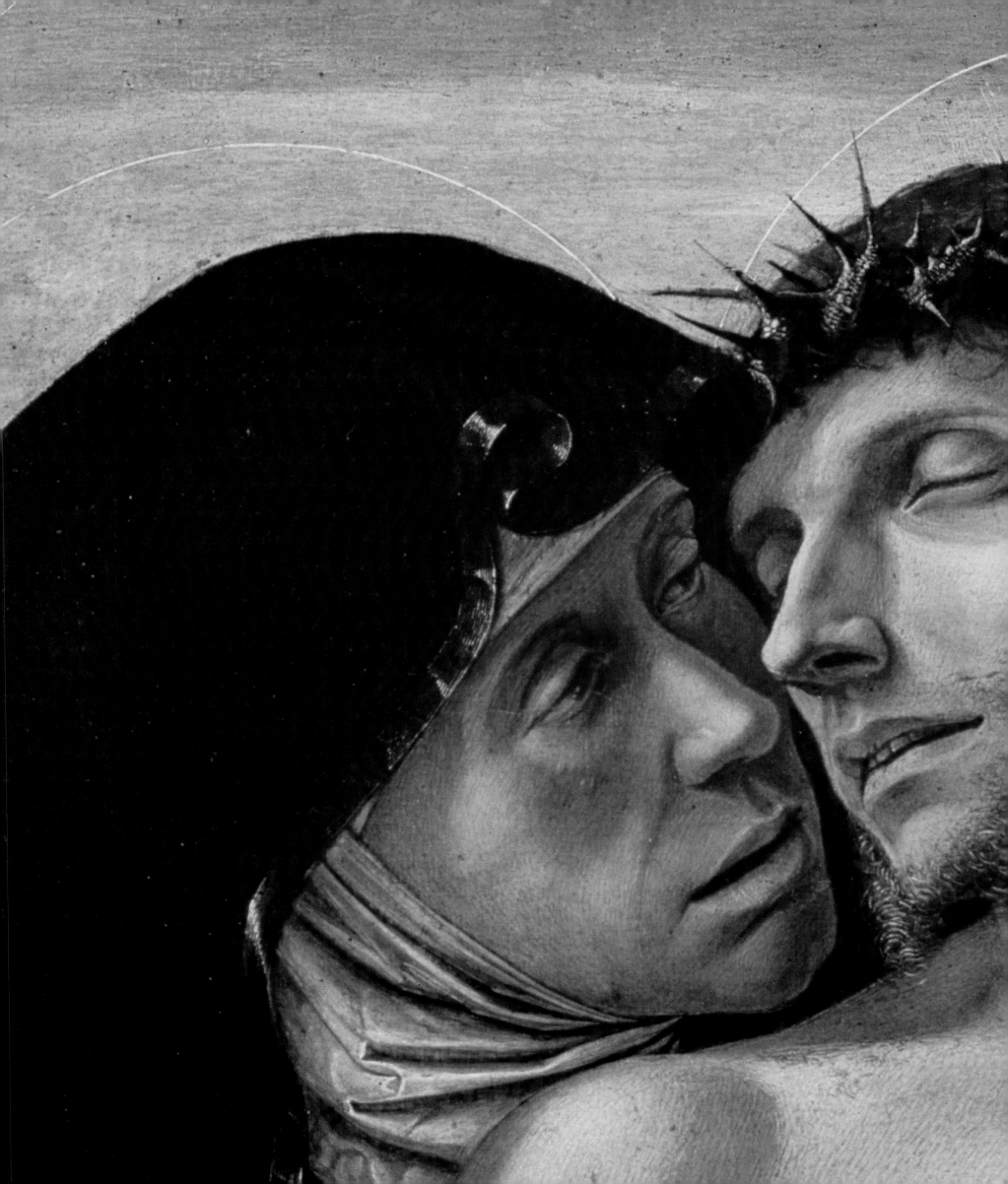

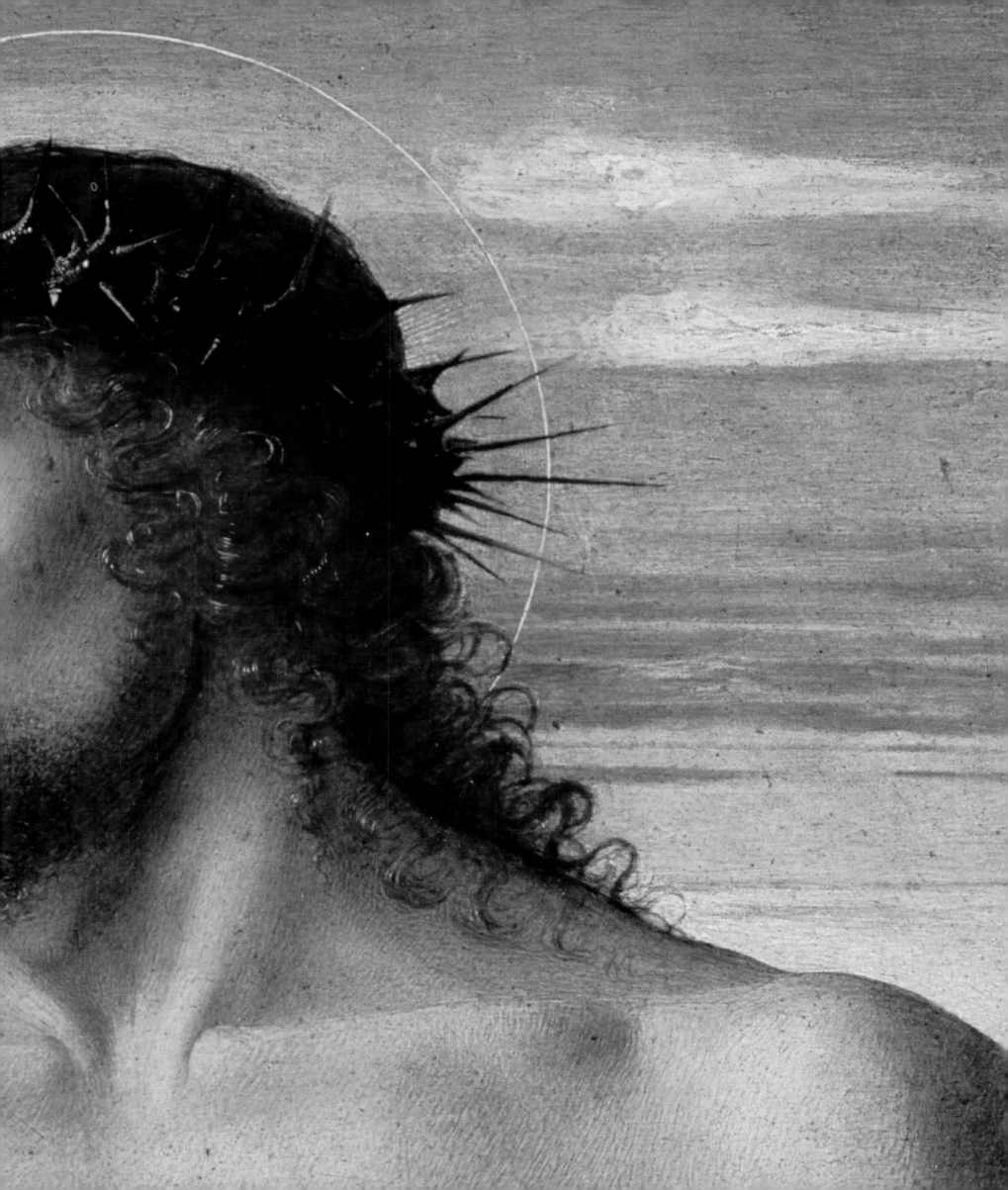

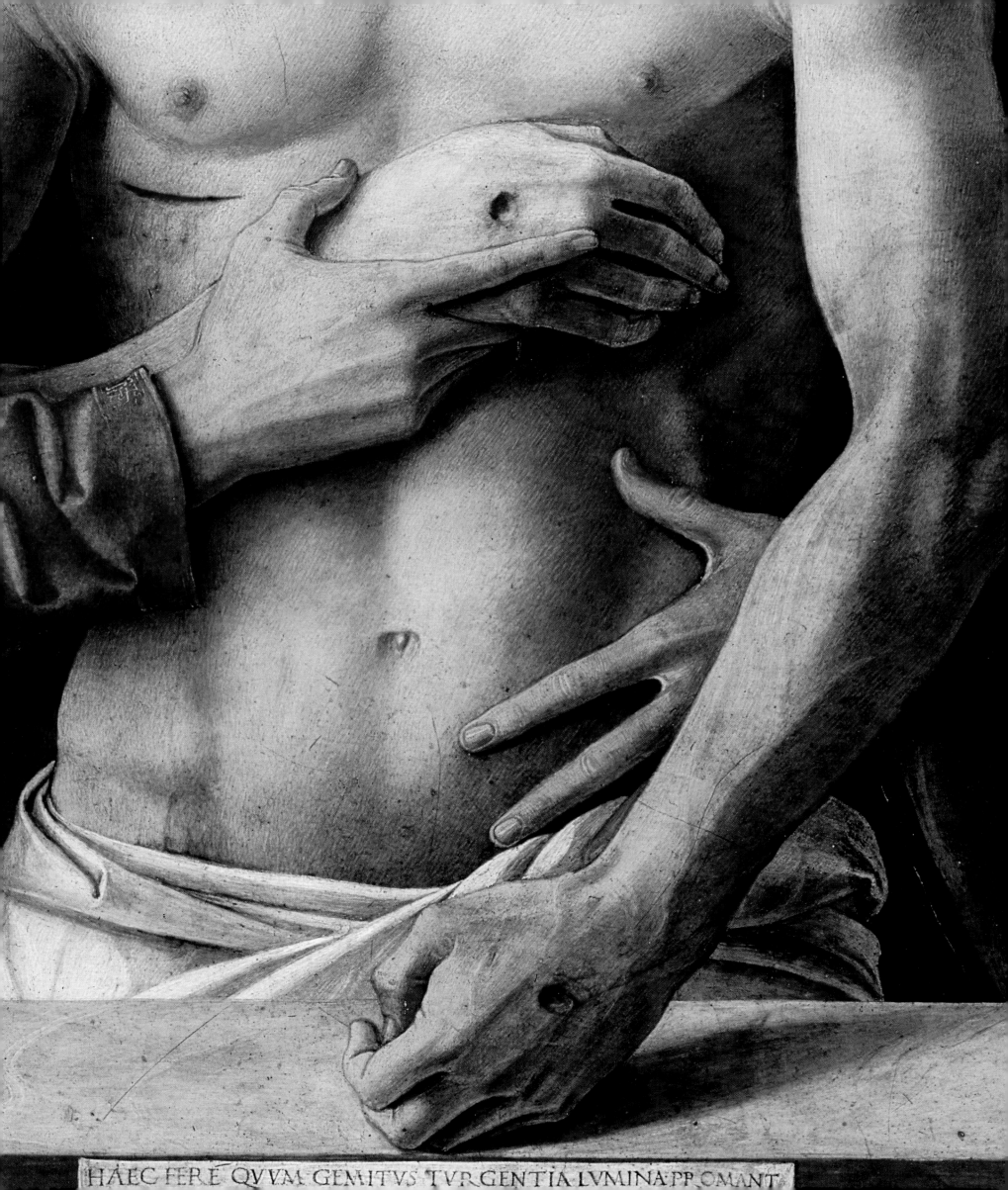

HÆC FERÉ QVVM GEMITVS TVRGENTIA LVMINA PP OMANT

PREFACE

Why Giovanni Bellini? Because over the course of three decades devoted to the study and research of art history, and primarily to Venetian painting in the broadest sense, from the Trentino region across northeastern Italy to Dalmatia, I have always found myself drawn back to that artist who has been recognized as a great master since the last decades of his long life. That artist who founded a school of vital importance, who proved himself able to blend profound but never excessive religious faith—free of any sense of the superstitious or the ascetic, not set apart from the world, but based on a sense of the divine immanence in nature—with a professionalism that drove him to perfectionism in the best sense of the word, that made him draw his compositions in meticulous detail on his panels before covering them in luminous colors. Giovanni Bellini, whom Albrecht Dürer in 1506 called very old but "still the best painter of all," a great man of whom he was happy to be a friend.

Although the initial stages of his career are little known due to problems of documentation, he evolved to become the most illustrious representative of the family of artists that dominated the scene of Venetian painting for many decades, beginning with his father, Jacopo Bellini, a painter and designer who spanned the period between the International Gothic and the Early Renaissance and was in that sense similar to Antonio Pisanello, who had been his fellow pupil under Gentile da Fabriano; then with his brother Gentile, a portraitist and painter of canvases for the Doge's Palace and the leading Venetian *scuole,* as well as court painter to Sultan Muhammad II in Constantinople; and with his brother-in-law Andrea Mantegna, head of the Paduan school and master of artists from all over the Po River valley area, a humanist imbued with the spirit of classical archaeology. Giovanni is considered the master of Giorgione and Titian, meaning that, after bringing one figurative language to a close with works that are today ranked as masterpieces, he went on to lay the basis for a new figurative language. To fully appreciate the role he played requires the ability to distinguish the works he himself created, which are often poorly documented and come to us with uncertain dating, from those works often quite similar and of good quality that were done by his very numerous students, assistants, followers, and imitators.

I have dedicated many years to the study of several Belliniani painters, from Rocco Marconi to Marco Bello to, most of all, Luca Antonio Busati. Before finding Busati's real name, I referred to him as the Venetian Master of the Incredulity of Saint Thomas, a proposal that was accepted by a host of scholars, from Peter Humfrey to Philip Rylands, from Federico Zeri to Mauro Lucco, from Vittorio Sgarbi to Mauro Natale, from Alessandro Ballarin to Davide Banzato, from Giordano Viroli to Enrico Maria Dal Pozzolo. In fact, some of them, for the sake of brevity, went so far as to rebaptize the artist the Tempestini Master. I did not dare approach the great artist Giovanni Bellini himself. I was convinced I would fail if I attempted to express in words a judgment anywhere equal to the quality of his masterpieces.

The sense that I was somehow not qualified to approach a great artist dates back to my origins, and over the years it led me to prefer a type of art history that made no pretense of being itself a work of art, was no more than any other historical discipline, sometimes based on the study of documentary evidence, sometimes on patronage, sometimes on the meanings to be found by reading figurative works as texts, investigating them in terms of their iconography and iconology. Although I believe that one needs an eye capable of recognizing, as far as possible, the environment in which a work was made, if not always the exact name of its creator, I am also convinced that one must be willing to change one's opinion whenever that opinion proves to be inexact; one must avoid any form of dogmatism, which in scholarly undertakings, as in politics, can be only deleterious. In the field of art history, authority is proven by solid contributions to research, not by the publicity surrounding one's name or by the veneration offered by students. As I see it, having accepted these conditions, it is still possible to dedicate oneself to the history of art, and to do so out of a spirit

Pages 8–10

THE DEAD CHRIST
SUPPORTED BY MARY
AND SAINT JOHN
EVANGELIST (PIETÀ)
Details

Pinacoteca di Brera, Milan
(cat. 10; complete image on
page 95)

of service and out of curiosity, taking pleasure in achievements and a sense of satisfaction in finding one's opinions shared by colleagues, but always being willing to take apart any hypothesis whenever doing so becomes necessary; for in the absence of historical facts, hypotheses often prove no more valuable than houses of cards. In this conviction I find myself in good and sometimes excellent company at the international level, although there are still certain pockets of resistance and obscurantism within the realm of art history that at times make me feel like no more than a part-time scholar, ready to abandon the field at any moment. I am further encouraged in this attitude by the fact that as a layman I have absolutely no sense of any sacredness in art history, a discipline that is often looked upon as being somehow superior, open only to initiates.

After university studies in political science that I broke off when I found myself interested only in Mario Luzi's course on Guillaume Apollinaire, and after studies in Italian literature with Walter Binni, whom, for family reasons, I could not follow to Rome, I abandoned a thesis in English literature on George Bernard Shaw because of the professor's Crocean approach and resigned myself to writing a thesis on art history, a discipline I had always considered part of the baggage of knowledge of every educated person, but not as a subject in which one might specialize. This opinion was in keeping with that bias according to which a doctor, engineer, or lawyer may well take an interest in art, perhaps even go so far as to become a collector, but must never dedicate his life to its study, just as he might subscribe to concerts but never perform in public. I changed my mind thanks to Mina Gregori, first, and then to the late Roberto Salvini, who had meanwhile become director of the Institute of Art History in the department of literature and philosophy at the University of Florence. In selecting a theme for my thesis, I abandoned my initial plans to examine either the cathedral of Gemona or that of Venzone, research that would been useful since both buildings were later destroyed by the earthquakes of 1976; but it was research that I could not carry out as a beginner, with no knowledge of the related bibliography, and from a distance where no one could truly oversee my research, as both towns are in Friuli. The decision to write a monograph on a Friulian painter of the Renaissance, Pellegrino da San Daniele (Mar-

tino da Udine), cited in the *Officina ferrarese* (1934) by Roberto Longhi, permitted me to study a Friulian subject while remaining in an area of research tied to the tradition of the Florentine academy. Even so, I had no intention of continuing my studies in art history, and I do not believe I would have if, following the flood in Florence on November 4, 1966, I had not been offered work there with the photographic archives of the Kunsthistorisches Institut in Florenz, thus beginning an association that has now lasted more than thirty years and that, step by step, has sanctioned my presence among art historians. After my thesis on the Friulian painter—who is classified in art history sources as a student of Bellini, even though no signs of that relationship have remained except for certain echoes noticeable in his early works—my knowledge of Italian art, and in particular the art of the Veneto region, increased though my activities preserving and enlarging one of the world's most important collections of photographs of works of art. In the early 1980s, the private photograph collection of Fritz Heinemann was added to the archives, its principal nucleus composed of images of the thousands of paintings that he cataloged in his two-volume *Giovanni Bellini e i Belliniani*. I remember the months in which Luisa Vertova Nicholson made her expertise available, assisted first by Peter Krückmann, then by Catarina Schmidt, and finally by me, studying that immense array of photographs and inserting it in the photo archives of the institute where I still work. It was in the Kunsthistorisches Institut, in contact with the history of art of at least three continents and with such institutions as the Villa I Tatti, the Fondazione Longhi, the Istituto Universitario Olandese di Storia dell'Arte in Florence, the Bibliotheca Hertziana in Rome, the Fondazione Cini in Venice, the Courtauld and Warburg Institutes in London, and the Zentralinstitut für Kunstgeschichte in Munich, that I came to appreciate the potential of this discipline. I became enthusiastic about my position within it, not only in terms of the opportunities to perform my own research but in equal measure with regard to my collaboration with and contributions to the research conducted by colleagues, friends, and their students. In thanking those who have helped me in my work, I would have to list all those who have in turn thanked me in their publications, which would be tiresome. They all know that I thank them.

ANCHISE TEMPESTINI

THE DEAD CHRIST IN THE
TOMB SUPPORTED BY TWO
ANGELS (PIETÀ)
Detail
Museo Civico Correr, Venice
(cat. 11)

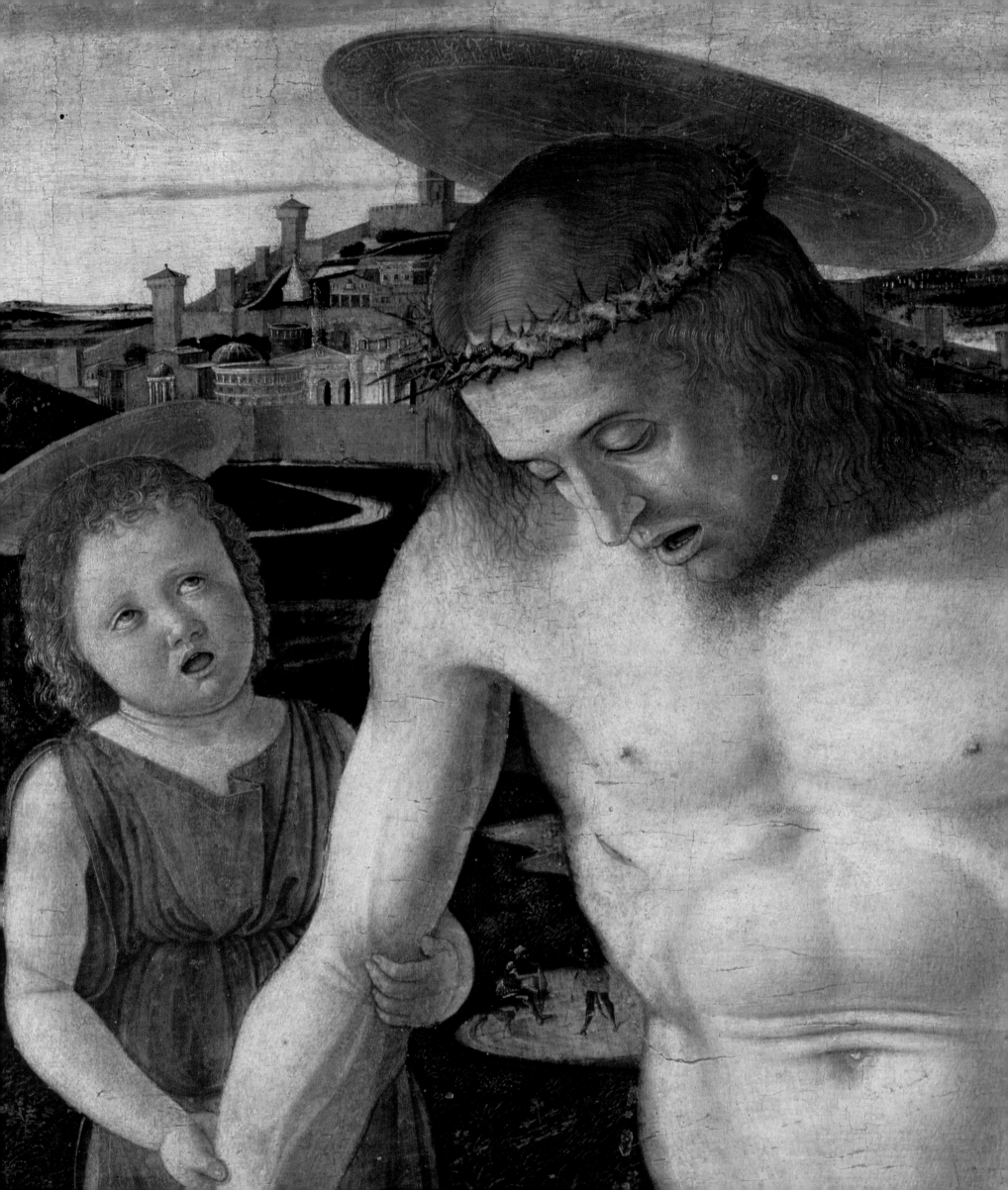

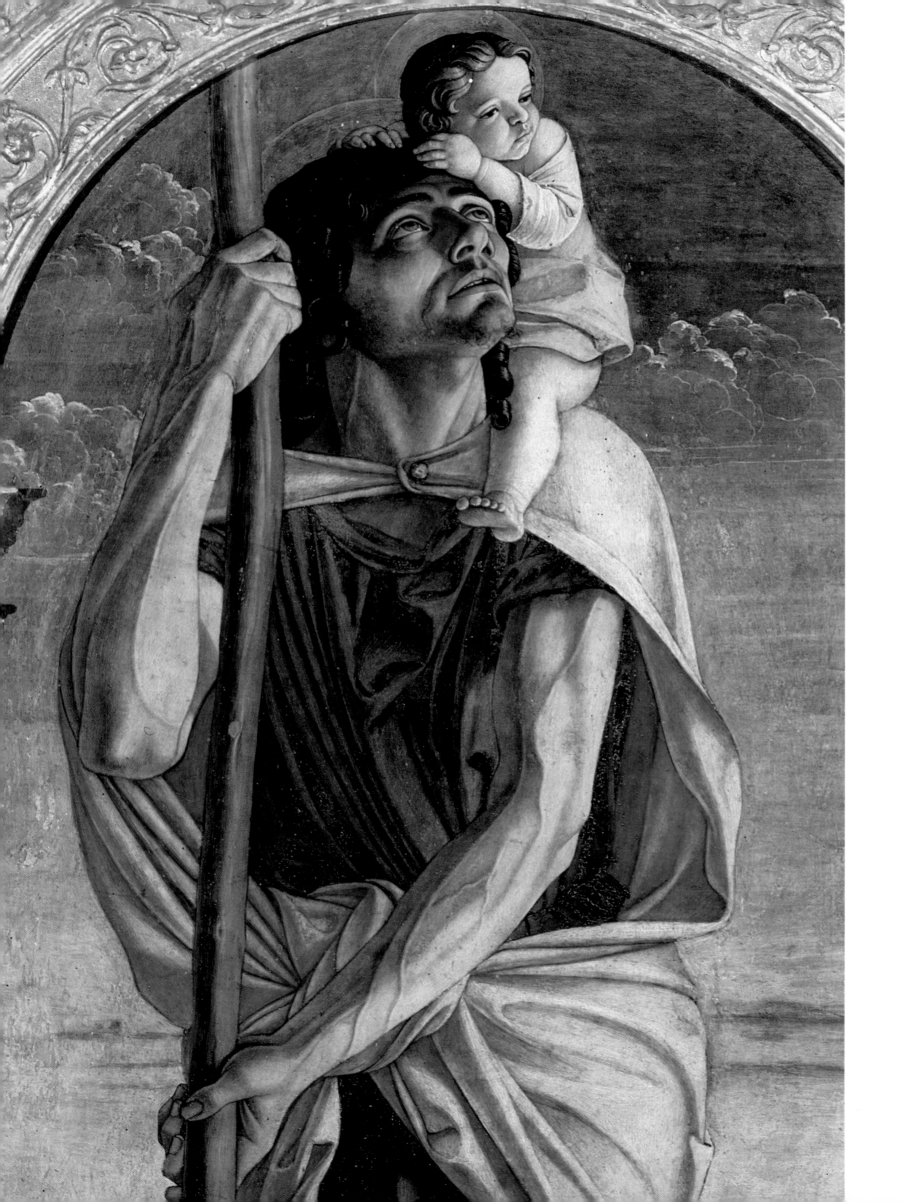

THE LIFE AND WORK OF

GIOVANNI BELLINI

Leonardo, Michelangelo, and Raphael are the names that spring to mind when considering the great artists of the past; perhaps Caravaggio, Rubens, Rembrandt, and—among the Italians—Titian. Titian is included not as the most important Venetian painter of his time but more likely because he was the painter for Emperor Charles V, the friend of Pietro Aretino, the creator of some of the most sensuous secular paintings of the day. The prominent artists of the Tuscan Quattrocento—Masaccio, Donatello, Brunelleschi, Ghiberti, Fra Angelico, Paolo Uccello, Andrea del Castagno, Filippo Lippi, Piero della Francesca—never go out of favor, thanks chiefly to the post-Romantic, Victorian, decadent movement that so often used them as models. But apart from these, Italian art before the seventeenth century is underrated.

In the tradition of Vasari, a "Florence-centric" history of art has obscured the painters, sculptors, and architects who were active in Venice, Milan, Bologna, Naples, and other cities in the fifteenth and sixteenth centuries, ensuring that they are less familiar to us than their contemporaries who worked in Florence or Siena. (This ideological positioning—which continues to affect visitors' choices of museums and exhibitions—is less Vasari's fault than it might appear at the superficial level of popular art history. Indeed, starting with the first edition of his *Lives* in 1550 the biographer, painter, and architect from Arezzo dedicated ample space to non-Florentine, non-Tuscan artists, even though he emphasized the primacy of the Tuscan drawing tradition and reprimanded the great masters of other regions for their real or presumed weakness in drawing.) Because of the general Tuscan focus, a visitor to the Uffizi in Florence—where works are grouped by school—is hard-pressed to string artists together in chronological succession and to grasp the indications of reciprocal exchange linking towns that were geographically quite distant from one another.

Only by reading a thoughtful work of art history can one discover that Donatello's presence and his work in Padua had profound importance for the development of figurative language in the second half of the fifteenth century throughout the plain of the Po River, stretching east to Mantua and Milan, down to Ferrara, and up to Venice. Discovering that Jacopo Bellini and Pisanello were pupils together in the school of Gentile da Fabriano, the leader of the International Gothic style who worked not only in his native region, the Marches, but elsewhere in central Italy—in Florence, Orvieto, and Rome—as well as in the Veneto, one can see the affinities between his two students. Affinities tying Jacopo Bellini, who became the patriarch of Venetian Renaissance painting, to Pisanello, an artist known less for his paintings than for his medals, examples of which are found in all the major public and private collections of the world. Their common teacher transmitted to both students his love for classical civilization, studied through drawing, and Jacopo Bellini in turn passed it on to his two painter sons, Gentile and Giovanni. But while Gentile went on to specialize in portraits and historical paintings and Giovanni in portraits and

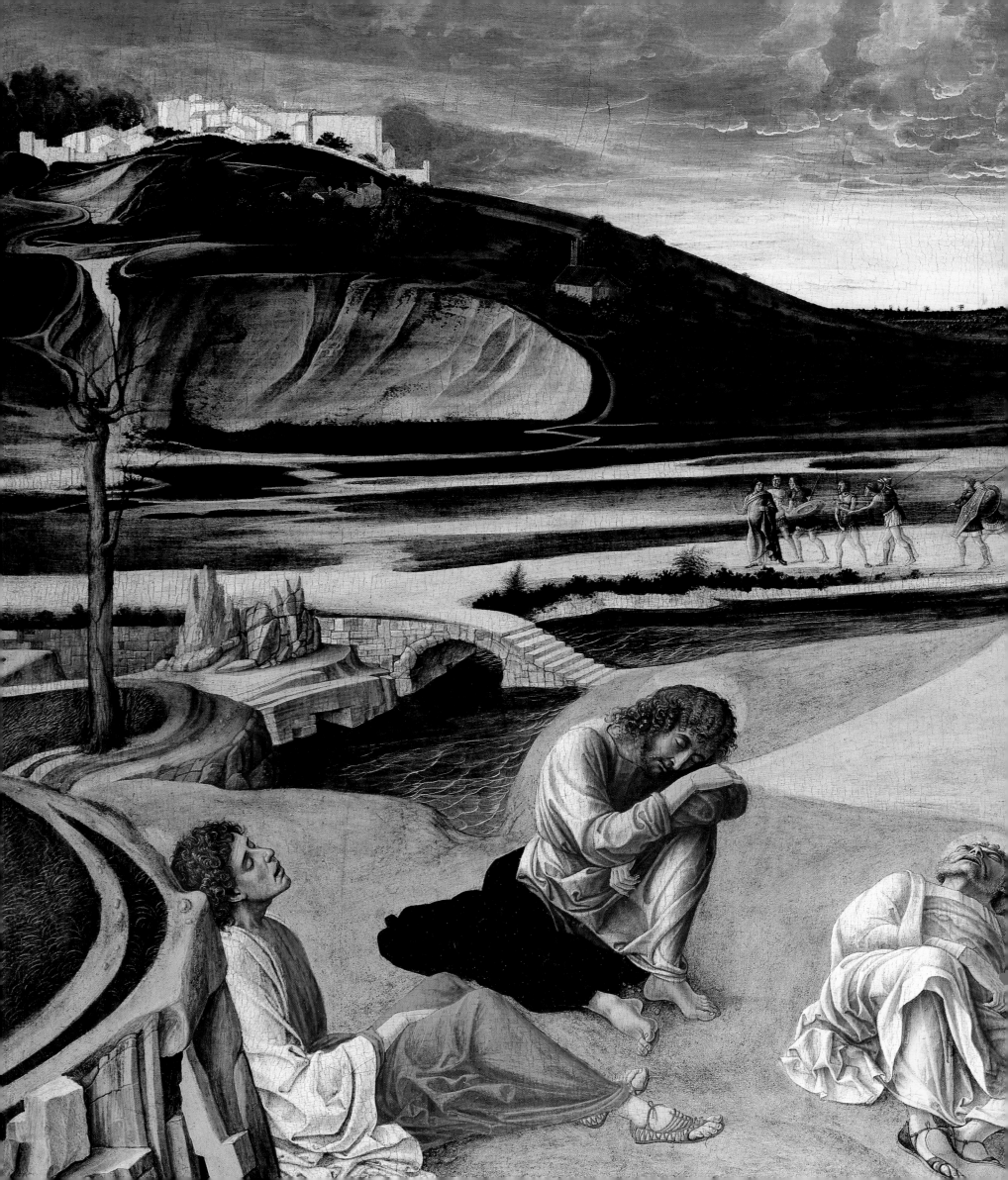

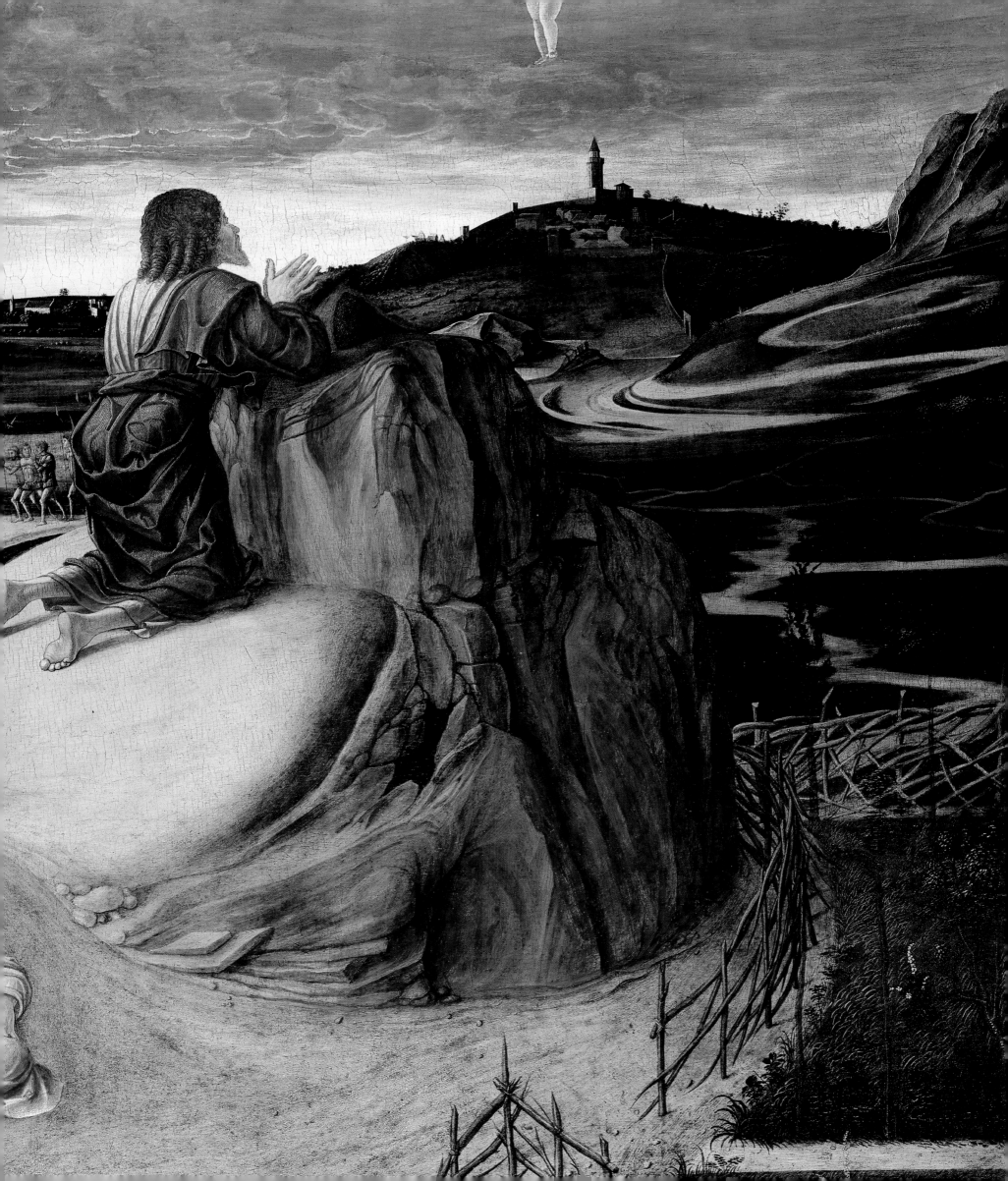

Christian works, it was Andrea Mantegna, Jacopo's son-in-law, who took up this interest in the classical and pagan world, an interest initially sparked while he was in the workshop of Francesco Squarcione.

Today visitors to Venice are fascinated primarily by the physical aspect of the city on the lagoon, the city once the mistress of the Mediterranean: by its unique urban situation, by the cultural and folkloric events that mark the seasons. Those who go deeper into the churches and the museums find numerous artistic treasures, including some of the works by the greatest Venetian painter bridging the fifteenth and the sixteenth centuries: Giovanni Bellini. The man considered by art historians to be the master of Giorgione, Titian, Sebastiano del Piombo—the master, that is, of the three greatest exponents of the pictorial school of the Serenissima in the early sixteenth century. Cultured tourists in Venice stand transfixed before his *Frari Triptych,* his *San Zaccaria Altarpiece,* and his works in the Accademia.

Many of Giovanni Bellini's masterpieces are owned by great museums and important collections around the world, from London, Paris, Berlin, and Stockholm to New York and Washington, D.C., while the Uffizi has three of his loveliest and most important works, though none of them were collected by the Medici. The taste and choices guiding the accumulation of the collection of the Grand Dukes of Tuscany could be the topic for a whole other book; here it suffices to say that the majority of non-Tuscan paintings in the Uffizi, and particularly the Venetian works, came to Florence from Urbino and Pesaro in 1631 in connection with the marriage of Vittoria della Rovere to the Grand Duke Ferdinand II.

On February 7, 1506, Albrecht Dürer, in Venice during the course of his second trip to Italy, wrote a letter to his friend and correspondent, the celebrated humanist Willibald Pirkheimer, in his home city of Nuremberg. Speaking of Giovanni Bellini, Dürer wrote, "Everyone tells me what an upright man he is, so that I am really friendly with him. He is very old, and yet he is the best painter of all." One of the most important artists in the history of European art, a painter, designer, engraver, and scholar of perspective, Dürer was tightly bound to Italy in a relationship of mutual exchange. Then thirty-five years old, he was at the height of his own artistic powers.

His opinion is of great importance to us since it indicates that he was fully aware of the role Giovanni Bellini held in Venetian painting immediately after the middle of the first decade of the sixteenth century, and because it also indicates how much the situation had changed since Dürer's first trip to northern Italy twelve years earlier, at which time he seems to have established a close relationship instead with Giovanni's brother-in-law Andrea Mantegna, another artist of the highest level, admired and heaped with honors by the most important patrons of his time, who died in that very year, 1506.

Giovanni's older brother, Gentile, was still active, if only for another year. He still enjoyed his position as state painter for Venice and had behind him his experience as court painter and portraitist at the court of Muhammad II in Constantinople. That same year Vittore Carpaccio was working on the canvases of San Giorgio degli Schiavoni.

Giovanni himself was especially busy at that time, working alongside a team of associates slowly covering the walls of the Sala del Maggior Consiglio in the Doge's Palace of Venice with history paintings—paintings destroyed by fire in 1577, a loss that has caused

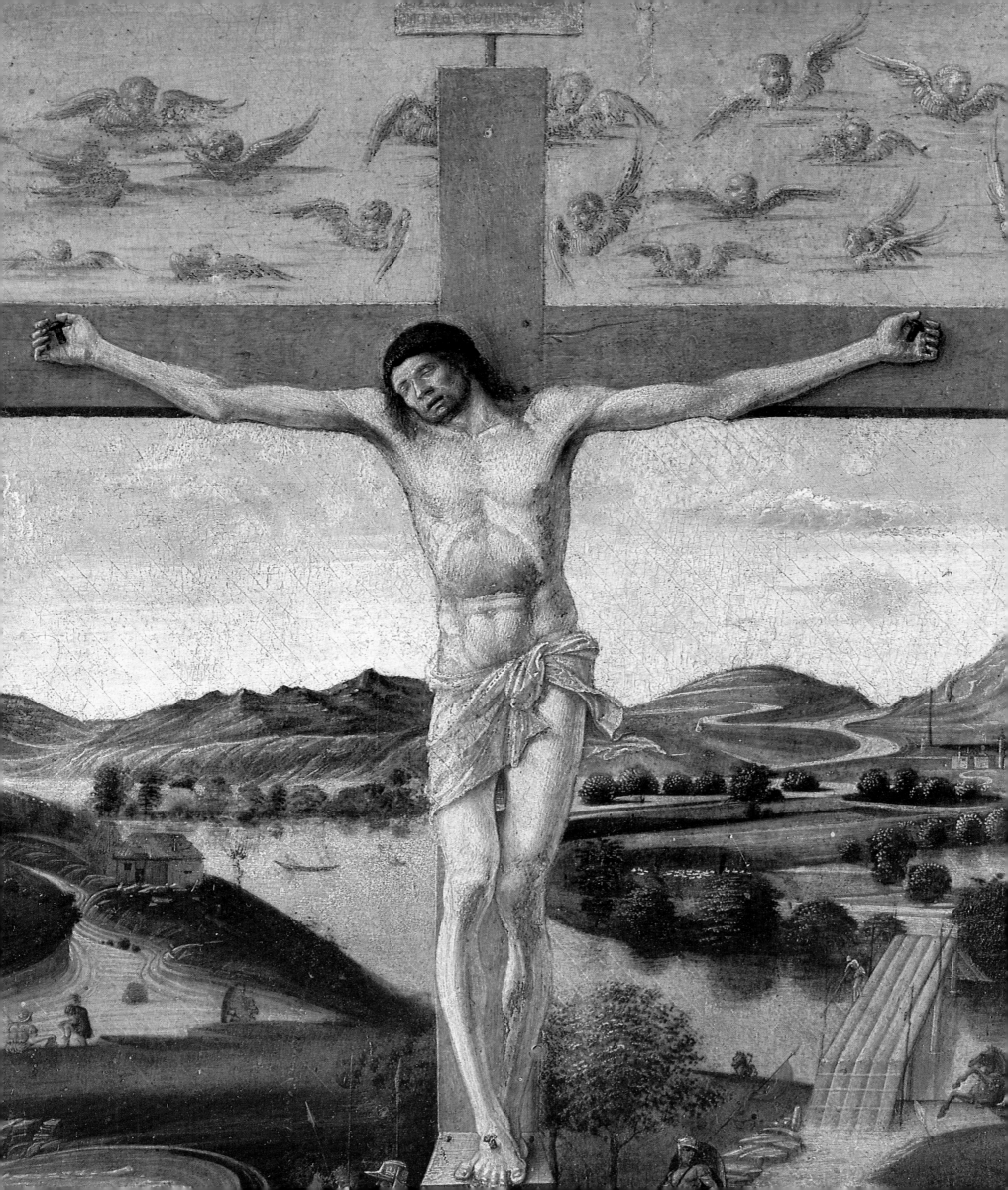

problems in the identification of the artist's late works. Dürer's statement can also be taken as an indication that early in 1506 Venice had not yet been taken over by the new vogue for Giorgione. It would therefore further confirm what is already known from historical sources: that there is no precise information before 1507 concerning activity by Giorgione in Venice. Titian and Sebastiano del Piombo appeared on the scene in 1508, making, respectively, the frescoes on the side walls of the Fondaco dei Tedeschi and (for the same clients, the German community in Venice) the organ doors of San Bartolomeo a Rialto, the church of the German community. Dürer himself worked for those same clients, painting the *Feast of the Rose Garlands* in 1506, a work that is now housed in the National Gallery of Prague.

Leonardo da Vinci was in Venice in 1500, and his presence in the city cannot have gone completely unnoticed; by then he was laying the basis for a revolution in tonalities. But there are good reasons to believe that, aside from experiments carried out in restricted circles and in cultural settings that could be called the fringe, his ideas did not affect much of Venice. New ideas, new painting techniques, and new artistic themes were taking hold in Italy, but proposing them to the rulers of Venice would have been impossible until well past the middle of the first decade of the new century. These same ideas had already begun to fascinate the rulers of the time in Mantua and Ferrara, but even in those cities such ideas would not have taken hold as firmly as they did had the setting not been well prepared with a firm foundation of culture and philosophical thought, such as that found in the group that gravitated around such humanists as Pietro Bembo and Paolo Giustiniani, the Paduan Averroists, and the small Asolo court of the exiled queen of Cyprus, Caterina Cornaro. By 1506 Giovanni Bellini was probably almost seventy-five years old. His work as a painter had begun in his father's workshop, one of the most active of the period, and one of the primary forces in the artistic evolution that led mid-fifteenth-century Venice to finally break with the Middle Ages and follow the route that had been traced at least two decades earlier by the painters, sculptors, and architects of Florence. Also important in that evolution, although using different models, were Jacopo Bellini's master, Gentile da Fabriano, and even Jacopo's fellow student and rival Pisanello.

BIOGRAPHY AND DOCUMENTS

Giovanni Bellini's early biography presents two mysteries, one concerning the date of his birth and the other his legitimacy.

In February 1429, Jacopo's wife, Anna Rinversi, made her will, for she was soon to give birth to her first child. That child is usually thought to be Gentile but, as Meyer zur Capellen (1985) made clear in his monograph on the artist, no sure facts exist to support that belief. The child might have been Nicolosia or the other child, named Nicolò, mentioned by Anna Rinversi in her later will, made in 1471 following the death of her husband. But it has been suggested that the name Nicolò in that document stands for Nicolosia and is no more than a handwriting error. Certainly it seems strange that the same name should be given to two children in both male and female versions; it seems more likely that the perpetuation of the name of Jacopo's father, Nicolò, was ensured with the

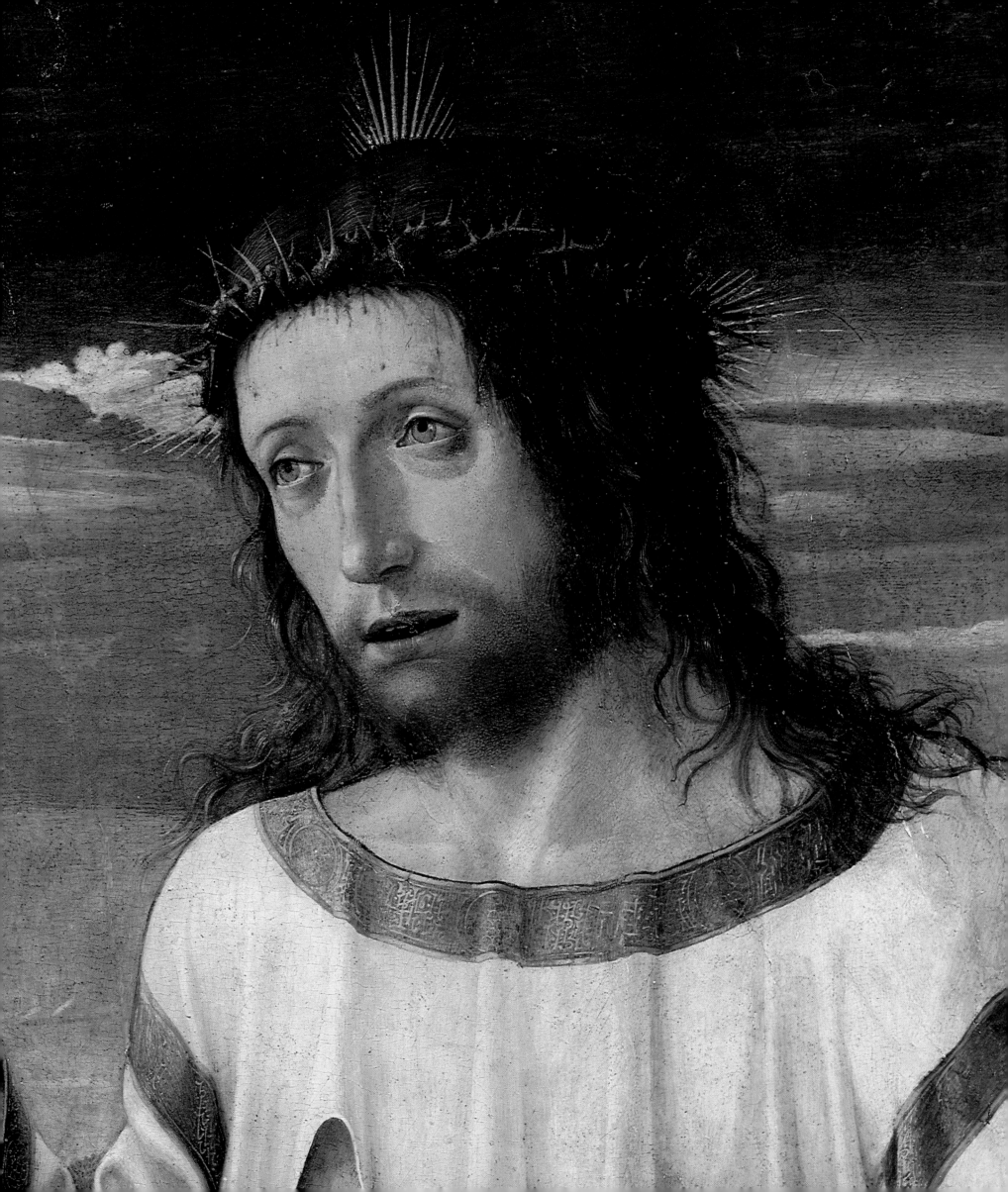

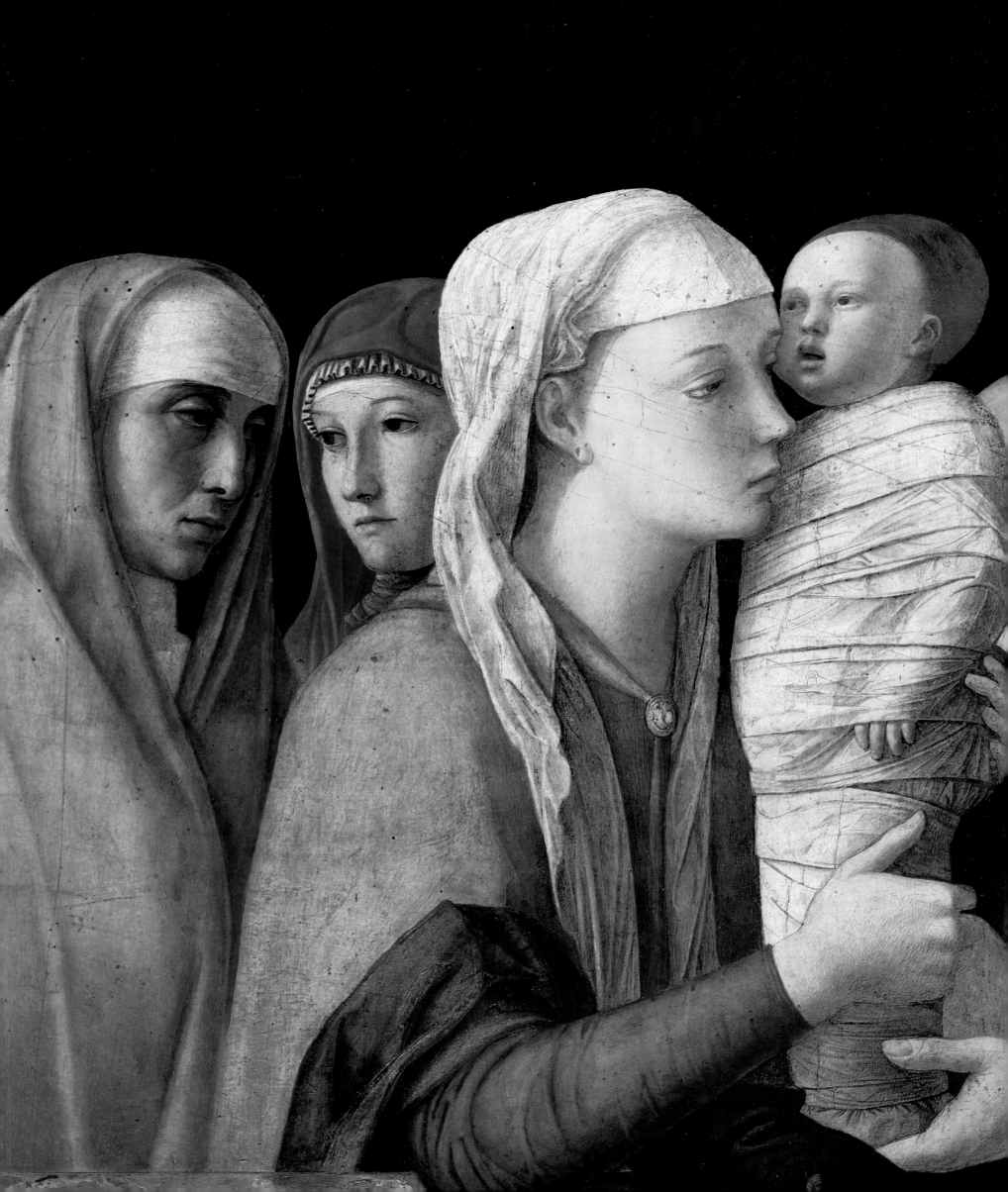

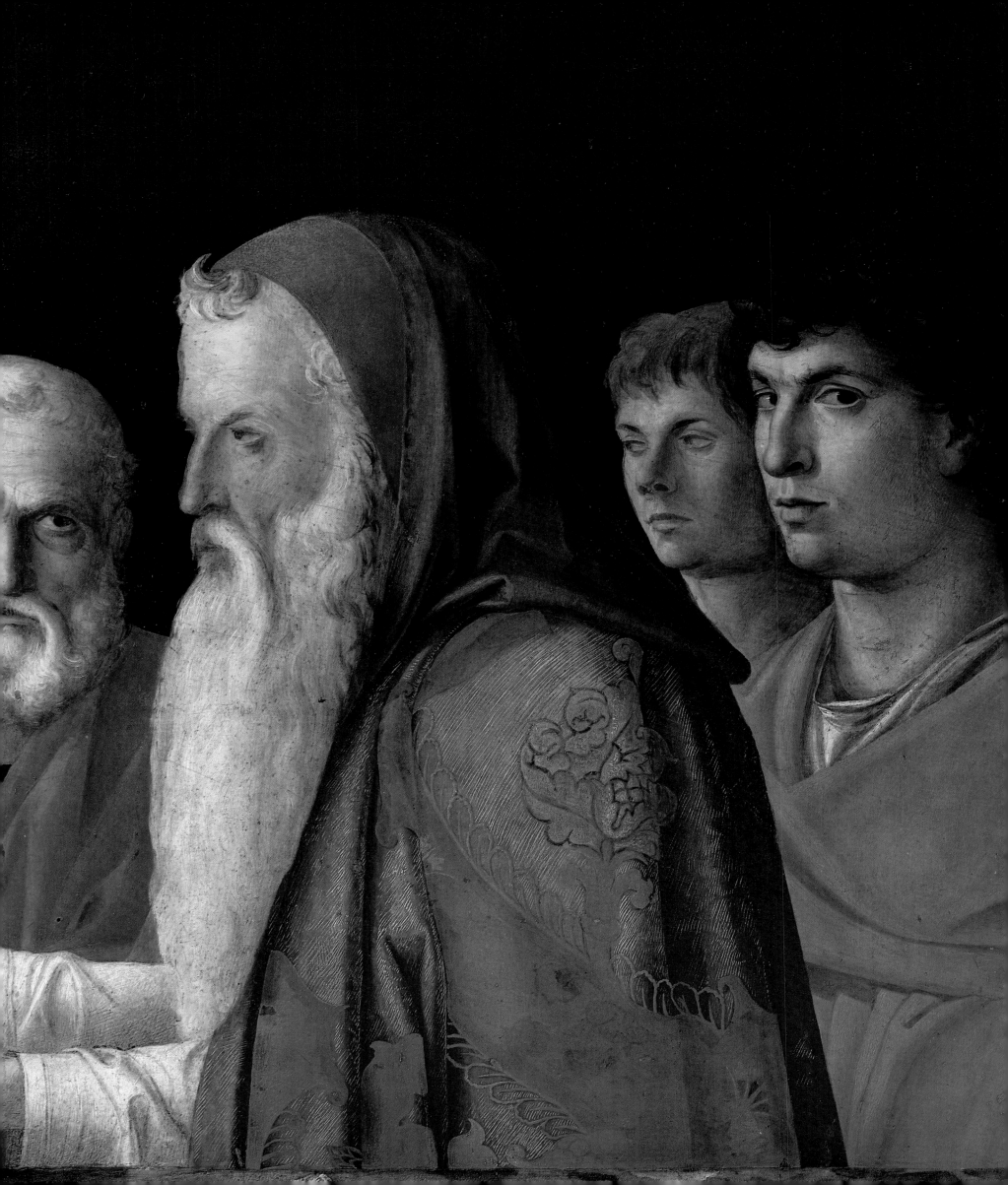

firstborn child—in keeping with the will Nicolò made in April 1424 in which he imposed his name on the firstborn child, even if female—and that both Gentile and Giovanni were born later. This confirms the thesis of the late Felton Gibbons (1963) who, on the basis of his identification of the members of the Bellini family in the *Miracle of the Cross,* made by Gentile in 1500 and today in the Accademia of Venice, asserted that Nicolosia was born in 1429 and that she married Andrea Mantegna in 1453, while Gentile was born in 1431, and Giovanni around 1433.

According to Giorgio Vasari, when Giovanni died in 1516 he was ninety years old. For that to be true he would have had to be born in 1426, which is impossible since he was younger than Gentile, who was the son of Jacopo Bellini and Anna Rinversi.

In 1460 Giovanni signed, with his father and his brother Gentile, the altarpiece in the Gattamelata Chapel of the basilica of Sant'Antonio, known as Il Santo, in Padua, a work that is in part lost. But the preceding year, when he signed as the witness to a will for the notary Giuseppe Moisis, he was living alone, or perhaps with his first wife, in the San Lio area of Venice, not far from the home in which he would live in 1485, near Santa Marina, when he guaranteed the dowry of his wife Ginevra Bocheta, probably his second wife. This is also in the area between the Rialto and Santi Giovanni e Paolo, the large Dominican church (better known by its Venetian name of San Zanipolo) in which both Giovanni and his brother Gentile were to be buried. In the signature on the Paduan altarpiece Giovanni's name follows that of Gentile, a further indication of his younger age and also, perhaps, of his illegitimacy.

According to Ridolfi (1648), Giovanni signed a painting (now lost) for the Scuola di San Girolamo in 1464. Thus he seems to have been independent in 1459, to have worked with his father and brother in 1460, and to have acted alone again in 1464; the *Carità Trip-tychs* (cat. 5; now lost) and the *Polyptych of Saint Vincent Ferrer* in San Zanipolo (cat. 9) date to the first years of the 1460s, and both works are in some measure attributable to him, but they certainly still belong to a period of formation and experimentation.

We must look to c. 1470 before we find Giovanni Bellini expressing himself with the kind of figurative language we would expect from an artist who is no longer a novice. If we accepted the date of birth implied in the statement from Vasari, which is put back by one year to 1425 by Fiocco (1949) and Bottari (1963), we would be forced to conclude that Giovanni Bellini was forty-four or forty-five years of age when he finally came into the beginning of his stylistic maturity. We would have to believe that until then he had made works that are rated highly by many art historians but that show him to be one of the most uncertain, eclectic, contradictory, tormented, and elusive artists of the fifteenth century. We would have to believe, finally, that at the exact midpoint of his existence he suddenly revealed himself to be one of the most balanced, serene, and coherent painters in the entire history of art. Simply put, his date of birth cannot possibly be earlier than the one proposed by Gibbons and should perhaps even be brought ahead to 1435: even Francesco Negro, writing between 1501 and 1521 (cited by Michiel, 1521-43), refers to Giovanni as Gentile's younger brother.

In the will she made out in 1471, Jacopo Bellini's widow does not name Giovanni. The theory that Giovanni was the child of an adulterous relationship of Jacopo's is based primarily on this circumstance, which a statement from Vasari seems to support: speaking

Pages 24–25
PRESENTATION OF JESUS
IN THE TEMPLE
Detail
Pinacoteca Querini
Stampalia, Venice
(cat. 21)

CORONATION OF THE
VIRGIN BETWEEN SAINTS
PAUL, PETER, JEROME,
AND FRANCIS
Detail of right pilaster:
SAINT LOUIS OF TOULOUSE
Museo Civico, Pesaro
(cat. 27; complete image on
page 97)

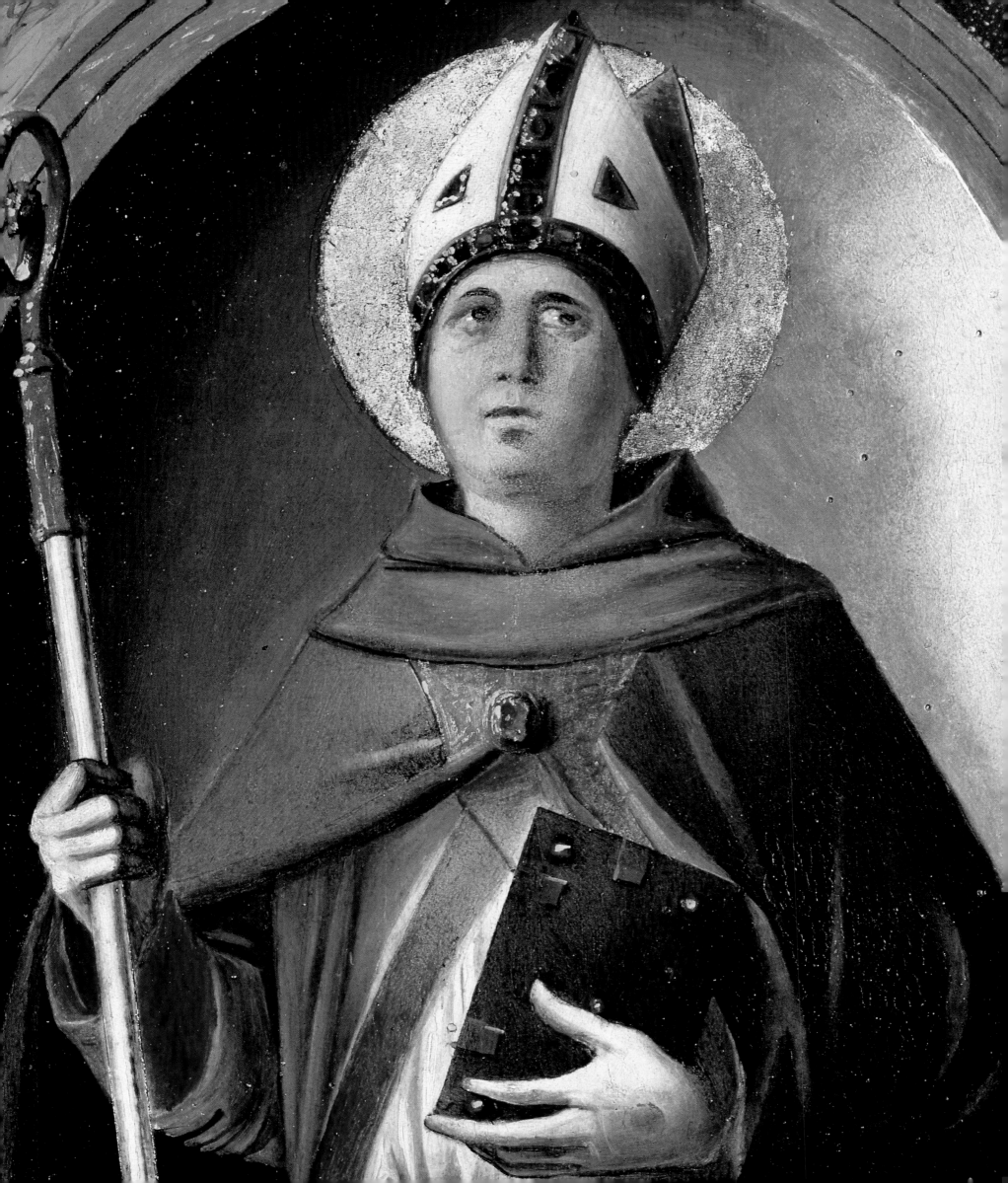

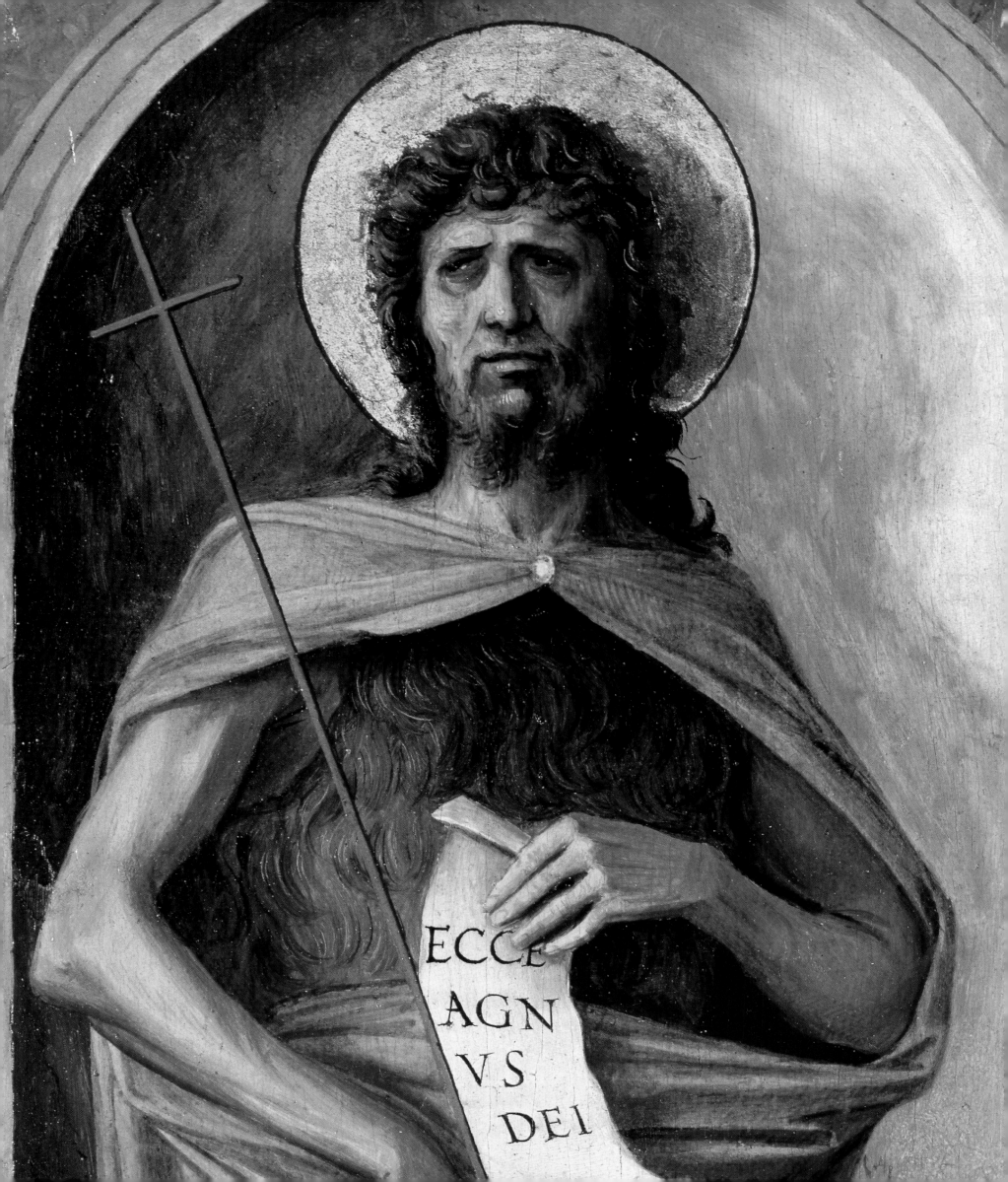

of Nicolosia's marriage to Andrea Mantegna, Vasari refers to her as the daughter of Jacopo and the sister of Gentile, but does not mention Giovanni.

Contemporary documents allow us to trace Giovanni's career. On April 24, 1470, Giovanni signed an agreement to make a canvas, *The Flood with the Ark of Noah,* for the Scuola Grande di San Marco, but the work may never have been made since the same commission was entrusted to Bartolomeo Montagna in 1482. In the same period, sometime between January 1470 and November 1471, Giovanni's father, Jacopo, died. The date of June 20, 1474, appears on the *Portrait of Jörg Fugger,* today in Pasadena, a work unanimously attributed to Giovanni (cat. 26). In 1475 he began working together with his brother Gentile on the execution of paintings for the Doge's Palace in Venice. On August 28, 1479, he officially replaced Gentile as director of the restoration of the paintings in the Sala del Maggior Consiglio, for his brother had been sent by the Venetian government to the court of Muhammad II in Constantinople. The following year, on July 1, the Ufficio del Sale allotted him, as payment for the aforementioned works, the sum of eighty ducats and the lifetime right to the next available *senseria* (broker's patent) of the Fondaco dei Tedeschi. On February 26, 1483, he was nominated official painter of the republic and thus exempted from paying fees to the painters' guild: the fact that he was already about fifty years old is an indication of the difficulties he encountered in establishing his reputation among the leading public patrons, perhaps because of his status as an illegitimate son. On June 30 of that year Gaspare Trissino of Vicenza provided for payments in his will for Giovanni to paint a Resurrection for the Trissino funerary chapel in the cathedral of Vicenza. The painter's name appears the next year in the *mariegola* (rule book) of the Scuola Grande di San Marco as a member; he was also a member of the Scuola di San Cristoforo dei Mercanti and, together with his brother Gentile, of the Scuola Grande della Misericordia.

As Robertson (1968) points out, 1487 is the earliest known date that is accompanied by Giovanni Bellini's signature on a work, *The Madonna of the Young Trees* (cat. 65), which is now in the Accademia of Venice. In May of that same year he is recorded as witnessing a document in the home of the Pesarese humanist Pandolfo Collenuccio, procurator in Venice of the Varano, lords of Camerino. In 1488, while working with Gentile for the Sala del Maggior Consiglio in the Doge's Palace, he signed and dated the *Barbarigo Votive Altarpiece* (cat. 66), now in San Pietro Martire in Murano, and the triptych still in place in the sacristy of Santa Maria Gloriosa dei Frari in Venice (cat. 67); the latter work was completed in February 1489. On September 23, 1489, his wife, Ginevra Bocheta, mother of Alvise, made her will; the year of her death is unknown, but she was dead in 1498 when Alvise wrote his will. Alvise is thought to have died in 1499, although this is not certain; it is known, though, that he did not outlive his father.

In 1490 Giovanni signed and dated the *Supper at Emmaus,* made for the Cornaro family and destroyed by fire in Vienna: the best surviving replica, which some scholars, including Goffen (1989), believe to be partly autograph, is the one now in the Venetian church of San Salvatore. On March 25, 1492, Giovanni began a new phase in his activity for the Sala del Maggior Consiglio; his collaborators were Alvise Vivarini, Cristoforo Caselli da Parma, Lattanzio da Rimini, Marco Marziale, Vincenzo dalle Destre, and Francesco Bissolo. On July 15 of that year he was sick: his brother Gentile assumed in both their names the

responsibility of making several canvases for the Scuola Grande di San Marco in order to replace those destroyed by fire in 1485.

On July 14, 1494, Giorgio Diletti provided in his will for the construction of a chapel and creation of an altarpiece in the Venetian church of San Giovanni Crisostomo. The painting is still in place, signed and dated by Giovanni in 1513 (cat. 119).

Between 1496 and 1505, Giovanni exchanged a series of letters with the court of Mantua concerning a painting that he was supposed to make for the studiolo of Isabella d'Este. The first letter regarding the work is from November 1496; the following year Isabella's husband, Francesco Gonzaga, wrote a letter to Giovanni, who had already refused to paint a view of Paris for him, explaining that he was unfamiliar with that city. Francesco now asked Giovanni to paint him a subject of his own choosing, and the artist promised to do the best he could. On August 10 of that year Donato Civalelli, in his will, allocated three hundred ducats to Giovanni for an altarpiece to be placed in the church of Santa Maria in Zara.

In August 1501 the painter was still working for the Doge's Palace and had finished the *Saint Dominic* for Duke Alfonso I d'Este (cat. 95); his dealings with Isabella d'Este continued. In July 1504 he delivered a Presepio, or Nativity, that she liked, as indicated in her letter of August 27, 1505; she then asked him to make a painting for her personal studiolo, leaving to him the choice of subject. In the same year, Giovanni dated the *San Zaccaria Altarpiece* (cat. 106), still in place; the *Saint Jerome in the Desert,* now in the National Gallery of Art in Washington, D.C. (cat. 107); and the *Vernon Sacra Conversazione,* now in the City Museum and Art Gallery of Birmingham (cat. 108).

In 1507, Giovanni Bellini signed and dated the *Dolfin Sacra Conversazione* in San Francesco della Vigna, Venice (cat. 112), which Giacomo Dolfin, in his will of February 7, 1506, referred to as a painting in the course of execution. On February 18, 1507, Gentile Bellini dictated his own last will and testament, entrusting to his brother Giovanni the task of completing *Saint Mark's Sermon in Alexandria* for the Scuola Grande di San Marco, now in Milan's Pinacoteca di Brera (cat. 113), in return for which Gentile bequeathed him one of the two sketchbooks made by their father, Jacopo (the one that is now in London). According to Gentile's will, the sketchbook would pass to Gentile's wife should Giovanni fail to meet his contractual obligation; on March 7, 1507, Giovanni agreed to complete his brother's painting.

On September 28, 1507, following the death of Alvise Vivarini, Giovanni was urged to complete (in collaboration with Vittore Carpaccio and Vittore Belliniano) the three main canvases still missing for the Sala del Maggior Consiglio. Of these paintings, one had been begun by Alvise and left unfinished at his death, and the other two were works commissioned from Giovanni.

It may have been during this same period, and was certainly sometime after January 1506, that Bartolomeo Leonico Tomeo, known as Fusco, composed a Latin poem, contained in Venice's Biblioteca Marciana (manuscript Lat. XII 158 [4023]), that refers to a homosexual relationship between Giovanni and an attractive youth. The poem was published by Giovanni Agosti (1996), who points out the incongruity between the title, which in the form of a dedication refers to Giovanni Bellini as a distinguished painter, and the text, in which the artist is called a marble sculptor. The work recalls those by Catullus

Jacopo Bellini
THE FLAGELLATION
Cabinet de Dessins RF 1483
Musée du Louvre, Paris

Pages 30–31
CORONATION OF THE
VIRGIN BETWEEN SAINTS
PAUL, PETER, JEROME,
AND FRANCIS
Detail
Museo Civico, Pesaro
(cat. 27; complete image on
page 97)

in which the Roman poet accused Julius Caesar and other leading figures of Rome of homosexuality. From its tone, Fusco's poem seems less like a eulogy to happy love than an ironic and perhaps intentionally defamatory pamphlet, designed to harm a painter who held great power in Venice precisely when a new generation of artists, in some senses led by Giorgione, was struggling to make its mark. It seems possible that following the death of Gentile, when the increased number of commissions given Giovanni only strengthened his position as state painter and favorite artist of the leading Venetian scuole, there were some who wished to cast a shadow on his moral image. An insinuation of this type could have seriously damaged the artist, for the Venetian government displayed little tolerance for homosexuality: numerous trials for sodomy were held during these decades in Venice and in the territories under its rule, including the trial of the painter Antonio di Cristoforo da Firenze in Udine in 1489.

Jacopo Bellini
INTERIOR WITH WARRIOR
PRESENTING THE HEAD OF
HANNIBAL TO PRUSIAS
Cabinet de Dessins RF 1509
Musée du Louvre, Paris

The date of 1509 appears on *The Killing of Saint Peter Martyr* in the Courtauld Institute in London, but today it is considered a variant replica by Andrea Previtali of the autograph version, which is in the National Gallery of London (cat. 109). In 1510 Giovanni signed and dated the *Virgin with the Blessing Child* in the Brera (cat. 117).

On November 13, 1514, Giovanni Bellini received the final payment of eighty-three ducats from Duke Alfonso I d'Este for *The Feast of the Gods* in the studiolo of Ferrara, today in the National Gallery of Art in Washington, D.C. (cat. 120). On February 27, 1515, he was still working for the Sala del Maggior Consiglio, as indicated by a payment received on that date by Vittore Belliniano, then working as one of his assistants. On July 4 of that year he was commissioned by the Scuola Grande di San Marco to paint *The Martyrdom of Saint Mark,* a work that was continued after his death by Vittore Belliniano and completed only in 1526 (cat. 126). Also dating to 1515 are the *Nude Woman with a Mirror* in the Kunsthistorisches Museum of Vienna (cat. 122) and the *Saint Dominic* in the National Gallery of London (cat. 123).

The date 1516 can be read along with the signature on a small painting made in Giovanni's workshop that is not an autograph work, the *Madonna and Child with John the Baptist* now in the Museo Civico of Padua; another example exists, also with a signature and date of 1516, in the Pinacoteca Querini Stampalia of Venice, while a third version shows up on the antiquarian market. By January 15, 1516, the painter had almost completed a Madonna destined for the sister of the king of France, Francis I, about which we have no further information.

On November 29, 1516, the diarist Marino Sanudo noted, "one heard this morning Giovanni Bellini, the excellent painter, is dead . . . his fame is known throughout the world." Unfortunately, Sanudo said nothing about the artist's age, although he did add that Giovanni was buried in the tomb in San Zanipolo where his brother Gentile already lay.

No journeys outside Venice are mentioned in the known biographical information on Giovanni Bellini. But it seems likely that Giovanni visited Romagna, the Marches, and Verona and Vicenza because buildings from Ravenna, Rimini, Ancona, and Verona appear in his paintings, and a view of Vicenza provides the background for the *Donà dalle Rose Pietà* now in Venice's Accademia (cat. 103). He could have used the repertory of pictures in sketchbooks or models to make these images, but it seems more probable that himself drew the classical monuments and civil and religious buildings that appear in his

works, from the *Coronation of the Virgin* (cat. 27) to *The Martyrdom of Saint Mark* (cat. 126), works ranging from right after 1470 all the way to 1516.

TRAINING

Alongside his brother Gentile, who was probably his senior by only a few years, Giovanni Bellini had the good fortune to receive his artistic training from his father, Jacopo, who played an important role in the evolution from the International Gothic to the Renaissance. Despite the almost total loss of his pictorial output, Jacopo Bellini's importance is made clear by the two sketchbooks he created, one now in the Louvre and the other in the British Museum. He left these to his widow, who then passed them on to Gentile, who, in February 1507, assigned one (the one today in London) to Giovanni in his will, having donated the other to Muhammad II while serving that ruler as court painter.

The marriage of Jacopo's daughter, Nicolosia, to Andrea Mantegna in 1453 sealed the ties between Jacopo's Venetian workshop and the Paduan workshop directed by Francesco Squarcione, Mantegna's master and godfather. In moving to the Veneto, the new artistic language from Tuscany first took hold in Padua, in large part because of the presence there of Donatello for at least ten years beginning in 1442. That artistic language reached Venice by way of artists working at the basilica of San Marco and the Doge's Palace. Among these were the sculptor Nanni di Bartolo, called Il Rosso, who passed through in 1424 and worked in San Marco; Andrea del Castagno, active in the San Tarasio Chapel in San Zaccaria in 1442; and Paolo Uccello, who had already been in Venice in 1425 and who went to Padua twenty years later at the behest of Donatello and made the frescoes of Famous Men (destroyed) in the entrance to the Casa Vitaliani. Filippo Lippi had also been active in Padua in 1443, so it is no surprise that a painter like Domenico Veneziano, though an enigmatic figure, was able to join the figural world of Florence at the end of the 1430s. Together with Piero della Francesca, who was then just beginning his career, Domenico brought a new energy to Florence and contributed to the spread of Leon Battista Alberti's ideas on perspective, which encountered resistance in the city of Brunelleschi, at least on the level of monumental architecture.

In addition to his father's teaching, one of the most important contributions to Giovanni's early artistic formation seems to have been Donatello's dramatic expressiveness as translated through Andrea Mantegna's works, leading him to make such works as *The Transfiguration* (cat. 7) and the *Crucifixion with the Mourners in a Landscape* (cat. 12) in the Museo Civico Correr in Venice, *The Prayer in the Garden* (cat. 8) in the National Gallery in London, and the *Presentation of Jesus in the Temple* (cat. 21) in the Pinacoteca Querini Stampalia, Venice. The tormented, analytic structure of the drapery on the lean figures, which seems engraved in some inflexible material, is also a trait peculiar to the Muranese school, which was itself strongly drawn to the figural universe of Donatello. This was especially true around the middle of the century when Bartolomeo Vivarini began to work in Padua alongside his brother Antonio. This is the cause of the uncertainty surrounding several paintings whose attribution oscillates from among Giovanni Bellini, Lazzaro Bastiani, and Bartolomeo and Alvise Vivarini.

THE DEAD CHRIST
WITH FOUR ANGELS
Detail
Pinacoteca Comunale, Rimini
(cat. 33; complete image on
page 107)

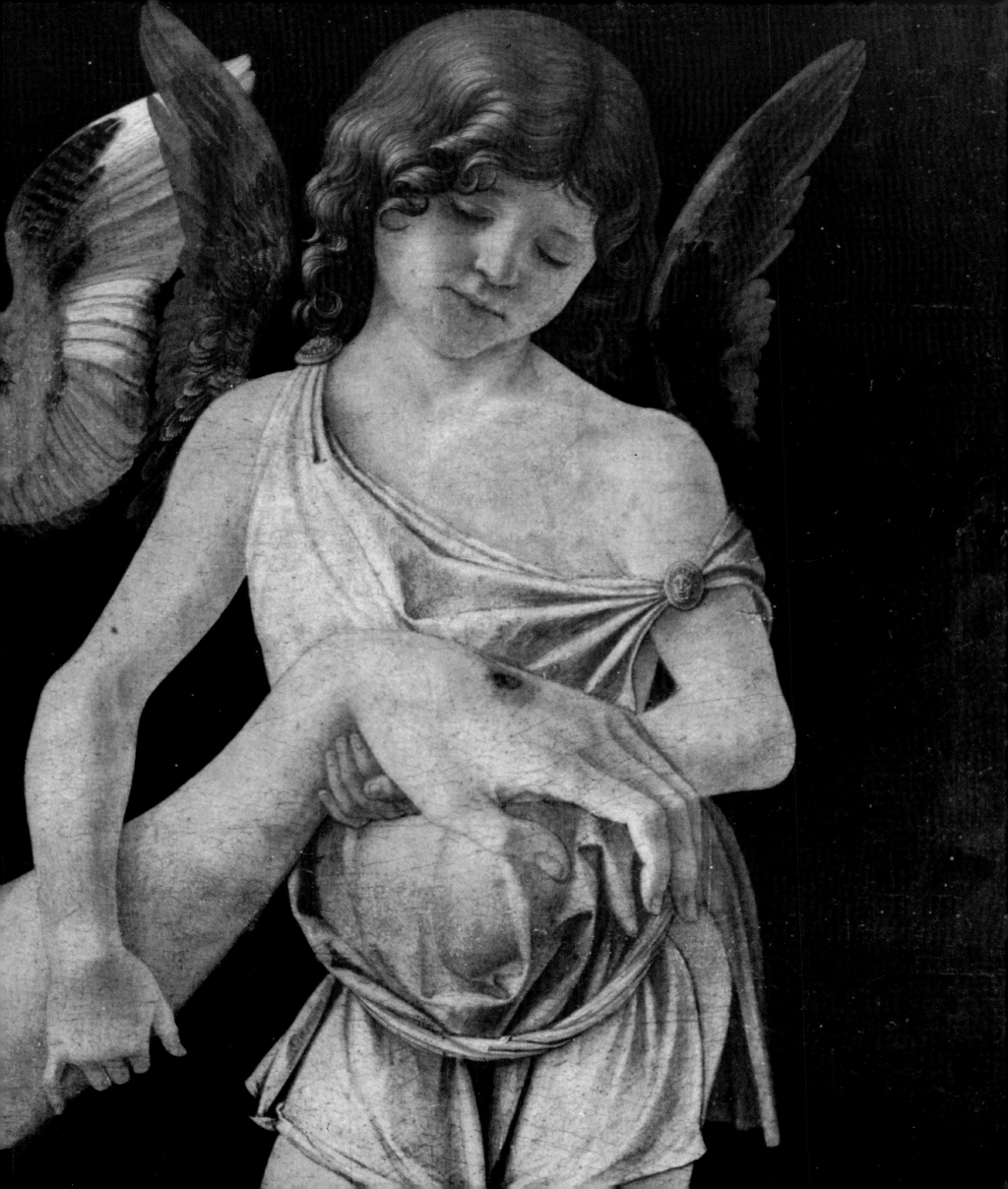

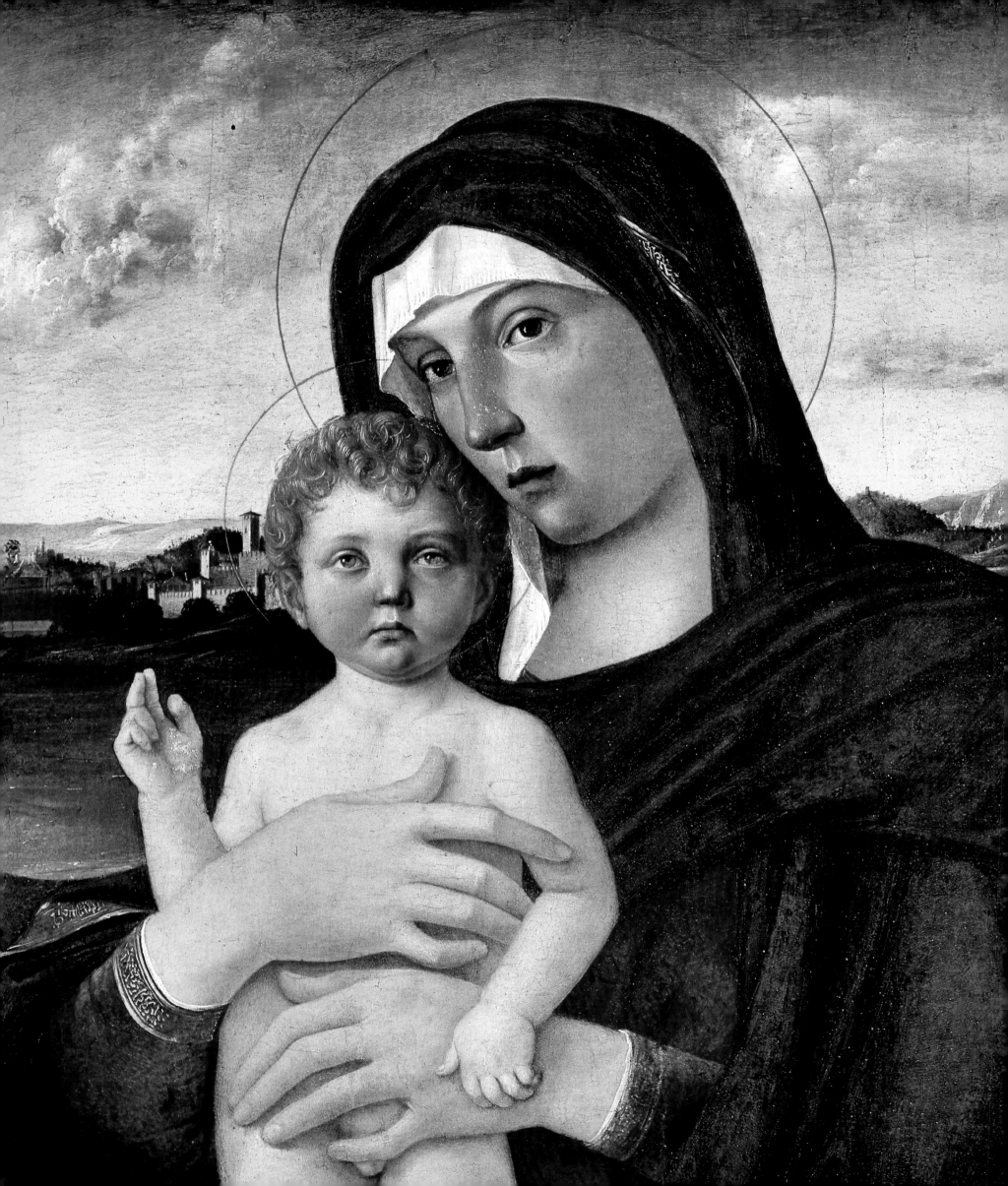

PROBLEMS IN ATTRIBUTION

Though the precise year of his birth is unknown, and though he may well have been an illegitimate child, Giovanni Bellini was the most important painter in Venice, at least between 1470 and 1516. An impressive catalog of works is attributed to him, but its outer edges, its beginning and end, are extremely vague because art historians from the time of Crowe and Cavalcaselle (1871) and Morelli (1897) to those in recent years have taken the relatively small number of unquestionable, documented works and added to them the most disparate paintings. Works on Bellini have presented catalogs ranging from around 120 to 160, 180, and even more than 200 works. Finding one's way among this bountiful crop of attributions is not always easy, in particular concerning the artist's early works and those from the closing years of his career.

Giovanni collaborated with his father and brother (or half brother) until at least 1460, the year in which the three of them signed the (in large part) lost altarpiece in the Gattamelata Chapel in Il Santo in Padua. But he must have won himself a certain amount of independence even earlier, since in 1459 he is documented as living on his own, perhaps already with a first wife, in Venice's San Lio parish.

The theory that Giovanni participated in works made by his father has been proposed many times, and by some of the leading scholars of the painter. Among the works to which Giovanni is said to have contributed is the *Crucifixion* in the Museo Civico Correr in Venice, which originally formed part of a single predella (identified by many as being from the *Gattamelata Altarpiece*) with *Christ's Descent into Limbo* in the Museo Civico in Padua and the *Adoration of the Magi* once in the Vendeghini collection in Ferrara, and now in the Pinacoteca Nazionale of Ferrara. Another is the altarpiece with *Seven Saints* in the Museo Piersanti in Matelica (Macerata). A great many Italian art critics agree that Giovanni may have participated in creating the panels of the predella, particularly the *Crucifixion* in the Correr, and even Robertson (1968) accepted this possibility. But only a small group of historians of Venetian art, led by Pallucchini (1959), who cited the convergent opinion of Coletti, has supported Giovanni's participation in the Matelica altarpiece. As for that work, it seems prudent to us to leave it in Jacopo's catalog, but for the other three paintings one must obviously first decide whether to relate them to the altarpiece made by Jacopo and his sons for the Santo in Padua. If they are related to that work, then Giovanni's participation is far more than probable, although the difficulties in identifying Giovanni's precise contribution lead us to prefer excluding the works from the list of autograph works.

When examining the body of works that art historians, from the period of Crowe and Cavalcaselle to the most recent publications, have attributed to Giovanni Bellini, several methods of orientation suggest themselves. One method is to trace clues in historical information, archival documents, authentic signatures, and indicated dates while examining quality and making stylistic comparisons. There is also another method, which involves the identification of the several guiding principles that recur across the span of the artist's activity. In this regard, it is not difficult to recognize the series of panels presenting the Madonna in half length, most of which were made for private devotion. In these works, the central group of the Madonna and Child is flanked sometimes by saints and sometimes by groups including other figures, such as the donor or patron of the work itself. In many

VIRGIN WITH STANDING
BLESSING CHILD
(CONTARINI MADONNA)
Detail
Gallerie dell'Accademia, Venice
(cat. 43)

cases, the differences among the many versions of this type are so minor that the works are referred to by the name of a famous collection that they belong to or once belonged to. The same use of names applies to the numerous Pietàs. There are also many portraits, which like the Pietàs are almost always half length or even more reduced. A fundamental characteristic of Giovanni Bellini is that when presenting religious themes he almost never employs narrations of episodes from sacred history. Exceptions, but only partial exceptions, are the three Transfigurations (cat. 7, 57, 82), *The Baptism of Christ* (cat. 100), *The Resurrection of Christ* (cat. 41), the lost *Supper at Emmaus* of 1490, the so-called Presepio (or Nativity), also lost, sent in 1504 to Isabella d'Este, and *Christ's Descent into Limbo* (cat. 38). This last should, however, be considered an exercise based on a composition designed by Mantegna, along with the oldest of the two examples of the *Presentation of Jesus in the Temple* (cat. 21); the other version of that subject (cat. 78), like *The Circumcision of the Christ Child* (cat. 86), is an intimate close-up view, and seems to be an *Andachtsbild,* a painting designed for meditation, and not a narrative work. All the other religious paintings by Giovanni are also close-ups, including the aforementioned Madonnas, the *Christ Bearing the Cross* (cat. 90), the various Crucifixions, and the Dead Christs. In this regard, we should repeat the attribution to Rocco Marconi of the *Lamentation* (today no. 321 in the Accademia of Venice), which many art historians have attributed to Giovanni, along with the *Annunciation* on the external doors of the organ of Santa Maria dei Miracoli, also in the Accademia (nos. 796 and 959), which should probably be restored, without too much hesitation, to Pier Maria Pennacchi. In the *Lamentation* (on which see also Benci and Stucky, 1987), everything speaks the stylistic language of Marconi, a painter of Bergamo who in his final phase was sometimes a sort of alter ego of Palma Vecchio, while the ingenious spatial box in the *Annunciation,* as well as its splendid marquetry, are simply not enough to make one overlook the total absence of the stylistic traits of Bellini.

Giovanni Bellini (?)
Frizzoni Madonna
Museo Civico Correr, Venice

The two panels with *The Two Crucified Thieves* (cat. 56) are probably surviving elements of a single Crucifixion made by Giovanni; this may well be the Crucifixion made for Santa Maria della Carità in Venice, today lost, which was dated 1472 and which is known to have also included the Three Marys and the Doctors of the Church.

There are two other cases in which Giovanni deals with the narration of an episode, but in one of these he was performing a task taken on together with his brother Gentile, and in the other he was completing a work left unfinished by Gentile. These are *The Martyrdom of Saint Mark* (cat. 126) and *Saint Mark's Sermon in Alexandria* (cat. 113), both made for the Scuola Grande di San Marco in Venice, although the second has since been moved to the Brera in Milan. There are also the extremely early *The Prayer in the Garden* (cat. 8), which seems, however, to have been the theme of a competition with his brother-in-law, and *The Killing of Saint Peter Martyr* (cat. 109).

Roberto Longhi (1946 and 1947) included in the catalog of works by Giovanni the two predella panels formerly from the Contini Bonacossi collection in Florence: the *Adoration of the Magi* and the *Marriage of the Virgin.* Mauro Lucco (1990) has explained that these, like the *Crucifixion with the Virgin,* and the *Saint John, the Magdalene, and Two Angels* in the Museo Civico of Pesaro and the older version in the Museo Poldi Pezzoli in Milan, although considered autograph works by Giovanni in the past by almost all Italian scholars, not to mention by Berenson, should instead be assigned to another Venetian painter,

whom he identifies as Alvise Vivarini. The artist who made these works is certainly a sort of pseudo-Bastiani stylistically, and identifying him with Alvise Vivarini, the youngest member of the family of Muranese masters, is intriguing. *The Adoration of the Magi,* formerly in the Contini Bonacossi collection, appeared in the auction of Finarte of Milan on March 11, 1997.

The one outstanding characteristic of Giovanni Bellini that shines through all his works is his profound sense of religious faith. Giovanni's religiosity is not worldly, it is not related to the more "earthly" aspects of the biographical story of Christ; it is free of any treatments of such themes as the miracles and parables, subjects what were quite popular with his students. In some ways, Bellini's faith seems less than fully "Catholic." This subject merits further exploration, particularly in light of the essay by the Tuscan scholar Del Bravo (1983) and the book by Ringbom (1984). According to Del Bravo, Bellini may have spent much time meditating on *De vero et falso bono* ("On the true and the false good") by the humanist Lorenzo Valla, which dates to about 1430, and he may even have been in contact with Venetian followers of that Roman thinker, such as the bishop Lorenzo Zane. Del Bravo interprets many of Bellini's works on the basis of this insight, from the Correr *Transfiguration* (cat. 7) to the Brera *Pietà* (cat. 10), *The Dead Christ Supported by Two Angels (Pietà)* in Berlin (cat. 39), the *Saint Francis in Ecstasy* at the Frick (cat. 45), the Pesaro *Coronation* (cat. 27), the *Sacred Allegory* in the Uffizi (cat. 88), *The Feast of the Gods* in Washington, D.C. (cat. 120), and the *Nude Woman with a Mirror* in Vienna (cat. 122). It would be best to determine how long it took for Valla's work, which is dated to the period when Giovanni was born, to arrive in Venice and become known there, but we fully agree with Del Bravo in concluding that "the basic coherence among them, which lasted the entire life of the artist, refers back to a particular cultural setting and to its art patrons, which he faithfully followed through its historical permutations: and this can be taken as the indication of a deeply felt decision."

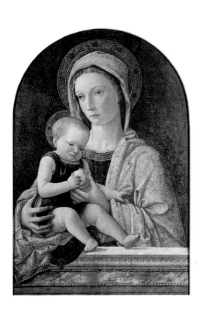

Giovanni Bellini (?)
Trivulzio Madonna
Civiche Raccolte d'Arte
Castello Sforzesco, Milan

GIOVANNI BELLINI AS ILLUMINATOR

Leonardo Bellini, an illuminator whose activity is documented, was the son of one of Jacopo Bellini's sisters and was thus a cousin of Giovanni's. Giovanni Bellini himself, according to the testimony of Michiel (1521-43), had professional contacts with the painter and illuminator Lauro Padovano, and he himself made a miniature in 1474, the portrait of Raffaele Zovenzoni that appeared as an illumination in the manuscript of Zovenzoni's poem *Istrias,* today in the Biblioteca Trivulziana in Milan. Recently Fletcher (1991) thought he had identified this work by Giovanni, believed lost, in an illuminated portrait in the same library that probably originally belonged to Zovenzoni's manuscript. But although the writing that identifies the portrayed person as the Veronese Guarino Guarini should almost certainly be judged unreliable, that fact alone is not enough to confirm attribution of the miniature to Giovanni. Ours is an age in which art history, fortunately, is based less and less on mere connoisseurship; but even so, the quality level of a work and the figurative lexicon of an artist must still be borne in mind as criteria for reference when making new attributions. Far more convincing, although somewhat uncertain given the current state of

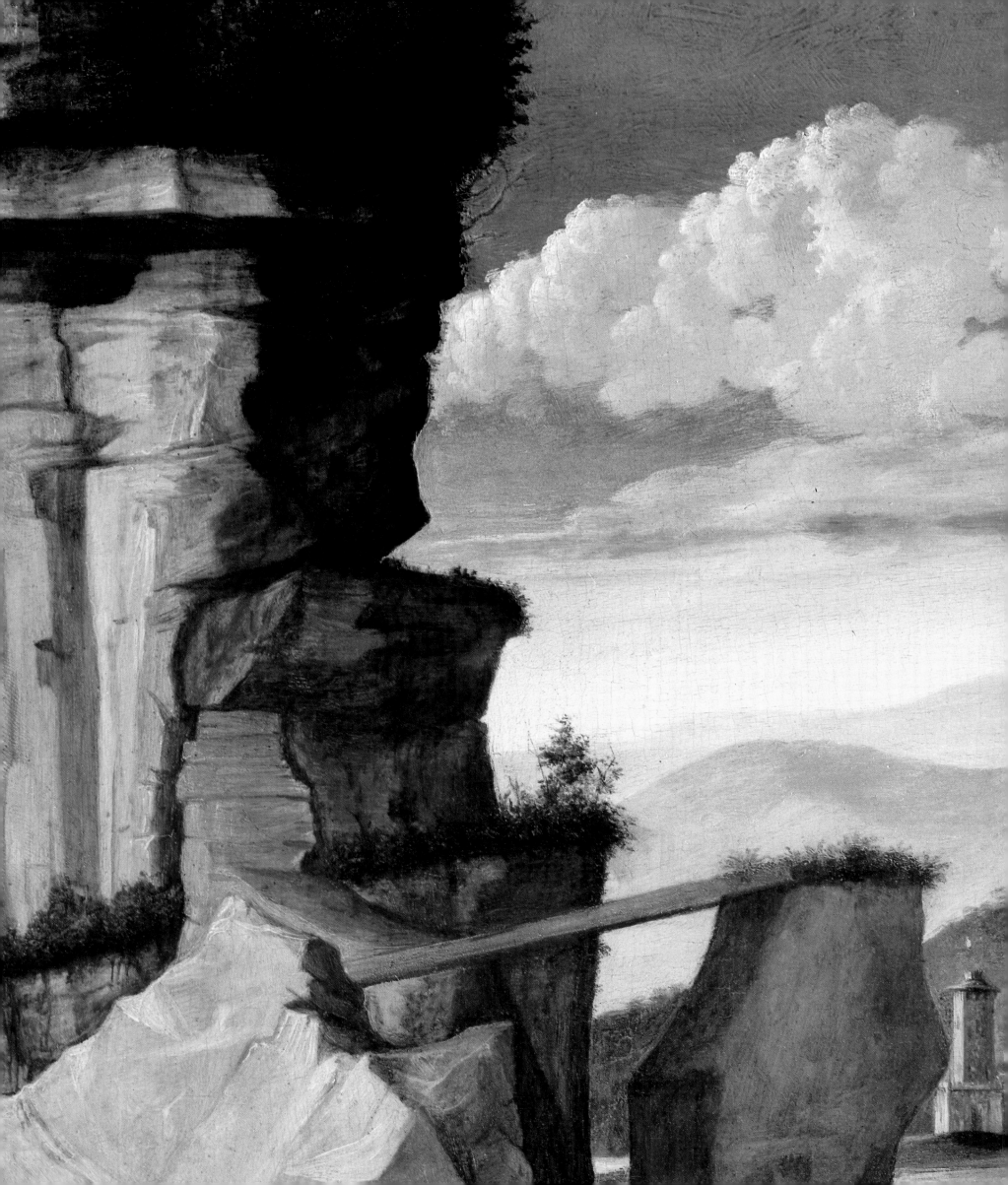

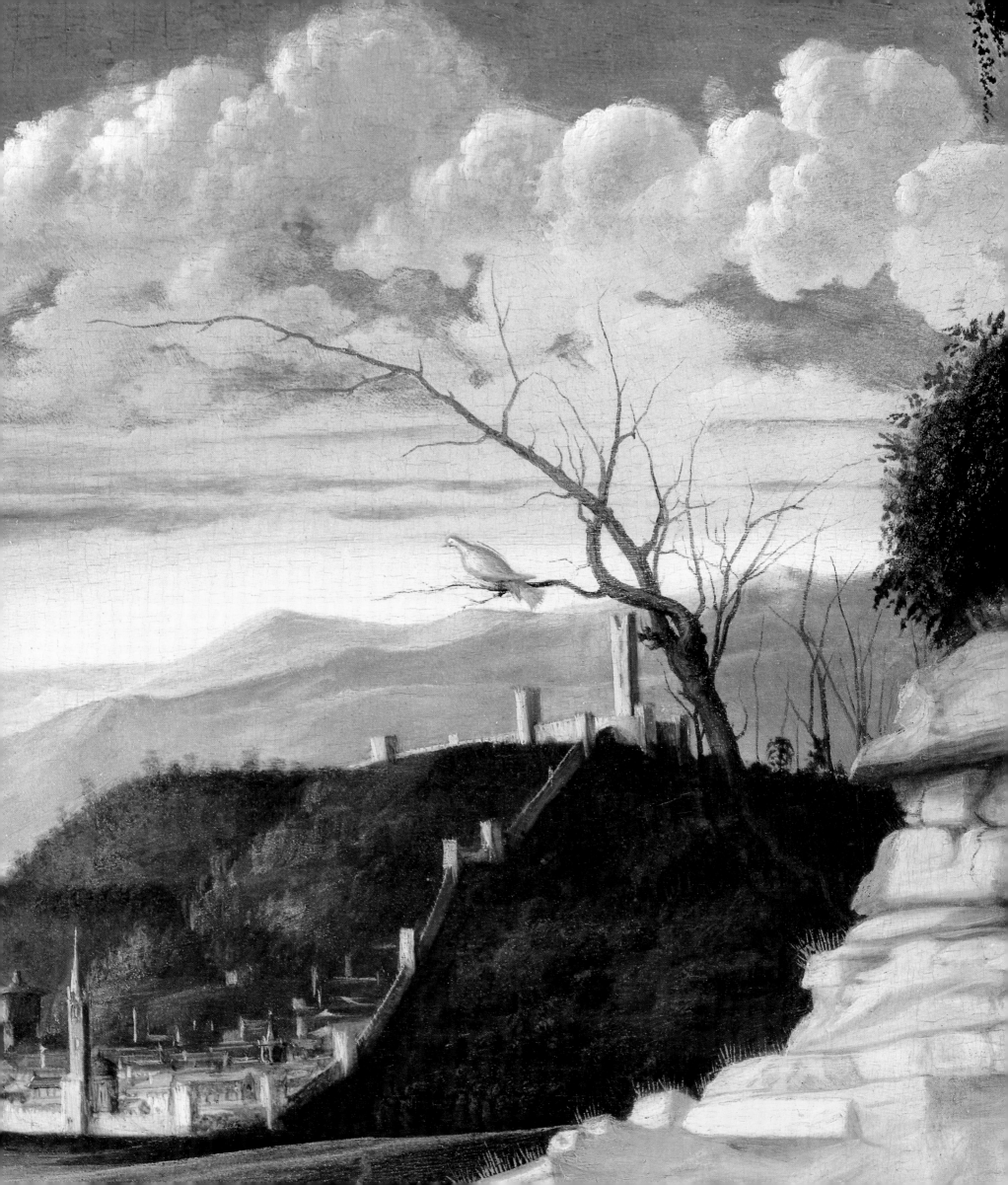

the research, is the recent proposal from Angela Dillon Bussi (1995), who claims to recognize Giovanni's Zovenzoni portrait in the so-called *Humanist (Bust of a Man with a Wreath)* in the Castello Sforzesco in Milan, a work traditionally attributed to Antonello da Messina (Berenson, 1894 and 1957), but then attributed to Giovanni on the basis of a proposal from Longhi (1932), followed by Gamba (1937), Bottari (1963), and Pignatti (1969), who dated it to 1475–80. Robertson (1968) recognized a certain affinity of the portrait with *The Dead Christ with Four Angels* in Rimini (cat. 33), but even so was skeptical of the attribution, while Huse (1972) and Tempestini (1992) did not mention the painting. Goffen (1989) placed it among the products of Giovanni's workshop; Heinemann (1962) presented the singular proposal in favor of Cima da Conegliano, while Agosti (1995, *Su Mantegna,* 4) proposed it as a portrait of Andrea Mantegna made by Giovanni.

To return to the question of Giovanni Bellini's activity in the field of illumination (see also Joost-Gaugier, 1979), there are also illuminations in two codices that have sometimes been attributed to him in the past, but reaching any definite conclusion concerning these works is problematic. There are the four images made in 1452–53 to illustrate the *Life of Saint Maurice,* preserved in the Bibliothèque de l'Arsenal in Paris (MS 940), and there are the two plates in the *Geography* by Strabo in the Bibliothèque Municipale of Albi (MS 77, fol. 3v and 4r), all of which Millard Meiss (1957) assigned to Andrea Mantegna or his workshop. The miniatures now in Paris, once ascribed to Leonardo Bellini, left Robertson (1968) still doubtful, and he claimed that the only certainty was that they should be ascribed to a major artist of the level of Mantegna or Giovanni. Bellosi (1986) attributed the images to Bellini, while Bauer-Eberhardt (1989) assigned the one in Albi to Lauro Padovano. The portrait in profile of *Jacopo Antonio Marcello* included in the manuscript of the *Life of Saint Maurice* is the only miniature in the two series that can be unhesitatingly associated with Andrea Mantegna, while the *Allegory* visible in the same codex presents unquestionable stylistic and compositional affinities with the drawings by Jacopo Bellini. In fact, the Tuscan style of the *Chapter of the Order of the Crescent* seems related to Jacopo's figural world; the full-length figure of Saint Maurice that appears over the doorway at the rear of the hall in that picture is identical to the figure that constitutes the fourth miniature in the codex. We believe that the most prudent and least controversial solution to this problem would be to refer the images to Giovanni's father, Jacopo, and to suggest that they were made at the time of his daughter's marriage to Mantegna. The two panels in Albi can be associated with Giovanni Bellini only if one follows the tradition that once attributed to him an entire series of youthful works that art history has in recent years subtracted from his catalog. This includes a group now assigned by Lucco to Alvise Vivarini, along with the panel with *Saint Ursula and Four Virgins,* no. 188 in the Accademia of Venice, displayed as no. 2 in the 1949 Venice exhibition, a work with stylistic elements very similar to those in the miniatures but which Bauer-Eberhardt believes should be included instead in the catalog of Leonardo Bellini. The *Tron Arch,* no. 727 in the same gallery of Venice, has sometimes also been included in this series; in 1969, in a short article in *Paragone,* Roberto Longhi attributed this work to Alvise Vivarini.

Pages 40–41
SAINT JEROME IN
THE DESERT
Detail
National Gallery, London
(cat. 54)

THE TRANSFIGURATION
Detail
Galleria Nazionale di
Capodimonte, Naples
(cat. 57; complete image on
page 123)

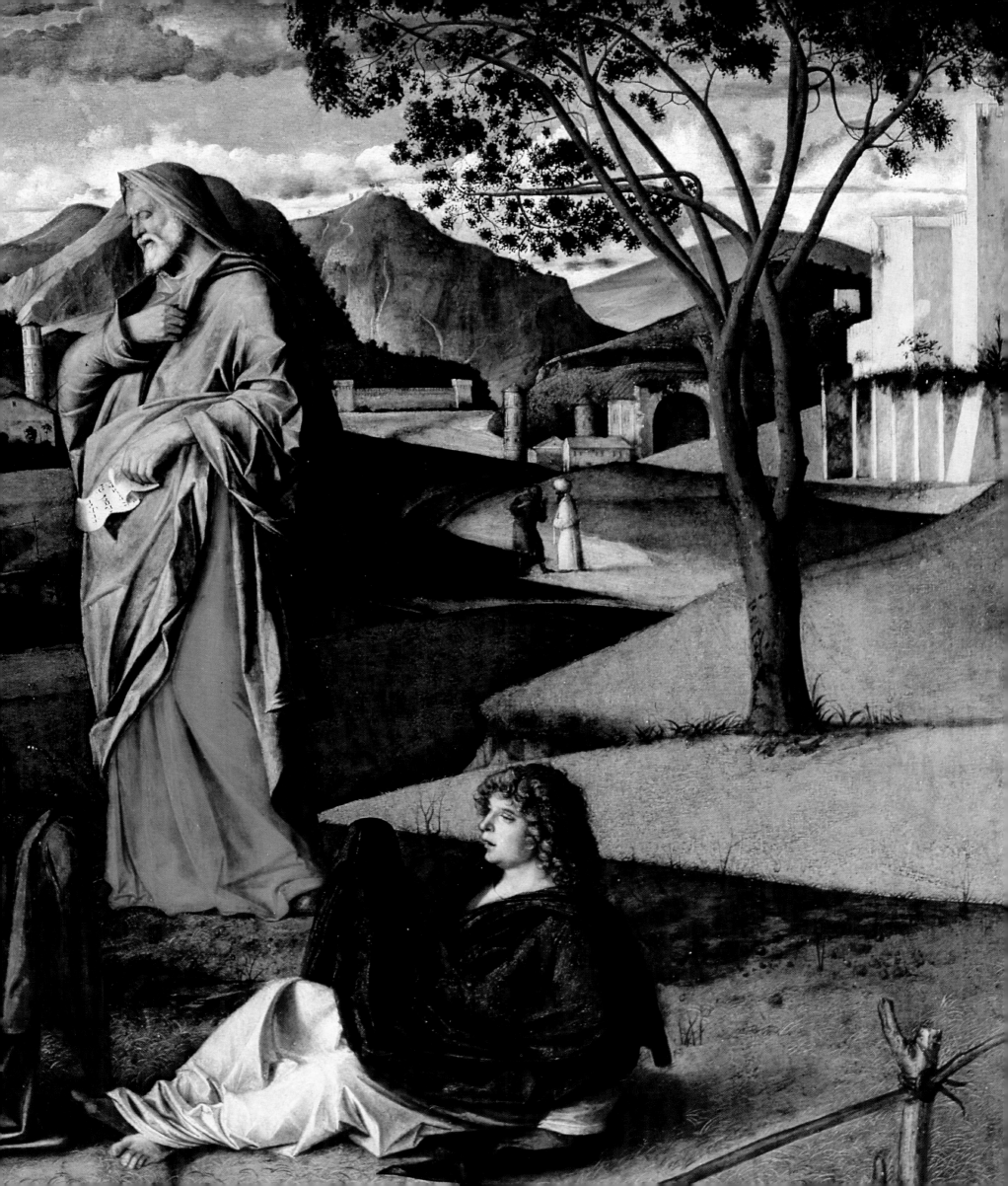

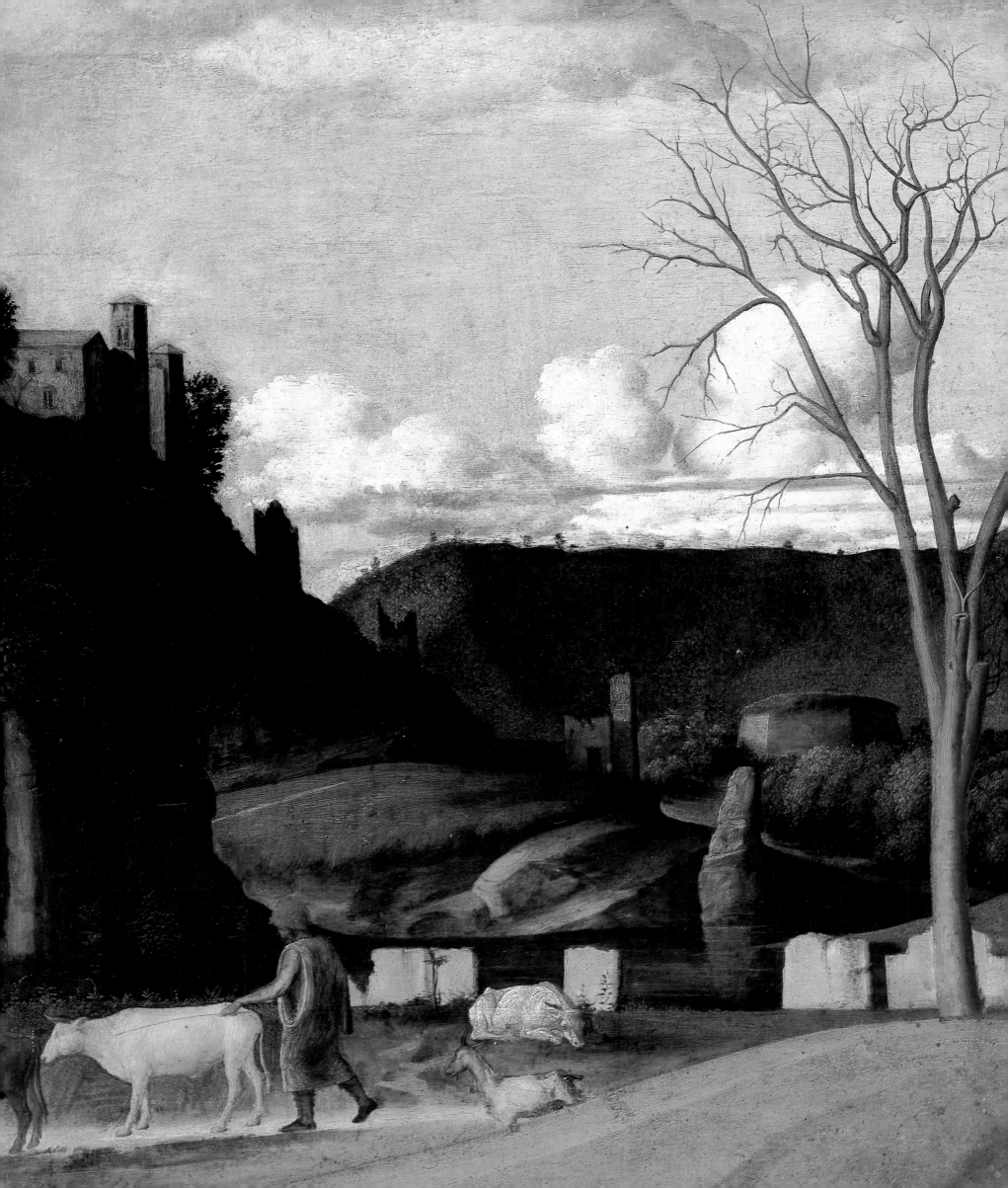

WORKS FORMERLY ATTRIBUTED
TO GIOVANNI BELLINI

The panel with the Johnson *Madonna,* no. 165 in the John G. Johnson collection in Philadelphia, belongs to a figural world extremely similar to that of the *Saint Ursula,* as was pointed out long ago by Pallucchini (1949). The panel bears a signature by Giovanni Bellini and was once attributed to him nearly unanimously, the outstanding exception being Goffen (1989), who considered it a work made with assistance. The *Madonna* no. 22 in the Galleria Malaspina in Pavia, also "signed," was rejected early in this century by Adolfo Venturi (1914), followed by Dussler (1935 and 1949) and Heinemann (1962), while Robertson (1968) felt it had been repainted too much to permit accurate judgment; recent restoration has confirmed the work's character, and it cannot be included in the oeuvre of Giovanni Bellini. Of the Madonnas routinely attributed to Giovanni, there are three others that we believe should not be included in the catalog of the artist's autograph works. The first of these is the *Trivulzio Madonna,* no. 542 in the Castello Sforzesco in Milan, which is signed and a work of high quality but completely atypical within the youthful activity of the artist because of the richness of the ornamentation and the almost "Crivellesque" detail (A. Venturi, 1915; Pignatti, 1969); it seems more closely related to the world of Gentile Bellini or the better artist Lazzaro Bastiani, toward whom Sandberg Vavalà leaned. Also not at the level of autograph works by Giovanni are the *Frizzoni Madonna,* no. 1836 in the Museo Civico Correr in Venice, which Anderson (1990) proposed identifying with the retouched panel made by Vincenzo Catena according to Michiel (1521-43), and the very attractive "signed" *Madonna,* particularly appealing for its invention of the Mother lost in absorbed meditation on the sleeping Child, in the Isabella Stewart Gardner Museum in Boston: both works were accepted by all preceding critics except Huse (1972), while Dussler (1949) considered the second a workshop variant of the first. They can both be associated with the workshop of the *Carità Triptychs* (cat. 5), but we do not think it possible to put aside all reservations: in particular, the *Frizzoni Madonna* is weak in draftsmanship, most of all in Mary's head and left hand. Anderson's proposal is very difficult to accept, in part because Catena is believed to have been just born at the time when the panel was painted.

One will search in vain in the catalog given here for the *Dead Christ,* no. 624 in the Museo Poldi Pezzoli in Milan, which is very weak in anatomy, and the *Borromeo Saint Justina* in the Museo Bagatti Valsecchi in Milan, which seems on first viewing to be a fascinating painting. The original destination and chronology of this work have been the subjects of ongoing discussion, but it does not stand up to investigations of its quality. Its derivation from the version of Saint Giustina given in the *Saint Luke Altarpiece* now in the Brera (but originally made for the reformed Benedictines of Santa Giustina, Padua), and from the Saint Euphemia in the Galleria Nazionale of Capodimonte, both works by Andrea Mantegna, is the only solid point for reading the panel, and the reference to Alvise Vivarini, credited by Dussler (1949), is not convincing. Even so, it is impossible to ascribe to an artist of the level of Giovanni Bellini the design errors present in the work, such as the figure's "arthritic" right hand, the shoddy belt, the truly trite and vulgar dagger; one has the impression that it is the work of a painter following Bastiani-Carpaccio-Diana directives. We

THE TRANSFIGURATION

Detail

Galleria Nazionale di
Capodimonte, Naples
(cat. 57; complete image on
page 123)

45

also remove from the oeuvre the signed *Madonna with the Pomegranate,* no. 280 in the National Gallery of London, probably related to a lost Bellini prototype of which it must have been a variant, as attested by the existence of various works derived from a similar model. Such works include a full-length version, no. 286 in the same gallery, signed by Francesco Tacconi; the workshop version in the church of the Scalzi in Venice; and the version with a young donor in the Friedsam Memorial Library of Saint Bonaventure University (New York State), which has at least been completely repainted but was cited in the literature as an autograph by Gronau (1930) and Gamba (1937) and included as a workshop product even as late as Goffen (1989); only Heinemann (1962) judged it a copy. The London example, which comes from the Galvagna collection in Venice, has always been included under the name of Giovanni Bellini. It is a powerful painting, but it should be attributed to another Venetian painter, one of the most capable and elegant of the period: Cima da Conegliano, whose relationship with Bellini is difficult to determine, but whose stylistic characteristics permeate the panel beyond any doubt.

GIOVANNI, ANTONELLO, AND PIERO DELLA FRANCESCA

The relationship between Giovanni Bellini and Antonello da Messina, who was active in Venice between 1474 and 1475, is a subject of much interest. The matter is related primarily to two works by Giovanni—the lost altarpiece that was once in the Venetian church of Santi Giovanni e Paolo (San Zanipolo; cat. 25) and the altarpiece with the *Coronation of the Virgin* (cat. 27) today in the Museo Civico of Pesaro—but the strongest resemblances between Bellini and Antonello appear in several male portraits, most of all the *Portrait of a Young Man in Red with Ducal Cap (Mellon Portrait;* cat. 46), now in the National Gallery of Art in Washington, D.C. Antonello's influence was more determinant, more evident, and of greater weight in the work of Cima da Conegliano, Vittore Carpaccio, and the Vicenza painters, chief among them Bartolomeo Montagna.

As for the role Piero della Francesca is assumed to have played in Giovanni's acquisition, beginning in the early 1470s, of a new way of using light to fuse figures and the space they inhabit and in the use of new settings, such as locating Mary's throne within an apse, we feel obliged to explain our position in regard to the hypothesis developed by Longhi (1914) and then accepted by many later Italian art historians, as well as by Humfrey (1994). We refer the reader to what Lucco (1990) has to say on this subject, but we also wish to point out that the problem is highly complex and cannot be explained merely by supposing that the Venetian painter Bellini spent time studying under the painter and portrait artist from Sansepolcro.

Piero's formation is itself extremely complex and remains in part to be clarified. As has been said, his presence in Florence in 1439 alongside the mysterious Domenico Veneziano contributed to making them both important exponents of the "Albertian" current in the history of Renaissance art, of which there had already been a first sign, in 1425, in the tabernacle of the Tribunale di Mercanzia in Orsanmichele. This work by Donatello and Michelozzo, with its marbled mirrorings and the motifs of the shell in the vault with niches was a figural text on which both Piero and Domenico must have meditated. They

probably saw it without statues, before the sculptural group by Andrea del Verrocchio of the *Incredulity of Thomas* was put in place (it has been seen empty even during more recent years, when Verrocchio's statue was removed for restoration and had not yet been replaced by a copy). Domenico echoed this work soon after in the *Saint Lucy Altarpiece* painted for the high altar of Santa Lucia de' Magnoli, the main panel of which is in the Uffizi; Piero responded to it as well, but only after a long period of contemplation—more than thirty years later—in the Urbino altarpiece now in the Brera. Rather than searching for traces of works by Piero in Giovanni Bellini's production, we think it would be more reasonable to posit an acquisition on the part of the family composed of Jacopo, his sons Gentile and Giovanni, and his son-in-law, Andrea Mantegna, of the complex ideas expressed by Leon Battista Alberti both at the theoretical level and in solid architectural works, only some of which were in Rimini and Mantua. Mantegna's trips to Tuscany, his activity in Rome, and from 1471 on his activity in Mantua, which became his new home and where Alberti had been working since 1459, can be taken to explain, better than any direct interest on the part of Giovanni in the works of Piero della Francesca, that stylistic maturation permitted Giovanni, always attentive to his brother-in-law's creations, to keep in step with the times, even in a field like architectural perspective where his interests would not have directed him.

The idealistic vision of humanity that emanates from the paintings of Bellini in those years is the furthest thing one could imagine from the abstract, introverted, and in-communicative figures created by Piero della Francesca.

As for light, we agree with Robertson (1968) who sees in Giovanni an absolute co-herence in the rendering of the atmosphere in which he placed the figures in his compo-sitions, displaying notable mastery and sensitivity right from his beginning. One can also ask whether an artist accustomed to the luminous transparency of the Venetian atmos-phere of that time would really have to travel to another region to learn how to express the effects of light.

THE WORKS OF GIOVANNI BELLINI

During the nineteenth century, the failure to recognize certain works as autograph or at least as works planned by Giovanni Bellini prevented an understanding of his true artistic character. These works include the *San Cristoforo della Pace Triptych* (cat. 105), *The Madonna of the Meadow* (cat. 102), *Meditation of Eight Saints on the Marian Mystery* or *Immaculate Conception* (cat. 115), *The Lamentation* in Berlin (cat. 76), and the *Giovanelli Sacra Conversazione* (cat. 104). These paintings were for the most part assigned to students and considered to be mostly by Marco Basaiti, until Ludwig (1905) and Gronau (1911) made clear the im-possibility of such a reference but presented, as an apparent solution to the dilemma, the imaginary personality of the pseudo-Basaiti. Gronau (1928-29 and 1930) deserves merit for having recognized his own error himself, on the basis of a glaring example, and for having restored to Giovanni Bellini the nucleus of his late production. His important contribution paved the road for those who later reconstructed the entire span of activity of the Venetian master: Bernard Berenson (1932 and 1957), Luitpold Dussler (1935 and 1949), Carlo Gamba (1937), Rodolfo Pallucchini (1949 and 1959), Fritz Heinemann (1962), Stefano Bottari

48

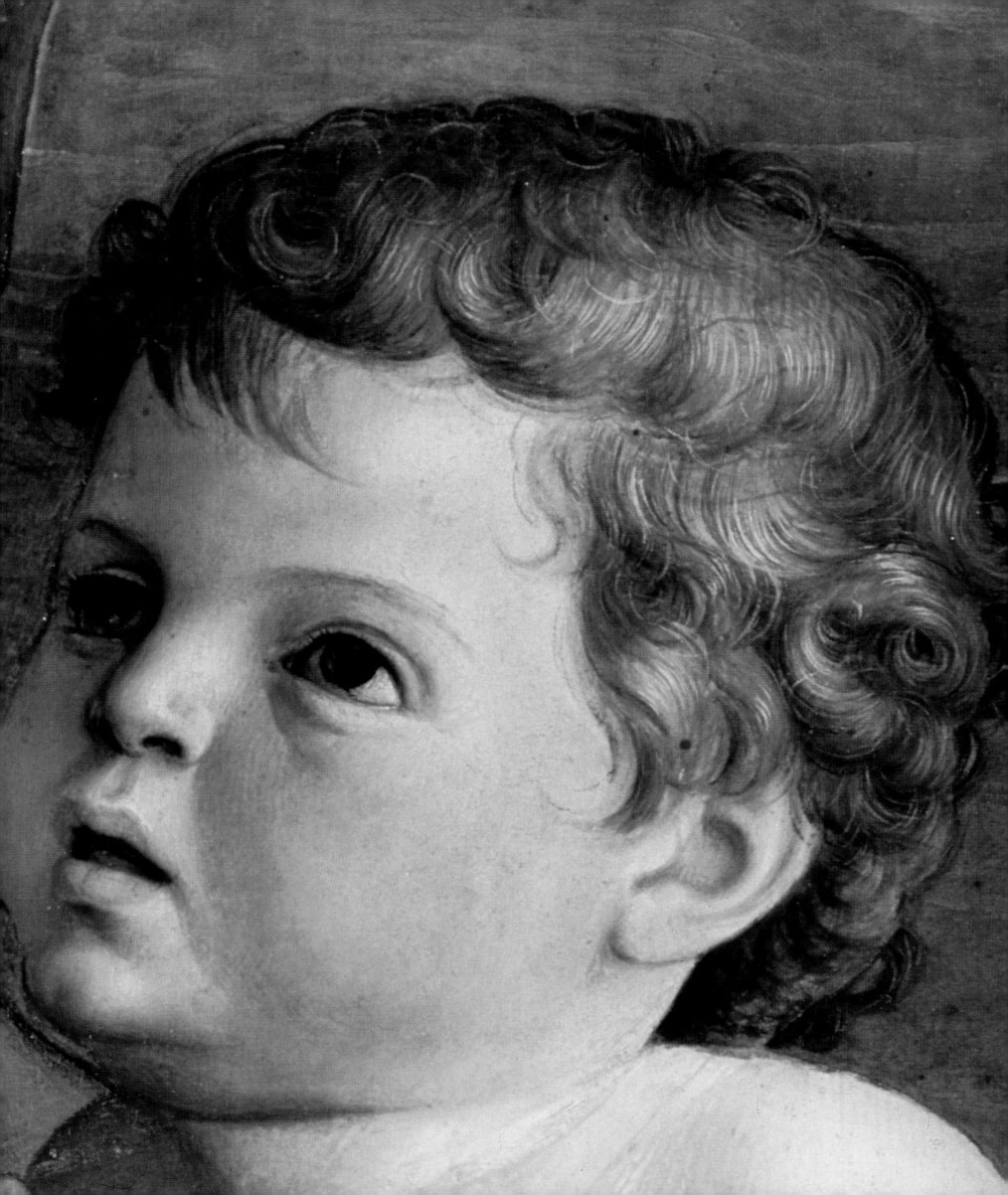

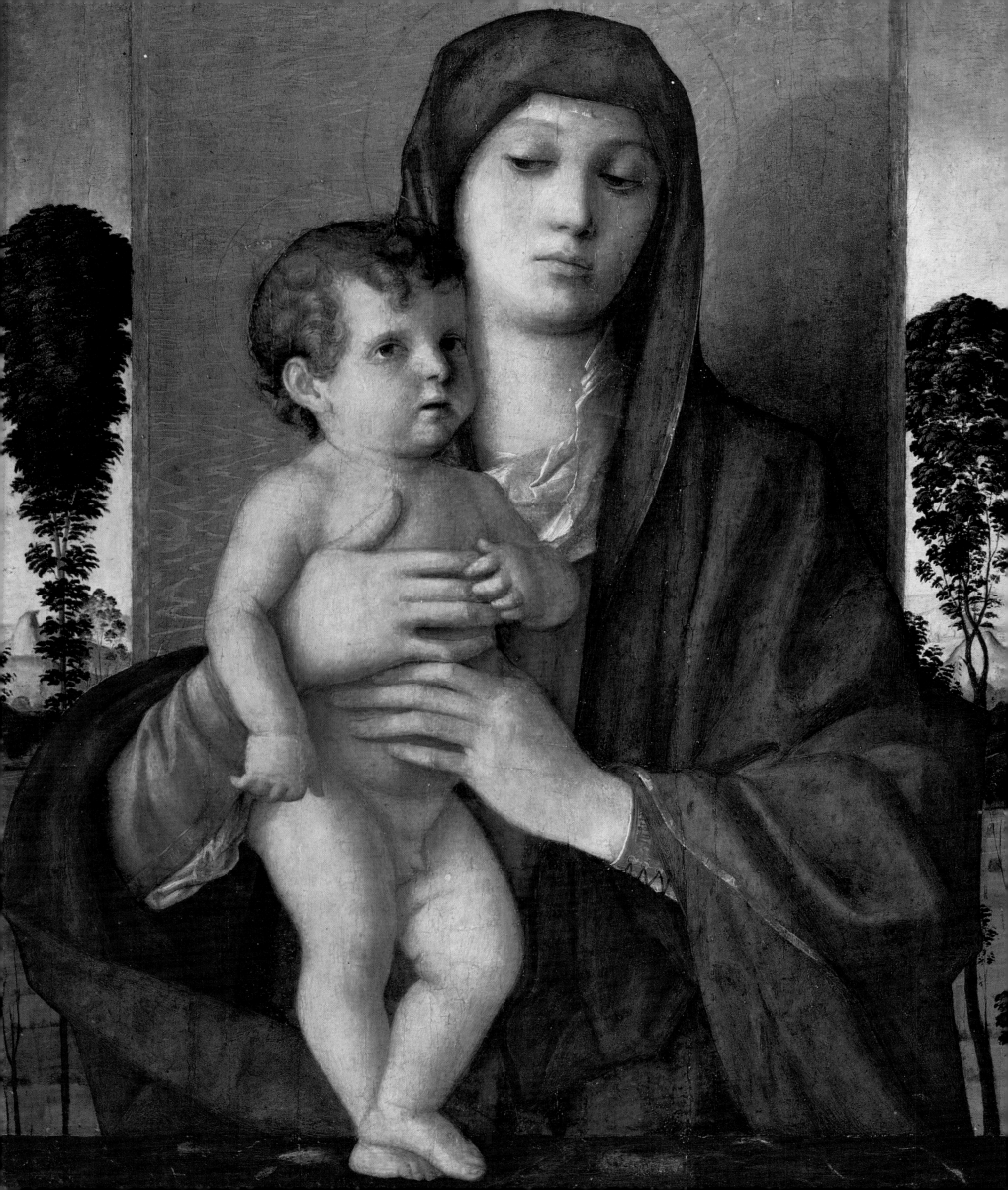

(1963), Giles Robertson (1968), Terisio Pignatti (1969), Norbert Huse (1972), Rona Goffen (1989), and Anchise Tempestini (1992).

Amid important contributions these scholars have sometimes stumbled by wrestling with problems that, in reality, had already been resolved due to a characteristic quirk of our discipline in which important conclusions, because of the margin of error in all hypotheses, are often submitted to further not-always-necessary examination.

With that said, we shall move on to consider the works. Specific notations on technique, support, and particular uses of preparatory designs by the artist are given in the catalog itself.

Saint Jerome and the Lion (cat. 1) in Birmingham should be considered the oldest surviving work by Giovanni Bellini. It stands out from the many others that have been posited at the beginning of his activity for its high quality, for the composition of the scene, and for the rocky landscape that does not merely provide a background but is itself alive, a place brimming with life. It has a donkey grazing in a field and a rabbit poking up from its hole, a detail that Pallucchini (1949) found especially appealing. Both motifs show up later in other works by Bellini, the first in the Frick *Saint Francis in Ecstasy* (cat. 45) and the second in the *Saint Jerome in the Desert* of 1505 (cat. 107). Saint Jerome is presented here in the act of blessing the seated lion before removing the thorn from its paw. The stylistic characteristics confirm Giovanni's training in his father's workshop, under the influence not only of Andrea Mantegna but also of the Vivarini family. Longhi (1949) proposed a date of c. 1450, which was accepted by Degenhart and Schmitt (1990), and it should be moved only slightly forward.

The Bergamo *Pietà* (cat. 2) is the earliest known work in which Giovanni deals with the theme of the Pietà, which he repeated and varied many times over the course of his career: as a Lamentation showing only Mary and Saint John the Evangelist or an even larger group of mourners, as an Embalming, or as a Man of Sorrows. This is without doubt one of the oldest surviving works by Giovanni; it is not derived, as Goffen implied (1989), from folio 53r in the Louvre sketchbook by Jacopo Bellini, from which Giovanni took inspiration for the *Dead Christ* in the Brera (cat. 10) and the *Pietà* in the Doge's Palace in Venice (cat. 13). In fact, the theme of the half-length Dead Christ with two mourners was already widespread in both Italian and Byzantine painting of the fourteenth and fifteenth centuries: Robertson (1968) suggested the composition may be derived from the layout of Byzantine icons, which would also explain the Greek writing at the top; and he also saw signs of Rogier van der Weyden in this work, along with the same borrowings from Donatello that have been pointed out by all critics. Dussler (1949) considered it a *Schularbeit* (workshop exercise), but did not explain to which workshop he was referring: such works were certainly not used in the workshop in which Giovanni Bellini got his earliest training.

The painting, which is not in a good state of conservation, belongs to the Vivarini-style period of Giovanni's formation, the period of his art on which Lazzaro Bastiani laid his foundations.

All art historians point out the Mantegna-style elements in the landscape of the *Davis Madonna* (cat. 4), but the adoring mother is most often related to the milieu of Florence, particularly Donatello. The theme of the Virgin meditating on the sleeping Child,

presaging the *Pietà,* had been widespread all across Europe since the first years of the fifteenth century, but it was taken up again in Venice around the middle of that century, both in the Vivarini workshop on Murano and in the Bellini family workshop in Venice: Giovanni himself used it again later in a full-length version (cat. 20).

With its classical architecture and mountains crossed by twisting paths, the landscape does present echoes of Mantegna's backgrounds, but the figure of Mary is an extraordinary fusion of form and sentiment. A sense of monumental stateliness, accentuated by the restrained redundancy of the drapery with its soft folds, echoes the concentration of the mother's gaze directed toward the motionless body of her Child, a perfectly fused balance of maternal love and meditation on the religious mystery. The pearl-like tones, a result of chemical alterations in the lapis lazuli pigment, only emphasize the essential mood of the composition.

Speaking of *The Blood of the Redeemer* (cat. 6) in the London National Gallery catalog (1961), Davies points out the overall weakness in the execution of the figures and then cites the opinion communicated from Wilde to Robertson that the work must have been made before 1464, since in that year Pope Pius II issued a bull regarding the veneration of the blood of Christ following a dispute that had lasted two years. Be that as it may, we should not forget that similar subjects can be found in a painting by Quirizio da Murano in the Accademia of Venice from c. 1475, in a panel by Carlo Crivelli in the Museo Poldi Pezzoli of Milan, usually dated to the 1480s, and in the altarpiece painted by Vittore Carpaccio in 1496 for San Pietro Martire in Udine and today in that city's Museo Civico (see also Braham, Wyld, Plesters, 1978).

Recent restoration of *The Blood of the Redeemer* in London revealed the presence of small clouds painted in gold and blue behind the legs of Christ; they cover part of the floor and also two reliefs in the transept, also painted in gold. The two scenes are difficult to identify: the one on the left is a pagan sacrifice in the presence of a fawn playing a double flute that is probably either Marysas or Pan; Dussler interpreted the scene on the right as the story of Mucius Scevola, a reading that Davies had already rejected primarily because of the seated figure bearing the caduceus of Mercury in his left hand (see also Thomas, 1984-86). Based on compositional similarity, Longhi (1927) attributed to Giovanni Bellini the pagan sacrifice in the Kress collection, today in Berea College in Kentucky, a proposal repeated only by Pallucchini (1959), Bottari (1963), and Pignatti (1969).

Because of its theme and the type of Christ figure used (see cat. 2 and 17), the suggestion has often been made that *The Blood of the Redeemer* was inspired by a Flemish model. Coltellacci and Lattanzi (1981) identify the two figures in the background as pilgrims on a mystic journey to the celestial city.

The triptych panel from the Kress collection, now in the El Paso Museum of Art in Texas, with *Saint Luke and Saint Albert of Sicily* must date to the period around *The Blood of the Redeemer.* A workshop product, the panel shows the influence of Alvise Vivarini, even in its layout. When he published the other side panel, which bears *Saint Jerome and Saint Louis of Toulouse,* in 1978, Lucco restored credit for the triptych to the circle of Giovanni during the period of the *Carità Triptychs.*

Lucco points out the Flemish influence in the landscape of *The Transfiguration* (cat. 7) in the Museo Civico Correr in Venice, but this landscape, like the field in the

THE FRARI TRIPTYCH
Detail
Church of Santa Maria Gloriosa
dei Frari, Venice
(cat. 67; complete image on
page 137)

foreground, is weighed down by old restoration and varnishes that, removed by recent preservation efforts, have sadly transformed the area into a sort of spinach puree, as was clearly evident in the exhibit held at the Correr in the spring of 1993.

Comparison of Giovanni's *The Prayer in the Garden* (cat. 8) in London's National Gallery with the version by Andrea Mantegna in the same gallery brings to light the thematic and compositional affinities one might expect, but it also reveals profound differences. Everything in Mantegna's version is solid, muscular, plastic, and rigorous, while in Giovanni's work the scenic elements, most of them based on ideas drawn from the Paris sketchbook of his father, are individually justified by their function, such as the rocky podium at which Christ kneels and the structure that serves as backrest to the sleeping John. The landscape extends across the background, crossed by the usual twisting pathways; human settlements appear in the distance, immersed in what seems to be the light of dawn; but as Lucco (1990) pointed out, it cannot be dawn, for the true source of light illuminates Christ from behind. The hill at left seems clearly derived from the Euganean Hills near Padua, with their quarries, while the fence in the right foreground is an early example of that taste for minor elements, for those objects of everyday life that appear in a landscape, that will become a constant in all of the master's later works, in particular such paintings as the Frick *Saint Francis in Ecstasy* (cat. 45) and the London *Madonna of the Meadow* (cat. 102). We also agree with Lucco when he points out that traces of Mantegna are indeed present in the painting, but that they are reminiscences of works that Andrea made in Padua during the 1450s.

Most art historians hold that the *Dead Christ* in the Museo Civico Correr (cat. 11) is based on the bronze relief on the same theme made by Donatello for the high altar of Il Santo in Padua; Goffen offers the opinion that Giovanni filled the background with a landscape in order to locate Christ's divine sacrifice in this world. In our opinion, Giovanni deals with the theme here for the fifth time in his career, again showing strong adhesion to the figural language of Andrea Mantegna. This work dates to the first half of the 1460s, not far from the side saints of the Carità *Saint Sebastian Triptych* (cat. 5), the *Polyptych of Saint Vincent Ferrer* (cat. 9), and, as indicated by the drapery of the two angels, from the *Crucifixion with the Two Mourners* in the Louvre (cat. 19). At the heart of the composition there may well be some memory of Donatello's bronze relief, in which the Man of Sorrows holds his hands crossed in front of his body, while behind him two weeping angels extend the winding sheet, or Veronica; but in place of this Giovanni proposes a Christ with a robust anatomy supported at the arms by two angels who express their sorrow in a more controlled manner, against the background of a Mantegna-style landscape dominated by a walled city of classical-style buildings. In his numerous presentations of the Pietà, Giovanni avoided declamatory statements and overly sentimental emotions: as we will see, he made a partial exception to this rule in the case of the *Pietà* for the Doge's Palace in Venice (cat. 13). In terms of its plasticism and its expressiveness, the figure of Christ in the panel in the Correr is similar to that in the Brera *Pietà* (cat. 10). Precisely because of the consistency with which Giovanni gave his Christ figures solid bodies, we are compelled to repeat indirectly the opinion of Morelli and to remove the *Dead Christ* in the Museo Poldi Pezzoli of Milan (no. 1587/624) from the list of autograph works.

As Goffen (1989) and Degenhart and Schmitt (1990) indicate, the composition of

THE FRARI TRIPTYCH
Detail
Church of Santa Maria Gloriosa dei Frari, Venice
(cat. 67; complete image on page 137)

the *Crucifixion with the Mourners in a Landscape* in the Correr (cat. 12) is based on folio 55 in the Louvre sketchbook of Jacopo Bellini; it differs from that work by the insertion of a landscape and by the contained sorrow of the Mother and the Disciple, as well as by the plasticism and the solid structure of the body of Christ.

The *Pietà* in the Doge's Palace (cat. 13) attests to a period in Giovanni's career when his style showed the influence not only of Mantegna but also of the Paduan world and, in the broadest sense, the Po region. Looking at a painting of this kind one is induced to accept the notion handed down from Vasari (1568) and Ridolfi (1648), according to which Jacopo da Montagnana was a student of Giovanni from 1461 to 1469: for that Paduan painter certainly used this canvas as a model. This work is a document from Giovanni's experimental period, when he was still in formation; in no other painting by Giovanni are the emotions of figures expressed so dramatically, with a vividness approaching the expressionistic.

The painting was made for the San Nicola Chapel in the Doge's Palace, a chapel that was destroyed around 1525 when the doge's private chapel, on the opposite side of the courtyard, was dedicated to the same saint. Zanetti (1773) claimed the painting bore the date of 1472, but perhaps he misread the numbers, for the *Pietà* in the Doge's Palace must certainly be placed a few years after the Brera *Pietà*, although Heinemann (1962) inverts the relationship, followed potentially by Goffen, who points out the double identity of the architectural element—both tomb and altar—from which the body of the Savior emerges.

The *Virgin with Child Standing on a Parapet* now in Amsterdam (cat. 14) and the one in Berlin (cat. 15) demonstrate the extraordinary leap ahead in the level of the figurative language that Giovanni achieves compared to the model created by his father. In these works Giovanni creates compositions that are in keeping with the earlier versions (already discussed) as is indicated, respectively, by Mary's hands and veil; but at the same time these works confirm the new horizons glimpsed in his youthful masterpiece, the Brera *Pietà* (cat. 10). Signs of experimentation of the type visible in the *Polyptych of Saint Vincent Ferrer* (cat. 9) can be spotted in both Madonnas, but there are also preliminary hints of elements that will be further developed later, such as the motif of the little finger of Mary's right hand, which moves away from the other fingers, a gesture that will become a constant in the artist's mature works. Giovanni must have liked the effect he achieved in these two panels, since almost a decade later he paraphrased it in another painting, which most scholars date to the period of the Pesaro *Coronation* (cat. 27), meaning the first years of the 1470s. This is the *Virgin with Child Standing on a Parapet* in the Museo di Castelvecchio in Verona (cat. 16), which constitutes an application of the lexicon of his early maturity to the compositional elements presented in the Madonnas of Amsterdam and Berlin; the landscape in the background disappears to give way to a sky veiled by almost white clouds, an effect that places the two figures in an indefinite realm and permits the observer to fully grasp their mystic dialogue, imbued with foreboding melancholy.

The *Blessing Christ* in the Louvre (cat. 17) occupies a place of extraordinary importance in the pictorial production of Giovanni Bellini primarily because of its characteristics as an *Andachtsbild*: it does not present an episode from the life of Christ, it is not a narrative work; it is a devotional image containing a series of symbolic elements on which the spectator can meditate. We are presented with an image of the risen Christ, postmortem, crowned with thorns, stigmata on his hands and side, in his left hand a volume of what

VIRGIN WITH TWO SAINTS
Detail
Gallerie dell'Accademia, Venice
(cat. 71; complete image on
page 141)

57

must certainly be his teachings, while his right is raised in a gesture of blessing that Huse (1972) understood as being not momentary but rather extending across all time. This is Christ with all of his attributes, first among them the symbols of his sacrifice. Nothing like this image existed in Italian painting until at least fifteen years later, in works from the Florentine school of Sandro Botticelli and his student Jacopo del Sellaio when that city was dominated by the religious preaching of Girolamo Savonarola, the Dominican father born in Ferrara—preaching that we would define today as fundamentalist. All scholars believe that Giovanni took his inspiration from a Flemish prototype, but exactly which one is not known. One work that is similar in certain aspects to this painting as well as *The Blood of the Redeemer* in London (cat. 6), is the *Christ as the Man of Sorrows* by Petrus Christus, now in the City Museum and Art Gallery of Birmingham, in which Christ displays the stigmata and crown of thorns and is flanked by two angels. But there the angel on the right bears a sword, an allusion to the Judgment, a recurrent theme in fifteenth-century Flemish painting, as in Rogier van der Weyden, whom various scholars, including Robertson (1968) and Goffen (1989), see as the inspiration for Giovanni's *Blessing Christ*. But Giovanni never presents Christ in the role of judge. During the 1460s Quirizio da Murano presented a living Man of Sorrows, dressed only in a loincloth but with all the traits of Christ, standing on the sepulchre, a work that indicates that Giovanni Bellini had contact with the Muranese milieu in his early years. In the painting in the Louvre the tunic seems to allude to the iconography of Christ of the *volto santo* (holy image) type, which was certainly known in Venice due to its Asian origins. As Huse indicates, the landscape is not really a background to the figure, which seems to detach from and soar over it. According to Heinemann the *Blessing Christ* in the Louvre, sometimes mistakenly defined as an Ecce Homo, should be read as a development of the theme of the Incredulity of Thomas.

The *Lehman Madonna* (cat. 18) is, like the *Blessing Christ* in the Louvre (cat. 17), a painting with warm, sensitive coloring and a melancholy foreboding in the Mother-Son relationship. The accentuated, unusual "Squarcione" style and the nervous movement in the hands of Mary might create doubts concerning the autograph status of the painting, but it is precisely by comparing this work with the *Madonna* in Philadelphia and the *Madonna* in Pavia, works that are accepted by all other scholars but expunged from the catalog by us, that the impossibility of assigning all three paintings to a single artist is revealed. Despite its apparent anomalies, which result from the artist's still being in search of a definitive lexicon, the *Lehman Madonna* should be placed among the most intense youthful works by this artist who was destined in a few years to become one of the greatest European painters of his period.

The *Crucifixion with the Two Mourners* in the Louvre (cat. 19) is, like almost all the works by Bellini that present the adult Christ, one of the heights of the painter's juvenile production, surpassing the Mantegna-style elements still visible in its landscape. Thanks to the use of a lower point of view than that employed in the *Crucifixion with the Mourners in a Landscape* in the Museo Civico Correr (cat. 12), and thanks also to the acquired ability to arrange his elements along the line toward a single vanishing point, Giovanni succeeds here in creating an environment that the three figures can inhabit perfectly. The style of the drapery is very similar to that of the little putti that support the *Dead Christ* in the panel in the Museo Civico Correr (cat. 11), a fact that confirms that the *Dead Christ* is not

VIRGIN WITH TWO SAINTS
Detail
Gallerie dell'Accademia, Venice
(cat. 71; complete image on
page 141)

58

The Circumcision of the Christ Child (cat. 86), works that are known to us only from work-shop copies. Schmidt (1990) points out that Mantegna's painting, along with the *Pietà* by Jacopo Bellini that is folio 7v in the Louvre sketchbook, was the prototype for the half-length *Sacre Conversazioni* in the Veneto painting. The panel in Venice has been heavily re-worked during restoration and can now be judged only on the basis of certain areas: the head, veil, and right arm of Mary; the Child; the face of the first woman to the left; the face of Saint Joseph; the hands and hood of the priest; and the head of the last youth to the right.

The Greek writing for which the *Madonna with Greek Inscription (Madonna greca)* in the Brera (cat. 22) is named probably is an expression of Venice's ever-present Byzan-tine tradition and not the result of a Greek patron: on this point Humfrey (1990) and Goffen (1989) are in agreement. As for the dating, it comes from the second half of the 1460s, a few years later than the date proposed by Pignatti (1969), while Humfrey pushes it to the beginning of the 1470s, meaning to the period of *The Dead Christ with Four Angels* in Rimini (cat. 33). Very similar to the *Madonna with Greek Inscription,* at a compo-sitional level, is the *Maniago Madonna,* now no. 445 in the National Gallery of Art in Washington, D.C. (Kress no. 1077), which is a product of Giovanni's workshop. Heinemann (1962) dated this work to around 1475, seeing the strong influence of Antonello; Gronau (1930) saw the two Madonnas as being very close in time, recalling that Crowe and Caval-caselle (1871) correctly considered the panel in the Brera earlier than the other, which was then in the Duveen collection, but they pushed too far and connected the *Madonna with Greek Inscription* with the *Virgin Holding the Child* formerly in the church of the Madonna dell'Orto in Venice (cat. 35) and with the *Virgin with Seated Child* in Rovigo (cat. 28), while Berenson (1916) pointed out the similarity of the Brera Madonna with the not-autograph Madonna now in New Haven (Yale University Art Gallery, no. 59.15.11) and with the Pesaro *Coronation* (cat. 27), dating the three works to 1475, an opinion later shared by Heinemann (1962).

While *The Madonna of the Thumb* (cat. 23) still exhibits strong traces of the influ-ence of Mantegna, it also has compositional similarities to the *Madonna with Greek Inscrip-tion* (cat. 22), compared to which one notices, however, a greater freedom in the design, a prelude to the language used in the creation of the masterpieces of the 1480s.

Near the top of the *Crespi Madonna,* today in the Fogg Art Museum of Cambridge, Massachusetts (cat. 24), is a Greek inscription similar to the one in the Brera's *Madonna with Greek Inscription;* here there is another inscription, a sort of monogram of Christ, beside the head of the Child. This work should be dated to a few years later than the Brera work, although the dates proposed by Robertson (1968), to the second half of the 1470s, and by Pignatti (1969), who goes all the way to 1488, are not acceptable: without doubt Dussler (1949) comes far closer to the truth, proposing a more acceptable date of 1470. Goffen (1989) does not mention the painting. An antique copy of it once existed and was cited by Gronau (1930); in 1878, this copy was in the von Hirsch collection in Würzburg.

The altarpiece for the church of San Zanipolo, the *Virgin Enthroned, Ten Saints, and Three Small Angels* (cat. 25), is lost, but a watercolor and the print by F. Zanotto inform us of its composition, which was one of the first in Venice to abandon the traditional polyp-tych division in favor of a single, vertical presentation. The panel is mentioned by Vasari (1568) and Ridolfi (1648), but its dating, in particular its chronological relationship to the

THE BAPTISM OF CHRIST
Detail
Church of Santa Corona, Vicenza
(cat. 100; complete image on
page 161)

San Cassiano altarpiece that Antonello da Messina made in Venice (see Robertson, 1977), has always been the source of controversy. The lost painting by Giovanni has been variously dated to the early 1470s or to between 1475 and 1480. Personally, we agree with Humfrey (1988) and Lucco (1983 and 1990) in believing Bellini's altarpiece to be datable to the first years of the decade, most of all because the composition is still overly crowded, demonstrating a lingering sense of horror vacui, because of the elongated shapes of the figures, because of the setting, and because of the architectural layout, which does not yet demonstrate the skill and coherence of the *San Giobbe Altarpiece* (cat. 58). This altarpiece should be placed chronologically before the Pesaro *Coronation* (cat. 27), during the period when the single-panel Sacra Conversazione was just beginning to appear in Venice, following the unexpected early version made by Bartolomeo Vivarini in 1465, today in the Pinacoteca di Capodimonte in Naples. As Schmidt (1990) indicated, the lexicon used by Giovanni in the painted architecture is related to the stone frame still in place, while the figures are located in a setting that creates an illusionistic spatial opening in the wall of the church. This is not the place to reopen the question of the proper reconstruction of Antonello da Messina's *San Cassiano Altarpiece,* today visible only as fragments preserved in the Kunsthistorisches Museum in Vienna, but it is enough to repeat that the proposal of Wilde (1929) should be enlarged by the addition of three angels at the feet of the throne, as can be seen in all the altarpieces that, in Venice and in the Veneto in general, even in later years, seem to repeat the model by Antonello and this one by Giovanni Bellini, from the examples by Bartolomeo Montagna to those by Alvise Vivarini and Cima da Conegliano. Gronau (1930), like Fry (1899), dated the San Zanipolo altarpiece to c. 1480, an opinion repeated by Heinemann (1962), who was inclined to push for an even slightly later date.

The person presented in the *Portrait of Jörg Fugger* (cat. 26) was a young banker who belonged to the most powerful family in Augsburg; in fact, that city still bears signs of the period when it was virtually ruled by the Fugger dynasty, beginning with the Fuggerei, a still operating model city quarter designed to offer a dignified life to the city's poor. This is the first example of the portrait genre in the oeuvre of Giovanni Bellini, the starting point for all portraiture that would follow, right up to the last years; the only variation is that the dark background is sometimes replaced by sky. The humanistic portrait, which was first presented in the Veneto by Pisanello, who studied under Gentile da Fabriano alongside Giovanni's father, Jacopo, came to constitute, together with the Madonna and the Pietà, one of the most frequently requested subjects from Giovanni's workshop.

The *Portrait of a Boy* in the Barber Institute of Fine Arts in Birmingham (cat. 34) was once commonly dated to around 1490, but this changed when the catalog of the 1949 exhibition in Venice called attention to the boy's extreme stylistic resemblance to the angels in the *Dead Christ* in Rimini (cat. 33), particularly in terms of the way hair is rendered. Heinemann believed the boy in the portrait could be recognized in the angel on the right in *The Dead Christ Supported by Two Angels (Pietà)* in London (cat. 40). Parronchi (1965) has claimed to make out the reverse side of the panel with the portrait in Birmingham in a panel in a private collection in Florence presenting a skull: this opinion is referred to by Pignatti (1969) and accepted as a possibility by Goffen (1989). The question is related to the meaning of the writing, which must be taken as NONALITER. According to Robertson (1968), this was the motto of the boy's family, but Pallucchini (1949) saw it as an allusion

to the premature death of the melancholy adolescent. Benedicenti (1993) has proven that the portrait in Birmingham is a work painted by Giovanni Bellini in 1475 on one of the external faces of an arabesqued casket made to enclose a marble bust of Angelo Probi, who was originally from Atri, an emissary of the king of Naples in Venice, and who died in Venice in 1474: no doubt the portrait presents the likeness of a son who died prematurely.

Unfortunately, the panel is in such an extremely poor state of preservation that the figure can be judged only in silhouette, and except for the areas of the hair and a few areas of the face, the pictorial surface has been largely worn away. The arrangement of the portrait, which is the second in chronological order of all the portraits by Giovanni that have survived, is no doubt based on Flemish models, which also explains the traditional attribution of the work to Antonello da Messina. We would also indicate that the panel belongs to a type of portraiture that was widespread in Venice during those decades; it was a genre in which Jacometto Veneziano specialized, an artist whose works have often been attributed to Giovanni Bellini.

Jacopo Bellini
Virgin and Child
Accademia Tadini, Lovere

The *Virgin Holding the Child* that was stolen in 1993 from the church of the Madonna dell'Orto in Venice (cat. 35) was signed at the bottom center and bore Greek writing alluding to Mary, mother of Christ, in the gold background to the sides of the Virgin and Child, the kind of inscription already seen twice in the painter's catalog (cat. 22 and 24). One can affirm that this work was stylistically related to the group of works made by Giovanni in the years immediately after 1475: the Child resembled a younger brother of the little angels in Rimini (cat. 33). In the opinion of all scholars, the example in Berlin (cat. 36), signed IOANNES BELLINVS P., is a later work, derived from the one in Venice. It varies in its background, which is entirely closed off by deeply folded drapery, by the robe of Mary, which completely covers the clothing underneath, by the position of the Child, whom Mary holds higher—and as a consequence her right hand is presented at a more oblique angle—and by the fact that the Child is sucking two fingers of his left hand: also different is the perspective from which the parapet in the foreground is viewed and the absence of Greek writing.

The *Madonna and Child* today in Fort Worth (cat. 37) is very similar to the one in Venice, of which it seems to be a workshop replica. It differs from that work primarily in terms of the detail in Mary's robe; her gaze, which is fixed on emptiness and is without the thoughtful and knowing melancholy with which she looks at us from the Venetian church; and for a book lying open on the parapet to emphasize the spatial depth of the marble balustrade, a motif that may have been derived from the *Madonna and Child* by Jacopo Bellini in the Accademia Tadini in Lovere. The painting in Fort Worth is from Bergamo, was cited by Crowe and Cavalcaselle (1871) in the Mündler collection in Paris, then passed into the collection of Napoleon III, as Borenius (1912) indicates, and was sold as part of that collection by Christie's in 1872. An antique copy of the Venetian example is in the Pinacoteca dell'Accademia dei Concordi in Rovigo.

All scholars agree that *Christ's Descent into Limbo* in the City Museum and Art Gallery of Bristol (cat. 38) is based on an idea from Mantegna. In reality, two versions of this theme are known, both of them based on inventions by Giovanni's brother-in-law. The first of the two is known from an engraving and a drawing, dated to 1473 (no. 189 in the Ecole des Beaux-Arts, Paris), which present the same composition as the painting in Bristol.

The second version shares with the first only the figure of Christ and the rocky platform in the foreground; the background of this second version is occupied by a dark zone, outside the portal of which the Redeemer, in the first version, steps across the fallen door: the figure of an old man emerges from the abyss, three praying figures are located at the left, and a seminude elder is on the right. Two painted examples of this version exist, neither of them autograph. The first one, in the Velier collection in Asolo, is completed above by a woody landscape; Fiocco (1927) held it to be by Correggio. The second example belonged to the Courtauld collection in London, was sold by Colnaghi in 1973, and is today in the collection of Barbara Piasecka Johnson in Princeton. There is also a drawing that relates only to the figure of Christ (no. 622 of the Kupferstichkabinett, Berlin), which is considered a copy based on the original by Mantegna.

The composition of the painting in Bristol is far more balanced than it is in the second version and has a clearer meaning at the theological level, with the good thief, to the left, bearing the cross, while to the right, added to the progenitors being deafened by flying devils, two of which blow strange horns, is a third nude figure that moves like the old man at right in the other version. The harmonious and stately anatomy of the figures; the rocky landscape with ivy and tufts of grass that stick up from crags, presented by the artist in detail; the branch of fig, a Christological symbol; the world in which religious fact is located in nature—all indicate that the painter has by now arrived at that phase in his activity in which he will produce some of his greatest masterpieces.

By the time of this work, Giovanni's interest in the works of his ingenious brother-in-law was much different than it had been in the preceding decade, when he had been experimenting with different ways of painting and composing while seeking out his own identity as a master. Indeed, by the time of this work, that search had come to an end. For this reason, the dating to 1470 proposed by Heinemann is unacceptable.

Art historians usually refer to the *Crucifixion* in the Galleria Corsini, Florence (cat. 42), as a narrative work, but as Degenhart and Schmitt indicate, this work is really an *Andachtsbild*. It is the crucifix that stands out against the landscape, it is redemption reaching the world, the rocks, the lakes, the mountains, the cities, and the sea; astonished and moved, nature seems to witness the event that marks the beginning of a new era: it is Christianity as experienced by a man of the Renaissance, a long way from medieval religiosity, even if this is a work by the son of a leader of the so-called International Gothic. The effect of the cross that soars over the landscape, a landscape in which it is not fixed, is that it seems to anticipate the *Crucifixion* by Salvador Dalí and must have been even more dramatic when the green of nature had not yet turned brown due to the chemical breakdown of the paint.

In the *Contarini Madonna* (cat. 43) and the *Virgin* in the Rijksmuseum in Amsterdam (cat. 44), the theme of the standing Child seems to be derived from the *Madonna* by Jacopo Bellini in Lovere; Giovanni had already turned to this work by his father for the model of the foreshortened open book in the *Madonna and Child* in Fort Worth (cat. 37). The erect, frontal position of the Child, the way in which his feet are drawn, seems to be a memory of a figure of the type of the *Saint Sebastian* in one of the *Carità Triptychs* (cat. 5), almost proving that Giovanni returned here to designs and cartoons from his father's workshop; but the landscape in the background is instead already that of the painter's mature

Pages 66–67
GOD THE FATHER
Detail
Museo Civico, Pesaro
(cat. 101)

GIOVANELLI SACRA
CONVERSAZIONE
Detail
Gallerie dell'Accademia, Venice
(cat. 104)

works: the light clouds have the same consistency as those in *The Resurrection of Christ* in Berlin (cat. 41). The river plain that extends at the lower right is marked off by wooded hills on which a tower stands and by rocky mountains in the distance; to the left, beyond what seems like the surface of a lake, is a city with a fortress and the unmistakable Palazzo della Ragione of Vicenza, the building that Palladio later (he began the work in 1548) transformed into his Basilica: at least twenty-five years later, another view of Vicenza will serve as background to the *Donà dalle Rose Pietà* (cat. 103).

There is a replica of the *Contarini Madonna* in the sanctuary of Santa Maria delle Grazie in Piove di Sacco (Padua); yet another was in the Contini Bonacossi collection in Florence: Gronau (1930) spoke of these as of a single painting, which had gone from the church into the private collection. The Madonna cataloged as a work by Giovanni in the Galleria Sabauda in Turin (no. 157), in which the Child is seated and the background is dark, is a variant replica, a product of the workshop. Recent restoration has removed the nineteenth-century repainting that made it seem a forgery.

The version in the Rijksmuseum comes from the von Rath collection in Amsterdam. It was made public by van Marle (1935) and was considered autograph by Pallucchini (1949 and 1959), Berenson (1957), Bottari (1963), and Pignatti (1969), while Heinemann (1962) held it a workshop product, judging only the hands of Mary to be autograph. The painting is not mentioned by Dussler (1935 and 1949), Robertson (1968), and Goffen (1989). Without doubt it was cut off at the bottom, giving it an almost square shape. It has the appearance of being a variant of the *Contarini Madonna,* very similar to it for the Mother-Son relationship: the Child is not nude, as he is in the Venetian panel, he is in the act of blessing, and he must be almost standing, but his legs are no longer visible; Mary holds him with both hands, in a confused position, very similar to the presentation in the juvenile Madonna, also in Amsterdam, in the version in Berlin, and in the later example in Verona (cat. 14, 15, 16). The panel formerly in the von Rath collection thus constitutes a variation on themes by the master, but because of its precarious state of preservation, and without real reason, a great many critics subtract this work from Giovanni's catalog; in reality, the intense, meditative, and melancholy expression of the Mother and the aware Son, the minutely analyzed drawing of the drapery, and the general quality of the painting speak in favor of its autography.

The *Portrait of a Young Man in Red with Ducal Cap* in the National Gallery of Art, Washington, D.C. (cat. 46), is the third example of a portrait by Giovanni to reach us following the archetypes constituted by the effigy of Jörg Fugger (cat. 26) and by the *Portrait of a Boy* in Birmingham (cat. 34). The similarity of the arrangement of these portraits to those made in Venice by Antonello da Messina cannot be denied, but there is probably no need to hypothesize that the man shown here came from Florence, as the National Gallery of Art's catalog (1979) suggests. The dating of Bellini's portraits, much like the dating of most of his Madonnas, presents many difficulties: in this case, we accept the general trend of critics in placing the creation of this panel sometime around 1480.

The National Gallery of Art also has a *Madonna and Child* (cat. 47) that was once in the collection of Leopold William, archduke of Austria and governor of Flanders, as can be seen in the painting made in 1651 by the Flemish painter David Teniers II showing the paintings in the archduke's gallery. After passing through a series of antiques dealers in

THE MADONNA OF

THE MEADOW

Detail

National Gallery, London
(cat. 102; complete image on
page 163)

70

London, Munich, and Lucerne, it was acquired in 1922 by Ralph Booth, who gave it to the gallery in 1947.

Several replicas of the *Booth Madonna* exist; the best two are the one in the Accademia Carrara in Bergamo (no. 930) and the one, which has a tent in the background, that was in the Giovanelli collection in Venice before entering the Galleria Bellini in Florence. The *Booth Madonna* presents Mary offering a small fruit to the Child, who rests on one corner of her robe atop a marble parapet. The artist expresses the wordless dialogue of the mother-son relationship in a highly effective manner. The Child responds to Mary's tactile solicitation by turning his glance to her; both figures express an aware melancholy that, together with their halos, indicates the sacred theme and lifts the image beyond what it might otherwise seem: the portrait of a deeply affectionate family relationship. To the sides a spring landscape is presented in great detail, and the sky is nearly covered by delicate, white clouds.

A similar theme is expressed in the undervalued *Mond Madonna* (cat. 51), which is in reality one of the most poetic inventions on this theme that Giovanni left us, a work of exceptional naturalness, with the two figures presented in a state of rapt, meditative concentration while involved in apparently normal, daily gestures; the shapely, still almost Antonellesque limbs of Christ, the hands of Mary, his absorbed face, the crag crowned by a castle, all are rendered with the refined elegance worthy of a master, even if the curators of the National Gallery of Art refuse to display it.

The Harewood *Virgin with Standing Child and Donor* (cat. 52) is a painting of notable quality, characterized above all by formal clarity and by the beauty of the landscape to the right just past the tent. As Heinemann (1962) noted, it should be located in a period "earlier than one might think," probably even before 1485. We can easily imagine it preceding the *Saint Jerome in the Desert* in the Uffizi (cat. 53).

Giovanni was able to set his religious works at any hour of the day, but he showed a preference for the first hours of the morning and those of evening sunset, hours that invite one to meditation and induce a sense of melancholy. The *Virgin with Red Cherubim* (cat. 72), which should be dated to a period quite near the *Virgin with Two Saints* (cat. 71), marks the moment at which the artist, without ever disowning the compositions of his first years and the models of his origins, expresses, a few years ahead of time, the naturalistic, solemnly monumental language that will be the style of the coming century. Strictly speaking, the so-called red cherubs should be called seraphims, meaning those members of the ranks "burning with charity" among the nine that make up the angelic choirs, as we are informed by Ortensia Martinez Fucini.

The number of replicas and copies of the composition presented in the *Presentation of Jesus in the Temple* (cat. 78), from the twelve listed by Ragghianti (1946) to the twenty-nine listed by Heinemann (1962), attests to the great success of this invention. Giovanni here repeats the half-length scheme for a theme of religious history, one that cannot be considered a Sacra Conversazione, as he had done earlier by paraphrasing the *Presentation in the Temple* by Andrea Mantegna (cat. 21) and in the half-length Pietàs. The Madonna of this composition turns up in works by Antonio Solario and Bartolomeo Veneto. It is one of Giovanni's most successful creations, characterized by formal fullness and linear clarity, and the minor Trevisan painter Vincenzo dalle Destre (or, as has become fashionable to say, dai

SAN ZACCARIA ALTARPIECE
Detail: SAINTS JEROME
AND LUCY
Church of San Zaccaria, Venice
(cat. 106; complete image on
page 171)

72

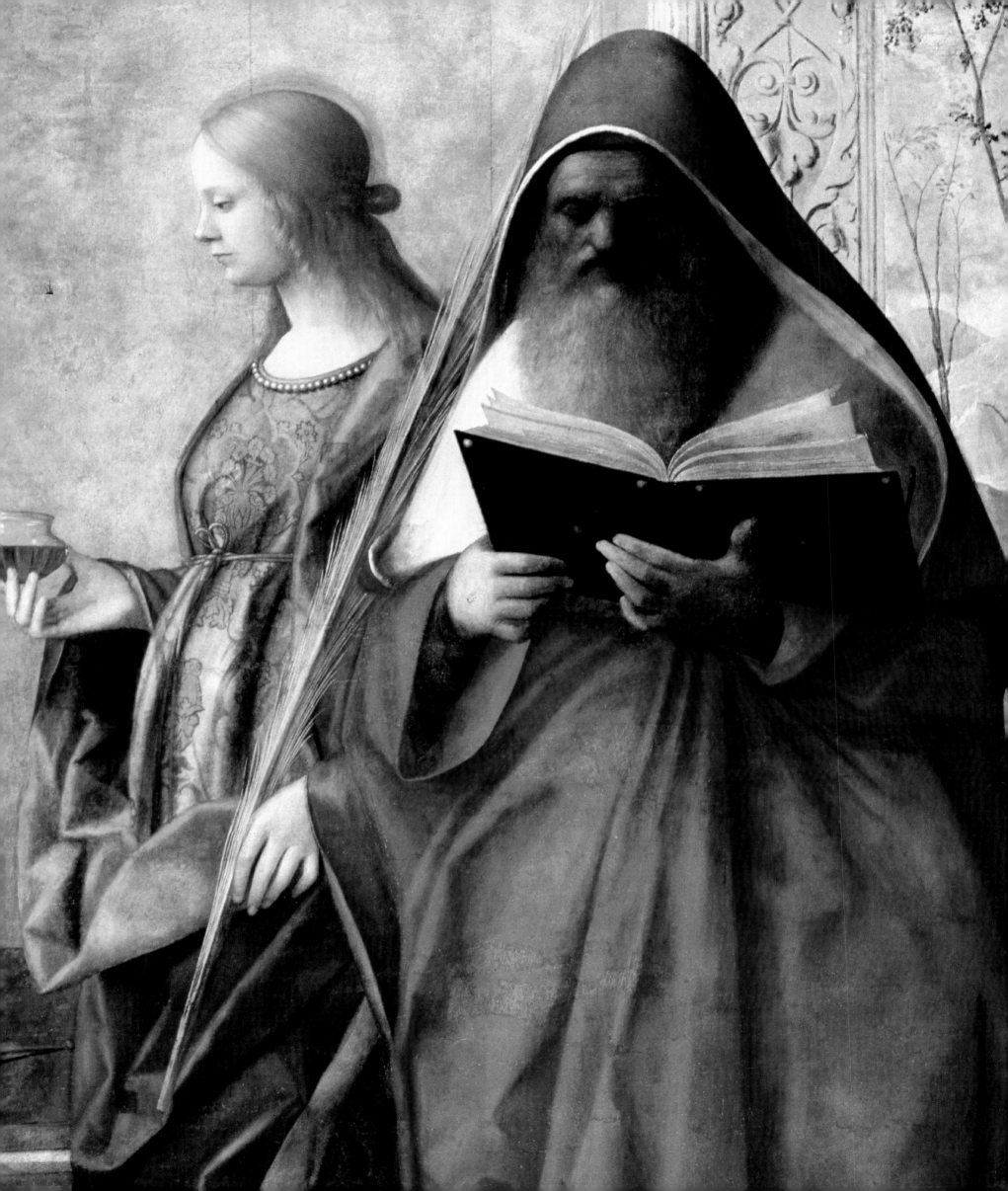

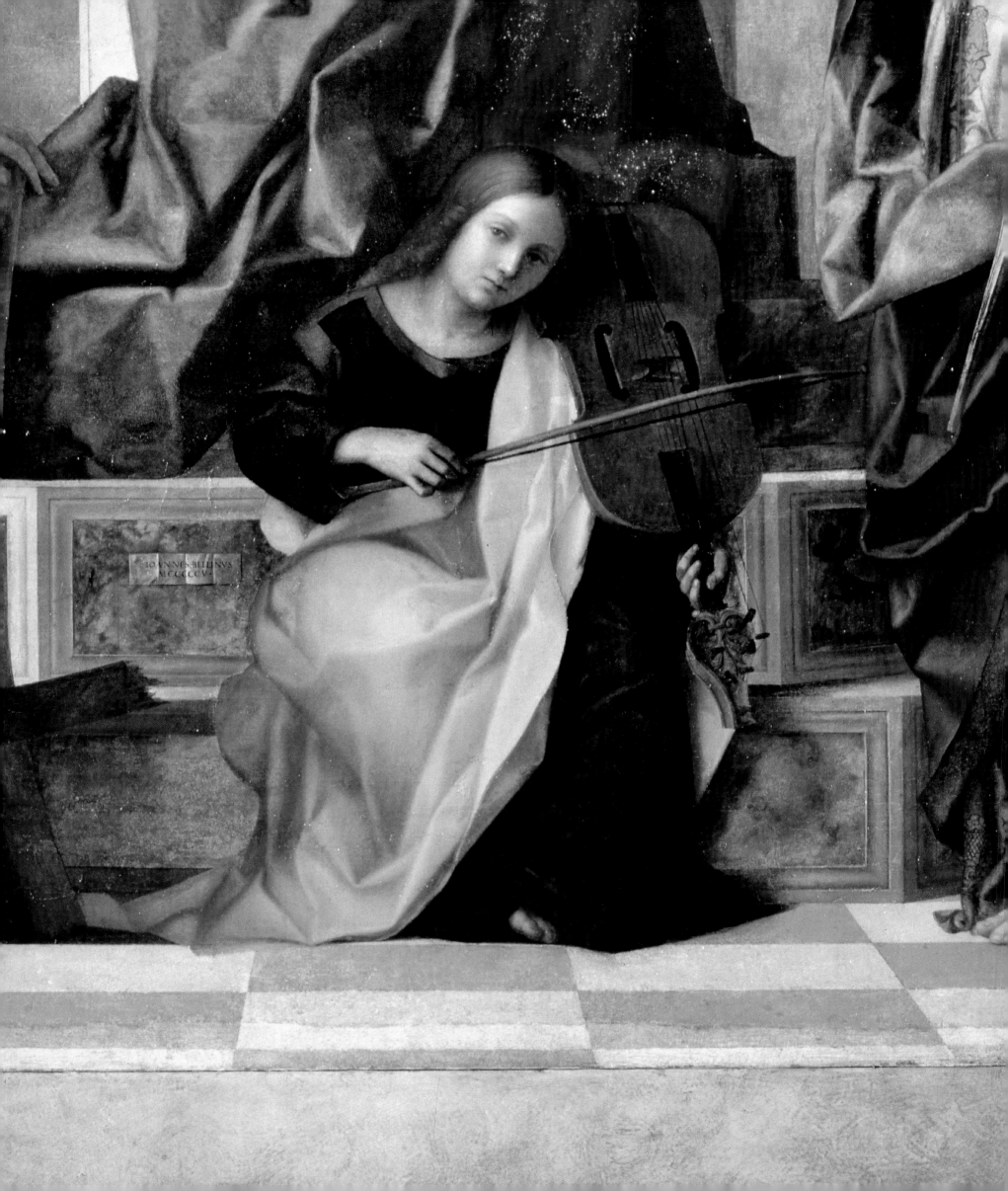

Destri) made two copies of it, both signed, one in the Museo Civico Correr in Venice and the other in the Museo Civico in Padua. In the latter work, the woman to the left repeats another idea by Giovanni Bellini, this one created as a Madonna and known to us from various examples that constitute the first works by Rocco Marconi—all of which provides further confirmation of how students combined and juxtaposed individual figures drawn from the *similes* (preparatory models) available in a master's workshop. The model by Giovanni must date to the early 1490s.

The *Portrait of a Young Man with Long Hair* (cat. 79), from the Vandeuil collection in Paris and now in the Louvre, belongs to a genre of painting that was quite popular in Venice during the last years of the century. While not recognizing this as an autograph work by Giovanni, Goffen (1989) points out that in this type of portrait the social status of the sitter may be revealed by his clothing, but the sitter here appears without any attributes to identify his political status or trade performed; sometimes these portraits are diptychs, such as in the celebrated example by the painter and illuminator Jacometto Veneziano preserved in the Lehman collection and deposited in the Metropolitan Museum of Art in New York. Alvise Vivarini and, later, Bartolomeo Veneto and Jacopo dei Barbari made pictures of this type. The derivation from Flemish prototypes and the use of the genre by Antonello da Messina confirm the success of this type of painting, which was often of a nuptial character. Another work from this genre is the *Portrait of a Man with Red Hair,* bearing a spurious signature, displayed under the name Giovanni Bellini in the Uffizi.

Like the portrait in the Louvre, and the three in Washington, D.C. (cat. 46, 62, and 81), the *Portrait of a Blond Young Man* in the Pinacoteca Capitolina in Rome (cat. 80) belongs to the series of portraits whose meaning and function are described above. Located just past a parapet against the background of a sky crossed by white clouds, this work takes place in an indefinite dimension: like the other figures in this portrait series, the young man gazes off at some object that is not visible to the viewer. His dress is customary for this kind of portrait: a black robe from which a white shirt can be seen, a black beret; the only note that distinguishes him from the others is the cape thrown over his right shoulder.

Like the two Presentation in the Temple paintings (cat. 21 and 78), *The Circumcision of the Christ Child* in the National Gallery in London (cat. 86) is one of Giovanni's rare half-length compositions presenting, on the example of Mantegna, an episode of sacred history that is not a Pietà and that cannot fit within the category of the Sacra Conversazione. This invention enjoyed great fortune among students and was evidently much in demand by patrons: Heinemann (1962) lists thirty-two replicas, aside from the one in the National Gallery of London; outstanding among all of these is the one signed by Marco Bello in the Pinacoteca of the Accademia dei Concordi in Rovigo (no. 89).

The example in the National Gallery in London has a dark background, as do the *Virgin with Two Saints* (cat. 71) and the prototype of the *Presentation in the Temple* by Andrea Mantegna in Berlin. The work's notable quality leads to the conclusion that it was painted on a design prepared by the master and was made under his direct supervision, even though the work cannot be judged as absolutely autograph because of its overall coldness compared to other paintings from the same period made directly by Giovanni. A painting based on it using full-length figures in a landscape, with slight variations at the compositional level, is in the Museo di Castelvecchio in Verona, attributable to the workshop of

SAN ZACCARIA ALTARPIECE
Detail
Church of San Zaccaria, Venice
(cat. 106; complete image on page 171)

75

Luca Antonio Busati, the artist formerly known as the Venetian Master of the Incredulity of Saint Thomas (Tempestini, 1994). The female figure to the right in the original composition appears, transformed into a Madonna, in a small painting in the Museo Civico Correr in Venice, and is held to be a forgery and thus excluded from the official catalog of the museum's holdings, compiled by Giovanni Mariacher (1957). In the past the transformed Madonna has been put in relation to the figurative world of Vittore Carpaccio, from whom all the elements are derived except for the figure of Mary, but including her hands: her hands, the Child, the young Saint John the Baptist, and the motif of the window recall the painting in the Städelsches Kunstinstitut of Frankfurt (cf. Sgarbi, 1994, p. 204, Sgarbi cat. 15). It seems reasonable to date the original by Giovanni Bellini to around 1500.

The *Virgin and Child with Saints Paul and George, Two Female Saints, and Donor (Pourtalès Sacra Conversazione;* cat. 87), today in the Pierpont Morgan Library in New York, is without doubt based on an invention by Giovanni, at least in terms of the main group, which shows up in works by many students and even in the *Madonna and Child with Saint Peter Martyr* by Lorenzo Lotto, signed and dated 1503 and today in the Galleria di Capodimonte, Naples (no. 55), in which the portrait of Lotto's patron in Treviso, Bishop Bernardino de' Rossi, has been replaced by a young Saint John the Baptist. The Madonna and Child as presented in the painting in New York appear in many other works made by the workshop or the school of Giovanni Bellini; we would cite here only the *Madonna* in the Staatsgalerie, Stuttgart (no. 237), which is usually considered a signed work by Marco Bello, but should be attributed to Fra' Marco Pensaben, like the *Sacra Conversazione* in the Accademia Carrara of Bergamo (no. 384), which even Berenson listed among the works of Marco Bello.

The painting in the Pierpont Morgan Library gives the impression of having been made by a student who combined motifs drawn from various similes, all designed by Giovanni. The praying female saint shows up in two paintings by Vincenzo Catena, one in the Staatsgalerie in Stuttgart (no. 176), and one in the Corporation Art Galleries in Glasgow (no. 199); the Saint Paul, the praying female saint, and the Madonna and Child appeared in the *Sacra Conversazione* by Andrea Previtali, formerly no. 39 in the Kaiser-Friedrich-Museum, Berlin (destroyed in 1945); the Saint Catherine on the right was based on the figure on the right in the *Circumcision* (cat. 86). Even the female saint with the garland (Saint Dorothy) shows up at least twice in Catena and appears in the *Sacra Conversazione* in the Metropolitan Museum of Art in New York (no. 49.7.1), bearing the signature of Giovanni Bellini but assignable to Vittore Belliniano. The motif of the pearls that decorate the head scarf, already present in the *Circumcision,* pleased not only Andrea Previtali but, among the other followers of Giovanni, in particular Francesco di Simone da Santacroce.

The *San Cristoforo della Pace Triptych* (cat. 105) served as a favorite storehouse of models for both individual figures—as with the *Baptist* by Girolamo da Santacroce in the Museum of Fine Arts in Budapest (no. 99), the Saint Francis that appears in the Cima-style *Saint Mark Enthroned with Saints Andrew and Francis* by Andrea Busaiti, in the Ca' d'Oro in Venice, and in a panel in the Museo of Castel Sant'Angelo in Rome that is attributed to Pietro degli Ingannati but should be restored to Marco Belli—and for half-length compositions in which the two side figures from this triptych are placed around a Madonna and Child designed after the version in the *San Zaccaria Altarpiece* (cat. 106); this type of

compilation can be found in works by various students of Giovanni Bellini, including in particular Francesco Bissolo, Pietro degli Ingannati, Vincenzo Catena, and Marco Bello.

The panel in the National Gallery of Art in Washington, D.C., showing *Saint Jerome in the Desert* (cat. 107) is an example of a theme that enjoyed great popularity among private patrons. It is also a painting of the highest quality, its composition reminiscent of the works Giovanni made in the 1470s and '80s, such as the two today in the Uffizi and the National Gallery in London (cat. 53 and 54) and *Christ's Descent into Limbo* in Bristol (cat. 38). In this case, the date given on the painting itself is to be trusted, meaning 1505, because of both the figure and the far-off landscape in the left background.

The *Madonna and Child with Saints and Donor* (cat. 108), today in the Birmingham City Museum and Art Gallery, is best known as the *Vernon Sacra Conversazione;* it was formerly in the Cornbury Park collection of Oliver Vernon Watney. X-rays have brought to light the sharp outlines of the Mother-Son group; the two saints, on the other hand, are revealed to have been built up on the basis of a design that was reworked several times. In particular, the heads of the saints seem to be smaller than the size originally planned, and there can be no doubt that the head of the donor was added by another hand; since the work was being made for a city on the mainland, Giovanni Bellini may well have agreed to permit a local painter to add the portrait of the donor.

Cannon-Brookes (1977) went so far as to hypothesize that Bellini had entrusted creation of the preparatory designs to his students and had then stepped in at the level of painting, modifying the design as he went and thus providing an autograph work. This would explain the fact that none of Bellini's students seems to have used the *Vernon Sacra Conversazione* as a source for models, for there would not have been any simile for it in the workshop. This is an intriguing suggestion.

The original size of the work itself presents another problem, and one that is difficult to resolve. Examination of the panel leads to the conclusion that it has been cut back on all four sides: if nothing else, this seems unquestionable since today the frame covers the top part of the throne and the cartellino bearing the signature and date. But whoever performed this reduction must have paid attention to the proportional relationships in the painting, which constitute one of the most fascinating aspects of the work, its slight asymmetry. Due to this asymmetry the throne is not located at the center but is pushed slightly to the left, an arrangement that seems to have been planned by the painter, since the distance between the right edge of the cartellino and the right edge of the painting is the same as that between the center of the throne and the left edge of the painting. If we accept this conclusion, we must see this small votive altarpiece as one of the oldest examples of an asymmetrical arrangement applied to this genre of painting, an arrangement full of consequences, both for Bellini himself and for his followers, from Sebastiano del Piombo to Titian to all the religious paintings in the Veneto, Emilia, and Rome up to the eighteenth century.

Many scholars refer to a late replica of this work, although it is signed and dated 1505, in the Staatsgalerie in Stuttgart, where, however, it is nowhere to be found today. As Cannon-Brookes has pointed out, the work in question is a variant pastiche that draws elements from several works, including the *Vernon Sacra Conversazione:* the throne is from the *Enthroned Virgin Adoring the Sleeping Child* (*Madonna della Milizia di Mare; cat. 20*), the head

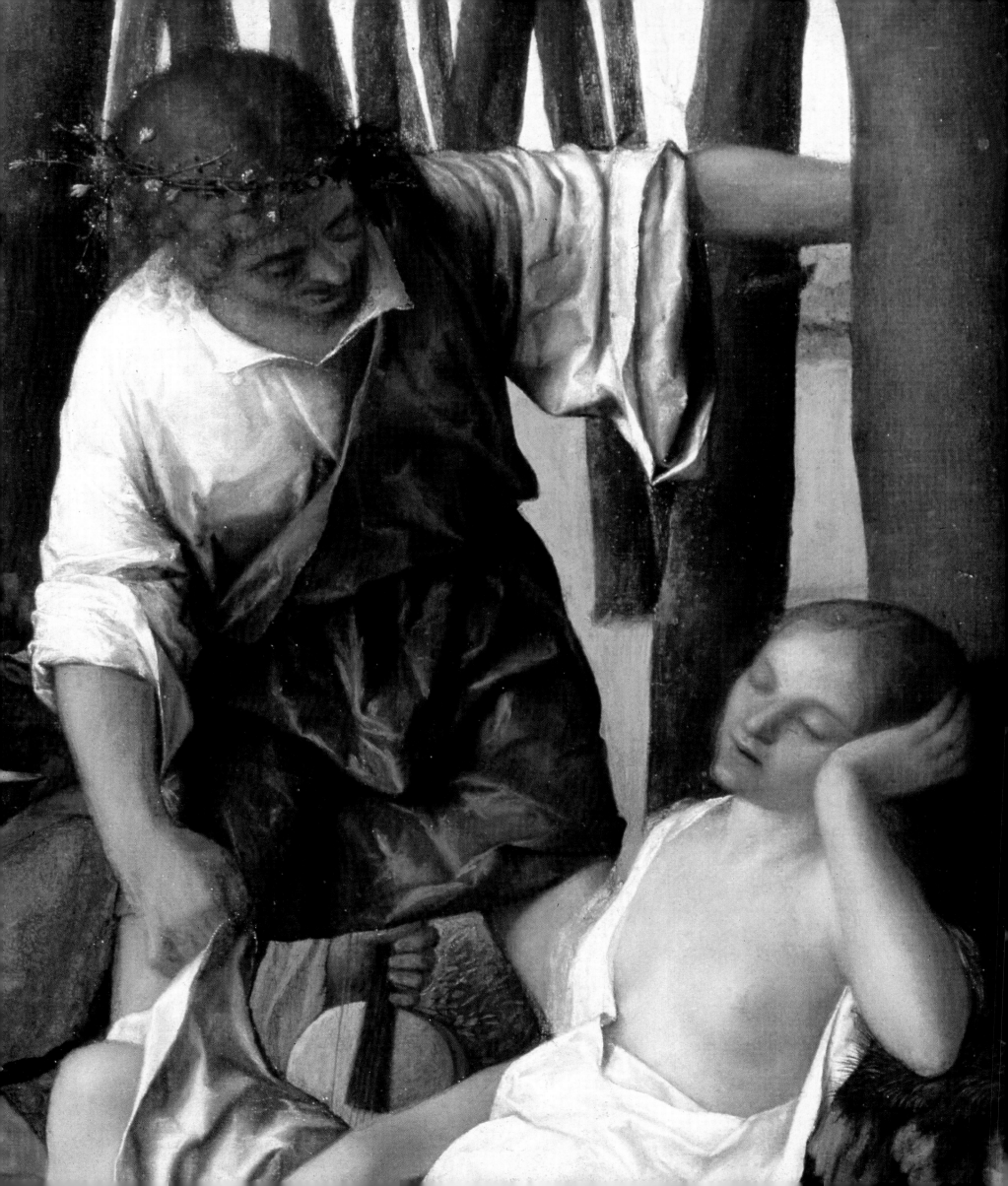

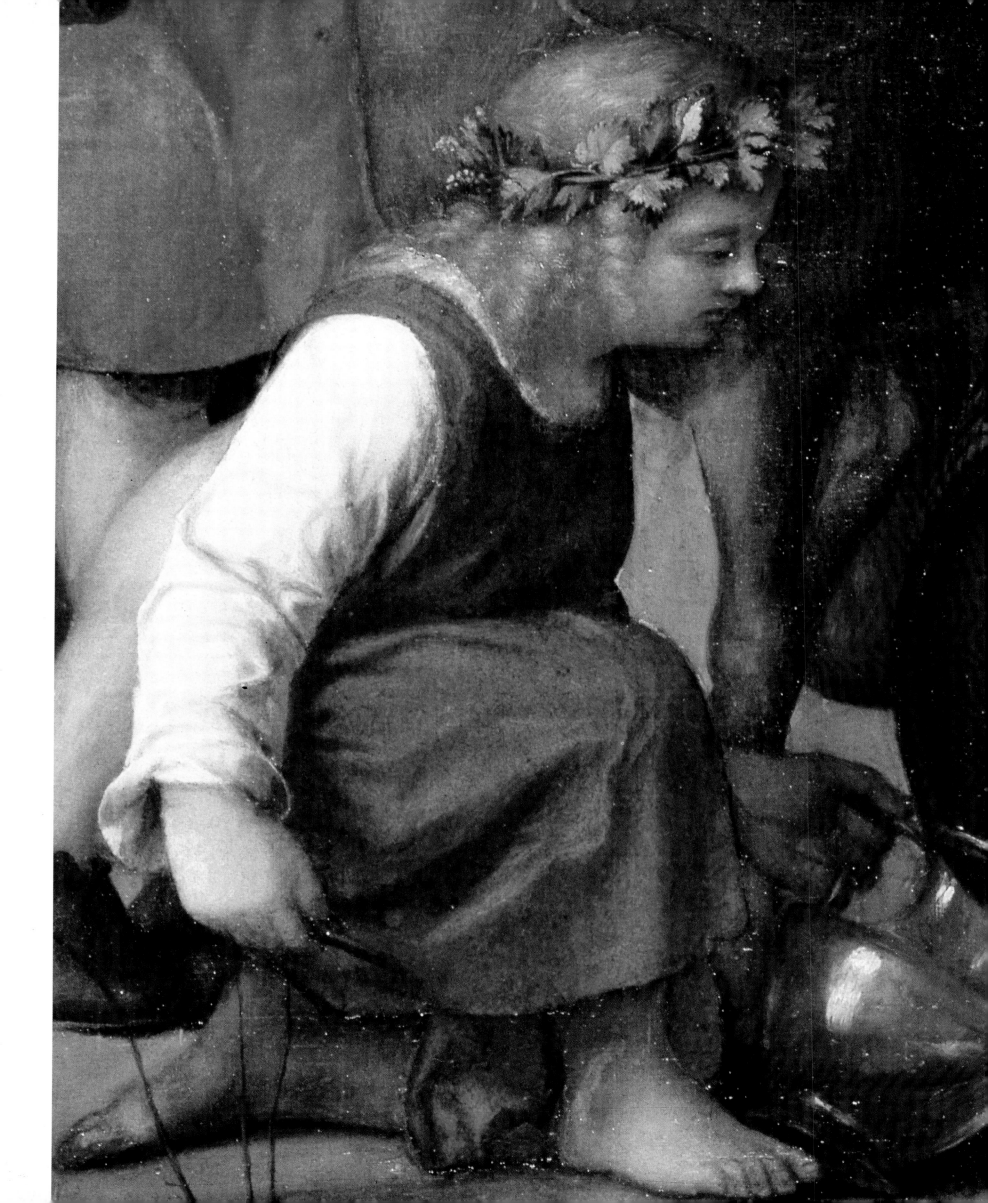

of Mary is from *The Virgin Between Saints Paul and George* (cat. 85), the figure of Saint Peter is banalized, the landscape changed, and the saint at right is transformed into a martyr; this last saint is usually identified as Saint Paul, although he would seem more like a Saint Mark, at least judging by his actual appearance, as Cannon-Brookes points out. In fact, this question constituted one of the problems connected to this panel, which was made for private devotion, since in the description of the Cornbury Park collection by Dawson Turner (1840) he is described as dressed in red and white, which would certainly indicate Saint Paul, while today he seems dressed in bright pink and blue. The top part of the throne is similar to that of the *San Zaccaria Altarpiece* (cat. 106), which would confirm its chronology.

Another point of great interest is the fact that the light comes in at an angle from the left and makes a dark shadow on the floor that is not visible in the Stuttgart replica; according to Cannon-Brookes, this shadow naturally cannot be thrown by the saint who was in the side panel, but rather from one or two columns that were part of the original frame and which the painter took into account; we believe one can suppose that the shadow was related in some way to the figure of the donor in the act of venerating the religious image, since it is pointed directly at him.

Despite its extremely poor state of preservation, the quality of *The Dead Christ Seated in a Landscape* in Stockholm (cat. 111) is very high. Originally probably signed, whereas today the cartellino is blank, the panel is spiritually very similar to the central part of the *San Giovanni Crisostomo Altarpiece* (cat. 119). The grassy vegetation that spurts from the rock against which the body of Christ stands out, surmounted by the symbolic branch of fig, makes one think of the plants that surround Saint Jerome in the great Venetian painting.

The chronological location of this painting presents difficulty. It certainly belongs to the painter's later period of production; in our catalog it precedes the *Dolfin Sacra Conversazione* (*San Francesco della Vigna Altarpiece;* cat. 112) as a result of arguments that have long been going on in the history of art, but it should probably be moved to between the end of the first decade and the beginning of the second decade. A work based on the Stockholm *Dead Christ,* ascribed to Marco Basaiti but attributed by us to Pier Maria Pennacchi, is in the Museum of Fine Arts in Budapest (no. 4206) and could be the twin—also in terms of its size ($34\frac{1}{4} \times 27\frac{1}{8}$ in.; 87×69 cm), if one hypothesized that its height had been scaled down by less than a fifth—of the painting located in the Venetian church in place of this work, made by a student who, according to Vasari, might have been (but was not necessarily) Girolamo Mocetto.

The arrangement of the *Dolfin Sacra Conversazione* met with much success in the area of Venice, as indicated by the replica by Girolamo da Santacroce in the Pinacoteca dell'Accademia dei Concordi in Rovigo, the copies in Bergamo and Boston, and the paraphrase in the Museo Civico of Padua, which can be attributed to the workshop of Bonifazio de' Pitati.

Giovanni Bellini was clearly a man of strong moral convictions. This aspect of his personality shows up in his refusal to depict in his works things of which he had no direct experience, a sort of *ante litteram* experimentalism. On October 4, 1497, he turned down the request from the duke of Mantua, Francesco Gonzaga, to use a view of Paris as the background for a painting. The artist had written to Gonzaga that he could not begin work on such a painting since he had never been in that city. This means that the views of cities

Pages 78–79, and opposite
THE FEAST OF THE GODS
Details
Widener Collection, National Gallery of Art, Washington, D.C (cat. 120; complete image on page 185)

80

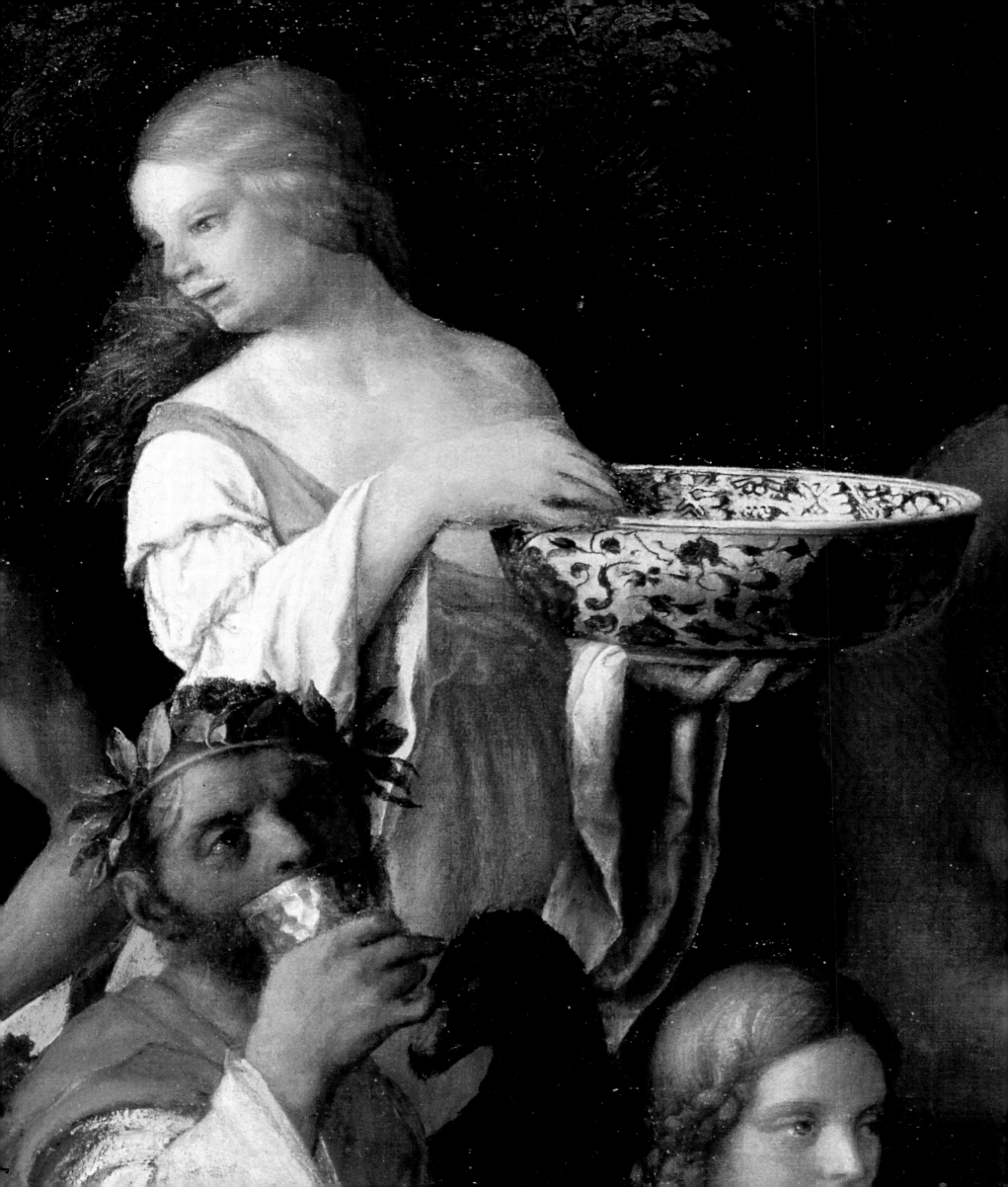

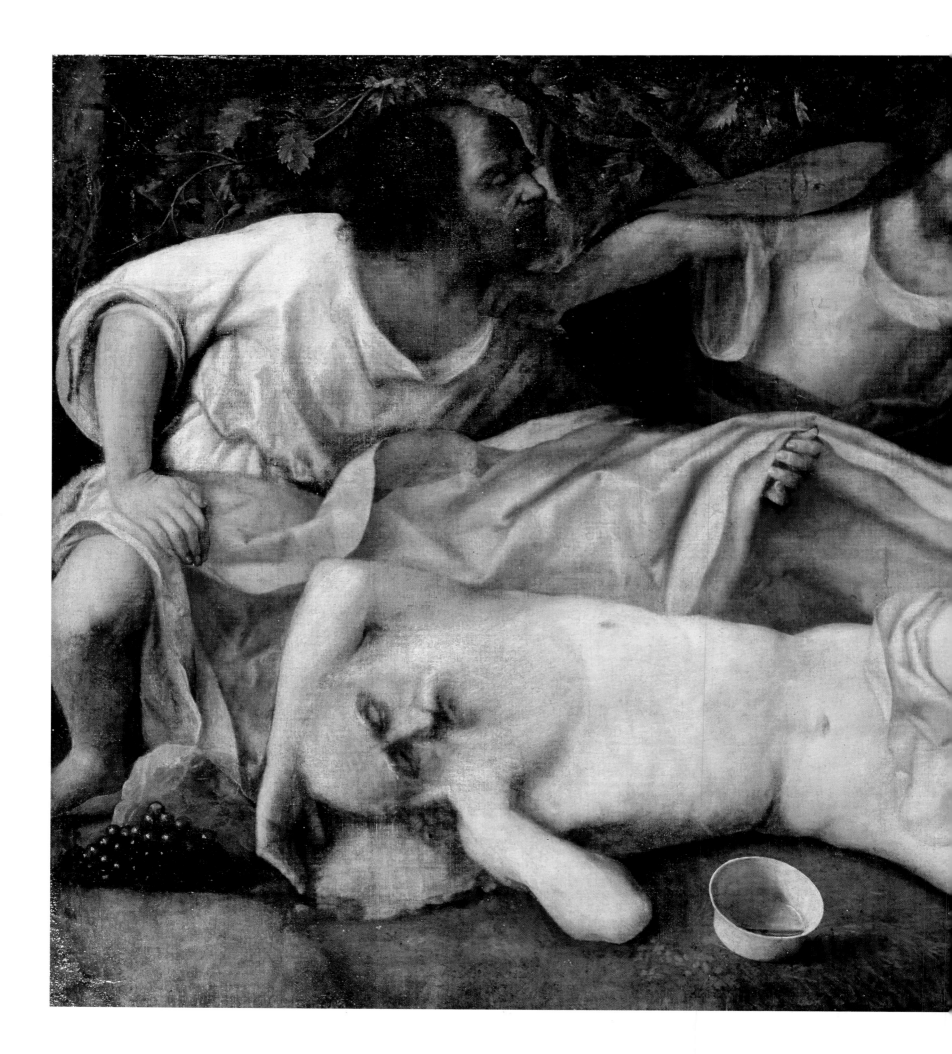

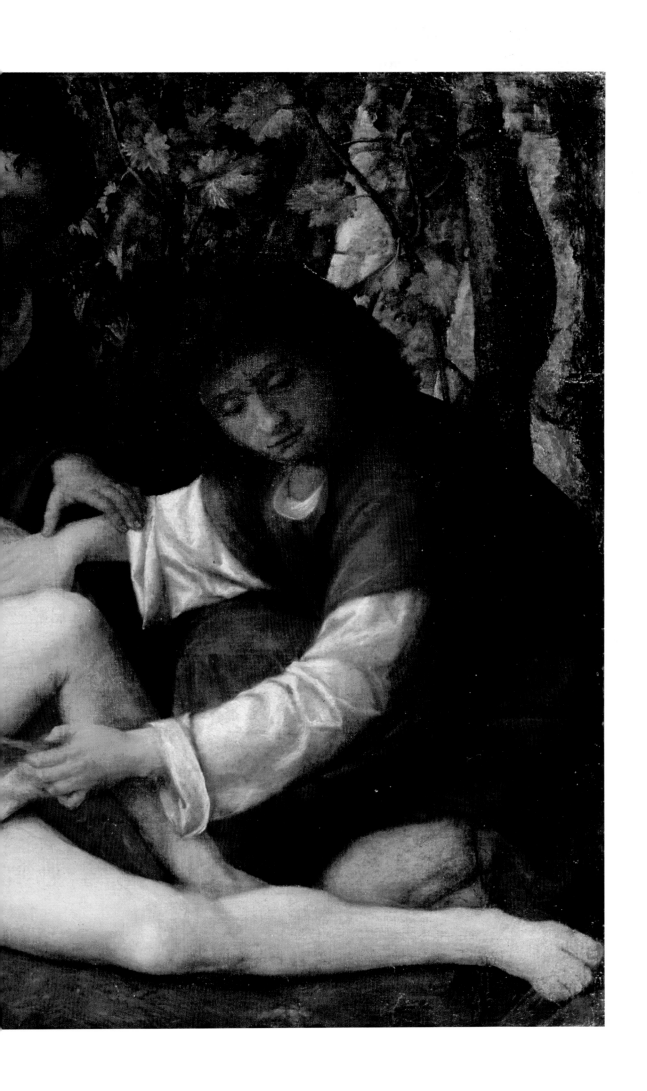

THE DRUNKENNESS
OF NOAH
Musée des Beaux-Arts,
Besançon
(cat. 125)

and individual structures from Vicenza, Verona, Rimini, Ravenna, and Ancona in the backgrounds of his pictorial works indicate that he stayed in or at least visited those cities (see also Gibbons, 1977). On January 30, 1516, in the last months of his life, Giovanni obtained from monks of the convent of San Zanipolo in Venice the loan of a silver crown that he wanted to reproduce in a Madonna that he was painting for the duchess of Alençon, sister of the king of France, Francis I. The painting has been lost, but the information is important, since it confirms what was said above: even precious objects, such as the bishop's pastorals or those of abbots that we see in the paintings by Giovanni Bellini, reproduce examples that the painter was able to draw from life, as confirmed by the fact that the same pastoral appears in the *Barbarigo Votive Altarpiece* (cat. 66) and *The Frari Triptych* (cat. 67), works that were practically contemporary, whereas the one in the *San Giovanni Crisostomo Altarpiece* (cat. 119) seems based on the one from the Primicerius, today in the Treasury of San Mark (Tempestini, 1992, *Oreficeria*).

As for the poem by Bartolomeo Leonico Tomeo, known as Fusco, which was titled "Ad Ioannem Bellinum eximium pictorem" and published by Giovanni Agosti (1996), the more we read it the more we are convinced that it is an ironic text, defamatory, designed to put dents in the halo of respect surrounding the elderly painter, and in so doing to diminish some of his power. The neo-Platonism that was so popular in certain cultural settings at the time, and not only in the Veneto, is not enough to make the poetic exaltation of a homosexual relationship seem credible. The consequences for the artist, had this accusation been confirmed, would have been very serious, and his fame would have been profoundly clouded.

Catarina Schmidt Arcangeli (1996 and 1997) has proposed attributing to Gentile and Giovanni Bellini the plans for the facade of the Scuola Grande di San Marco, an institution of which both men were members. Her hypothesis is supported by interesting similarities in drawings by the two artists and with some of their pictorial works. If confirmed by documents, this proposal would open a new chapter in the story of the Bellini brothers, who may have been not only painters but also architects.

FOLLOWERS

Giovanni Bellini was the founder of a school; some of the most outstanding artists formed in Venice between the end of the fifteenth and beginning of the sixteenth centuries got their start in his workshop. Lorenzo Lotto, Giorgione, Sebastiano del Piombo, and Titian: these names alone indicate the importance of the role Giovanni played in the evolution of figurative language in Venice, which can be seen as a reflection of his ability to constantly renew his own lexicon on the basis of the creations of some of his best students. Painters from other regions participated in Giovanni's school, most from the Emilia and Romagna areas but also from all of the territory then controlled by Venice, an area that reached Brescia and Bergamo to the west and extended up into Friuli, Istria, Dalmatia, and Albania. Some of these students created good works, later maturing their lexicon on the basis of experience.

The extraordinary success of certain works designed by Giovanni, in particular certain devotional panels presenting the Madonna and Child at half-length, led to a proliferation of works by other artists—second- and third-class painters as well as the true Veneto-Crete *Madonneri* (Madonna artists) of the so-called Rialto school, artists who translated Giovanni's creations in their neo-Byzantine lexicon. The works of these artists, which enjoyed continuing popularity in provincial regions, varied in quality and were based on cartoons or similes by the master, using juxtapositions and combinations of figures and sometimes incongruous arrangements. Looking back today, we can say that such works invaded the art market and affected popular taste, at least at the level of less well educated buyers, and did so until well past the middle of the sixteenth century, meaning at least forty years after the death of the founder of the school. But to hold Giovanni Bellini in any way responsible for such corruptions of taste would be to demonstrate a lack of historical perspective, for in that period, as in all others, the more progressive line of artistic evolution was always accompanied by lesser products. The painter to whom these lines are dedicated occupies a place of great importance in the history of human civilization because of the message he was able to transmit to us, a message based on beauty and harmony, on the idea that humans are not unaware of their limits, but despite that, or precisely because of it, they are able to find their way in the world and to carry on their daily existence on the basis of a serene awareness.

Page 86
FOUR ALLEGORIES
(VINCENZO CATENA'S
"RESTELO")
Detail of VAINGLORY
Gallerie dell'Accademia, Venice
(cat. 77; complete image on
page 150)

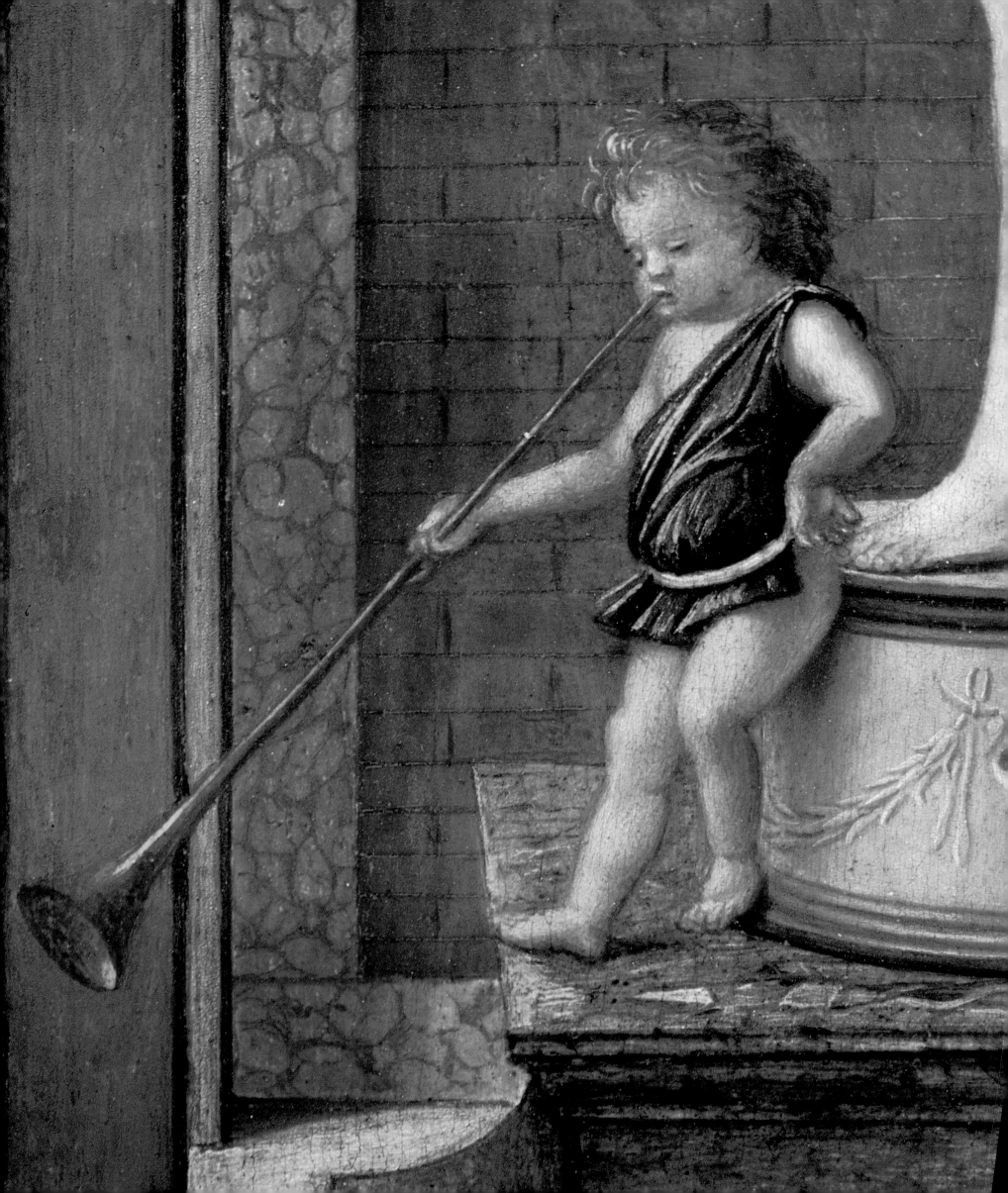

PLATES

POLYPTYCH OF SAINT VINCENT FERRER

Angel of Annunciation; The Dead Christ Supported by Two Angels; Annunciate Virgin
Panels, 28⅜ × 26⅜ in. (72 × 67 cm) each
Saint Christopher; Saint Vincent Ferrer in Ecstasy; Saint Sebastian
Panels, 65¾ × 26⅜ in. (167 × 67 cm) each
Predella: *Five Scenes from the Life of Saint Vincent Ferrer*
Three panels, 14⅛ × 23⅝ in. (36 × 60 cm) each
Santi Giovanni e Paolo (San Zanipolo), Venice

The Venetian scuola of San Vincenzo Ferrer was officially established in the Dominican church of Santi Giovanni e Paolo in 1450, five years before Vincent Ferrer was canonized, for the famous preacher was venerated as a saint long before his actual canonization. A document in the Archivio di Stato of Venice refers to a payment made in 1464 for an unspecified work connected to the altar; we have no specific information about the polyptych itself. We do not know who made it, the precise date when it was made, or the extent to which the arrangement we see today corresponds to the original structure.

The attribution to Giovanni Bellini dates to Sansovino (1581), but was not supported by writers in the seventeenth and eighteenth centuries; Ridolfi (1648) proposed instead Alvise Vivarini, Boschini (1664) was in favor of Bartolomeo Vivarini, and A. M. Zanetti (1733), a follower of Vittore Carpaccio. It was Longhi (1914) who reproposed Bellini's paternity, which has been supported by all Italian art historians as well as by Gronau (1930), van Marle (1935) and Berenson (1957), who expressed doubts only concerning the predella and who earlier (1895) had attributed the work to Francesco Bonsignori, an opinion later shared by L. Venturi (1907) and Borenius (1912). German scholars along with English and American scholars have usually attributed the entire structure to Lauro Padovano, to whom Michiel (1521-43) had dubiously attributed the predella of the lost altarpiece of Saint John the Evangelist, made by Bellini for the Venetian church of Santa Maria della Carità (cat. 5).

Among German scholars, Gronau leaned toward Giovanni Bellini but assigned the predella to Lauro Padovano, while Dussler, after first opposing (1935) Bellini's paternity, in his second edition (1949) credited Bellini with the composition of the principal figures; both Heinemann (1962) and Huse (1972) expressed great difficulties in recognizing Bellini's hand in the structure and were drawn instead to Lauro Padovano; only Belting (1985 and 1996) followed Dussler's second thesis, but also judged the *Dead Christ* to be a sure autograph work by Bellini. Arslan (1952) noted vague Belliniesque characteristics only in the upper panels and proposed dating the polyptych to the mid-1470s or earlier.

Robertson (1968) provided one of the most well-reasoned analyses of the problem, attributing the polyptych to the workshop of Giovanni without ruling out the possibility that the most important contribution to its execution had come from an able assistant like Lauro Padovano. Goffen (1989) assigned the polyptych to Giovanni with assistance; Degenhart and Schmitt (1990) agreed on attributing the polyptych to Giovanni. Lucco (1990) gave Bellini credit for at least the overall design of the structure and dated it to the middle of the 1460s on the basis of references to a series of contemporary works. The two most incisive points in his discussion are recognition of the close affinity at the lexical level with Marco Zoppo and acknowledgment of the progress made by the artist compared to the *Carità Triptychs* (cat. 5): each of the three principal saints of the *Polyptych of Saint Vincent Ferrer* is located in a well-defined space and stands out against, even looms over, the landscape. Lucco reaches the same conclusion we do with regard to the central panel with *Saint Vincent Ferrer in Ecstasy:* the saint's figure inhabits its panel only with difficulty, and the panel itself must once have been located in a more elevated position than those of the saints on either side of it, as indicated by the fact that the two side saints are looking upward and by the fact that the Dominican's feet rest on clouds of glory amid black

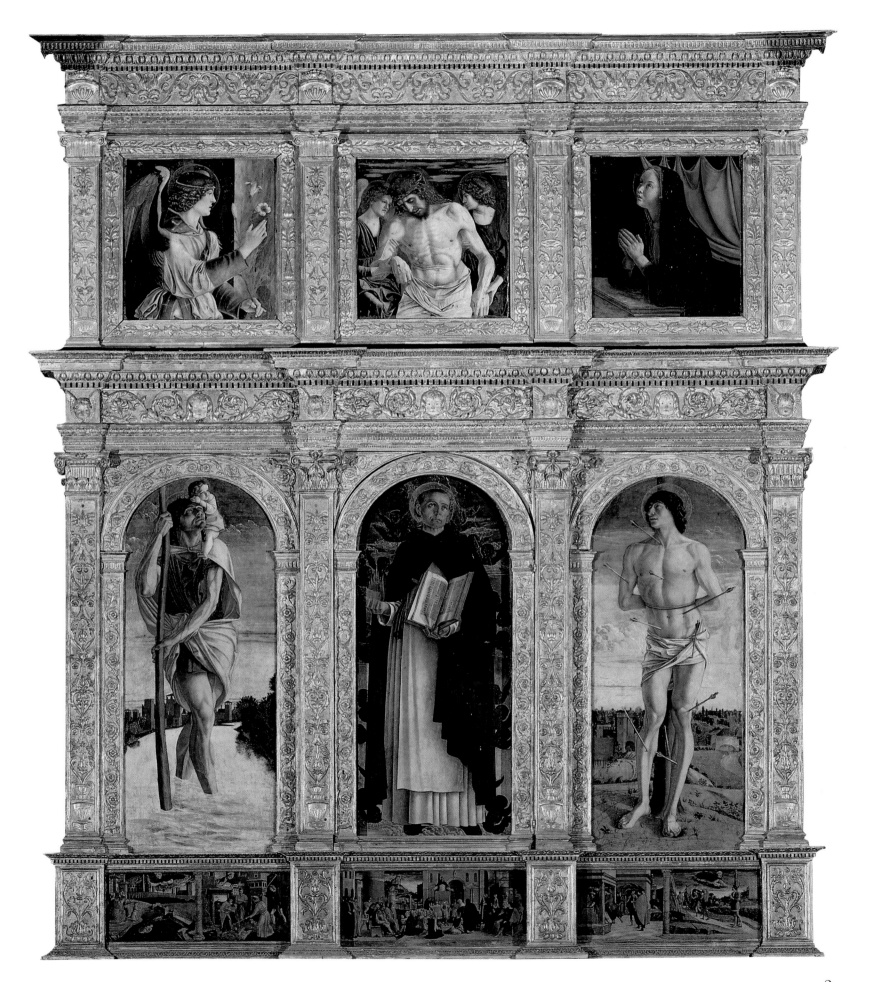

POLYPTYCH OF SAINT VINCENT FERRER

Detail of the left panel of the predella

Church of Santi Giovanni e Paolo (San Zanipolo), Venice
(cat. 9)

90

POLYPTYCH OF SAINT VINCENT FERRER

Detail: SAINT VINCENT FERRER SAVES A DROWNED

WOMAN AND RAISES THOSE BURIED UNDER THE DEBRIS

Church of Santi Giovanni e Paolo (San Zanipolo), Venice

(cat. 9)

cherubs. The central panel with Saint Vincent Ferrer was probably also both wider and higher originally, in which case the overall structure of the polyptych would have been far more similar to that of almost all those we know from northern Italy between the last decades of the fifteenth century and the first years of the sixteenth. There is also the example of the *Griffoni Altarpiece,* a triptych painted by Francesco del Cossa early in the 1470s in Bologna, which also presents the figure of Saint Vincent Ferrer in its central panel and which includes so many structural similarities with the polyptych in Santi Giovanni e Paolo—aside from other shared elements, such as the two half-figures of the Annunciation—that Heinemann was led to suggest that the Dominicans imposed a predetermined program for the worship of this saint. Conti (1987) also thought that the Saint Vincent Ferrer panel had originally been located above the other two and dated the polyptych to c. 1468, holding that the current frame was made in the last decade of the fifteenth century and pointing out that the original overhanging lunette with the *God the Father* (lost), was moved to the scuola of San Vincenzo Ferrer in 1777.

Art history has traditionally emphasized the presumed stylistic resemblance of the predella of this polyptych to the predella presenting *Three Scenes from the Life of Drusiana* that is today in the castle of Berchtesgaden in Bavaria, a work that almost always has been considered the only surviving part of the *Carità Triptychs.* In the summer of 1992, thanks to special permission obtained from Verwaltung der Bayerische Schlosser und Garten and with the kind assistance of our late friend and colleague Richard Harprath, and after a futile preliminary trip, we had the opportunity to analyze the work directly and found that the presumed resemblances are only superficial, related to exterior, compositional elements. Bauer-Eberhardt (1989) recently proposed attributing the predella in Berchtesgaden to Giovanni Bellini's cousin Leonardo Bellini, along with the *Saint Ursula and Four Virgins* in the Accademia of Venice, which bears the spurious signature of Caterina Vigri. Longhi (1946) attributed this same *Saint Ursula* to Giovanni Bellini, and it appeared as no. 2 in the Venetian exhibition in 1949. The comparison of that work with the two miniatures by Leonardo Bellini that Bauer-Eberhardt proposes does not permit us to express a definitive judgment on his hypothesis: it should be pointed out, however, that his essay offers a striking presentation of the figure by Lauro Padovano, who seems to have been a talented painter, certainly one of the most gifted assistants in Jacopo Bellini's workshop. Bauer-Eberhardt proposes attributing to Lauro, as surviving portions of the predella of Saint John the Evangelist, the two fragments of the *Resurrection of Drusiana* and the *Martyrdom of Saint John the Evangelist,* respectively in the Accademia Carrara in Bergamo and on the international art market, both once attributed to Francesco Bonsignori. Heinemann had earlier attributed the *Martyrdom of Saint John the Evangelist* to Lauro, but he had refused to see in it, or in any part of the Berchtesgaden predella, a connection to the lost altarpiece by Giovanni Bellini.

We are convinced that the *Polyptych of Saint Vincent Ferrer* dates to a period when Giovanni was still experimenting with his creative genius in search of his definitive language, meaning the language of his mature period. There are unquestionable affinities to Marco Zoppo, an artist who is often presented in confrontation to Giovanni but who must have been in close contact with him during the second half of the 1460s, since he too was active in Venice, was more or less the same age, and, too, had been greatly influenced by Andrea Mantegna. But the resemblance of this polyptych to works by Marco Zoppo does not extend, as Lucco made clear, beyond the emphasis given blood vessels and the look of metallic shavings in the hair of the Dead Christ, of the angels supporting him, of the angel in the Annunciation, and of Saints Sebastian and Christopher. Because of a presumed resemblance to the head of Saint Christopher, and based on an opinion expressed by Longhi, the *Head of the Baptist* in the Museo Civico of Pesaro is still often today attributed to Bellini, whereas it should instead be assigned, as indeed Lucco assigns it, to Marco Zoppo, both because of similarities to the angels flanking the Dead Christ in the work by Zoppo in the same hall of the Pesaro museum and because of the heightened expressivity, more in keeping with the works of Zoppo than with the always contained emotions of Giovanni; on this last point we agree with what Ruhmer (1966) writes in his monograph.

It must be admitted that resemblances to Marco Zoppo appear in no other work by Giovanni, and seeking them out elsewhere in this polyptych, whether in the figure of the *Annunciate Virgin,* in the titular saint, or in the predella, is futile: the anatomy of the other two saints, aside from the already noted emphasis given veins, has the appearance of carved wood, and in that sense is similar to the side saints in the Carità *Saint Sebastian Triptych* (cat. 5).

Goffen (1985) proposed dating the *Polyptych of Saint Vincent Ferrer* to circa 1455, since the altar, as indicated by a document she herself located, was built in 1453–54; this thesis has been rejected by Boskovits (1986) as well as by all later writers. As Fogolari (1932 and 1946) made clear, the work must date to about ten years later. Several charcoal drawings appear on the backs of the three main panels, some of them autograph works by Giovanni, others made by Gaspare Diziani, who restored the polyptych in the eighteenth century.

A small panel, formerly in the Brass collection in Venice, bearing a replica (or perhaps a copy) of the *Dead Christ* was displayed as no. 27 in the 1949 Venetian exhibition. The *Polyptych of Saint Vincent Ferrer* appeared in that exhibition as nos. 28 to 36.

THE DEAD CHRIST SUPPORTED BY MARY
AND SAINT JOHN EVANGELIST (PIETÀ)

Panel, 33⅞ × 42⅛ in. (86 × 107 cm)
Pinacoteca di Brera, Milan, no. 204

On the front of the sarcophagus, beneath the left hand of Christ, is a Latin inscription that includes the signature: HAEC FERE QVVM GEMITUS TVRGENTIA LVMINA PROMANT/BELLINI POTERAT FLERE IOANNIS OPVS (When these swelling eyes evoke groans this work of Giovanni Bellini could shed tears). This is a paraphrase of a Latin couplet from an elegy by the Roman poet Propertius that appeared in a printed edition in Venice in 1472, but had been known much earlier from manuscript copies and had been possessed by Petrarch. The Roman poet's work had been dedicated to a slain warrior, but that fact alone is not a convincing reason to accept the hypothesis presented by Goffen (1989) that Bellini may have intended this as an allusion to a Christian soldier killed in the Turkish conquest of Constantinople in 1453. Goffen dates the work to c. 1460, in part because she sees an affinity between the forms of the drapery of Saint John the Evangelist and that of the *Davis Madonna* (cat. 4) and other early works. Longhi (1949) had proposed this same dating, and it was followed dubiously by Pallucchini (1959), who in 1949 had proposed instead a period immediately after 1470, by Bottari (1963), and by Pignatti (1969). Dussler (1935 and 1949), Robertson (1960 and 1968), and Belting (1985) inclined toward a date of c. 1470, while Huse (1972) judged it a contemporary of Giovanni's contributions to the *Carità Triptychs* (cat. 5); Humfrey (1990) opted for 1467-68. We think it should be located toward the end of the 1460s, both because it shows traces of the works influenced by Mantegna in the landscape and in the hair of the apostle and because of the maturity the artist demonstrates, exceeding in this work both the *Carità Triptychs* and the *Polyptych of Saint Vincent Ferrer* (cat. 9), without, however, achieving the Olympic classicism of the Pesaro *Coronation* (cat. 27). This is the third example of the theme of the Pietà in Giovanni's catalog, but, as all scholars point out, it is also the first complete masterpiece by the artist, who strikes a perfect balance between form and expression, between the stately, majestic volumes of the three figures and the eloquent use of color, the red of Mary's tunic contrasting with the blue of the Evangelist's cloak, a contrast that is brought into further evidence by the contrast between the midnight blue of Mary's mantle and the black of the Evangelist's tunic. The figure of Christ is placed at the center, his body athletic and emaciated, sharply angular, all at the same time, and his hands—always a fundamental means of expression in the masterpieces of Giovanni—given great emphasis. The mute dialogue between Mother and Son, a manifestation of intense and restrained sorrow, is highly effective. The drawing at folio 53r in the Louvre sketchbook of Jacopo Bellini was probably the basis for this composition, but Giovanni far exceeded the model, furnishing a fully humanistic reading in which the figures are the only protagonists in the painting and leaving very little space at the sides for the landscape; the clouds are arranged across the sky in long cirrus strips, almost as though to avoid distracting the observer while at the same time echoing the linearity of the sarcophagus, the far ends of which, as Robertson (1968) points out, are not visible. The plasticity of the figures suggests the possibility that they were based on a sculptural prototype unknown to us, a work by Donatello, perhaps, or by one of his followers, made around 1453 and displayed in Padua. The bas-relief by the sculptor Desiderio da Settignano in his tabernacle in Florence's basilica of San Lorenzo, which is dated to shortly before that artist's death in 1464, might possibly present an echo of such a model.

This panel was in the collection of the Sampieri family of Bologna and was recorded in the catalog of that collection in 1795; in 1811, it was donated to the Brera by Eugene Beauharnais. It was included in the 1949 Venetian exhibition as no. 49.

THE DEAD CHRIST SUPPORTED BY MARY AND SAINT JOHN EVANGELIST (PIETÀ)
Pinacoteca di Brera, Milan (cat. 10)

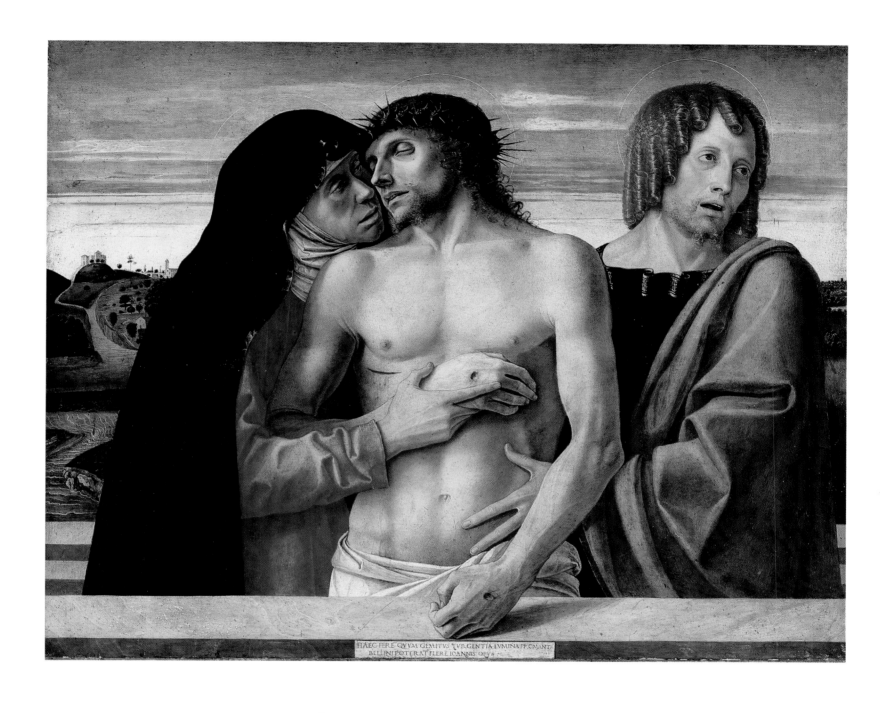

CORONATION OF THE VIRGIN BETWEEN SAINTS PAUL, PETER, JEROME, AND FRANCIS

Central panel, 104⅛ × 94½ in. (262 × 240 cm)

Pilasters: *Saint Catherine of Alexandria; Saint Lawrence; Saint Anthony of Padua;*
The Baptist; Blessed Michelina of Pesaro; Saint Bernardino of Siena;
Saint Louis of Toulouse; Saint Andrew
Panels, 24 × 9⅞ in. (61 × 25 cm) each

Bases of pilasters: *Saint George Killing the Dragon; Saint Terentius*
Panels, 15¾ × 14⅛ in. (40 × 36 cm) each

Predella: *The Conversion of Saul; The Crucifixion of Saint Peter; The Nativity of Christ;*
Saint Jerome in the Desert; Saint Francis Receives the Stigmata
Panels, 15¾ × 16½ in. (40 × 42 cm)
Museo Civico, Pesaro, no. 81

Cyma: Embalming of Christ
Panel, 42⅛ × 33⅛ in. (107 × 84 cm)
Pinacoteca Vaticana, Rome, no. 290

Signed IOANNES BELLINVS on the step of the throne. Made for the high altar of the church of San Francesco in Pesaro, this is the most monumental surviving work by Giovanni Bellini. It marks his maturity as an artist and is the most complete and, in terms of its autograph status, the least debated among those analyzed so far. It is with the subject of its dating that divergent opinions arise.

The dating of the work presents problems for two reasons, one related to the commission for the work, the other to Giovanni's artistic career. Based on a proposal from Vaccaj (1909), offered as a possibility in a popular context, the notion has been often repeated that the castle visible in the background, through the opening in the back of the throne with Mary and Christ, is—aside from any theological allusion to a celestial Jerusalem or to the Marian ivory towers—a representation of the rocca, or fortress, of Gradara, a town about nine miles northwest of Pesaro. This hypothesis has served as the starting point for various theories seeking to establish why the painting was commissioned. These range from celebration of the conquest of Gradara by Alessandro Sforza, ruler of Pesaro, in 1463 to celebration of the wedding of his son Costanzo in 1474; Fahy (1964) claimed to recognize the model of a fortress that Saint Terentius is holding as the Rocca Costanza of Pesaro, built by the architect Luciano Laurana between 1474 and 1479 for Costanzo Sforza, lord of Pesaro. Taking into consideration instead the development of the painter's artistic language, many scholars, on the basis of Pallucchini (1949 and 1959), have claimed that the altarpiece must date to sometime before 1471, the year in which Marco Zoppo signed a major altarpiece (*Madonna and Child with Saints John the Baptist, Francis, Paul, and Jerome*) that is structurally similar to this one and that was made for the church of San Giovanni Battista in Pesaro; its central panel is today in the Bodemuseum (one of the Staatliche Museen) in Berlin. There are then the supporters of the "one-way" influence of Antonello da Messina on Giovanni, according to whom Bellini learned the technique of painting in oils, which he used in this altarpiece, from that Sicilian master. These theorists find themselves compelled to move the dating to 1475, the year Antonello arrived in Venice, if not even later, creating problems with the question of this work's precedence over the lost San Zanipolo altarpiece (cat. 25). We have already presented our position (see the introductory essay): the San Zanipolo altarpiece, which was destroyed by fire in 1867, must date to shortly before this altarpiece since the painter here demonstrates greater skill at locating his figures in space. Indeed, it is this masterpiece that brings to a close the youthful phase of his artistic career.

CORONATION OF THE
VIRGIN BETWEEN SAINTS
PAUL, PETER, JEROME,
AND FRANCIS
Museo Civico, Pesaro
(cat. 27)

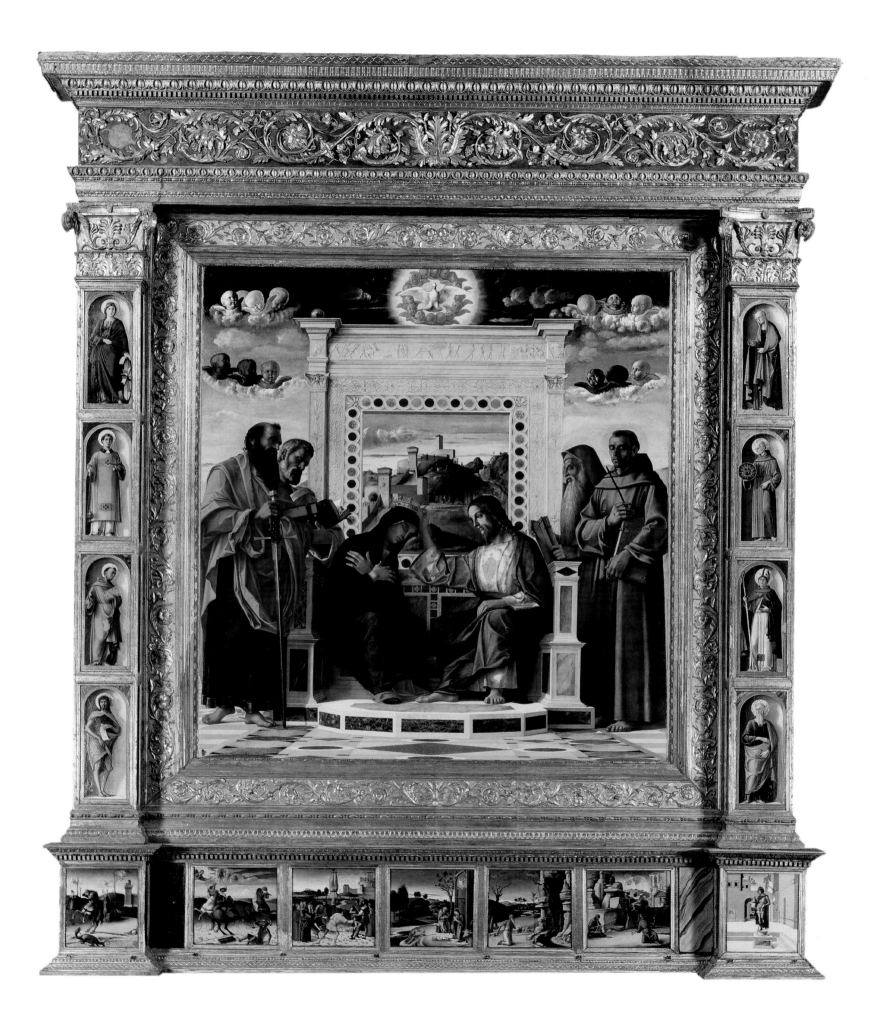

97

The technique of painting in oils must have been well known in Venice before Antonello's arrival, as Huse (1972) points out, since Flemish paintings and painters had been present in the city. We must assume that an artist at the level of Giovanni Bellini, who drew inspiration from works by Rogier van der Weyden and other Flemish artists, as indicated by the youthful Bergamo *Pietà* (cat. 2), was also able to understand the techniques such artists used to make their works.

As for the castle in the background, there are no firm reasons to believe it to be Gradara. Above all, as Huse pointed out and Lucco (1990) seconded, it is hard to imagine a historical reason why Giovanni would have presented the same castle in 1488 in the *Barbarigo Votive Altarpiece* (cat. 66): at that date there was no reason to put a Sforzesco building in the background of a painting made for a political figure like a Venetian doge. In fact, of course, the castle, in this work in Pesaro as well as in the *Barbarigo Votive,* is nothing more than a repertory motif, inserted as needed, in keeping with a practice that we often find used by Giovanni and his students. Furthermore, as Huse has also pointed out, it would seem nonsensical for Giovanni to have located the scene of the stigmatization of Saint Francis in the predella of the Pesaro altarpiece in front of the apse of a Gothic church that reproduces the Dominican church of Santi Giovanni e Paolo in Venice, a religious building to which the Bellini family was closely tied and in which both Gentile and Giovanni were buried. Regardless of the various means of approaching the work, the Pesaro *Coronation* stands like a milestone along the artistic route of Giovanni Bellini; it is the work that marks the achievement of expressive maturity by the forty-year-old artist, on his way to becoming the leading painter in Venice for the next four decades.

In the main painting and its cyma, the panel above it, the artist places his figures within an essential space; the throne (in the style of Pietro Lombardo) on which Mary and Christ are seated is located on a platform and in a space marked off by the floor mosaic; a hilly landscape is visible just beyond the four saints witnessing the scene; and above it all is the sky, inhabited by four groups of three cherubs each soaring along and, at the top center, framed by red cherubs, the dove of the Holy Spirit. We are in the open, but at the same time in a dimension in which nature has been pushed into the background and the foreground is dominated by architectural elements: many years are still to pass before the Sacra Conversazione set in an open landscape will become common in Venice, but such a setting could already be seen in the Pesaro altarpiece made by Marco Zoppo in 1471.

The pictorial surface of the central panel and the entire complex emerged in good condition from the 1988 restoration except for two spots above Mary's head where a crown had been attached during the period when the painting was used as a devotional image; some fall in color can be seen in the pilaster panels presenting Saint Anthony of Padua, the Blessed Michelina of Pesaro, and Saint Louis of Toulouse. The cyma, taken to Paris during the Napoleonic period, by which time it had already been detached from the complex, was recuperated by Antonio Canova and brought to Rome, then capital of the Papal States, which included the Marches; it is held today in the Pinacoteca Vaticana. It was taken to Pesaro for the exhibition *La pala ricostituita,* held in the Museo Civico from 1988 to 1989, but then, sad to say, it was returned to the Vatican, while its frame remains where it has been since the beginning, in Pesaro. As has been said and written many times, this missing piece should be given back to the commune of Pesaro, perhaps in exchange for some other work of art.

All critics, with the single exception of Chiappini di Sorio (1986), agree that the panel was the original cyma of the altarpiece, but because of the differences in size between the two parts, some believe it must have been flanked by other connecting elements: Frizzoni (1913), for example, theorized that the painted cyma had been flanked by volutes, one at each side. Most art historians believe that the scene presented in the Vatican cyma is a Pietà, or Lamentation, while Huse, followed by Gelting (1985), calls it an Embalming of Christ, which seems correct to us. Reference has already been made in the introductory essay to our opinion of Longhi's hypothesis of contact between Giovanni Bellini and Piero della Francesca, contact that would have been at the base of Bellini's achieving the "classical" language with which he expresses himself from the Pesaro *Coronation* onward. Most recent articles repeat dating

of the work to later than the altarpiece by Marco Zoppo (1471). Conti (1987) holds it was made over a very broad span of time, beginning in 1473, and points out stylistic similarities between the saints of the pilaster panels and the Berlin *Resurrection* (cat. 41), which was painted in 1475-79; he also claims that the saint at the base of the pilaster on the right, usually identified as Saint Terentius, is instead Alexander. Degenhart and Schmitt (1990) date the altarpiece to the first years of the 1470s, Lucco places it not later than 1475, and Schmidt (1990) suggests 1473-74. Hetzer (1985) reports that the cyma was long attributed to Bartolomeo Montagna, but after its return from France and movement to Rome it was attributed to Mantegna, as Chiappini di Sorio also indicates. The panels in Pesaro were displayed as nos. 59 to 74 in the 1949 Venice exhibition.

CORONATION OF THE
VIRGIN BETWEEN SAINTS
PAUL, PETER, JEROME,
AND FRANCIS
Detail of the predella:
THE CONVERSION OF SAUL
Museo Civico, Pesaro
(cat. 27)

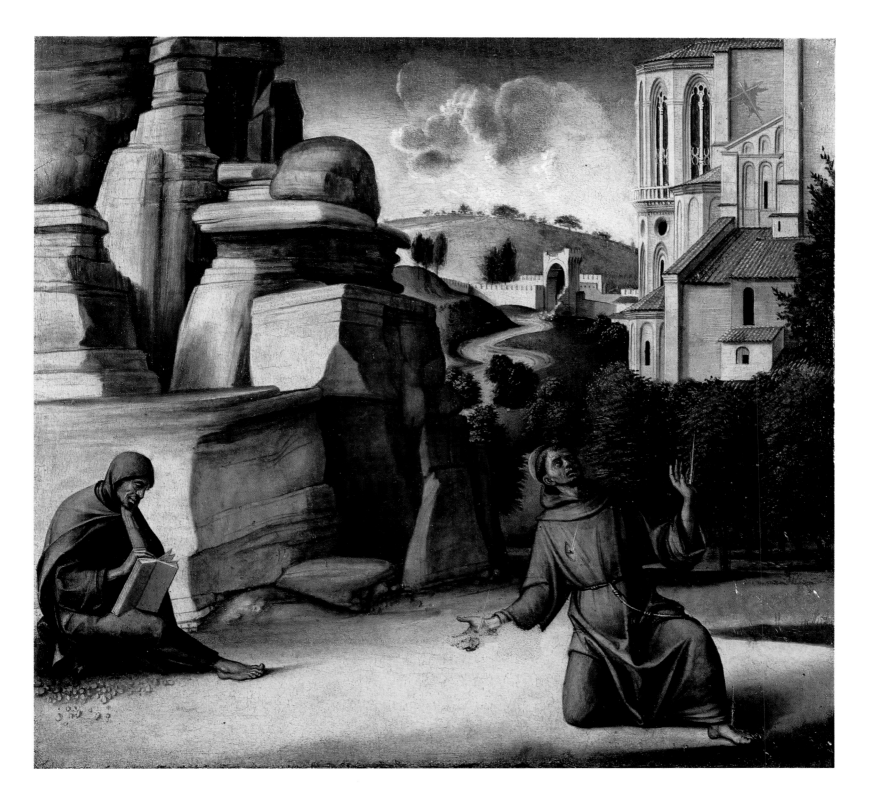

CORONATION OF THE
VIRGIN BETWEEN SAINTS
PAUL, PETER, JEROME,
AND FRANCIS
Detail of the predella:
SAINT FRANCIS RECEIVES
THE STIGMATA
Museo Civico, Pesaro
(cat. 27)

LOCHIS MADONNA

Panel, 18½ × 13⅜ in. (47 × 34 cm)

Galleria dell'Accademia Carrara, Bergamo, no. 724 (formerly no. 167)

Signed IOANNES BELLINVS. Scholars agree this is an autograph work by Bellini, but the problem of its dating remains open. Dussler (1935) first proposed a date slightly earlier than 1470, but then (1949) put it later, between 1475 and 1480. Longhi (1949) attributed it to a decidedly too early date, but even so he judged it a later work than the *Polyptych of Saint Vincent Ferrer* (cat. 9). Berenson (1957) classified it as a juvenile work; A. Venturi (1915) placed it after the Pesaro *Coronation* (cat. 27), and Gronau (1930) agreed with this. Gronau also, on the basis of Mary's right hand, established a connection between this painting and the *Clark Madonna* (cat. 30). The dating suggested by Pignatti (1969) is unacceptable, since he returns to Longhi's notions and proposes for both panels a date of 1460–64.

The handling of the folds of the Virgin's mantle is reminiscent of the *Madonna with Greek Inscription* (cat. 22), but the sureness of the draftsmanship of the drapery, the classical, serene beauty of Mary's face, the characterization of the two figures, the sense of ordinary motherhood, belied only by the halos—all this suggests that the date of this work should be moved ahead, to after the great Pesaro *Coronation,* as proposed by Goffen (1989), who gave a date of c. 1475. Goffen paid close attention to the posture of the Child, suggesting that it might be meant to evoke an image of Christ as bearer of the cross while also pointing out that Mary's manner of holding him calls our attention to his genitals so as to remind the viewer of his humanity and thus his sacrifice. I would say rather that the mother seems to be protecting him with an attentiveness that contributes to giving the painting a value and significance that take it beyond the usual devotional image. We believed the Child's pose was based on that of a snake-strangling Heracles until the recent essay by Aurenhammer (1996), who demonstrates its probable derivation from a Roman sarcophagus bearing the relief of a battle, today in Rome's Galleria Doria Pamphilj, by way of an engraving by Mantegna that presents the *Death of Orpheus* and a drawing by Marco Zoppo on a similar subject, preserved in the British Museum.

This work was displayed as no. 47 in the 1949 Venetian exhibition.

LOCHIS MADONNA

Galleria dell'Accademia

Carrara, Bergamo

(cat. 29)

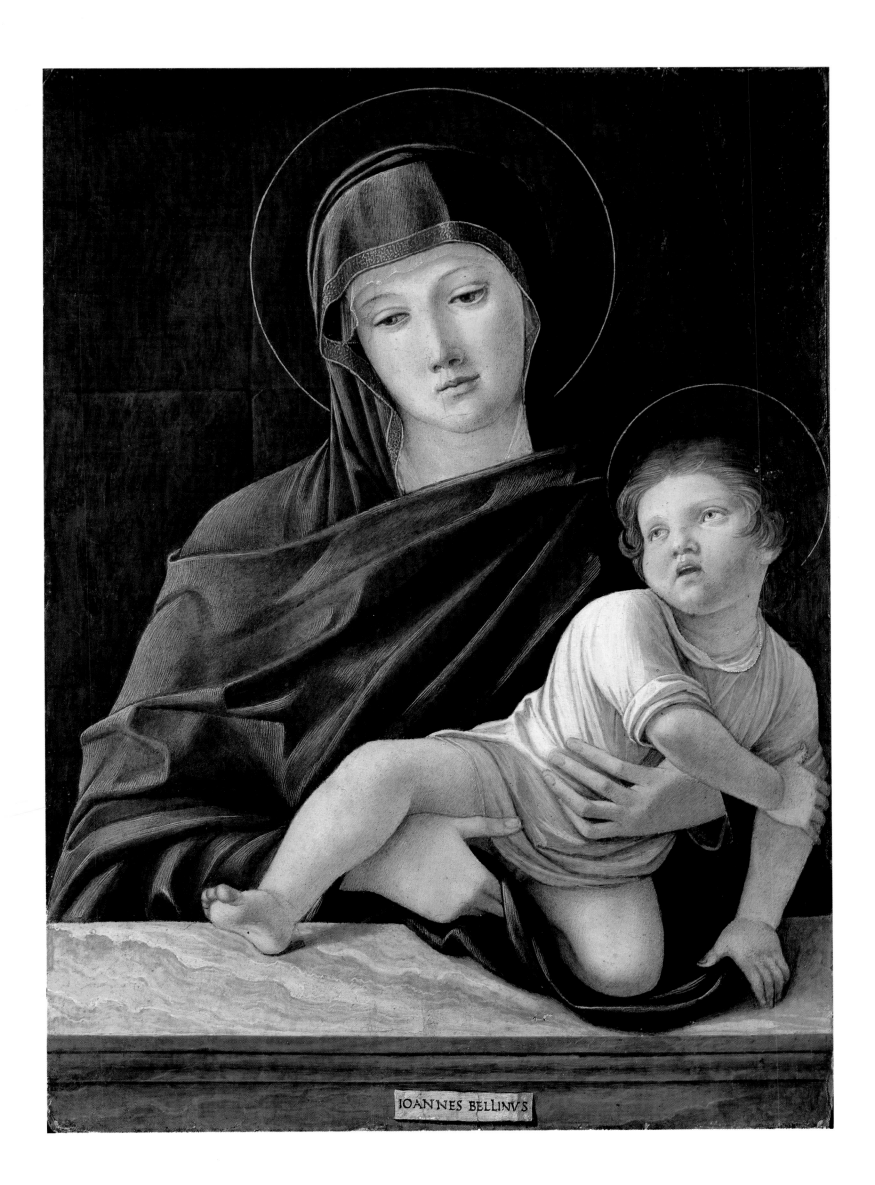

IOANNES BELLINVS

THE DEAD CHRIST WITH FOUR ANGELS

Panel, 31¾ × 47¼ in. (80.5 × 120 cm)
Pinacoteca Comunale, Rimini

This painting is from the Tempio Malatestiano. Vasari (1550) describes the work as having only two putti and says it was made for Sigismondo Malatesta; that ruler died in 1468, but the year cannot be taken as a *terminus ante quem* for the work, which bears at the lower right a signature that is not considered autograph but that is believable since the panel constitutes one of the highest and most intense achievements of the artist and was made during the period of the Pesaro *Coronation* (cat. 27). Only Crowe and Cavalcaselle (1871), who attributed it to Francesco Zaganelli, and Hertzer (1985) have refused to include the painting in Giovanni Bellini's catalog.

Today, following a proposal made by Paoletti (1929), the patron of the work is thought to have been Carlo Malatesta, son of the captain general Roberto, who was in turn a natural son of Sigismondo. Carlo, captain general of the Venetians, was enrolled in the Scuola Grande di San Marco in 1480. He died in 1482. Heinemann (1962) presents the singular opinion that the work was based on a prototype by Mantegna; in reality, the painter here shows himself to be completely free of any influence of his famous brother-in-law and can be seen to have found his own original means of expression, employing that fusion between form and content that will be at the base of his unmistakable mature language. The fact that no direct echoes of Antonello da Messina can be perceived in this painting does not mean, as Heinemann concludes, that the work must date to between 1470 and 1475, since in reality Giovanni here indicates that he has completely assimilated whatever he was to learn from Antonello's example. Following the great Pesaro *Coronation,* Giovanni here offers an updating of his way of experiencing the death of Christ, which is fully in harmony with what is presented in the Brera *Pietà* (cat. 10); here, too, the drama is restrained, even though the crown of thorns, wound in the side, and stigmata on the hands are all in clear evidence: the angels seem to be meditating, and only one of them is actually supporting his body. As Goffen points out (1989), the fact that the legs of Christ disappear in the foreground, somewhere beyond the far edge of the marble surface on which the little angels stand, locates the tomb of the Redeemer in our space. It seems that, among scholars of our time, Huse (1972) is alone in accepting the dating suggested by Vasari, including the *Dead Christ* among the works made in the second half of the 1460s, the group that includes the *Enthroned Virgin Adoring the Sleeping Child* in the Accademia in Venice (cat. 20).

This work was displayed as no. 80 in the 1949 Venetian exhibition.

THE DEAD CHRIST WITH
FOUR ANGELS
Pinacoteca Comunale, Rimini
(cat. 33)

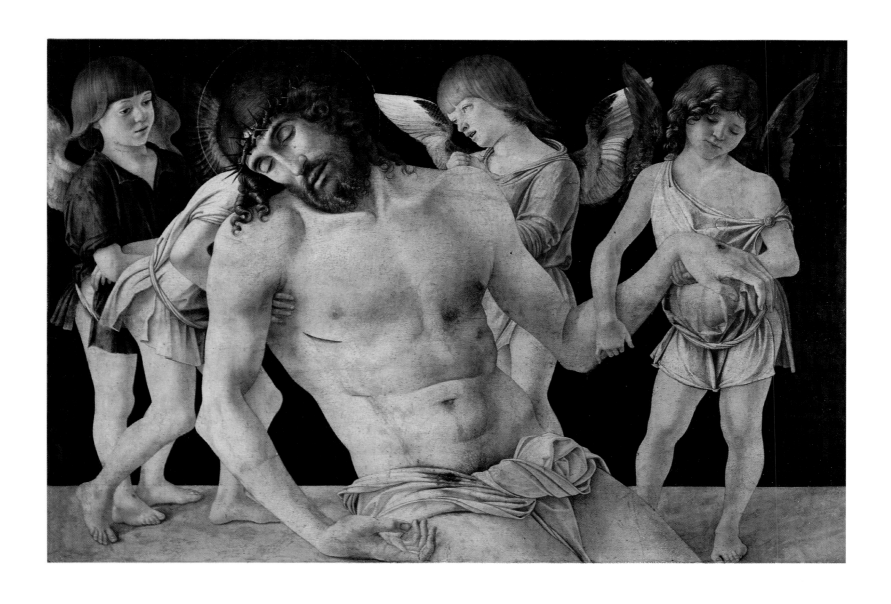

THE RESURRECTION OF CHRIST

Panel, 58¼ × 50⅜ in. (148 × 128 cm)

Gemäldegalerie, Berlin, no. 1177 A

This work was made for the altar commissioned by Marin Zorzi for his family chapel in the church of San Michele in Isola, on the island between Venice and Murano, today the site of the communal cemetery. It was made between 1475 and 1478, or immediately thereafter: the first date is that of Marin Zorzi's will, the second is that of the erection of the altar.

Ridolfi (1648) recognized this as a work by Giovanni Bellini, but from Boschini (1674) on it was attributed to Cima da Conegliano. Following the suppression of the Carmelite convent of San Michele, the work entered the Roncalli collection in Bergamo, where it was attributed to Andrea Previtali, an attribution that dates back to Crowe and Cavalcaselle (1871). A. Venturi (1915) endorsed an earlier attribution to Bartolomeo Veneto, while Cantalamessa (1903) sought in vain to establish the panel as an autograph work by Giovanni Bellini: in the very year that he failed to convince the Italian government to acquire the painting for the Galleria Borghese in Rome, it was moved to the Kaiser-Friedrich-Museum in Berlin, depriving Italy of one of the masterpieces of European painting of the fifteenth century. Dussler (1949) still expressed doubts that the work had been made by Giovanni, citing presumed weaknesses and disorganized elements in the figures in the foreground and in the landscape, in which Ludwig and Bode (1903) had already recognized, to the right, the hill of Monselice, south of Padua, but which, in Dussler's opinion, was not of the same level of quality as the Pesaro *Coronation* (cat. 27). Dussler went so far as to wonder whether the painting in Berlin really was the one referred to in documents, and he called attention to the existence of a variant copy, a work by Filippo Mazzola, in the Musée des Beaux-Arts in Strasbourg. However, all later scholars have accepted the painting as an autograph work by Giovanni. Heinemann (1962) noted the nonmonumental composition with the individual figures spread across a landscape, an arrangement that can be seen as a particularity of the artist, as in *The Prayer in the Garden* in London (cat. 8). Lucco (1983) was the first to note "a solemn tone of Greekness, almost Hellenism" and observed that the work's true theme was the evocation of a time and place.

In effect, the luminous apparition of Christ, suspended in the cool, clear air of a spring morning, far from creating a dramatic disturbance, awakens only motionless, hushed astonishment in the two soldiers standing guard, while their companions continue to sleep, even though the stone falling away from the tomb has nearly struck one of them. The fact that one of the sleeping soldiers is almost naked might seem incongruent, but this nakedness may be an allusion to the pagan world of which Christ's resurrection declares the end: this may be why Girolamo Mocetto, in an engraving cited by Dussler, transformed this figure into a Bacchus. Of the pious women in the distance only the Magdalene is aware of the event taking place, and the season, early spring, is indicated most of all by the wild rabbits scampering over the hillside, although there are also the trees, still bare, on one of which perches a heraldic raptor, which Lucco (1990) identified as a vulture, symbolic of the death that is defeated by Christ.

The painter expresses a sense of the divine immanence in earthly nature, which does not impose itself on nature and does not relegate it to a secondary role, but instead identifies with it, as we will see in the works of later years. The sense of Mantegna's work in the Ovetari Chapel in Padua is still quite vivid at the level of basic draftsmanship in the soldier on the left, but by the time of this painting the unmistakable hand of Giovanni can be distinguished, for it reveals itself in a kind of modern sensibility, in his taking the earthly world not as an illusory surrogate of some transcendent reality, but as the setting in which people live in contact with beautiful nature and lead a serenely aware existence.

Related to the *Resurrection* in Berlin is a *View of Monselice,* a brush drawing in the Biblioteca Ambrosiana in Milan that presents the landscape and buildings to the right, the pious women, and Saint John. It is one of the few unquestionably autograph preparatory studies by Giovanni that has survived.

THE RESURRECTION OF CHRIST
Gemäldegalerie, Berlin
(cat. 41)

108

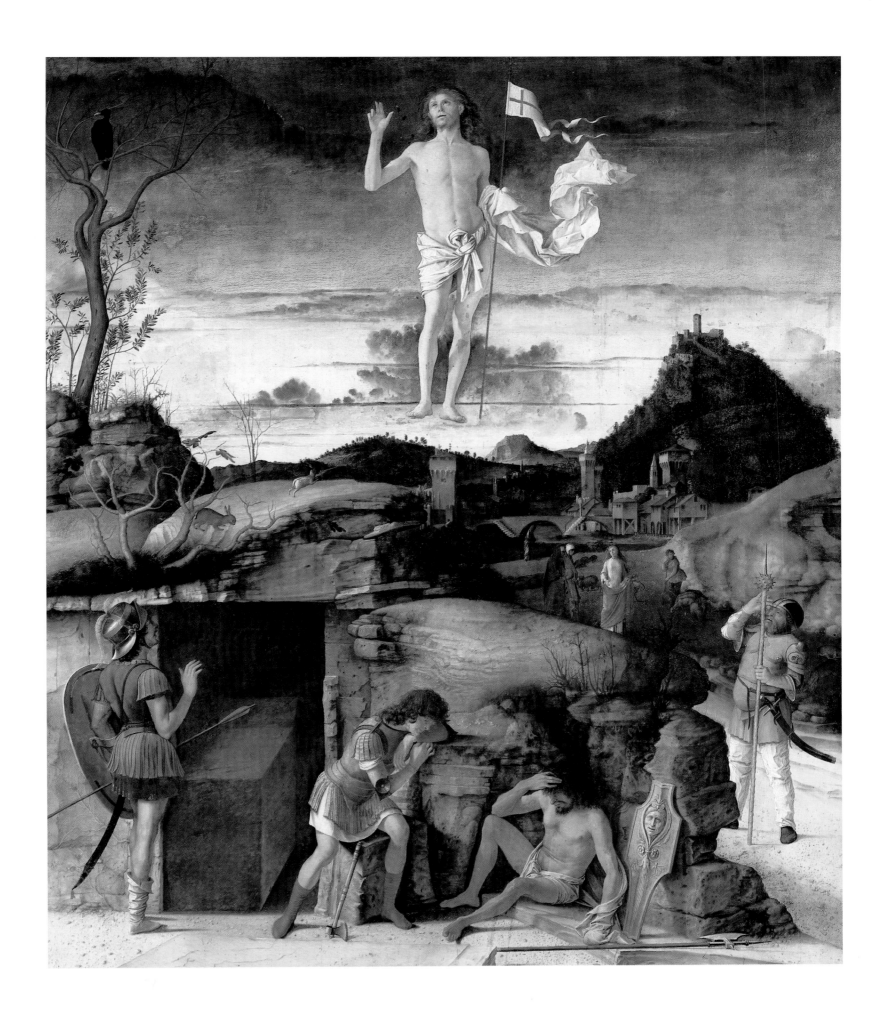

THE RESURRECTION
OF CHRIST
Detail
Gemäldegalerie, Berlin
(cat. 41)

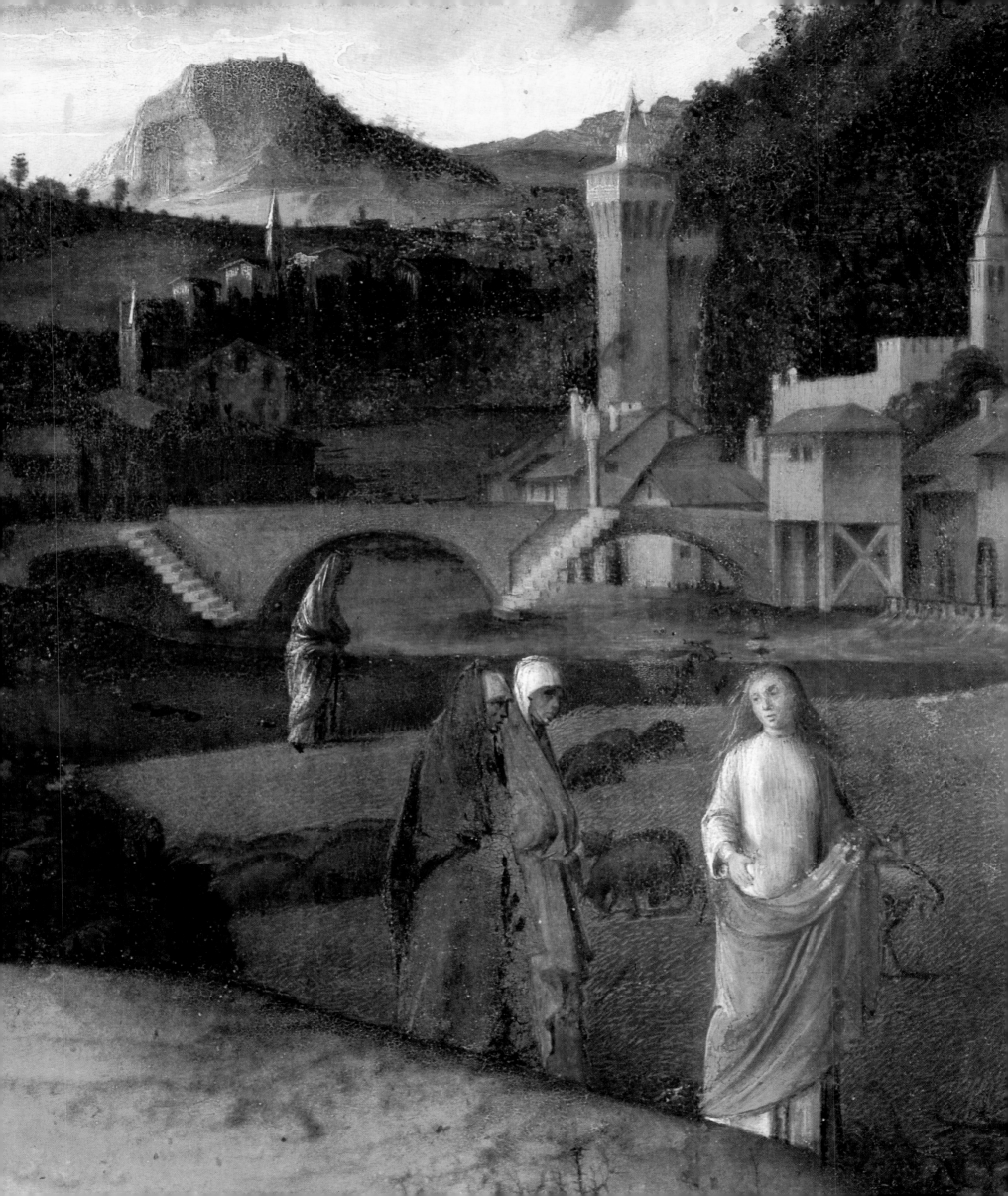

SAINT FRANCIS IN ECSTASY

Panel, 47¼ × 54 in. (120 × 137 cm)
The Frick Collection, New York, no. 15.1.3

Signed IOANNES BELLINVS on a cartellino attached to a bush at lower left. Michiel (1521-43) saw this work in 1525 in the home of the Venetian nobleman Taddeo Contarini; Crowe and Cavalcaselle (1871) included it and referred to it as the painting cited by Lanzi (1789) in the Palazzo Corner in Venice, which was then taken out of the country and displayed in 1857 in Manchester.

Borenius (1912) repeats and shares the opinion of Fry (1899), according to whom most of the painting was done by Marco Basaiti: this idea is based on an incorrect reading of the text by Michiel, who relates that the painting was begun by Bellini for Giovanni Michiel, which persuaded several scholars to conclude that the work had been completed by some other artist. The work was restored to Giovanni by Berenson (1916), was highly esteemed by A. Venturi (1915), and was recognized as autograph by all later scholars. Dussler (1935 and 1949) placed it c. 1480; Heinemann (1962) preferred ante-dating it to 1478 because, according to him, it resembled the *Crucifixion* once owned by the Niccolini di Camugliano (cat. 55) in the Antonellesque hardness of the landscape; he then contradicted himself, holding that the figure of Saint Francis is less active than those of the lost figures of the destroyed *San Zanipolo Altarpiece* (cat. 25), which in reality cannot be moved so late. In any case, he restored the complete autograph status of the work. Bottari (1963) repeated the dating to c. 1480, while Pignatti (1969) pushed it to 1480-85. Robertson (1968) placed the painting at the end of the 1470s, holding, for example, that the silhouetted trunks in the center of the landscape are no longer reminiscent of Mantegna, as had basically still been true in the *Resurrection* in Berlin (cat. 41), but are already foreshadowing the presentation of nature in *The Feast of the Gods* (cat. 120) or in Giorgione's *Three Philosophers*.

In this work, Giovanni has reached his mature style. As for the theme presented, Robertson relates the opinion of Meiss (1964), who in his long essay concluded that all things considered, even though the Seraph-Crucifix and Brother Leo are absent—whereas they are present in the version of the scene in the predella of the Pesaro *Coronation* (cat. 27)—the work should be read as the moment of Saint Francis's stigmatization. The cliff alludes to Monte La Verna, the site where the event took place, but Giovanni has reworked the event on the basis of his identification of the divine in nature. The sun assumes the function of the Seraph-Crucifix: the painting is both "stigmatization" and Cantico delle Creature (Canticle of Created Things). The donkey is the one on which the saint arrived in La Verna and is also the one on which Christ entered Jerusalem, and the cross on top of the skull, visible on the saint's desk in his cell, further contributes to identifying him with Christ: hence he receives the stigmata. Robertson contests Meiss's opinion that the two sources of light discernible in the painting are an allusion to the supernatural nocturnal illumination referred to by some of the first biographers of Saint Francis and points out that incongruencies in the various light sources can be found as early as *The Prayer in the Garden* in London (cat. 8). Huse (1972) basically confirmed Robertson's reading but insisted on the fact that the divine light emanates from the laurel on the left. We would say that there is the impression of a sort of dialogue going on between the saint and a divinity that expresses itself through the laurel, somewhat like the episode of Moses and the burning bush.

Goffen (1989), who dates the painting to the mid-1470s, reports information expressed to her by Everett Fahy and Keith Christianson of the Metropolitan Museum of Art and by Ria O'Foghludha of Columbia University, who both had the chance to examine the painting out of its frame and who explain that of the two panels on which the painting is made the upper one has been reduced at the top by about 7⅞ inches (20 cm). That the top panel has been cut down is further indicated by the fact that there is an unpainted area along the edges of the bottom panel whereas on the top panel the paint

SAINT FRANCIS IN ECSTASY
The Frick Collection, New York
(cat. 45)

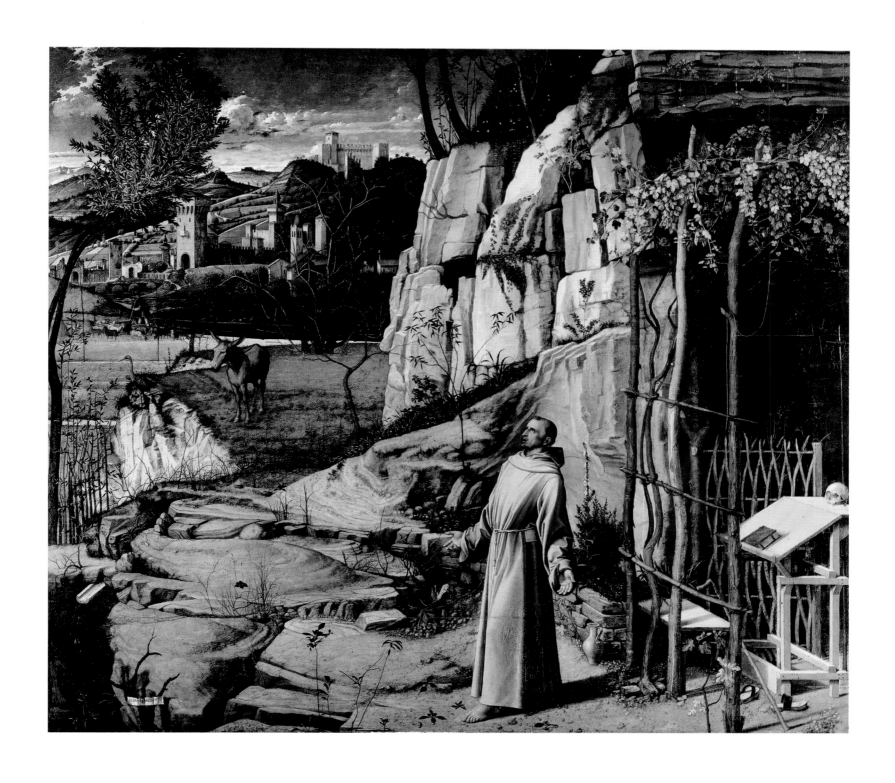

extends to the edge, indicating that it has been cut; there is also the simple fact that the panels are now of different sizes but were most probably originally equal. If as much as 8⅛ inches has truly been eliminated, it is possible, at least in theory, that a Crucifixion once appeared in the painting. The stigmata identifies Saint Francis with Christ: the saint intercedes with God on behalf of humans, and God responds with the second light. According to Goffen, the Frick painting cannot be the *Stigmatization of Saint Francis* ascribed to Bellini by Boschini (1660), since he described rays emanating from Christ's wounds and penetrating the saint's flesh.

Lucco (1990) dates the work to immediately after the Pesaro *Coronation* and to just before the Berlin *Resurrection*. He refers to a book by Fleming (1982) in which the overall meaning of the painting as well as the significance of even the smallest detail are explained. Nature has been rendered divine by way of a representation of a landscape recreated with the utmost credibility.

Because of its profound religious spirit, the multiplicity of its symbols, and its wealth of details minutely analyzed and rendered with unmatched dexterity, the *Saint Francis in Ecstasy* ranks as one of the highest achievements of Renaissance art. Not surprisingly, many American art historians see it as the work most emblematic of the career of Giovanni Bellini.

Regardless of any theological significance or possible religious interpretation, this masterpiece has the power to emotionally affect humans witnessing the end of the second millennium because of the extraordinary synthesis with which the artist succeeds in presenting a landscape animated by the human presence, by various species of animals, and by plants, which grow scantily among the rocks but are luxuriant on the fertile plain and on the hills in the background. It is a nature in which humans have intervened without disturbing its harmony and balance; for us, it is a nostalgic view of a way of life within the natural environment that we see as lost and irretrievable. Saint Francis, without the stigmata and without his role as Intercessor with Christ, is most of all a human being raising the only true prayer possible for modern humanity: a hymn to the beauty and harmony of creation that is expressed with an ecstasy that has no need of words. Here is a true poetics of silence, achieved for the first time in the history of art by Giovanni Bellini, who successfully blended all the compositional elements with a mastery that was unknown to him at the time of *The Prayer in the Garden* and the *Resurrection*.

SAINT FRANCIS IN ECSTASY
Detail
The Frick Collection, New York
(cat. 45)

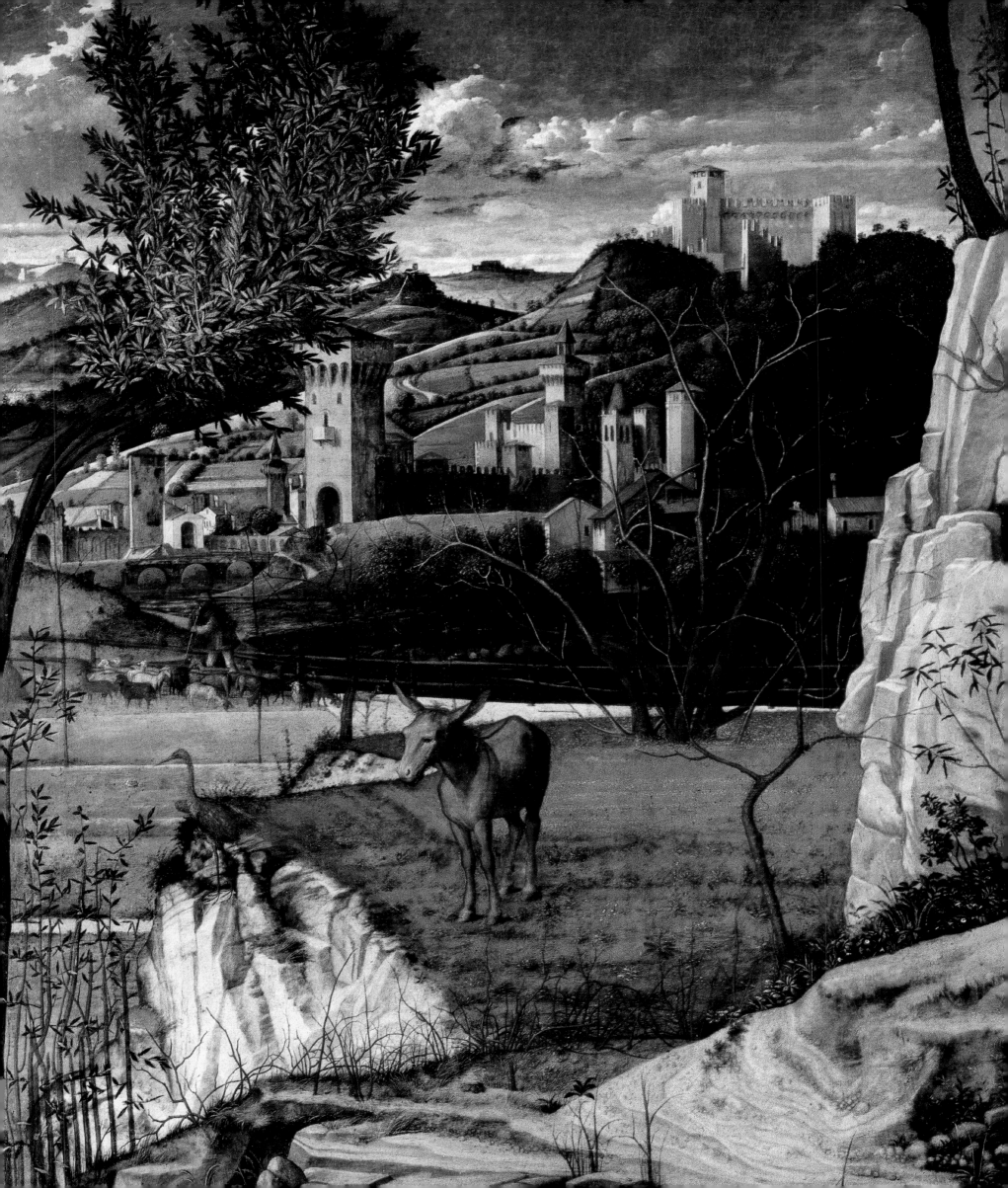

SAINT JEROME IN THE DESERT

Panel, 59½ × 44½ in. (151 × 113 cm)
Galleria degli Uffizi, Florence, no. CB 25

This panel, today in the Uffizi, was in the collection of the Papafava counts of Padua and then in the Contini Bonacossi collection before being acquired by the Italian state with other works from that collection. As most scholars agree, it was painted before the version of the same subject in London (cat. 54), as indicated by the landscape, which is presented in greater detail in the version in Florence, full of symbolic elements much like the Frick *Saint Francis* (cat. 45), but which is more relaxed and silent, less sharp but more blended, in the panel at the National Gallery.

Both paintings were considered works by Marco Basaiti until Gronau (1930) attributed them to Giovanni, indicating the work in London as the later one; Gronau also noted a Ravenna-style bell tower in the background of the Uffizi painting; Pignatti (1969) took this further, recognizing several buildings, including the church of San Vitale and the mausoleum of Theodoric in Ravenna, along with the arch of Augustus or of Tiberius in Rimini; we would add the unmistakable bell tower of Sant'Anastasia in Verona. Gronau reported that Sansovino (1581) and Boschini (1664) spoke of a *Saint Jerome* by Giovanni Bellini in Santa Maria dei Miracoli in Venice; Gamba (1937) thought that the Uffizi painting might be a replica of that work. According to Dussler (1949), the London panel is a workshop variant, made later, of the original in the Uffizi; Dussler also noted that the example in London is of the same size as the *Saint Jerome* signed and dated 1505 in the National Gallery of Art in Washington, D.C. (cat. 107); this may be why Robertson (1968) advanced the hypothesis that the work in Washington was begun by Giovanni at the time of the works that are today in Florence and London (1480) but was left unfinished and then completed only in 1505 with the help of an assistant. Dussler dates the versions discussed here to 1480-85, pointing out that the size of the panel in the Uffizi suggests that it may have been part of an altarpiece of the type cited by sources in Santa Maria dei Miracoli. Berenson (1957) accepts both paintings as autograph works by Giovanni. Heinemann (1962) dismisses doubts concerning Giovanni's paternity and restores both panels to him; he dates the Uffizi version to 1477-78, before the Frick *Saint Francis,* and dates the version in London to 1480-90. Bottari (1963) supports the autograph status, dating both paintings to 1480-85 and relating the history of the attribution story, adding the repetition of the attribution to Basaiti proposed by Arslan (1962). According to Robertson, the Uffizi painting is in many ways similar to the Frick *Saint Francis,* but does not have that work's magic in execution; he considers it a workshop version based on a lost original from the closing years of the 1470s, like the example in London and the Ashmolean Museum of Oxford (the latter not an autograph work). Pignatti rules out the possibility that the painting in the Uffizi was part of the altarpiece in Santa Maria dei Miracoli, both because of the different size of the altar and because the church was erected in 1489. Personally, we think the only real obstacle is the difference in size, since the painting could have been commissioned for the Venetian church, which was built by Pietro Lombardo and his sons, Antonio and Tullio, who began construction of the church in 1481 and completed it in 1489, following a plan that foresaw its creation over a brief period and that therefore must necessarily have involved the planning of the interior furnishings.

This is made impossible, of course, if one accepts the dating proposed by Pignatti, to 1479; he dates the London version to 1480-85, pointing out that the work is attributed to a follower of Giovanni, with the exclusion of Basaiti, in the National Gallery catalog (1961), wonderfully edited by Davies. Huse (1972) compares the *Saint Jerome* in the Uffizi to the panels of the predella of the Pesaro *Coronation* (cat. 27), holding that Giovanni went from the *puritas* and *perspicuitas* of his simple style to a more elevated intermediate style characterized by *gratia, suavitas, iucunditas:* landscape and nature are no longer

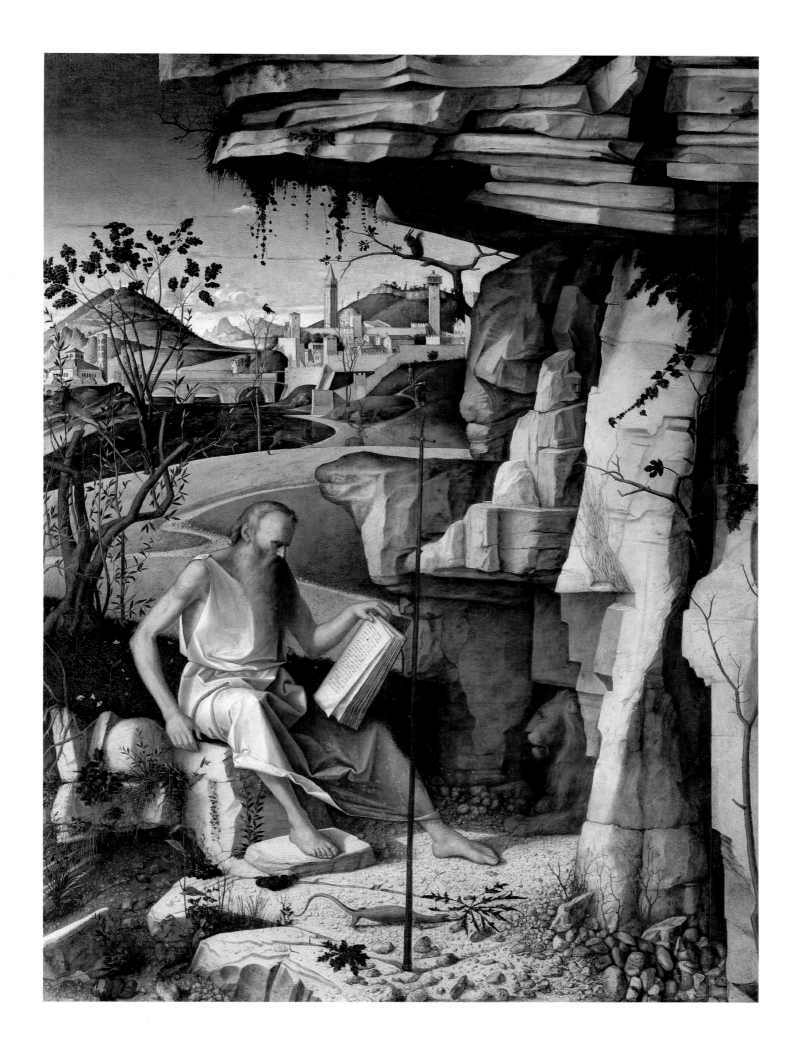

located in the background, but invade the foreground, with an evolution not only in the repertory of motifs but also in their arrangement; however, in the end he concludes that the example in Florence may be a copy, and he makes no mention of the version in London. Goffen (1989) made no mention of the Florentine panel, and considered the one in London fruit of a collaboration between Giovanni and a student.

The autography of the painting in the Uffizi is beyond question to anyone familiar with the original, which was once difficult to view: it is a masterpiece made a little later than the Frick *Saint Francis,* of which it shares the sense of nature pervaded by astonishment in the presence of a divine reality that is one with it. The panel in London is a variant and was certainly made several years later; it must be supposed that the first version was commissioned during the building of the church of Santa Maria dei Miracoli and was made immediately and that the replica was requested by a patron after the building had been open for worship. In that case the panel in the National Gallery might date to the early years of the last decade of the century.

The Uffizi *Saint Jerome* was displayed as no. 87 in the 1949 Venetian exhibition.

SAINT JEROME IN
THE DESERT
Detail
Galleria degli Uffizi, Florence
(cat. 53)

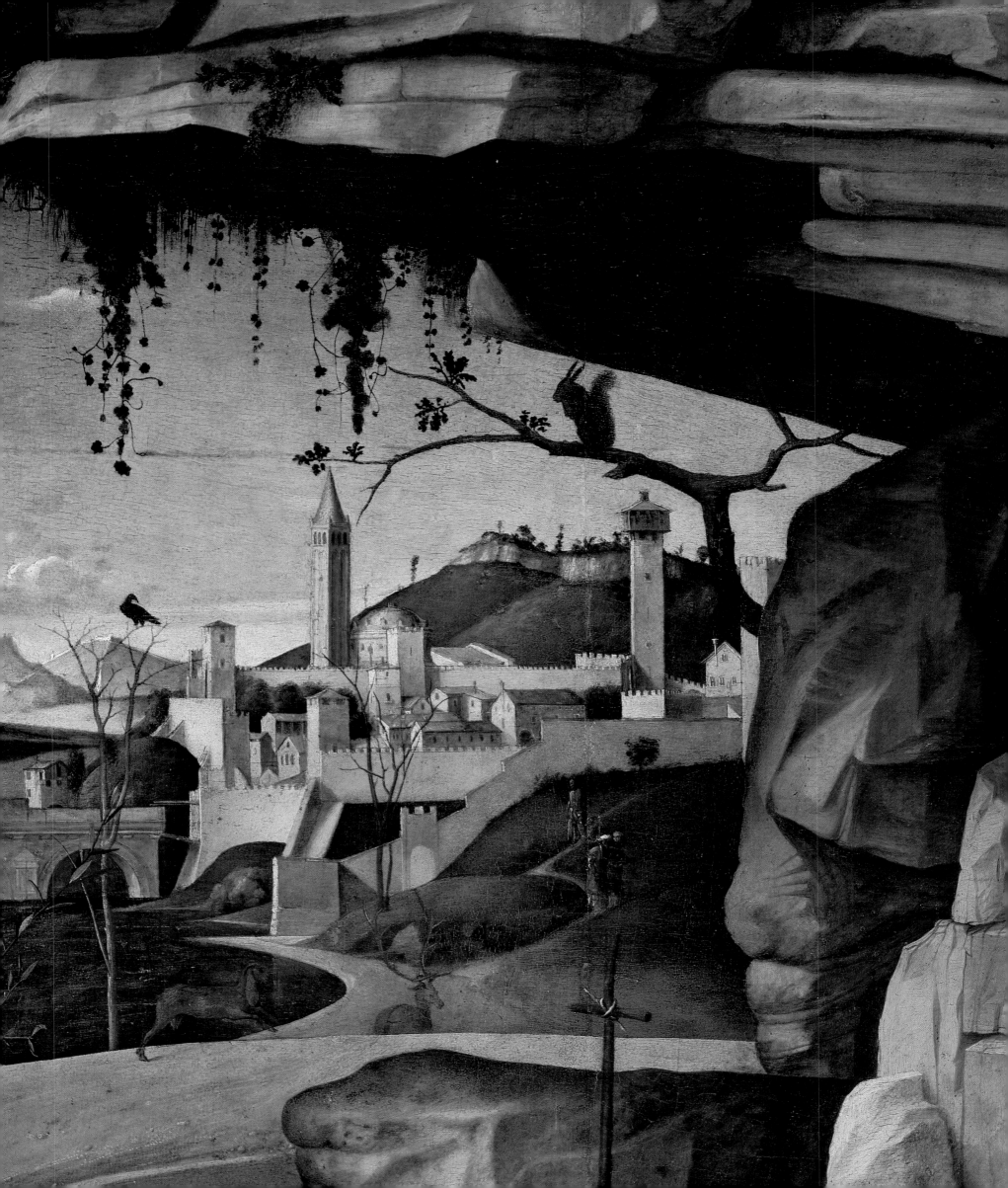

CRUCIFIXION WITH JEWISH CEMETERY (NICCOLINI DI CAMUGLIANO CRUCIFIXION)

Panel, 31⅞ × 19¼ in. (81 × 49 cm)
Cassa di Risparmio, Prato

From the Niccolini di Camugliano collection in Florence. Gamba (1937) attributed this work to Giovanni Bellini, thus correcting the earlier, traditional attribution to Marco Basaiti. Gamba also proposed dating it to the first five years of the sixteenth century, an opinion shared by Pallucchini (1949), who later (1959) related the opinion of Toaff, according to whom the date 1501 can be read in one of the Hebrew epigraphs, while 1502 or 1503 is written on another.

The placement of the work in the first years of the new century was confirmed by Berenson (1957), Bottari (1963), Robertson (1968), Pignatti (1969), and Ruggeri Augusti (1978), most of all because several buildings from Vicenza can be identified from among the buildings in the background, much like in the *Donà dalle Rose Pietà* (cat. 103), aside from the cathedral of San Ciriaco in Ancona, which also appears in *The Martyrdom of Saint Mark* (cat. 126). Dussler (1949) and Huse (1972) expressed doubts concerning the autography of the work. According to Heinemann (1962), the work is a contemporary of the Frick *Saint Francis* (cat. 45), characterized by the length of the legs of Christ, in this similar to the figures of *Christ's Descent into Limbo* in Bristol (cat. 38); Heinemann also cites the influence of Antonello and points out chromatic effects of an almost Flemish style. The similarity in terms of composition to the *Crucifixion* by Antonello da Messina in the National Gallery in London is also emphasized by Lucco (1990), who sees in the painting the same sense of identification of divinity with nature that is revealed in the Frick *Saint Francis* and places this *Crucifixion* between the Frick painting and the *Transfiguration* in Naples (cat. 57). Aside from the supporting evidence made known by Pallucchini, which was not confirmed by Avraham Ronen (1992), who deciphered and interpreted the epigraphs in the Hebrew cemetery in the field behind the cross without finding any sign of the dates 1502 or 1503, we would confirm that from a stylistic point of view the work easily fits in the production of Giovanni in the first years of the 1480s, between the Frick *Saint Francis,* the *Transfiguration* in Naples, and the *San Giobbe Altarpiece* (cat. 58). From the iconographic point of view, this image can be taken as similar to the *Crucifixion* in the Galleria Corsini in Florence (cat. 42), as Bottari indicated; however, it should be noted that the painter expresses himself in a language of more elevated formal beauty in this *Crucifixion,* but does so without reaching the intensity of expression and the pregnancy of meaning achieved with the rigorous synthesis that make the small *Crucifixion* in the Galleria Corsini particularly fascinating. In this *Crucifixion with Jewish Cemetery* we have a representation on three layers: first, the cross, erected on rocky soil spread with skulls, then the field spread with headstones as in the cemetery of Prague, up to the background in which a city crowded with civil and religious structures alludes to the life of the human species that Christ saves from death with his sacrifice. The buildings that can be recognized include, aside from the cathedral of San Ciriaco in Ancona, the facade of the cathedral of Vicenza, that city's Torre di Piazza, and the bell tower of Santa Fosca in Venice, while the compositional similarity with the Frick *Saint Francis* reaches the level of citations with the laurel tree to the left. Goffen (1989) does not mention this painting.

This work was displayed as no. 114 in the 1949 Venice exhibition.

CRUCIFIXION WITH
JEWISH CEMETERY
(NICCOLINI DI CAMUGLIANO
CRUCIFIXION)
Cassa di Risparmio, Prato
(cat. 55)

120

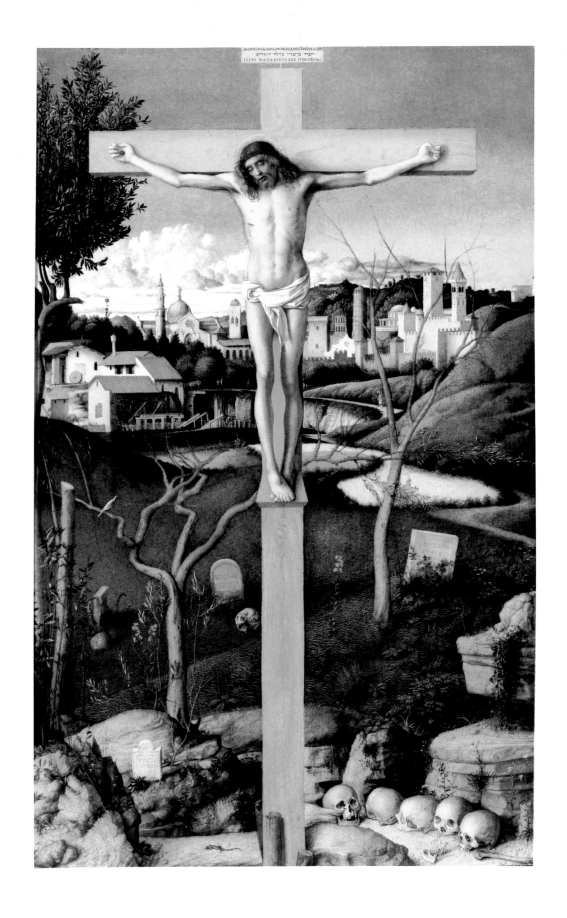

THE TRANSFIGURATION

Panel, 45⅝ × 60⅝ in. (116 × 154 cm)

Galleria Nazionale di Capodimonte, Naples, no. 56

Signed IOANNES BELLI[NVS]. From the Farnese collection of Parma, transferred to Naples in the eighteenth century. Arslan (1956) connected the panel to the altarpiece Giovanni made for the Fioccardo Chapel in the cathedral of Vicenza, the donor of which made out his will in 1467. Although well preserved, the painting has been reworked several times: in particular, the heads of the apostles Peter and James have been repainted, and leaves were added to the tree on the right, perhaps during the sixteenth century; the two men, one of them turbaned, on the right in the background are further additions.

Most scholars agree that the work was made in the opening years of the 1480s. Dussler (1949) proposed c. 1480, while Longhi (1946) placed it between 1480 and 1485, a dating accepted by Pallucchini (1949 and 1959) and Bottari (1963). Heinemann (1962) placed it no earlier than 1480, but also no later, because of the relatively weak draftsmanship in the Saint John. Robertson (1968) dated it to the middle of the decade, while Pignatti (1969) pushed the date ahead to 1487, and Huse (1972) placed it in the 1470s. Goffen (1989) preferred sometime between 1475 and 1480; Tanzi (1990) felt it was made about 1480, an opinion shared by Lucco (1990). Fry (1899) had already identified various structures in the background, including the mausoleum of Theodoric and the bell tower of Sant'Apollinare in Classe in Ravenna.

This is one of three surviving representations of the same theme made by Giovanni, although only two fragments exist of the third (cat. 82). Comparing this work with the first example (cat. 7) makes abundantly clear the evolution and transformation that took place in Giovanni Bellini's figurative language and poetic expression over the years. The catalog of the 1949 exhibition in Venice (this work appeared as no. 85) explains that the grassy hillside of this painting represents Mount Tabor, where the religious event took place, and the spectator is separated from the event by the fence to which the cartellino is attached in a precarious way, folded so that it bears an abbreviated signature of the painter; the fence marks off a steep area beyond which extends a landscape pervaded by the divine, represented in such a way as to awaken stupor only in the three apostles. The colors are well blended and applied, as Robertson and Goffen have pointed out, with the prophets repeating the warm colors of the landscape, while the stronger tones of the apostles serve as intermediaries between the countryside and the sky. The pale figure of Christ seems to burst out of the white clouds of the sky; this figure of Christ was soon to serve as a model for Benedetto Diana in his *Sacra Conversazione* today in the Kress collection in Coral Gables, Florida. In the sky above the Savior is an area of lead gray storm clouds, as though before a summer cloudburst, an allusion to the manifestation of God. As Fry pointed out, Giovanni places the event in an autumnal atmosphere; the two trees, one on the left and one on the right, were originally both without leaves, and the predominance of brown hues makes it clear that this is a day in October, at the time of year when the first winds from the north have laid bare the boughs. Just as it is about to go into winter hibernation, nature is awakened by the manifestation of the Redeemer who announces to an ecstatic world the coming of a new era. The fusion of the human and the divine has already been announced by works like the Frick *Saint Francis* (cat. 45), in which, however, the figure seems to blend into the landscape, and here it reaches a perfect balance of clarity, lucidity, and extraordinary luminosity; we are on the route that will lead to the *Sacred Allegory* in the Uffizi (cat. 88). This work must date to around 1480.

THE TRANSFIGURATION

Galleria Nazionale di
Capodimonte, Naples
(cat. 57)

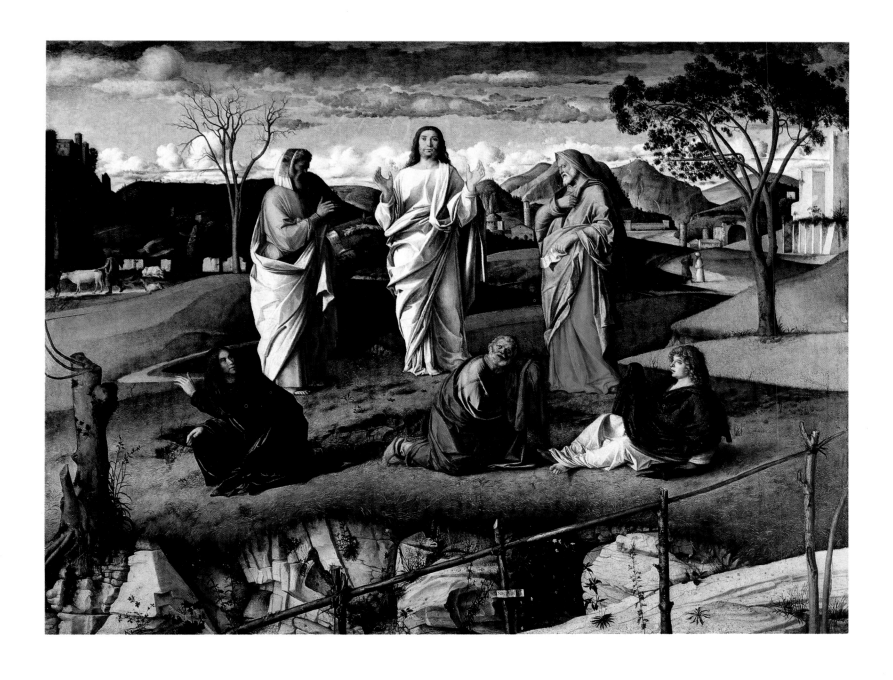

SAN GIOBBE ALTARPIECE

Panel, 184 × 101⅝ in. (471 × 258 cm)
Gallerie dell'Accademia, Venice, cat. no. 38

Signed IOANNES/BELLINVS. From the second altar on the right in the Venetian church of San Giobbe. This altarpiece presents the Virgin and Child enthroned, Saints Francis, John the Baptist, Job, Dominic, Sebastian, and Louis of Toulouse. Painted on thirteen horizontal panels, it was originally arched and was reduced above by 21⅝ inches (55 cm) when it was removed from the church, between 1814 and 1818.

As early as the first edition of his work (1550), Vasari mentioned and admired this altarpiece, citing it as the work that had made Giovanni famous and also maintained his fame in the city; in 1568 Vasari called it "a richly designed and beautifully colored panel," adding that "this picture was not only praised for its great beauty then, when newly seen, but has also been praised constantly since." In terms of chronology, Vasari placed the altarpiece between the destroyed San Zanipolo altarpiece (cat. 25) and the beginning of Giovanni's activity in the Doge's Palace in Venice, after his brother Gentile's departure for Constantinople in the fall of 1479.

The dating of this altarpiece is still the subject of debate. It is the largest work by Giovanni that has reached us after the *San Zaccaria Altarpiece* (cat. 106) and is the only one in which he located his composition within the apse of a church completely closed off from any landscape, without doubt basing himself, as he did in other works, on Flemish models, according to the opinion expressed also by Lucco (1990). The painting is mentioned by Sabellico (1502), who, writing between 1487 and 1489, saw it already finished; this fact has led some critics to conclude that Giovanni had finished the work in 1487: Paoletti (1929), Longhi (1949), Pallucchini (1959), Bottari (1963), Pignatti (1969), and Coltellacci and Lattanzi (1981) were of this opinion. Crowe and Cavalcaselle (1871) proposed dating the work to the middle of the 1470s, corrected by Borenius (1912) in favor of an execution in 1486-87, after *The Frari Triptych* (cat. 67); Berenson (1916) suggested 1483, van Marle (1935) 1488, Gamba (1937) 1484-85. Coletti (1949) moved this back to 1470-75, while Gronau (1930) dated the work to c. 1483, Dussler (1935 and 1949) to 1480-85, Heinemann (1962) went as late as c. 1490. Robertson (1968) followed Dussler's opinion, while Huse (1972) placed it at the end of the 1470s, an opinion repeated as a possibility by Goffen (1989) and then by Lucco (1990), both of whom believe it was commissioned to ward off the plague of 1478. Schmidt (1990) places it not before 1478-80. Personally, we think that date might very probably be taken as a *terminus post quem* in the sense that the altarpiece may have been commissioned from Giovanni during the terrible epidemic, against which the saints usually invoked were Job, Sebastian, and Roch. The first two are present in the painting and very much in evidence, the first because he is the titular saint of the church, but the second probably for purposes of warding off the plague; and as Lucco (1983) points out, Saint Roch is not known to appear in any work by Giovanni Bellini. Of the other saints presented, Francis of Assisi and Louis of Toulouse refer to the order of Observing Franciscans, to which the church belonged; the presence of Dominic constitutes a relatively common homage to the founder of the other great order, that of the preachers; and the Baptist may have been the patron saint of the donor, whose coat of arms has yet to be identified.

The detailed drawing of folds, still a little rough and uneven in some areas, most of all in the robes of Mary, confirms that the work must have been begun relatively early; but at the same time, as noted by Borenius, Robertson, and Pignatti, Giovanni already shows signs here of his mature style, primarily in the figure of the saints, where the pictorial technique is more fused, almost tonal, the style that characterizes the works dated from 1487 and 1488, meaning the *Madonna of the Small Trees* (cat. 65), *The Frari Triptych,* and the *Barbarigo Votive Altarpiece* (cat. 66). Therefore it seems likely that Giovanni received the commission for the altarpiece in 1478 but did not finish it before 1485.

SAN GIOBBE ALTARPIECE
Gallerie dell'Accademia, Venice
(cat. 58)

124

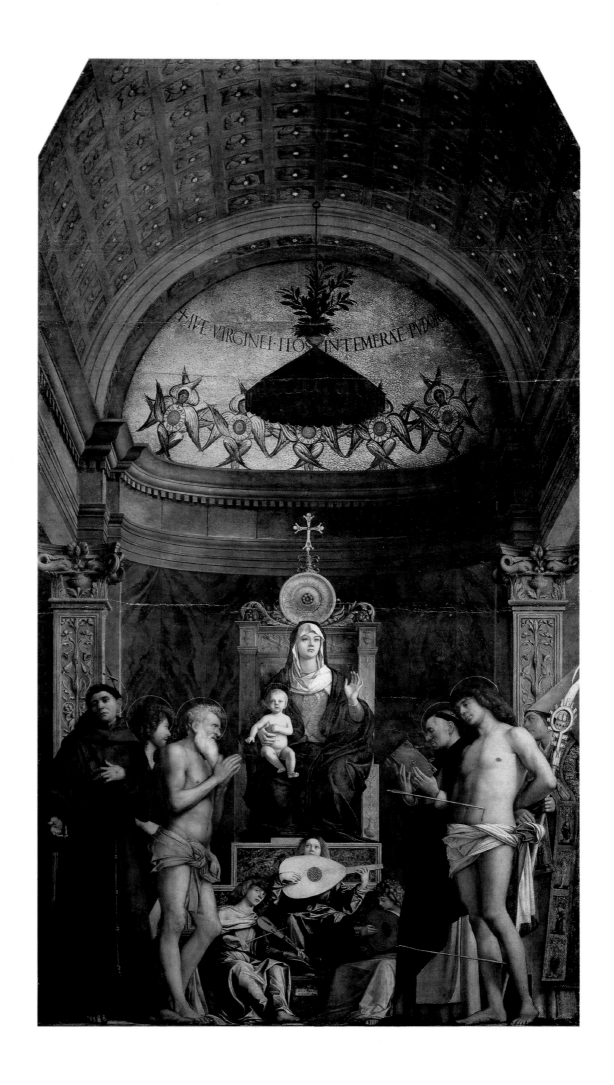

Because the picture was removed from the altar for which it was made, it cannot be fully appreciated. This is not merely because the colors have darkened, or because of the narrow space in the hall where it is displayed, and not even because of the nearby presence of so many other monumental paintings, which distract attention and prevent the viewer from admiring it from the correct point of view, which as Robertson pointed out should be from the height of the base of the panel. The reason it cannot be fully appreciated, what is missing most of all, is the architectural frame that matches the painted architecture to give the illusion that the painting constitutes a chapel opened in the wall of the church. This is an artifice that we find again, although in a less precise way, in the *San Zaccaria Altarpiece.* In creating this architectural frame, Giovanni had been following the example of Andrea Mantegna in his *San Zeno Altarpiece,* although he himself had done it before in the lost San Zanipolo altarpiece. The *San Giobbe Altarpiece,* together with the Urbino altarpiece by Piero della Francesca, today in the Brera, datable to the beginning of the 1470s, and perhaps also the *San Cassiano Altarpiece* painted in Venice by Antonello da Messina around 1475, constitutes the oldest example in Italian painting of an enthroned Virgin and saints located in a closed apse. We agree with Goffen's suggestion that when Giovanni went to Pesaro to execute the *Coronation* altarpiece (cat. 27), or to oversee its installation, he may have had the opportunity to see Piero's work in nearby Urbino. He may indeed have taken inspiration from that work, but he then completely reworked it, for the result, in terms of color and composition and most of all the way in which Giovanni interprets and renders the human figure and fills the work with a sense of participation in the mystery of divinity, is as far distant as could be imagined from the substantially abstract and intellectualized figurative world of the Tuscan painter Piero.

For the study of the evolution of the altarpiece from polyptych to single painting we refer the reader to the essay on this panel by Hubala (1969) and to the already cited essay by Schmidt. In the *San Giobbe Altarpiece,* as in the one formerly in San Zanipolo and probably also the one by Antonello formerly in San Cassiano, the saints are no longer crowded together or lined up as in polyptychs; instead, they are arranged in triads in triangular formations that, as Goffen indicates, may seem accidental but that are in reality carefully worked out according to precise geometric rules, which also applies to the arrangement of the three musical angels. With regard to the angels, however, we feel obliged to point out that the instrument played by the angel on left is not, as Goffen indicates, a *lira da braccio,* meaning a viola, but is instead a giga.

This work was displayed as no. 88 in the 1949 Venetian exhibition.

MADONNA OF THE PEAR
(MORELLI MADONNA)

Panel, 33¼ × 25¾ in. (84.3 × 65.5 cm)
Galleria dell'Accademia Carrara, Bergamo, no. 958

Signed IOANNES BELLINUS/P in a cartellino attached to the parapet. Cited by Ridolfi (1648) as located in a convent of nuns at Alzano Maggiore (Bergamo), it passed to the Morelli collection, from which it was bequeathed to the Accademia Carrara in 1891. This composition has enjoyed much success, as indicated by the two replicas of it made by Giovan Battista Moroni and by the fact that Cima da Conegliano used it as a model from at least 1496 on. Bellini himself reused the composition a few years later in the *Virgin with Red Cherubim* (cat. 72). Another work related to the same basic idea is the *Madonna of the Pomegranate,* no. 280 in the National Gallery of London, which all scholars attribute to Bellini but which should be restored to Cima da Conegliano (see the introductory essay). The compositional connection between the *Morelli Madonna* and the *Madonna of the Pomegranate* has been pointed out already by various scholars, first among them Borenius (1912), followed by Gronau (1930), Heinemann (1962), and Lucco (1990). It was Lucco who brought to light the relationship between the *Morelli Madonna* and a compositional idea that must have originated with Giovanni but that is known to us from echoes in three pictorial versions that are not attributable to his hand at the autograph level: the full-length Madonna figure signed and dated (1489) by Francesco Tacconi, no. 286 in the National Gallery in London; the half-figure Madonna in the church of the Scalzi in Venice, which is a workshop replica; and the *Madonna and Child with Donor* in the Friedsam Library in Saint Bonaventure University, New York, which Goffen (1989) presents as a workshop creation but which has been so completely reworked that it is unjudgeable. Morelli dated "his" *Madonna* to 1496-98; Borenius dated it earlier, to 1485; Gronau considered it a contemporary of *The Frari Triptych* (cat. 67), therefore 1488-89; Gamba (1937) placed it between *The Madonna of the Young Trees* (cat. 65) and the *Barbarigo Votive Altarpiece* (cat. 66), meaning between 1487 and 1488, an opinion shared by Pallucchini (1949), Bottari (1963), and Pignatti (1969); Dussler (1935 and 1949) opted for a period between 1485 and 1490, while Heinemann took the position of Gronau. Robertson (1968), who along with Berenson (1957) and Goffen dubbed it the *Madonna of the Pear,* claimed it was a little later than *The Madonna of the Young Trees* but very similar; in particular, he pointed out that the same child at the same state of development had been used as the model for the Christ Child. We think the *Morelli Madonna* was made a few years before 1487, so the dating proposed by Borenius seems to us the most acceptable, for this work does not yet demonstrate the fullness of form, and the richness of the pictorial material, already sightly fused, foreshadows the new style that is present in *The Madonna of the Young Trees* and in the *Barbarigo Votive Altarpiece.*

The *Morelli Madonna* is one of the great masterpieces by Giovanni, a painting that constitutes a point of arrival in his career. This is evident in the dialogue between Mother and Son, in the beauty of forms, in the clarity of line, in the precious chromatics—lacking only in the blue robe of Mary—and in the minutely peopled landscape, of almost Eyckian intensity, as Robertson indicated, which some critics have considered an element of weakness. We should add that the Staatsgalerie of Stuttgart has a Madonna offering a pear to a standing Child; the design of the Child closely resembles that in *The Frari Triptych,* but the panel is a workshop product.

The *Morelli Madonna* was displayed as no. 92 in the 1949 Venetian exhibition.

MADONNA OF THE PEAR
(MORELLI MADONNA)
Galleria dell'Accademia Carrara,
Bergamo
(cat. 63)

128

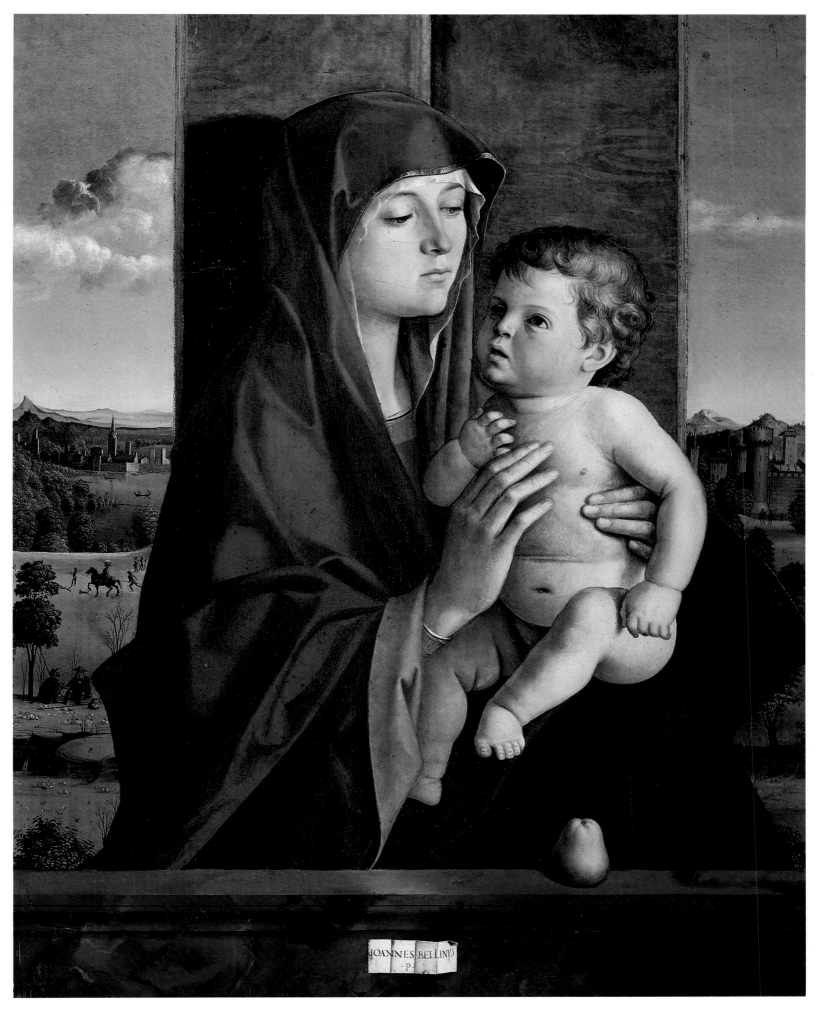

BARBARIGO VOTIVE ALTARPIECE

Canvas, 78¾ × 126 in. (200 × 320 cm)
Church of San Pietro Martire, Murano

Signed IOANNES BELLINVS 1488. The last two numbers are not easily legible, but no one has ever doubted the date. Agostino Barbarigo was elected doge amid furious public debate in 1486, and he probably commissioned the altarpiece as a tribute to Mary immediately afterward: it remained in his apartment in the Doge's Palace, as confirmed by Roeck (1991), until 1501, the year in which he died. He had bequeathed it by will to the church of Santa Maria degli Angeli on Murano. The painting, which, aside from the *Pietà* in the Doge's Palace (cat. 13), is the oldest work of Giovanni Bellini on canvas, passed to the church of San Michele in Isola, where Vasari saw it (1550 and 1568). During the time of Ridolfi (1648) it was in Santa Maria degli Angeli; it has been in its present location since at least 1815, when it was seen there by Moschini. It was recently restored by the Soprintendenza ai Beni Artistici e Storici of Venice (1981).

Giovanni is known to have made two votive altarpieces for doges, both with horizontal formats and eccentric compositions, meaning the throne of Mary is not located frontally at the center. The other is the one made for Giovanni Mocenigo, who was elected doge in 1478. Today in the National Gallery of London, in recent years it has been repeatedly assigned to an anonymous Venetian painter, but the traditional attribution of the work to Gentile and Giovanni Bellini remains valid, as has already been proposed by Lucco (1990), with whom we are in agreement in holding Giovanni partially responsible for the execution of the painting, on which his older brother had begun work before departing for Constantinople in 1479. In particular, the portrait of the kneeling doge and at least the design of the main group should be attributed to Gentile, while Saints Christopher and John the Baptist, as well as the beautiful background landscape, are unmistakable fruit of the brush of Giovanni; only the author of the Pesaro *Coronation,* and not some ordinary minor artist, could have painted the parts described.

The landscape view on the right in the Barbarigo picture repeats the background view inserted in the opening behind the throne in the Pesaro *Coronation*. But aside from abandoning centrality in favor of an asymmetrical layout that proved full of consequences—from the *San Giovanni Crisostomo Altarpiece* in Venice by Sebastiano del Piombo to the altarpiece in Pesaro by Titian—the Barbarigo painting uses its horizontal format, which, as Schmidt (1990) indicates, was typical of this genre of painting, as the opportunity, as Huse (1972) insists, to create a broad zone of silence behind Mary. Robertson (1968) points out the similarity of the red curtains with the predominance of that color in the central panel of *The Frari Triptych* (cat. 67). The doge is not presented by his patron or onomastic saint (Augustine, who stands on the other side of the throne) but rather by Saint Mark, protector of Venice, the city he represented: the birds to the right are a partridge, usually a symbol of sin, which the nearness of Saint Augustine exorcises; a heron, auspicious of the longevity of the doge; and a peacock, which is an allusion to the immortality guaranteed by divine grace.

During recent decades, all art historians, from Pallucchini (1949 and 1959) to Bottari (1963), Pignatti (1969), and Goffen (1989), have insisted on Bellini's great skill at rendering atmospheric light and using it to fuse figures and landscapes; in this landscape, which does not present a city, Goffen sees an indication on the part of the artist of nature as the seat of the beneficent presence of God. As Pallucchini and Huse have indicated, the use of canvas as support probably resulted from a desire to conform to the traditional usage for paintings made for the Doge's Palace, since this work, which is a prelude to

BARBARIGO VOTIVE
ALTARPIECE
Detail: SAINT MARK AND
DOGE AGOSTINO BARBARIGO
Church of San Pietro Martire,
Murano
(cat. 66)

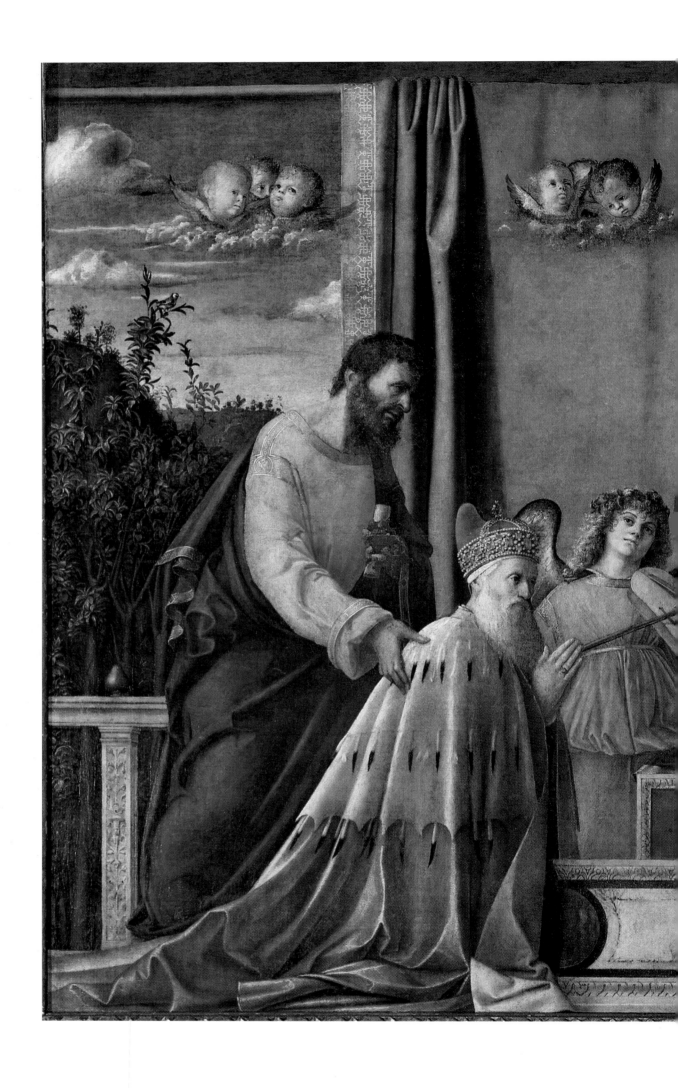

BARBARIGO VOTIVE
ALTARPIECE
Church of San Pietro
Martire, Murano
(cat. 66)

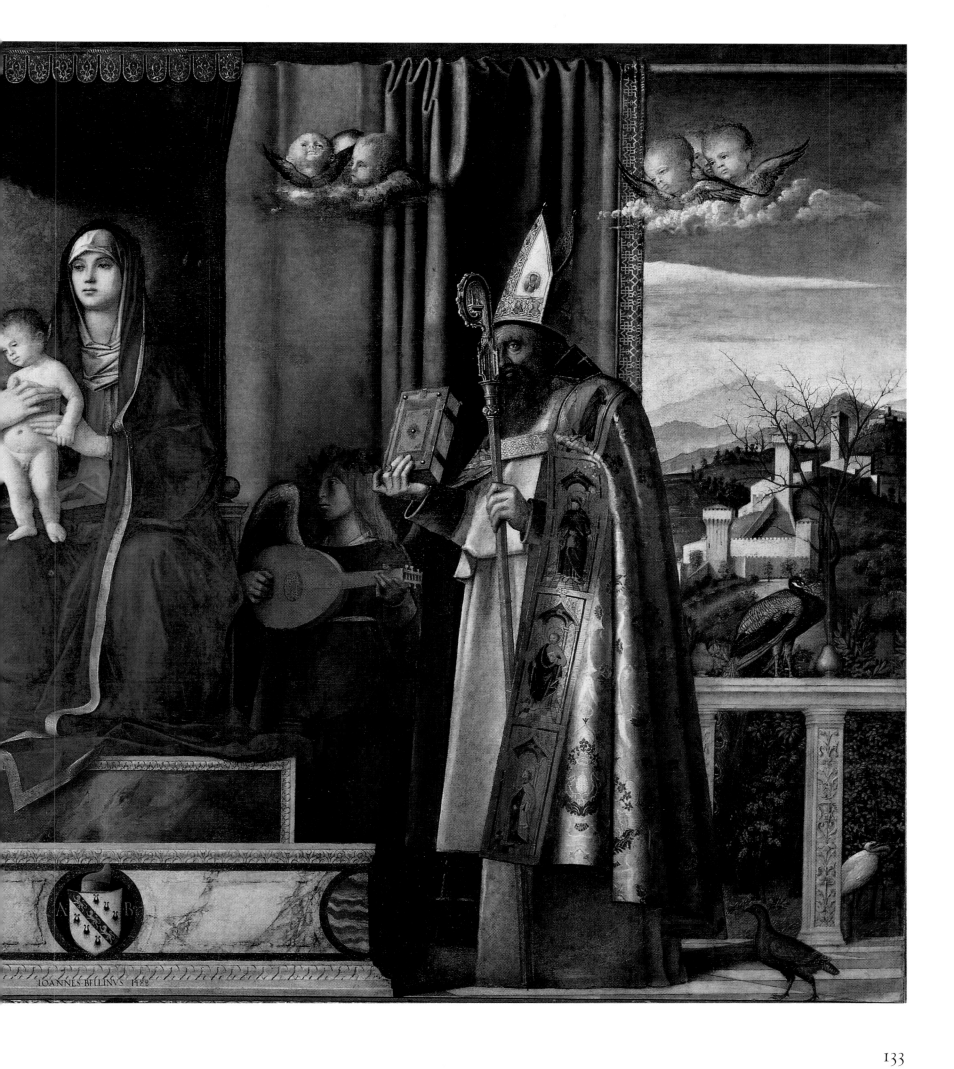

IOANNES BELLINVS 1488

the monumentality of the sixteenth century, was an official painting. As Huse noted, the central group returns in an almost identical form in the *Dolfin Sacra Conversazione,* in San Francesco della Vigna, of 1507 (cat. 112) while the Child, the same Child that can be seen in the *Virgin with the Standing Blessing Child (Northhampton Madonna;* cat. 64), appears again in *The Frari Triptych* and in the *Virgin Between Saints Peter and Clare* in Washington, D.C. (cat. 68).

This painting was displayed as no. 93 in the 1949 Venetian exhibition.

BARBARIGO VOTIVE
ALTARPIECE
Detail
Church of San Pietro
Martire, Murano
(cat. 66)

THE FRARI TRIPTYCH

Enthroned Virgin with the Child and Two Small Musical Angels
Central panel, 72½ × 31⅛ in. (184 × 79 cm)
Saints Nicholas of Bari and Peter; Saints Mark and Benedict
Side panels, 45¼ × 18⅛ in. (115 × 46 cm) each
Sacristy, Church of Santa Maria Gloriosa dei Frari, Venice

Signed IOANNES BELLINVS/F./1488. Writing on the back of the central panel gives the date of February 13, 1488, which should be understood, *more veneto,* as 1489. This was thus completed after the *Barbarigo Votive Altarpiece* (cat. 66).

The work was commissioned in 1478 by Nicolò, Benedetto, and Marco, sons of Pietro Pesaro, who in that year had the tomb of their mother, Franceschina, placed in the chapel that would become the sepulchre for the entire family; this is the reason for the choice of the saints on the side panels, whose identity has often been the subject of misguided discussion. Vasari (1550 and 1568) cites the work, as does Ridolfi (1648). Crowe and Cavalcaselle (1871) called attention to the memory of the *San Zeno Altarpiece* by Mantegna for the composition and the relationship between the frame and the painted architecture. Fry (1899) claimed that Giovanni had begun the triptych in 1485 only to complete it nearly four years later, which would explain the quality of the draftsmanship, clearly more archaic than in other works from this period. With the exception of Davies (1961), all later art historians have dismissed this theory, and only Robertson (1968) explains the apparent contradiction as a result of the old-fashioned taste of the patrons and the reduced size of the work, such that the Madonna more closely resembles a half-figure made for domestic worship than the monumental *San Giobbe Altarpiece* (cat. 58). The triptych arrangement itself might seem oddly anachronistic, but in reality it was still widespread in Venice, even within the sphere of the Vivarini family of artists; it was precisely in 1488 that Alvise offered to collaborate in the painted decoration of the Sala del Maggior Consiglio, the work site that was directed by Gentile and Giovanni Bellini.

Most recent authors agree that Giovanni must have designed the frame as well, since the complex is conceived in its whole with an extraordinary homogeneity. Even so, it does not achieve that unity of painting and real surrounding space that is seen in the *San Giobbe Altarpiece,* since in this case there is not that connection between a Gothic church and the altarpiece, which Lucco (1990) sees as a Venetian version of ideas from Alberti. As Schmidt (1990) indicates, while respecting the character of a traditional Venetian cultural image, Giovanni nevertheless manages to create one of his masterpieces in the fully Renaissance sense, as indicated by the perfect control of perspective and the space inhabited by figures and by the incomparable mastery with which he attains a complete fusion of volumes, color, light, and space, succeeding to creating not only the sense of natural lighting, but pervading the composition with a golden atmospheric dust that has been admired by art historians over the last decades. According to Pignatti (1969), Giovanni here presents architecture in the style of the Lombardo family, reminiscent of Santa Maria dei Miracoli, the church completed by Pietro Lombardo and his sons in the year 1489. Seeking to explain the roles performed by individual saints, Huse (1972) sees Nicholas as a symbol of sagacity, Mark as representative of the contemplative life, and Benedict, the active life; Huse also points out that the musical angels, one of whom is playing the only wind instrument presented in a religious painting by Bellini, are no longer the adolescents of the *San Giobbe Altarpiece,* but are two putti; Robertson had already seen them as reminiscent of the Donatello altar in Padua, such that this triptych might offer guidelines for the correct reconstruction of that work. Huse also points out how different chromatic harmonies are achieved in the various parts and that, particularly in the central panel, the darker tones of the colors used in the lower area exalt the brighter colors used in the upper area.

THE FRARI TRIPTYCH
Sacristy, Church of Santa Maria
Gloriosa dei Frari, Venice
(cat. 67)

The Marian writing in the gold mosaic of the apse ("Sure gate of Heaven, lead my mind, direct my life, may all that I do be committed to thy care") may well have been specifically requested by the donors, but according to Robertson it could also be taken as a motto of Giovanni's life and work; Goffen recognized it as the text of the office for the Feast of the Immaculate Conception, approved by Sixtus IV in 1478, meaning the year in which this work was commissioned, while Saint Benedict, with his willful expression, holds a Bible open to Ecclesiasticus 4, a text central to the cult of Mary's immaculacy.

We agree with Heinemann (1962) in holding that Albrecht Dürer, great admirer of Giovanni Bellini that he was, made use of the lateral saints—in particular, I would say, of Benedict—in pairs on two panels, when in 1526 he painted his *Four Apostles,* today in the Alte Pinakothek in Munich.

This work was displayed as no. 89 in the 1949 Venetian exhibition.

THE FRARI TRIPTYCH
Detail of the right panel:
SAINTS MARK AND
BENEDICT
Sacristy, Church of Santa Maria
Gloriosa dei Frari, Venice
(cat. 67)

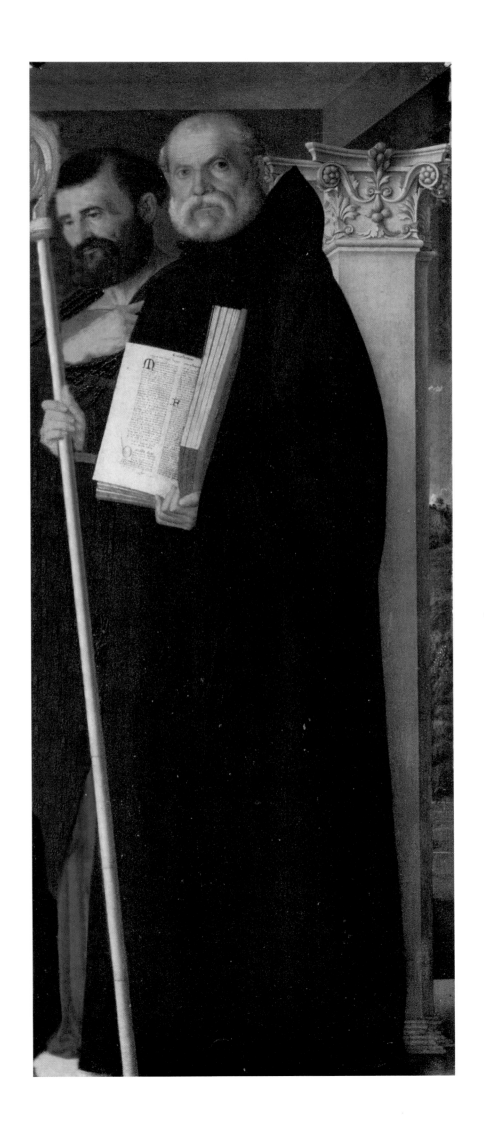

VIRGIN WITH TWO SAINTS

Panel, 42⅛ × 61¾ in. (107 × 157 cm)
Gallerie dell'Accademia, Venice, cat. no. 613

From the Vernier collection in Venice. Crowe and Cavalcaselle (1871) attributed this work to Giovanni, and that attribution has been accepted by all scholars. When he painted this panel, at the beginning of the last decade of the fifteenth century, Giovanni was at the height of his creative powers, in the fullness of his maturity. The two female saints are usually identified as Catherine of Alexandria and Mary Magdalene, and they have the physical characteristics of those figures, although not the attributes.

As Robertson (1968) correctly points out, the figures stand out against the dark background of the painting, as had been done previously in the *Presentation of Jesus in the Temple* of the Pinacoteca Querini Stampalia (cat. 21) and the *Dead Christ* in Rimini (cat. 33); but only in this work is it light that identifies them, with a chiaroscuro rendering that was admired by Bottari (1963) and Pignatti (1969), such that Robertson suggested that by that date Giovanni might possibly have had some direct contact with a work by Leonardo. Schmidt (1990) noted the hints that this Sacra Conversazione is taking place in an interior.

As for the dating, Crowe and Cavalcaselle, followed by Pallucchini (1959) and Bottari, tended for a period near that of *The Frari Triptych* (cat. 67), and Gronau (1930) noticed strong similarities with the *San Giobbe Altarpiece* (cat. 58); Schmidt agreed with him, while Dussler (1935 and 1949) opted for c. 1490, followed by Robertson and Pignatti; Heinemann (1962) returned to 1485, Berenson (1932) remained uncertain between 1480 and 1500, Longhi (1949) opted for the last decade, while Lucco (1990) pulled back to c. 1480. The Prado in Madrid has a workshop variant of the painting in Venice; in this variant Mary is flanked by Ursula and another female saint, identified as Catherine or as Mary Magdalene. Gamba (1937) thought this version was the result of a collaboration between Giovanni and Filippo Mazzola, but all other scholars have judged it a replica made without the master, or even a copy.

Lucco published a painting with a very similar composition and of good quality, which he had already presented at the Bellini conference in Pesaro in 1989; the panel, which is signed, appeared at a Christie's sale in London in 1969—later restoration has eliminated the landscape, cutting the two saints out against a luminous sky, while a tent is spread behind Mary; this example is certainly in part autograph, but was designed a few years later than the Venetian painting, during the period of the *Giovanelli Sacra Conversazione* (cat. 104) or a little earlier. From it Vincenzo Catena drew a very accurate replica, with a town for background, that in 1989 was found in the shop of an antiques dealer in Lugano, who displayed it that same year at the Mostra Mercato Internazionale in Palazzo Strozzi in Florence: this is probably the example cited by Dussler and Bottari in the Widener collection in Philadelphia.

The panel in the Accademia was displayed as no. 96 in the 1949 Venice exhibition.

VIRGIN WITH TWO SAINTS
Gallerie dell'Accademia, Venice
(cat. 71)

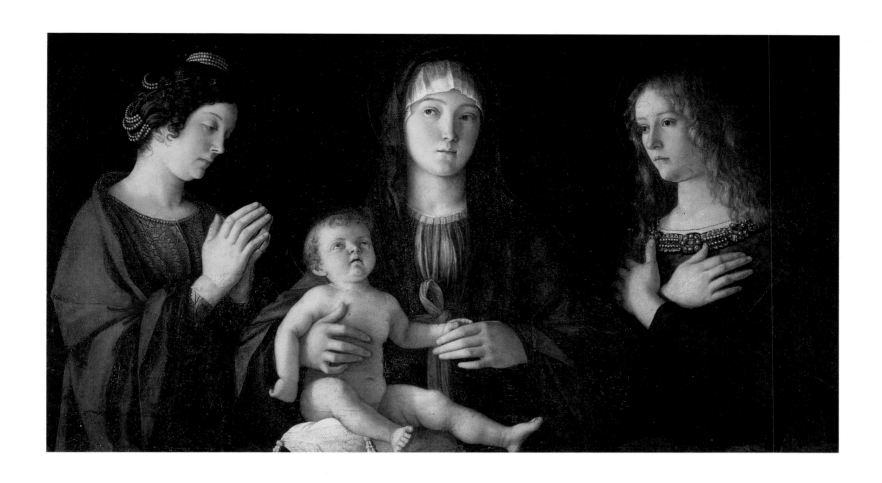

THE LAMENTATION OVER THE DEAD CHRIST (PIETÀ)

Panel, 29⅛ × 46½ in. (74 × 118 cm)
Galleria degli Uffizi, Florence, no. 943

Formerly in the Galleria Aldobrandini in Rome, this panel was acquired by Alvise Mocenigo, who donated it to the grand duke of Tuscany Ferdinando III in 1798. This monochrome painted in oil has always been a source of debate among critics, who variously considered it a preparatory drawing made to be covered by paint, a *simile* that was used to provide workshop assistants with a repertory of figures to use as models, or a finished work, in keeping with the Flemish style of the type such as the *Saint Barbara* by Jan van Eyck or the *Annunciation* painted in grisaille by Hugo van der Goes on the outer doors of the *Portinari Triptych*.

The attribution to Giovanni was proposed by Crowe and Cavalcaselle (1871) and has been accepted by all scholars except Tietze (1944), who considered it a compilation of Bellini motifs, thus indirectly repeating the underestimation of Morelli (1897) and the opinion first expressed by Dussler (1935). Berenson (1916) proposed dating the work to 1485. Lucco (1990) agreed with this, but an entire series of scholars has opted instead for the closing decade of the century: thus Gronau (1930), who thought the date suggested by Berenson was too early; Dussler (1949), who placed the work in the period 1490–1500, and Pallucchini (1949 and 1959), according to whom it was made between 1490 and 1493. In the last *Elenchi* (1957), Berenson called it "late"; Heinemann (1962) placed it in 1495; Bottari (1963) gave a date between 1485 and 1490. Robertson (1968) pushed the date back to after 1503, comparing this painting to *The Madonna of the Meadow* (cat. 102) and *The Drunkenness of Noah* (cat. 125) and suggesting influence from Dürer during his second stay in Venice. Pignatti (1969), like Degenhart and Schmitt (1990), opted for 1500, Huse (1972) thought instead of a date after 1505, and Goffen (1989) brought the date back to c. 1490.

There can be no doubt that this work belongs to a period just after *The Frari Triptych* (cat. 67), for the draftsmanship is very sharp-edged and exact, the handling of the drapery is rich but contained, and the figures are of a classical, Olympic beauty. Giovanni here repeats a theme he had dealt with many times in his juvenile years (cat. 2, 5, 9, 10, 11, 13, 27, 33, 39, 40) and to which he would return (cat. 74, 103, 111, 124): the Dead Christ alone, or supported or adored by angels, or with his mother only, or with Mary and John the Evangelist. In this panel, which constitutes his highest achievement within this iconographic context in his maturity, Jesus is at the center of a true Lamentation: this is not the presentation of any precise moment of religious history but rather a painting made for meditation on the redemptive death of Christ.

As for the problem of whether or not this is a finished work, we believe we should look on this as an example of how Giovanni brought his works to completion on the basis of what Paolo Pino wrote in his *Dialogo di pittura* (1548), when he discouraged young artists from making overly detailed drawings on the support, as Giovanni Bellini did, for such drawings would only be hidden by paint. As Ames Lewis points out (1990), research conducted during restoration work in 1988 brought to light a finished preparatory design beneath the Pesaro *Coronation* (cat. 27). On the other hand, the models from which students could draw inspiration were available for years in the workshop in the form of sketches on paper and cartoons; Robertson himself points out that *The Continence of Scipio* (cat. 110), painted in grisaille like a finished work, has technical characteristics and chiaroscuro very different from this *Pietà*.

Lucco called attention to the fact that two of the figures, the turbaned woman behind Mary and the man behind Christ, also appear in the *Presentation of Jesus in the Temple* (cat. 78). Many scholars have mentioned the fact that a preparatory study in the Gabinetto Disegni e Stampe of the Uffizi bears

THE LAMENTATION OVER
THE DEAD CHRIST (PIETÀ)
Galleria degli Uffizi, Florence
(cat. 74)

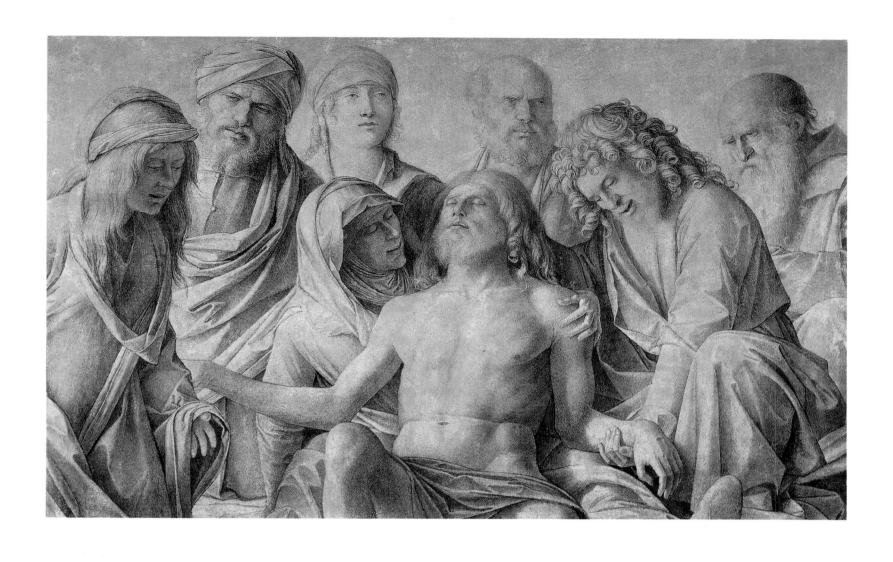

the figure of the bearded man with the turban. For our part, we would point out that none of the three masterpieces by Giovanni Bellini today preserved in the Uffizi is a result of true Medici collecting: the triptych by Mantegna was acquired by the son of Bianca Cappello, most of the works by Titian today in the Florentine galleries came from the Urbino inheritance or from the imperial Vienna collections, and only a few were acquired by Cardinal Leopold on the advice of Paolo del Sera. It seems that the prejudices at the base of the contrast between the two schools of painting, Florentine and Venetian, influenced the decisions made by the collectors from the house of Medici. Their lack of knowledge of the Veneto painting school was such that, as in the case of paintings by Jacopo Bassano, the Medici often mistook third-level works for good paintings, which is why they are today in the warehouses of the Florentine galleries.

The Uffizi *Pietà* was displayed as no. 105 in the 1949 Venetian exhibition.

THE LAMENTATION OVER
THE DEAD CHRIST (PIETÀ)
Detail
Galleria degli Uffizi, Florence
(cat. 74)

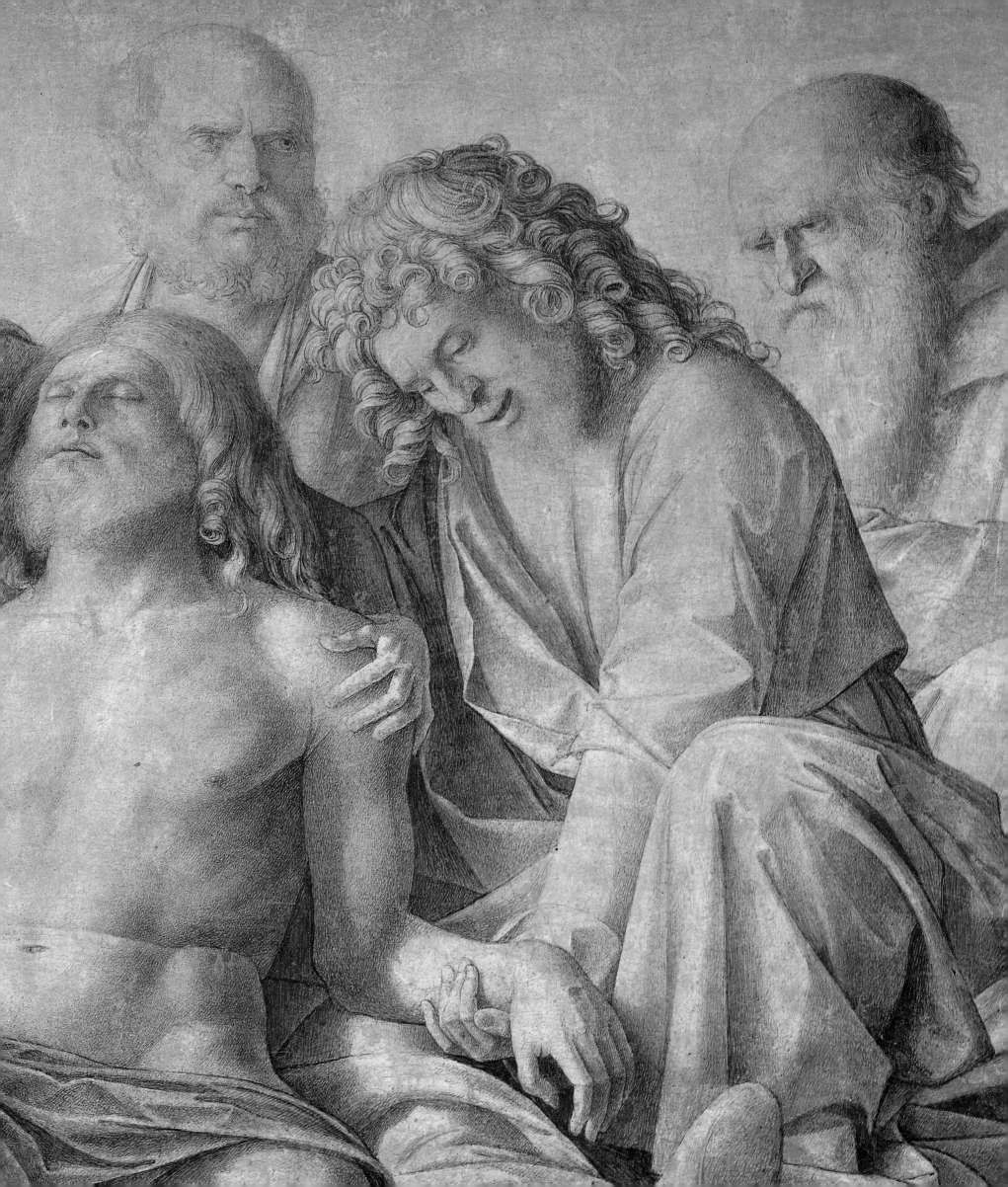

FOUR ALLEGORIES (VINCENZO CATENA'S "RESTELO")

1. *Fortune/Melancholy*
Panel, 13⅜ × 8⅝ in. (34 × 22 cm)
2. *Vainglory*
Panel, 13⅜ × 8⅝ in. (34 × 22 cm)
3. *Perseverance*
Panel, 12½ × 8⅝ in. (32 × 22 cm)
4. *Envy/Sloth*
Panel, 13⅜ × 8⅝ in. (34 × 22 cm)
Gallerie dell'Accademia, Venice, cat. no. 595

From the Contarini bequest, this came into possession of the Accademia in 1838. The fourth panel bears the writing IOANNES. BELLINVS. P., so that the signature for the entire complex appears at the lower right if the panels are arranged with the first two placed side by side and set over the third and fourth. The Accademia also has a fifth panel (10⅝ × 7½ in.; 27 × 19 cm) that presents a blindfolded harpy, its clawed feet resting on two spheres, in the act of pouring the contents of two amphoras that it holds with its hands, against a background of a river landscape. Art historians believed this panel was part of the complex and was an autograph work by Giovanni Bellini until Longhi (1946) ascribed it to Andrea Previtali, an artist whose style can be discerned in the pictorial language and the rendering of the landscape, an opinion cautiously embraced by Dussler (1949). The scholars who agree that the fifth allegory either belonged to a different group or was made by a different artist include Bottari (1963), Pignatti (1969), Huse (1972), and Goffen (1989). The series was identified by Ludwig (1905 and 1906) as the painted decoration, made by Giovanni Bellini, of the "*restelo*" that the painter Vincenzo Catena mentions in his holograph will of November 25, 1525, according to precise information from Goffen, who explains that the restelo, a piece of furniture like a dressing table used for a woman's toilet articles, had not been mentioned in Catena's earlier will of 1513, at which time Giovanni Bellini was still alive and may have still been in possession of the precious object himself. Robertson (1968) gives the date of 1525 and affirms the restelo had been named in an earlier document, which he dates to 1518, but all preceding scholars refer to a will of 1530, evidently confused by a marginal addition that was added in that year and followed by another in 1531, immediately after the death of the painter, who was a student of Bellini and was called a colleague of Giorgione.

The complex presents a kind of puzzle in terms of its dating, its correct reconstruction, and even the meaning of the individual allegories. Various scholars have proposed their own ordering of the panels; the following are several versions of such arrangements preceded by the numbering proposed in this volume: Ludwig interpreted them as (3) *Perseverance,* (1) *Fortuna inconstans,* (5) *Summa virtus* (Temperance, Fortune, and Justice), (2) *Prudence,* (4) *Exposure of Shame;* Gronau (1930) agreed with Ludwig's proposal. Hartlaub (1942) gave this reading: (3) *Lust and Virtue,* (5) *Fortune,* (1) *Wisdom Divinatrice,* (4) *Deceit and False Prophesy,* (2) *Truth* or *Vanity.* Wind (1948) presents them in the order provided here, which is also accepted by Robertson and Goffen; the only difference is that Wind and Robertson include the fifth panel, placing it in the center, above or below the mirror that must have been part of this piece of furniture. As for the meanings, Wind proposed: (1) *Fortuna Amoris,* (2) *Vana Gloria,* (3) *Comes Virtutis,* (4) *Servitudo Acediae,* the whole surmounted by (5) *Nemesis.* Cieri Via (1981) dedicated a highly articulate essay to the complex: she sees the series as contrasting virtue and ignorance, according to the *Gorgias* by Plato and on the basis of the confirmation of that principle in two letters of Andrea Mantegna; there must have been six panels, and the missing one, according to the iconology, may have represented Mercury. Robertson hypothesized a *Coronation of the Virtuous Hero.* In Wind's interpretation, the overall meaning alluded

to good fortune, female and male, with their negative aspects; Cieri Via's reading is characterized most of all by the negative identification of Fortune, which coincides with ignorance, and by the positive interpretation of the fourth panel, which constitutes an *unicum* attempted by the scholar on the basis of a symbology no longer medieval but rather classical: the shell and the serpent are allegories for generation, both physical and intellectual, and consequently of language and communication.

The dating of this work oscillates between the last years of the 1480s, the opinion shared by Crowe and Cavalcaselle (1871), Fry (1899), Pignatti, Ruggeri Augusti (1978), and Goffen, who put it at c. 1490; Gronau argued for an earlier date because of stylistic similarities he saw between the warrior in the third panel and the drawing of a male nude on the back of the *Saint Peter Martyr* in Bari (cat. 59). Dussler moved the date to 1490-95, followed by Pallucchini (1949 and 1959), Heinemann (1962), and Bottari. Robertson confessed difficulty interpreting the work, stating that since the paintings were being made to decorate a piece of furniture and were therefore minor works, achieving absolute clarity in meaning may not have been of paramount importance to the painter himself, and the same could be true of the purity of the style and complete autography; he did not rule out the possibility that the work had been made in the opening years of the sixteenth century, perhaps with the collaboration of a student, perhaps even Sebastiano del Piombo at the outset of his career. This identification leaves us quite skeptical. Cieri Via is firmly in favor of a dating of 1504–5, the same period as the execution of the *Pellizzari Frieze* in the presumed home of Giorgione in Castelfranco Veneto, which employs a symbiology that is in some senses similar to that used in Bellini's allegories. Goffen and Degenhart and Schmitt (1990) have pointed out that drawings by Jacopo Bellini are behind several of these images, in particular the figure of Bacchus that appears in the third panel.

It is our opinion that the complex cannot date to much later than 1490, given the stylistic language, which is still fully fifteenth century and which also reveals a similarity to northern European stylistic traits in the rendering of the female nude in the second painting; many art historians have emphasized that figure's striking resemblance to the Eve carved by Antonio Rizzo for the Doge's Palace no earlier than 1483. Goffen sees a negative value in the so-called Fortune, basing this opinion on the fact that the putti surrounding the female figure are playing wind and percussion instruments, musical instruments of which Aristotle expressed a low opinion.

These panels were displayed as nos. 97, 98, 99, and 100 in the 1949 Venice exhibition.

Pages 148–151

FOUR ALLEGORIES
(VINCENZO CATENA'S
"RESTELO")
Gallerie dell'Accademia, Venice
(cat. 77)

PERSEVERANCE *(p. 148)*

FORTUNE/MELANCHOLY *(p. 149)*

VAINGLORY *(p. 150)*

ENVY/SLOTH *(p. 151)*

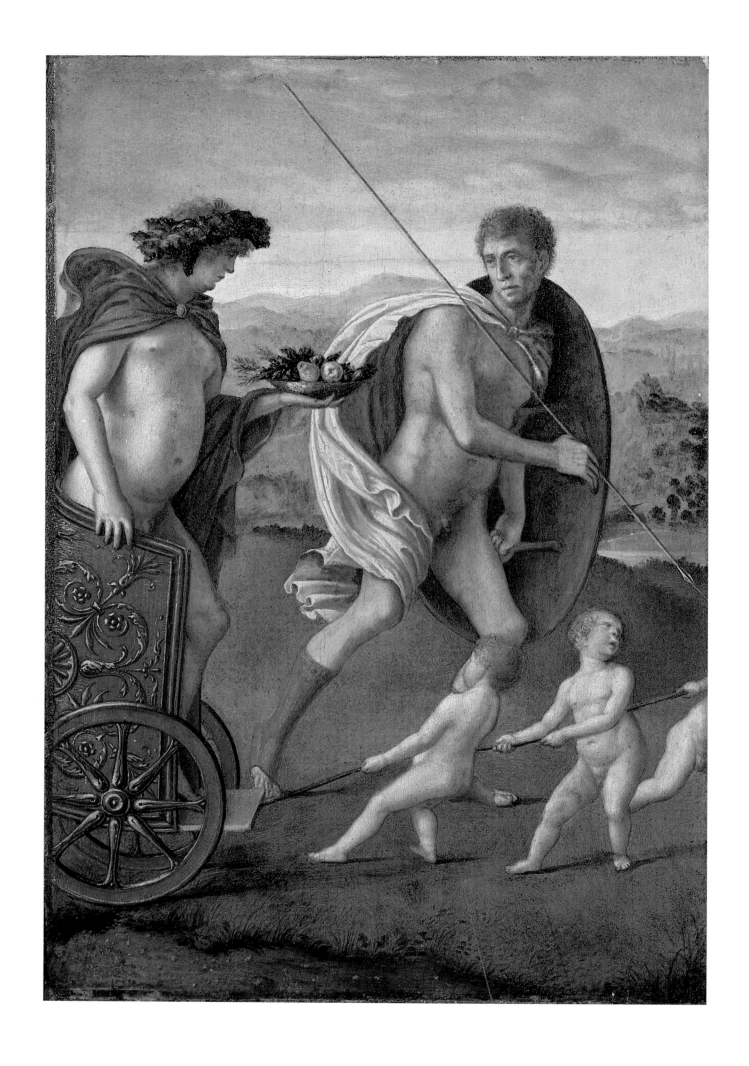

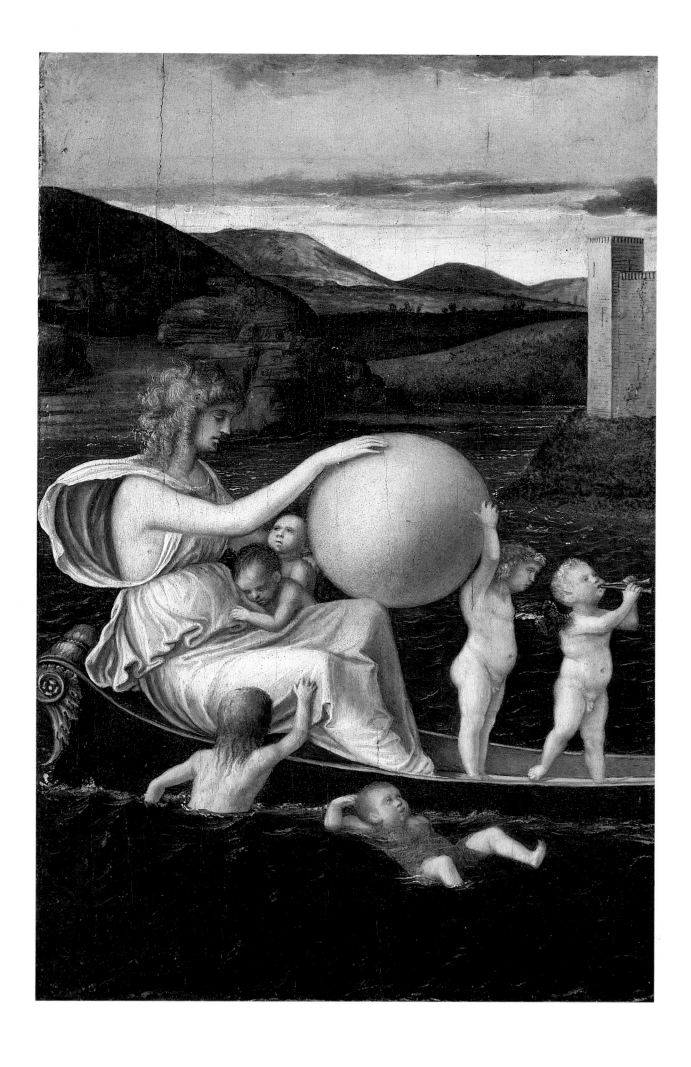

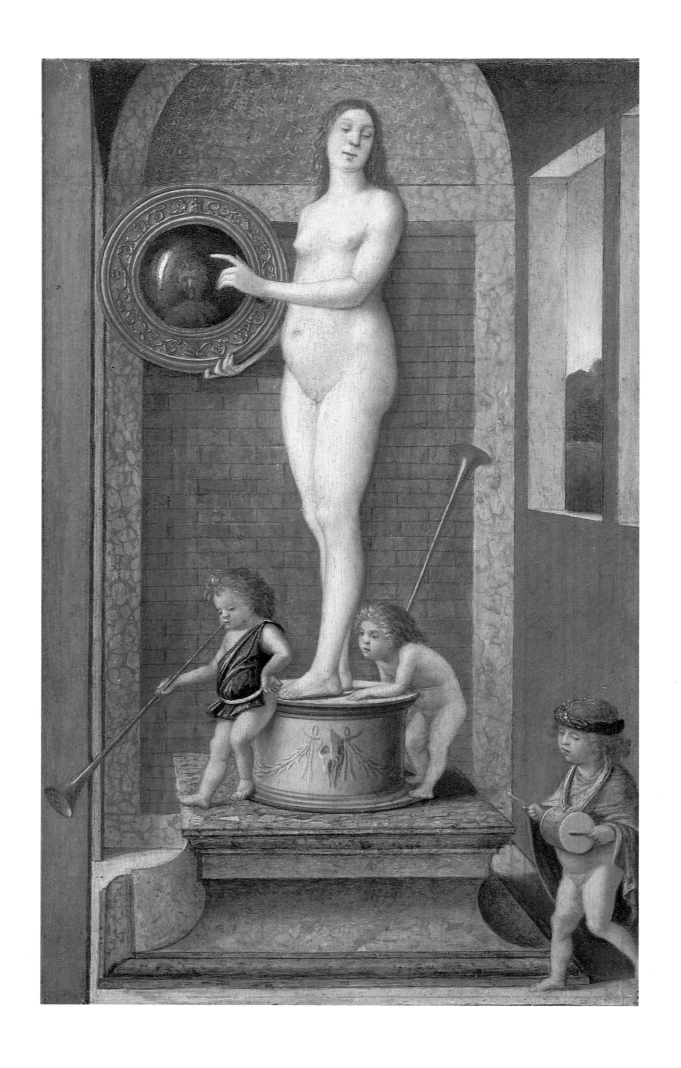

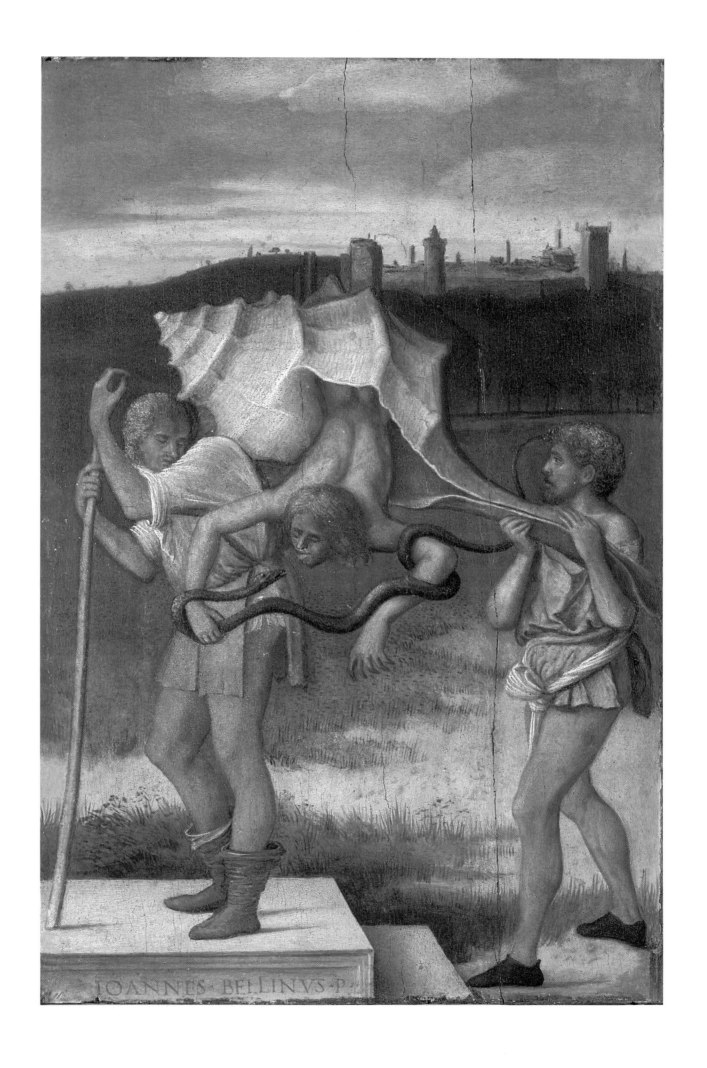

IOANNES·BELLINVS·P·

SACRED ALLEGORY

Panel, 28¾ × 46⅞ in. (73 × 119 cm)

Galleria degli Uffizi, Florence, no. 903

Thanks to the efforts of Luigi Lanzi, this work arrived in Florence in 1793 as part of an exchange with the imperial gallery in Vienna. Edgar Degas was fascinated by the painting and copied it during the period 1858-59. The attribution to Giovanni Bellini dates to Crowe and Cavalcaselle (1871), who thereby ended the traditional attribution to Giorgione, and since then this attribution has been questioned only once, by Bode (1884), who assigned it to Marco Basaiti. The aspect of this painting that is still the subject of debate concerns the interpretation of what is obviously a religious theme; as for the date of the work, it oscillates among scholars from between the end of the 1470s, indicated by Fry (1899), Gronau (1930), and Bottari (1963), who saw strong similarities with the *San Giobbe Altarpiece* (cat. 58); the years 1487-90, in the opinion of Berenson (1916), Dussler (1949), Pallucchini (1949 and 1959), Braunfels (1956), Paolucci (1981), Goffen (1989), and Lucco (1990); and finally the early years of the new century, a proposal supported by Rasmo (1946), Heinemann (1962), and Huse (1972). Robertson (1968) proposed the mid-1490s, while Pignatti (1969) indicated the general period 1490-1500. Some of the iconographic motifs, such as Mary's canopied throne and the two saints at the right, are reminiscent of the *San Giobbe Altarpiece,* but the pictorial technique, the extremely well blended colors, the beautifully rendered harmony between the figures and the landscape following Giorgionesque stylistic modules that presuppose an awareness of Leonardo, mean that the painting must date to early in the new century.

As for the meaning, we can do no more than cite the most important readings suggested for the work without presenting any single idea as conclusive. Ludwig (1902) saw the painting as a figurative translation of the French poem by Guillaume de Deguilleville (fourteenth century) "Le Pèlerinage de l'âme": the painting would thus present Purgatory in the form of an earthly paradise, in which the souls waiting to present themselves before God, already purified, are represented by innocent putti. This interpretation was adopted by Heinemann, who then explained many symbolic elements in the painting: the river is the Lethe; among the animals, the donkey stands for patience, the sheep humility, the goat temperance, the centaur temptation; the Easterner at the far left is symbolic of commercial acumen. Such readings had already been contested by Rasmo, who saw the painting as a Sacra Conversazione laid out in a novel way in which the old saint resting against the balustrade is not Peter, as he is usually held to be, but rather Joseph. Verdier (1952-53) identified the painting as a medieval Christian allegory of Mercy and Justice, while according to Braunfels it is a representation of Paradise. Robertson has provided the most thorough analysis of the painting and devotes most of his discussion to these last two proposals. His hypothesis that it is a "Meditation on the Incarnation" remains the most acceptable; the putto seated on the cushion is the Christ Child, to whom the angels offer fruits from the Tree of Knowledge; Robertson blends elements of interpretation from Ludwig, according to whom the woman with the crown is Justice, and other elements taken from Verdier, who, however, saw Truth/Justice as the woman to the left who has no feet, in accordance with Psalm 84. Robertson thinks the figure was meant to have feet but that the feet have disappeared because they were painted in on top of the pictorial surface of the floor, as is also the case with the figure of Saint Sebastian. In reality, the left foot is still visible, as Coltellacci and Lattanzi (1981) point out. Robertson identifies a motif of great interest in the asymmetry, which results from the difficult shifting of balance between the central paved terrace and the vanishing point, located above right, at the top of the cross that marks the hermitage of Saint Anthony Abbot: the sense of calm silence that pervades the painting is accentuated and also caused by

the motionless expanse of water; the Easterner moving away is symbolic of the refusal of Grace. One can find precedents for many elements in the *Sacred Allegory* in the *Blood of the Redeemer* in London (cat. 6); also in the Uffizi, at the base of the throne of Mary, one can make out mythological figures in a false relief with a dark background: according to Robertson, this could refer to the myth of Marsyas, which can be taken as a parallel of the Passion of Christ.

As Pignatti points out, this masterpiece by Giovanni came into being in the learned atmosphere imbued with Averroist philosophy, theology, and humanistic culture that characterized the Venetian and Padua civilization astride the two centuries. According to Huse this painting may well have been the work announced in 1501 to Isabella d'Este as an alternative to one she had requested for her studiolo in Mantua. The figures later added were the Sebastian, off axis with respect to the figure usually held to be Saint Job, and the Asian. Many elements suggest that Huse's proposal has validity; Isabella did not like the idea of Giovanni's making her a Nativity, since she wanted the figure of the Baptist to be included in her painting; the letters written on behalf of the painter make it clear that he intended to make "a fantasy in his own style." The so-called Job could also be Saint Jerome, another figure requested by Isabella, while the putto reaching for fruit could be the young Saint John the Baptist: he appears as such in a panel by Luca Antonio Busati (the artist formerly called the Venetian Master of the Incredulity of Saint Thomas), displayed in Palazzo Strozzi in Florence in 1971 (Temptestini, 1994). If the painting in the Uffizi is the one made for Isabella d'Este, it was completed before July 6, 1504, according to what is indicated in a letter of Lorenzo da Pavia, the second correspondent of the duchess of Mantua in Venice.

Coltellacci and Lattanzi, already cited, dedicated an essay full of iconological studies to the painting. Aside from the other proposals for interpretation, they also discuss that of Delaney (1977). According to their reading, in the *hortus conclusus* to which the spectator is admitted, an allegory of the Redemption is being presented; at the center of the pavement, which forms the motif of the cross, is the tree that is *fons vitae,* near which is Christ, the mediator between the throne of Maria Sedes Sapientiae and Job, who is the hope of resurrection of the body. The reliefs on the base of the throne do not present Mercury, as Delaney proposed, but rather a satyr lusting after a sleeping woman and pointing to a dry tree that is partially flowering again, an allusion to redemption, as are the cornucopia and the bunches of grapes on the canopy over Mary's head. These are Dionysian symbols, but also allusions, respectively, to the uterus of the Mother and to Christ. The Easterner whom Saint Paul is driving off with his sword is a heretic, in reference to the Averroist groups of Padua. Saint Anthony Abbot, presented in the moment in which, while searching for Paul the Hermit, he has the vision of the centaur, represents repentant pride, which is redeemed by humility. The shepherd is symbolic of a man overtaken by the torpor of sin who does not see the mystical reincarnation that takes place in the hortus conclusus. Sacred Allegory and also Holy Family: the old saint, as indicated by Rasmo, is Joseph. Coltellacci and Lattanzi are uncertain about accepting the interpretation of the two female figures near the throne, proposed by Delaney as Faith and Hope; they could be two saints, the one with the diadem perhaps Catherine of Alexandria, or they could stand for the active and contemplative life. The two scholars leave this problem unresolved, as they do that of the possible levitation of the figure on the left. According to this theory Saint Sebastian was added as a patron saint against the plague. Del Bravo (1983) interprets the painting on the basis of the book of Ezekiel interpreted by Lorenzo Valla: the figure on the throne is Infinite Felicity flanked by Christian Honesty and Virtue, all within the *hortus voluptatis.*

We find convincing elements in the interpretation proposals of Robertson, Huse, Coltellacci and Lattanzi, and Del Bravo. In particular, the hypothesis that the painting is the one made for Isabella d'Este seems particularly well founded. But we would not want the debate on the meaning to make us forget the sublime beauty of the painting, perfectly constructed on an equilibrium between the

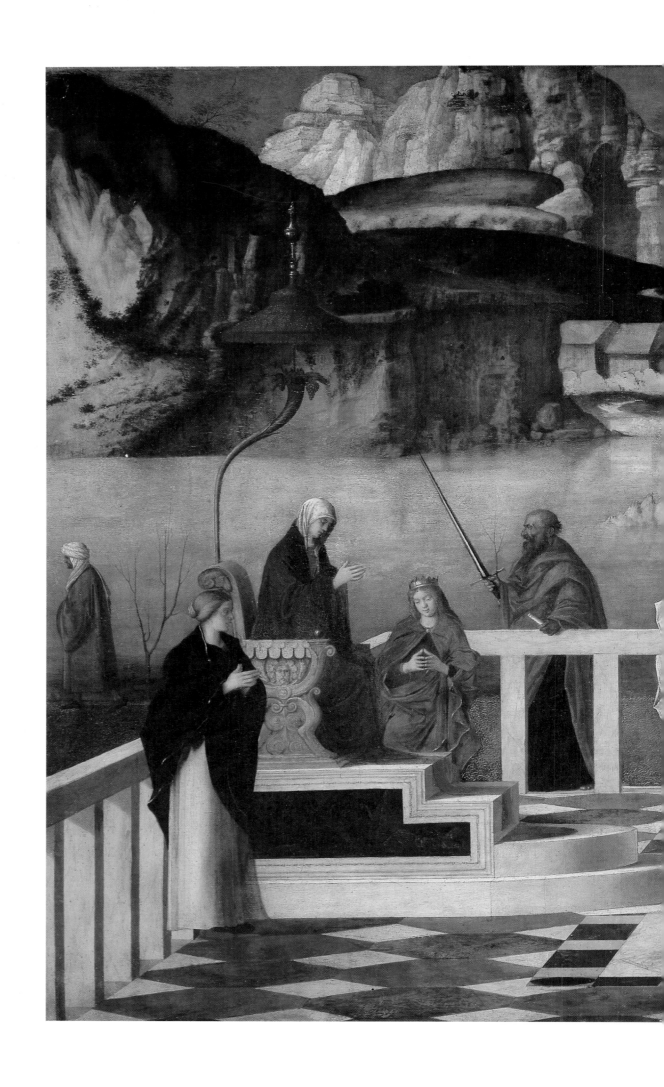

SACRED ALLEGORY
Galleria degli Uffizi, Florence
(cat. 88)

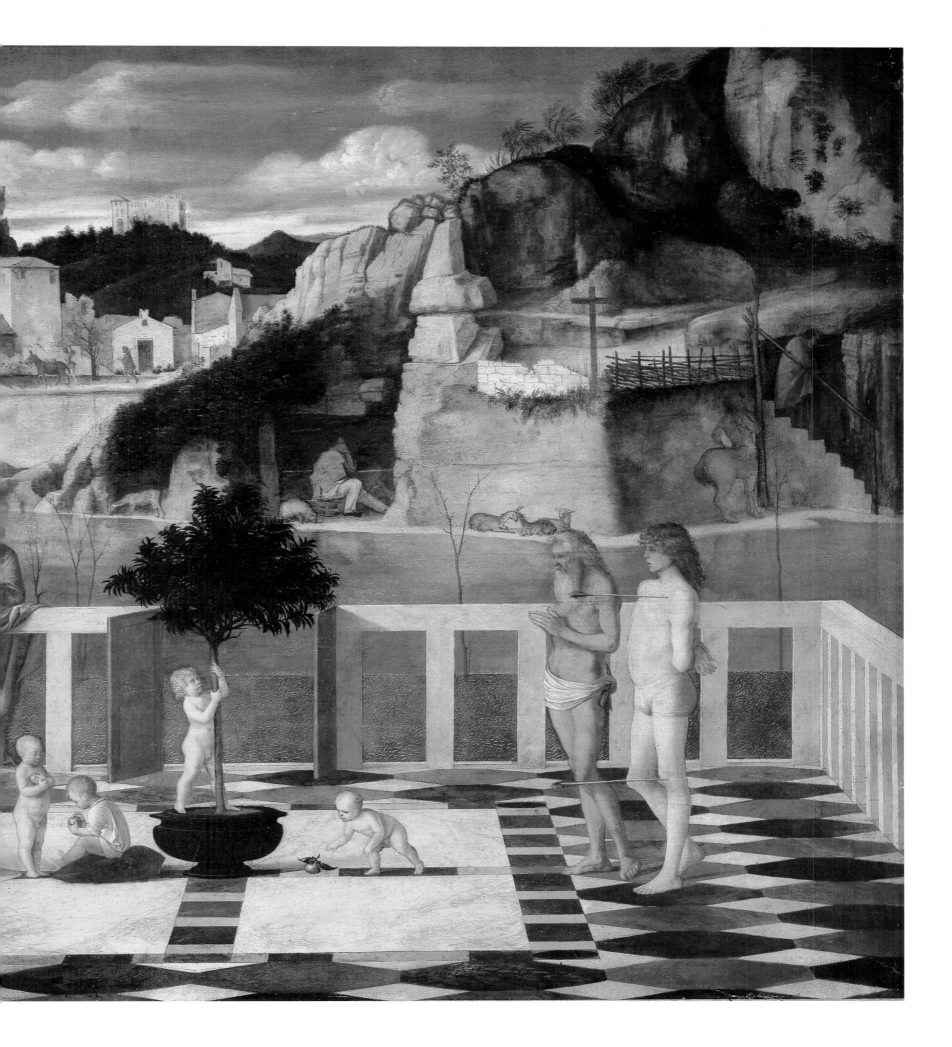

foreground, in which the sacred scene takes place according to a serene choreography, and the background landscape, connected to the terrace not only by the door that opens onto it and by the expanse of water, but most of all by the richness of symbolic elements that populate it: it is striking how the viewer's eyes are drawn to the cross on the rock near the hermitage.

Displayed as no. 86 in the 1949 Venice exhibition.

SACRED ALLEGORY
Detail
Galleria degli Uffizi, Florence
(cat. 88)

PORTRAIT OF DOGE LEONARDO LOREDAN

Panel, 24¼ × 17¾ in. (61.5 × 45 cm)
National Gallery, London, no. 189

Today in London, the painting is signed IOANNES BELLINVS and is universally considered Giovanni Bellini's greatest achievement in this genre of painting. In 1821 it went from the Palazzo Grimani in Venice to a private collector in England. Its autograph status was confirmed by Crowe and Cavalcaselle (1871) and has never been questioned; even Vasari (1550) speaks of the work, and in his second edition (1568) he calls it one of the first works made by Giovanni, admitting that he may be confusing it with the *Barbarigo Votive Altarpiece* (cat. 66).

Leonardo Loredan was elected doge on October 2, 1501, and ruled until 1521; his reign thus spans years in which Venice experienced grave economic and military crises. The doge is recalled (Sanudo) as being "rather choleric but savvy in government"; in the portrait he seems animated, as indicated by Huse (1972) and Goffen (1989), by the kind of tranquil self-possession demanded by his high office. All scholars hold that Giovanni made the portrait immediately after Loredan's election except Huse, who thinks it is a contemporary of the *San Zaccaria Altarpiece* (cat. 106), meaning it would date to 1505.

While this is an official painting, it does not present the doge in profile, following the most common usage, handed down to us by Gentile and even in images of Loredan, of whom various examples are known, more or less autograph works, that are attributed to Carpaccio (Sgarbi, 1994). Here we have a bust, seen almost frontally, with the head turned slightly to the side and the gaze, as almost always in portraits by Giovanni, fixed on a point to the left of the spectator toward the source of the light that illuminates the precious cloak in white and gold brocade, the ceremonial *corno* made using the same fabric, the gilt buttons that close the cloak at the chest, the face with its fine features and wistful smile. Giovanni shows here all of his masterfulness, proving himself one of the most refined, sensitive, and skilled artists of the period.

Another portrait of Doge Leonardo Loredan (cat. 94) has reached us signed and dated IOANNES BELLINVS/MCCCCCVII. This painting is mentioned by Ridolfi (1648) as located in the Loredan palace in Campo Santo Stefano in Venice (later the Loredan-Mocenigo, today the Institute of Sciences, Letters and Arts). This work passed through the hands of several private collectors, and only in 1961 was its acquisition by the Bodemuseum in Berlin made known. In it the doge, older compared to the London portrait, appears seated at a work table, flanked by four young magistrates, two on each side, one of whom Heinemann (1962) has recognized as the doge's son Bernardo. The group is located on the far side of a marble balustrade, open at the center to show the entire figure of the main character; an Oriental rug covers the table, another is laid on the floor, while the background wall is covered in a precious fabric. It is a portrait that exalts the high dignity of the position, as if the doge were a pope or divinity; Goffen quite aptly makes a typological comparison to a Sacra Conversazione. The setting of the scene on two levels separated by the balustrade presents some similarities with the *San Giovanni Crisostomo Altarpiece* (cat. 119). Indicated by Tietze-Conrat (1929), the painting today in Berlin has been accepted as autograph by Gronau (1930), Gamba (1937), Pallucchini (1959), Heinemann, and Pignatti (1969); Dussler (1949) was cautious because of its poor state of preservation; Berenson (1957) held it partially autograph, an opinion shared by Meyer zur Capellen (1985) and Goffen, while Bottari (1963) listed it as attributed; Robertson (1968) and Huse ignore it.

PORTRAIT OF DOGE
LEONARDO LOREDAN
National Gallery, London
(cat. 93)

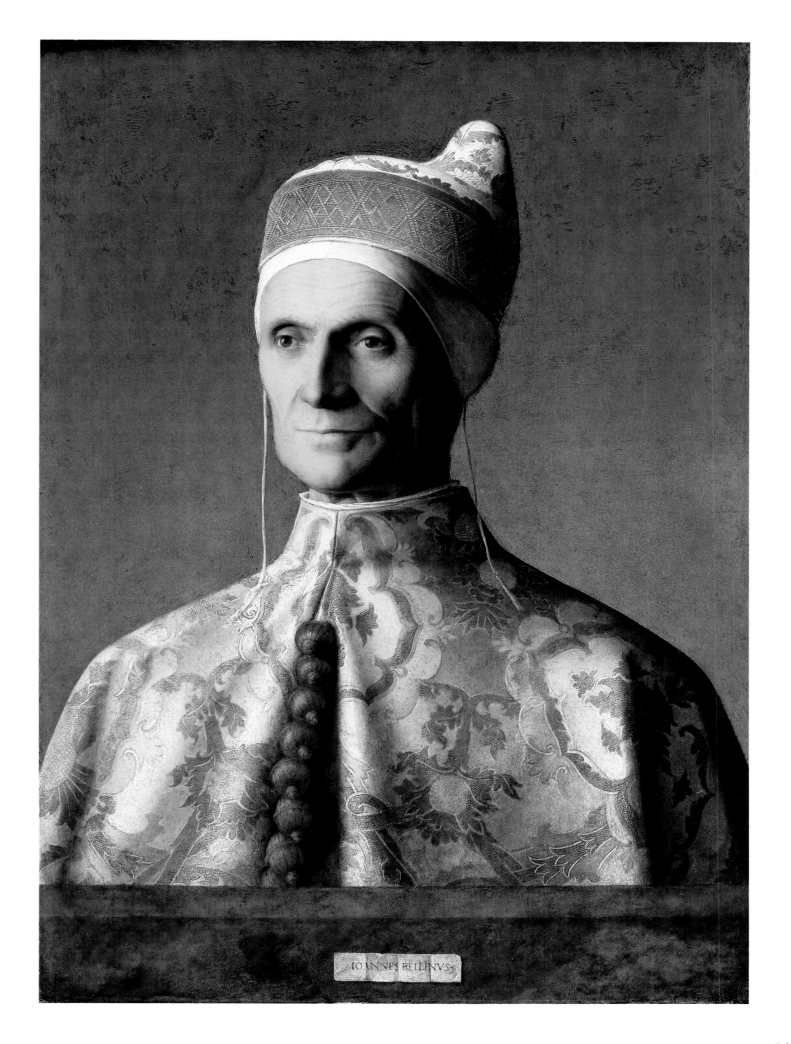

THE BAPTISM OF CHRIST

Canvas, 156 × 103⅝ in. (400 × 263 cm)
Church of Santa Corona, Vicenza

Signed IOANNES/BELLINVS. This work was made for the altar in the family chapel that Gian Battista Graziano Garzadori had built in the Dominican church between 1500 and 1502 to fulfill a vow, made before departing on a pilgrimage to the Holy Land, to have an altar built dedicated to the Baptist on his safe return, as related in writing with his coat of arms on two of the piers facing the altar and reported by Goffen (1989). Giovanni's work, which Ridolfi (1648) mentions, must have been made at the same time as the architectural complex; all scholars agree with this with the exception of Crowe and Cavalcaselle (1871), who dated it to the end of the fifteenth century, and A. Venturi (1915), who thought it was a little earlier than the *San Zaccaria Altarpiece* (cat. 106), meaning it dated to the very first years of the sixteenth century, while Arslan (1956) went to the second half of the first decade, since he hypothesized the participation of Giorgione in the group of angels; the stylistic traits of these figures are instead those of Bellini himself in his last years. Furthermore, as Pignatti (1969) points out, Boschini (1676) had already advanced and then discarded the notion that Giorgione had contributed to the making of this painting and, further, even if Giorgione did have a hand, he would have done so as Giovanni's student, and therefore not after 1505 but at the beginning of the century. Huse (1972) thought the work had been begun in 1501 and completed in 1505.

This *Baptism* is often compared to the *Baptism* made by Cima da Conegliano between 1492 and 1495 for the high altar of the Venetian church of San Giovanni in Bragora and still in place there. Attention is usually given the great differences between the two works, which are only apparently similar; this is a point on which both Robertson (1968) and Huse have insisted. The figure of God the Father is not included in Cima's Venetian altarpiece; in Giovanni's work it appears in the upper area of the arched canvas and forms a sort of Trinity with the dove and Christ. Cima's work thus does not include the axis line linking the Father, the dove, the bowl held by the Baptist, and Christ; Huse aptly points out that Bellini presents not so much John baptizing Christ with water as the Holy Father baptizing his Son by way of the Holy Spirit. Furthermore, in Cima's painting John the Baptist stands out against the sky, while in Bellini's painting there are two distinct chromatic and semantic zones: the divine zone, which includes God the Father, the angelic cherubs (two of which support God's robes), the sky, the dove, and Christ; and the terrestrial zone, which includes the Baptist in its brown-green tonalities. By the time of this work, Giovanni's fusion of figures and landscape had reached perfection: he can be seen to follow the route already traced in the *Transfiguration* in Naples (cat. 57) and confirmed in the *Sacred Allegory* in the Uffizi (cat. 88), which recalls the hermitage in the background at right; according to Panofsky (1969) as cited in Huse, the parrot in the foreground near Christ is an allusion to the birth of Christ, son of a virgin. A workshop replica of this painting exists in the Venetian church of San Giovanni dei Cavalieri; it is in poor condition, does not include the God the Father, but does include a Knight of Malta as donor.

This altarpiece was displayed as no. 31 in the 1949 Venice exhibition.

THE BAPTISM OF CHRIST
Church of Santa Corona, Vicenza
(cat. 100)

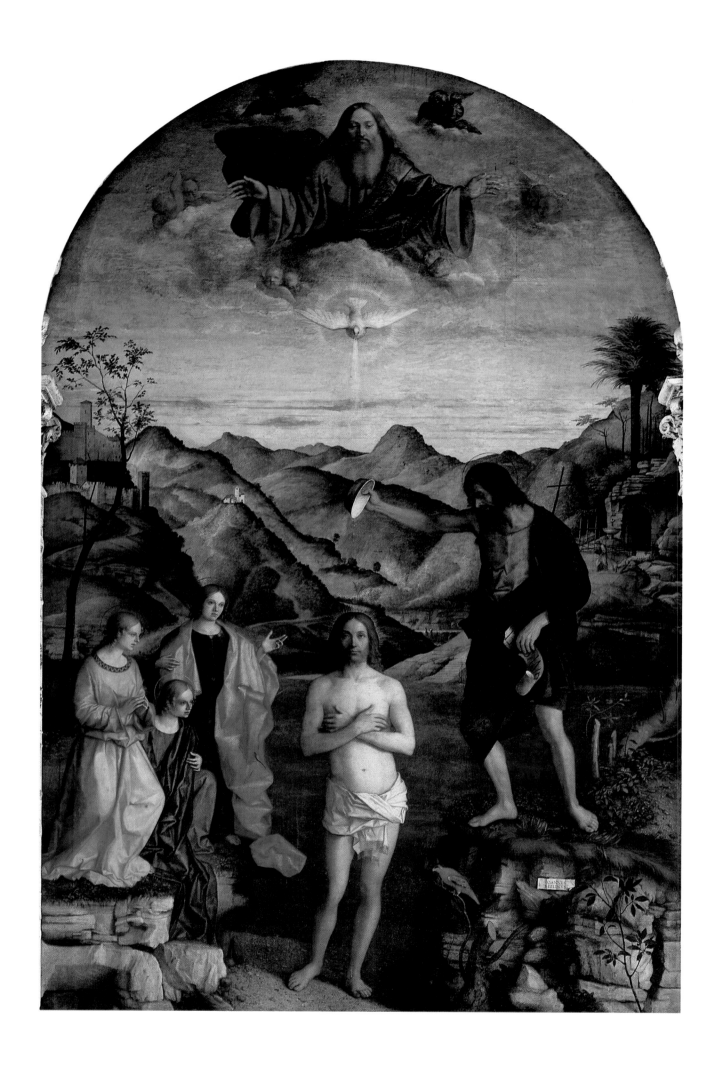

THE MADONNA OF
THE MEADOW

Canvas (transferred from panel), 26½ × 34 in. (67.3 × 86.4 cm)
National Gallery, London, no. 599

Acquired in Faenza in 1858. Richter (1883) attributed this painting to Vincenzo Catena after Frizzoni (1879) had first opted for Francesco Bissolo and then (1891) decided on Marco Basaiti, to whom Crowe and Cavalcaselle (1871) also attributed it; the work was restored to Giovanni Bellini by Gronau (1928–29 and 1930). The painting was in such precarious condition that it had to be transferred to a new support in 1949; it was then that Wind, as reported by Robertson (1968), noted traces on the back of the painted surface of an elaborate preparatory drawing very similar to that of the Uffizi *Pietà* (cat. 74), composed of the foreground group, the walled hilltown in the background, and the trees to the right, while the other elements of the landscape and the small figures are later additions in glaze. With the exception of Dussler, who accepted the work as a Bellini autograph (1949) only after first (1935) considering it a workshop product, all scholars rank this Madonna among the masterpieces of Giovanni Bellini's later career. The dating oscillates between the beginning of the century and 1505: in particular, Robertson and Huse (1972) believe it to be later than the *Donà dalle Rose Pietà* (cat. 103).

The Madonna of the Meadow is based on the medieval theme of the Madonna of Humility, but in this case, as Huse and Goffen (1989) indicate, precisely where Mary is seated is unclear, although it seems to be in a field. In reality, the landscape, illuminated by the same light source that joins it to the divine group, has its own autonomous identity, is self-justified as one of the motifs of greatest interest to the artist, and is related to the foreground only by means of the interpretation of the symbols within it. On the left, the battle between the ibis and the snake alludes to Christianity's defeat of sin and is also a literary reference to the second book of the *Georgics* by Virgil, while the vulture, according to Lucco (1990), returns here after being seen in the *Resurrection* in Berlin (cat. 41). The difference is that in the *Resurrection* the bird faces outward, toward the exterior of the painting, symbolizing victory over death, while here it is a funereal bird and looks toward the interior of the painting, thus adding a further sense of the theme of divine sacrifice, emphasized by the ancient altar in the background to the right, but in particular adumbrated as the subject of the composition, which even more than the *Davis Madonna* (cat. 4) or the *Enthroned Virgin Adoring the Sleeping Child* in the Accademia in Venice (cat. 20), presents Mary adoring the sleeping child but most of all presages the *Donà dalle Rose Pietà,* since the pale Child has the appearance of a tiny cadaver. The painter may have drawn the idea of a raptor sitting in a tree in a heraldic pose from his father's drawing (96v in the London sketchbook).

Beyond the principal theme, Giovanni here takes special interest not only in the buildings in the background but even more in the presentations of agricultural life, with the cows in a field watched over by the resting shepherd, the peasant woman, almost a Berber, wrapped in white robes under the reflection of a sun that, were it not for the still bare trees, would make one think of a hot summer afternoon and not, as Robertson notes, an early spring day, which is the season in which the Passion of Christ is renewed. The artist's attention is highly concentrated on the drapery of Mary's robes; in fact, she does not exist as a figure except for her head, neck, and arms. The way of rendering folds, perhaps influenced by northern European artists, shows up in a similar but not identical way in the works of Giorgione and also shows up, in particular, in other late works by Giovanni: the *Donà dalle Rose Pietà,* the lost *San Cristoforo della Pace Triptych* (cat. 105), *The Continence of Scipio*

THE MADONNA OF
THE MEADOW
National Gallery, London
(cat. 102)

162

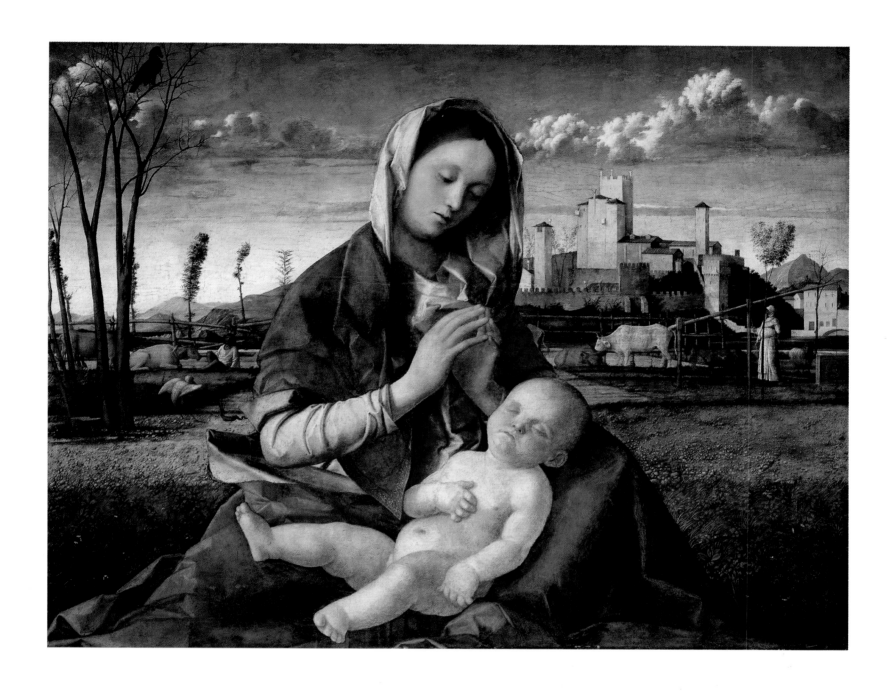

(cat. 110), the *Saint Mark's Sermon in Alexandria* (cat. 113), *The Feast of the Gods* (cat. 120), and *The Drunkenness of Noah* (cat. 125). Despite the opinion presented by Huse, it is not so similar in the *Judith* by Giorgione.

The theme of the Madonna of the Meadow, which Lattanzio da Rimini repeated in a painting in the Kress collection today in the Snite Museum of Art of the University of Notre Dame in Indiana (no. 61.47.5), shows up in works by Pietro degli Ingannati, Vincenzo Catena, and Marco Bello.

DONÀ DALLE ROSE PIETÀ

Panel, 25⅝ × 34¼ in. (65 × 87 cm)

Gallerie dell'Accademia, Venice, cat. no. 883

Signed IOANNES/BELLINVS on the rock to the left. From the Michiel collection this work passed in inheritance to the Martinengo collection and then to the Donà dalle Rose family; it entered the collection of Venice's Accademia in 1934. It was poorly restored by Luigi Tagliapietra in 1884 on a commission from Leopoldo Martinengo; in 1953, Pellicioli made efforts to remove the repainting from the figures.

L. Venturi (1907) ascribed this panel to the workshop of Giovanni Bellini and Berenson (1919) originally agreed; it was restored to the master by von Hadeln (1922), who dated it to the period of the Vicenza *Baptism* (cat. 100), a dating that is fully acceptable because of the views of Vicenza in the background and because of shared stylistic characteristics. Berenson (1932) and Dussler (1935) expressed hesitation, which they overcame in more recent editions (1957 and 1949), while van Marle (1935) opted for Basaiti; following Gronau (1926, 1928–29, 1930), all scholars have supported the autograph status of the painting.

Several of the most important buildings in Vicenza can be identified in the background: the Palazzo della Ragione in its Gothic form, not yet changed by Palladio into his Basilica, its tower, and the Cathedral; Moschini Marconi (1955) also noted the presence of two buildings from Ravenna, San Vitale and the bell tower of Sant'Apollinare in Classe. Mutinelli (1958) claimed to recognize the landscape to the right not as Monte Berico but as Cividale del Friuli, but as of yet this proposal has elicited no supporting comments.

In this work, Bellini presents the theme of the Pietà in the iconographic form of a *Vesperbild,* which was not really so very unusual in northern Italy, as Pallucchini (1949) proved, given the *Pietà* by Ercole de' Roberti, today in the Walker Art Gallery in Liverpool, and the *Pietà* by Cosimo Tura today in the Museo Civico Correr in Venice. The motif is characteristic of late Gothic German sculpture, examples of which can be found both in the Venetian region and in areas along the Adriatic coast all the way down to Molise; it seems needless to cite here the *Pietà* by Michelangelo in Saint Peter's, which preceded Giovanni's panel by only a few years. As Robertson (1968) notes, Bellini did not follow Michelangelo's example in portraying the mother of Christ as a young woman.

According to Arslan (1956), if the painting, as seems probable, was made in Vicenza or for a patron in Vicenza, Giovanni or the patron may have drawn inspiration from the presence in the Marian sanctuary of Monte Berico of three *Vesperbilder,* one sculpture and two paintings made by Bartolomeo Montagna. We can state with certainty that this composition is extremely similar to that of *The Madonna of the Meadow* (cat. 102), characterized by the pyramidal shape of the group, the great attention the artist gives to his rendering of the landscape, and the fact that the body of Mary is almost exclusively identified by the folds of robes in which she is wrapped; in these notations we agree with Robertson, Huse (1972), and Ruggeri Augusti (1978). Nor should it be forgotten that the two paintings are almost identical in size.

The *Donà dalle Rose Pietà* belongs to that group of late works that Robertson sees as having been particularly influenced by Dürer, as indicated by a certain sharpness in the treatment of fabrics; this is a figurative language with which Giovanni expressed himself in some of his works from 1500 on but that cannot be limited to any restricted chronological period, since it shows up in works from the beginning of the century to *The Feast of the Gods* (cat. 120), dated 1514.

Unlike the situation in *The Madonna of the Meadow,* in which the figure of the adoring Mary appears cut out against the landscape background without seeming to occupy any precise area, here the figures are located inside the nature that surrounds them, although, according to Huse, the area in direct contact with the Mother and Son seems barren and lifeless, almost as though through contagion

DONÀ DALLE ROSE PIETÀ
Gallerie dell'Accademia, Venice
(cat. 103)

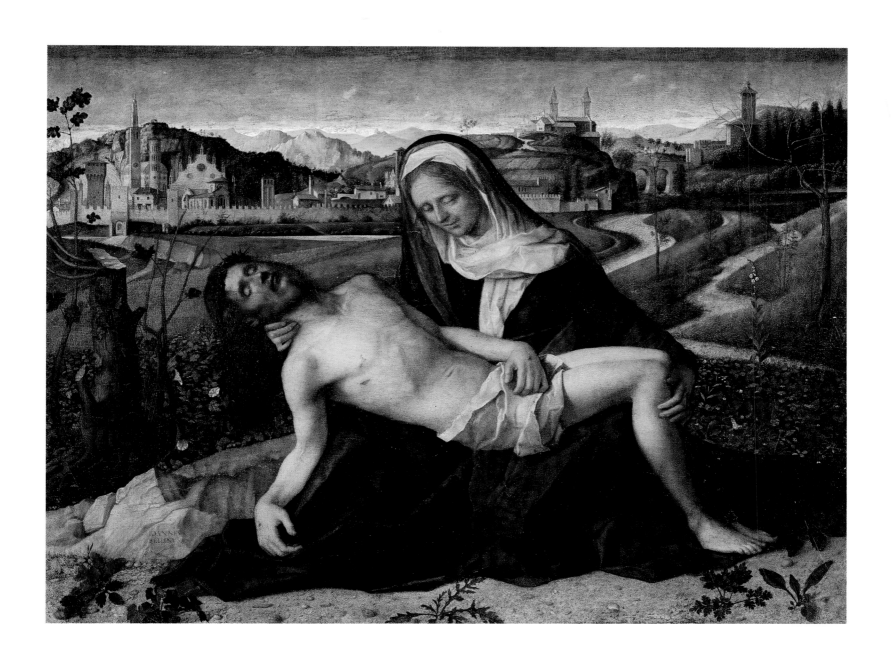

with the mournful event; the landscape in the distance seems suitable for human life but such life cannot be perceived, meaning, we would say, that the Resurrection will signal the beginning of a new era for humanity.

As in *The Madonna of the Meadow,* the pure colors, with contrasting tonalities, of Mary's robes contribute to the sense of detachment between the foreground and the background view, which is chromatically far more blended, moving from the silent fields to the city, whose buildings stand out against the wooded hillside, and then shading off to the distant mountains and the sky with its remnants of twilight that contrast with the early darkness of the foreground.

This painting was displayed as no. 115 in the 1949 Venice exhibition.

DONÀ DALLE ROSE PIETÀ
Detail
Gallerie dell'Accademia, Venice
(cat. 103)

SAN ZACCARIA ALTARPIECE

Canvas (transferred from panel), 195 × 92½ in. (500 × 235 cm)
Church of San Zaccaria, Venice

Signed and dated IOANNES BELLINVS/MCCCCCV. This was originally made for the San Girolamo altar, the exact location of which is not known, but it must have been on the same side of the church, the left, on which the altarpiece is located today.

Huse (1972) refuted the idea, repeated by various earlier scholars on the basis of Pallucchini (1949 and 1959), that this work had been commissioned in memory of Pietro Cappello, for whom in reality the *Presentation of Jesus in the Temple,* today in one of the chapels of the apsidal ambulatory, was made. Derived from the composition by Giovanni Bellini (cf. cat. 78), that work is universally attributed to Francesco di Simione da Santacroce; Heinemann (1962) used it to construct the figure of a "maestro."

The painting has been cut off at the bottom, where three more rows of tiles were once visible on the floor and made the figures appear in a deeper spatial opening; at the top, the arching has been eliminated, but in order to fit the altarpiece to its current altar, a strip that was removed during the 1976 restoration was added; that operation has philologically restored the only original surface still visible, although it must be said that the two panels located above and below to fill out the frame give a very unpleasant effect. As is also the case with the *San Giobbe Altarpiece* (cat. 58), the relationship between the Lombardo-style painted architecture and the real architecture of the altar has been lost, and the two must have matched originally.

The painting was stolen by Napoleon's army and taken to Paris, where it was transferred from its original panels to canvas. It was brought back in 1815 and was then restored in 1835. It has suffered in particular in the face of Mary and in the Child, which today seem crudely drawn, having lost a part of the velature, and pentimenti appear in the heads of the saints. The altarpiece was highly praised by Vasari (1550 and 1568) and is cited by Sansovino (1981), Ridolfi (1648), Boschini (1674), and A. M. Zanetti (1771). The autograph status of this masterpiece has never been questioned.

As in the *San Giobbe Altarpiece,* the painter locates the Sacra Conversazione in a painted apse "opened" in the wall of the church, but this time it is open on the sides, offering views of two strips of landscape that are wider than those in *The Frari Triptych* (cat. 67) and are made with the usual, highly detailed precision. In the opening to the left is a Christological fig tree, and to the right is a bush and a tree, perhaps an acacia. The saints flanking the throne of Mary are Peter, Catherine of Alexandria, Lucy, and Jerome. The Saint Jerome offered inspiration to Lorenzo Lotto in the immediately later altarpiece of Santa Cristina in Tiverone (Treviso) and to Giorgione for one of his so-called *Three Philosophers* in the Kunsthistorisches Museum in Vienna (no. 111), while the Saint Peter, with his absorbed expression, common to all the figures on this altarpiece, served as a model for the biblical king in the Giorgionesque *Judgment of Solomon* by Sebastiano del Piombo, formerly in Kingston Lacy and today the property of the National Trust in London. A lone angel plays a *lira da braccio* at the foot of the throne, but does so without seeming to disturb the suspended silence that pervades the scene. Hanging from above, in the shadowy area that is not brightened by its gold mosaic, is a typical Venetian chandelier of Byzantine styling, and above that is an ostrich egg, symbol of the virginal maternity of Mary, as in the Urbino altarpiece, today in the Brera, by Piero della Francesca. Reducing the participants to four saints and a single angel gives the painting a sense of increased spaciousness, which is increased by the light that enters on the sides, although the true light source is to the left of the viewer, as if it came in by way of the church's door.

Although there is no supporting documentary evidence, and we certainly cannot consider the Castelfranco altarpiece an earlier work than this, Giovanni must have already been under the influence of his former student Giorgione when he made this painting, which seems so closely related to that artist's

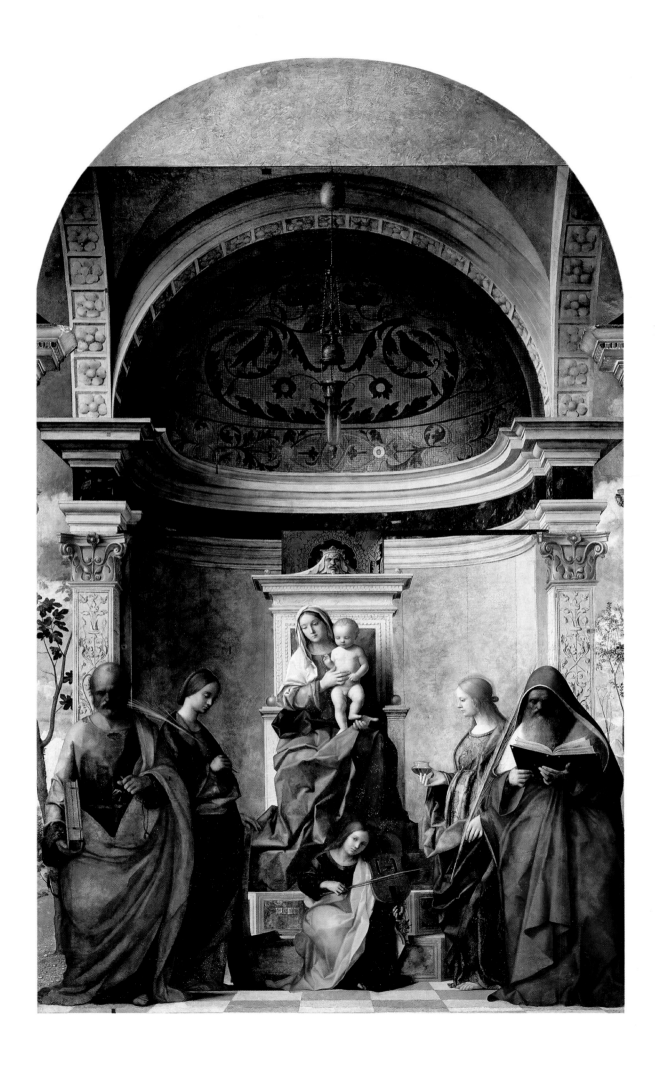

poetics. This is the first great altarpiece of the new century, and it preserves the traditional compositional layout, but in reality it is constructed on the basis of new relationships among volumes, which are no longer forced into precise, abstract fifteenth-century outlines but are instead fashioned of a natural light that blends and harmonizes the whole. This is the new figurative lexicon, which was spreading among the centers of northern and central Italy and which numbered among its fathers, aside from Venetian masters, Leonardo, Raphael, and Michelangelo. Carved at the top of the throne is the head of a king, which Goffen (1989) convincingly suggests should be taken as David, founder of the family line of Mary.

The Madonna in the *San Zaccaria Altarpiece* was often repeated by students of Giovanni Bellini: in particular, Francesco Bissolo, Girolamo da Santacroce, and, in his only altarpiece, Domenico Mancini, in the parish church of Lendinara (Rovigo); furthermore, it often shows up as a half-length figure flanked by the two side figures of the *San Cristoforo della Pace Triptych* (cat. 105). The Saint Catherine appears in several of the versions of the Presentation in the Temple already cited.

According to Robertson (1968), the stylistic characteristics of this altarpiece could justify attribution to Giovanni of the so-called *Three Ages of Man* in the Galleria Palatina of Florence, a proposal made by Longhi (1927); Berenson (1932) used that painting as the basis for his Master of the Three Ages of Man, and today it is usually assigned to Giorgione, although without any historical support.

The *San Zaccaria Altarpiece* was displayed as no. 116 in the 1949 Venice exhibition, and on that occasion it was cleaned by Pellicioli.

SAN ZACCARIA ALTARPIECE
Detail
Church of San Zaccaria, Venice
(cat. 106)

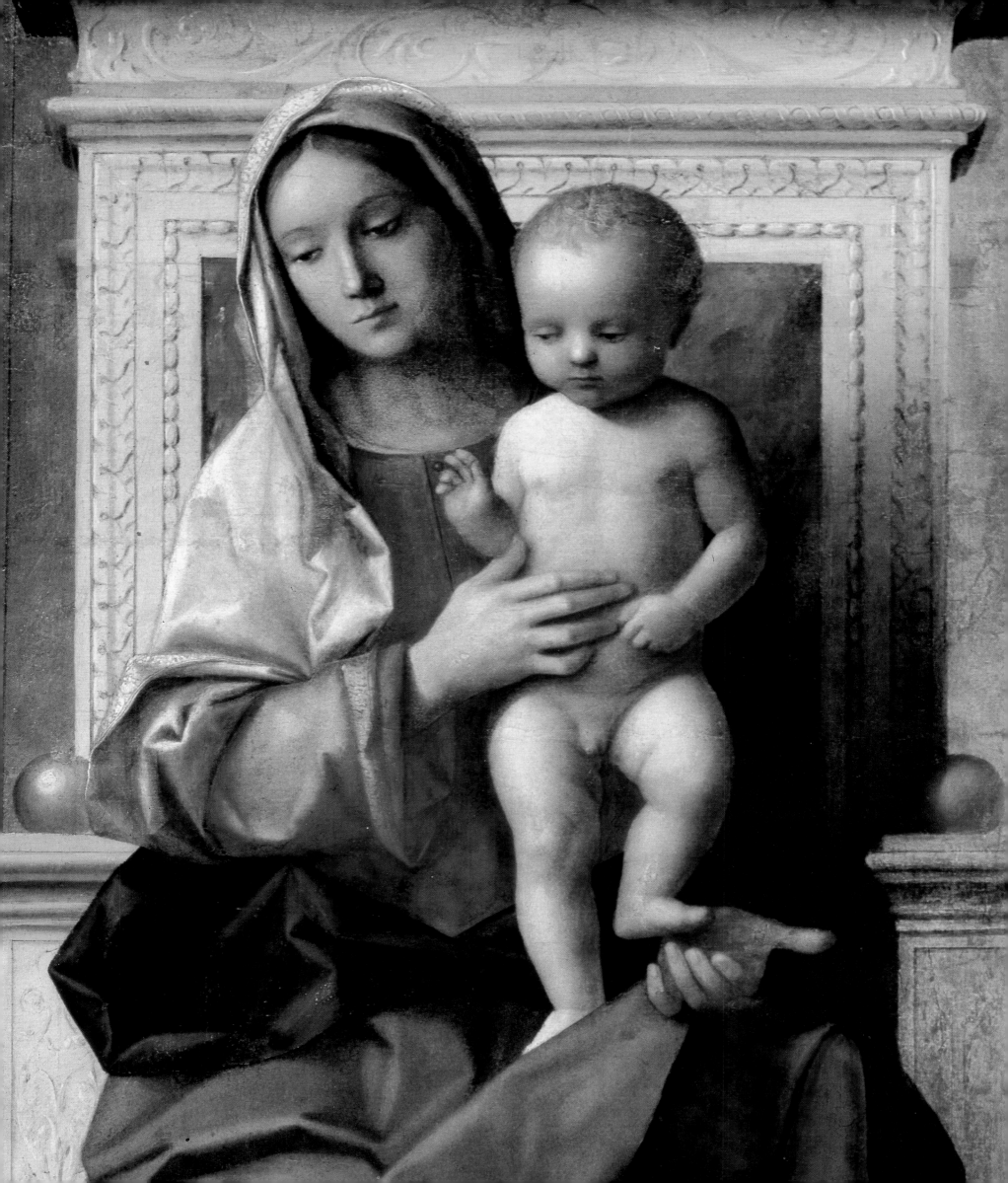

THE KILLING OF SAINT PETER MARTYR

Panel, 39⅜ × 65 in. (100 × 165 cm)
National Gallery, London, no. 812

Charles Eastlake bought this painting in the study of the painter Natale Schiavone in Venice in 1854. The cartellino attached to the fence in the foreground to the right bears the signature "Joannes/ Bellinvs/p.," which is barely legible and considered apocryphal by Davies (1961). The scene is the murder of the Dominican saint by the heretic Pietro da Balsamo, called Carino, while the blessed confratello Domenico tries to escape assault by another murderer, against a background of a forest animated by the activity of woodcutters whose motions repeat those of the assassins. To the left the landscape opens onto fields, with scenes of country life and a city and hills in the distance beneath a sky partly covered by clouds.

Since Crowe and Cavalcaselle (1871), the autograph status of this painting has been generally accepted by critics. Berenson originally (1897) thought it was the work of Rocco Marconi, but he later (1932 and 1957) decided on Giovanni, while Jacobsen (1901) attributed it to Marco Basaiti, followed in this by van Marle (1935). Dussler first (1935) thought it was a workshop product based on a drawing by Bellini, but he later (1949) accepted a partial autograph status. Pallucchini (1959) attributed it to Giovanni, but thought it had been made later than the variant version in the Lee of Fareham collection at the Courtauld Institute in London (panel, 26½ × 39¾ in.; 67.5 × 101 cm), which in his opinion was also an autograph work by Giovanni. According to all other scholars, this last version, which once bore the date 1509 on its reverse, is instead later than the panel in the National Gallery, the dating of which is moved a few years back. Personally, we do not think it necessary to hypothesize that Lorenzo Lotto drew inspiration from it in 1504 for his *Bridgewater House Madonna,* today in the National Gallery of Scotland in Edinburgh, as proposed by Gronau (1930) and Robertson (1968); Robertson attributes the Lee of Fareham version to Andrea Previtali, which was made known as a work by Giovanni by Borenius (1923). He is right in stating that the painting in the National Gallery has been cut off to the left, where one sees only the hind portion of a grazing cow. Following the restoration of both panels, in particular the work in the Courtauld Institute in 1985, it became possible to reach a more precise opinion. We find the conclusions of Fletcher and Skipsey (1991) convincing: according to them the Lee of Fareham version is later, most of all because pentimenti appear in X-ray examination of the version in the National Gallery, whereas the figures in the other work, although larger in scale in relation to the landscape, correspond exactly to the final rendering as given in the National Gallery version.

We know nothing of the patron: certainly neither of the two paintings was made for the Dominican church of Santi Giovanni e Paolo, in which the altar dedicated to Saint Peter Martyr was occupied by an altarpiece by Jacobello del Fiore that was later replaced with one by Titian. Fletcher and Skipsey thought the Lee of Fareham panel had had a church patron, since a greyhound appears in it, probably an allusion to the Dominican "Domini canes," just as the flowering buttercup in front of the figure of the saint being struck down would be a *flos martirum;* the painting would have had a private, secular patron, whose coat of arms is reproduced on the shield of the warrior to the left, a figure added later, as revealed by analyses to which the painting has been subjected. If the date 1509 is believable, the first recipient could have been the church of San Pietro Martire on Murano, which was reopened to worship in that same year following a fire that had devastated it in 1474, and the prior of which, until 1508, had been Bartolomeo d'Alzano, editor of the Aldine edition of the letters of Saint Catherine of Siena. Fletcher and Skipsey move forward the date of the painting in the National Gallery to 1507–8 and theorize that the author of the Lee painting may have been Vittore Belliniano, the artist who was Giovanni Bellini's primary collaborator after 1507.

THE KILLING OF
SAINT PETER MARTYR
National Gallery, London
(cat. 109)

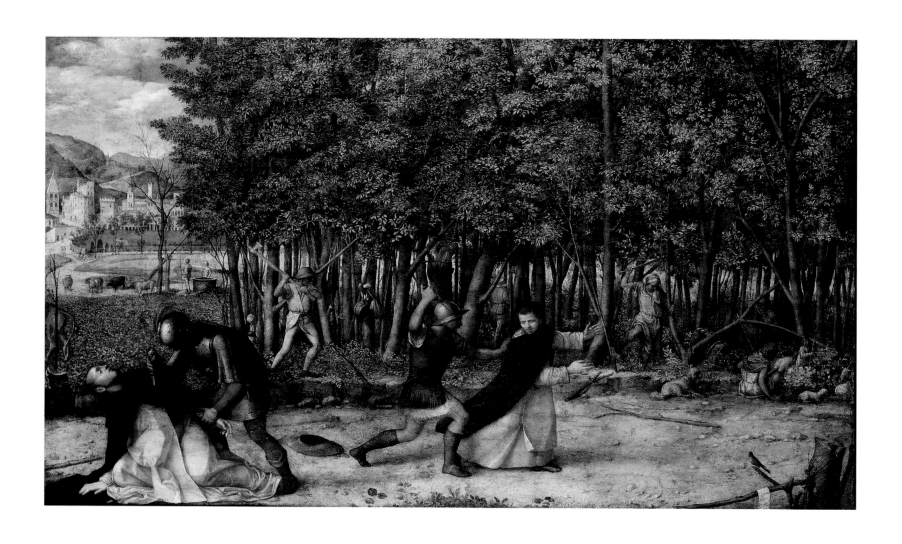

Therefore, the work in the National Gallery is an autograph creation by the master, made shortly after 1505. It is powerfully evocative because of the way it tempers the bloody drama by placing it against the poetry of the landscape, with the dense, shadowy woods that anticipate the highly original background of *The Feast of the Gods* (cat. 120). The version in the Courtauld Institute is a variant, based on the prototype by the master, characterized by the larger size of the figures, the richness of its lifelike objects, such as the prayer book and the armor, and the background landscape in which the woods open not to the left but rather in the central zone to reveal a distant city and the sky. The different proportional relationships used in this version make the bloody act stand out more against the surrounding area, which does not achieve the poetic levels of the autograph painting, but which shows the unmistakable stylistic traits of Andrea Previtali, to whom it must be restored, confirming Robertson's proposal.

THE KILLING OF
SAINT PETER MARTYR
Detail: THE BLESSED
DOMINIC
National Gallery, London
(cat. 109)

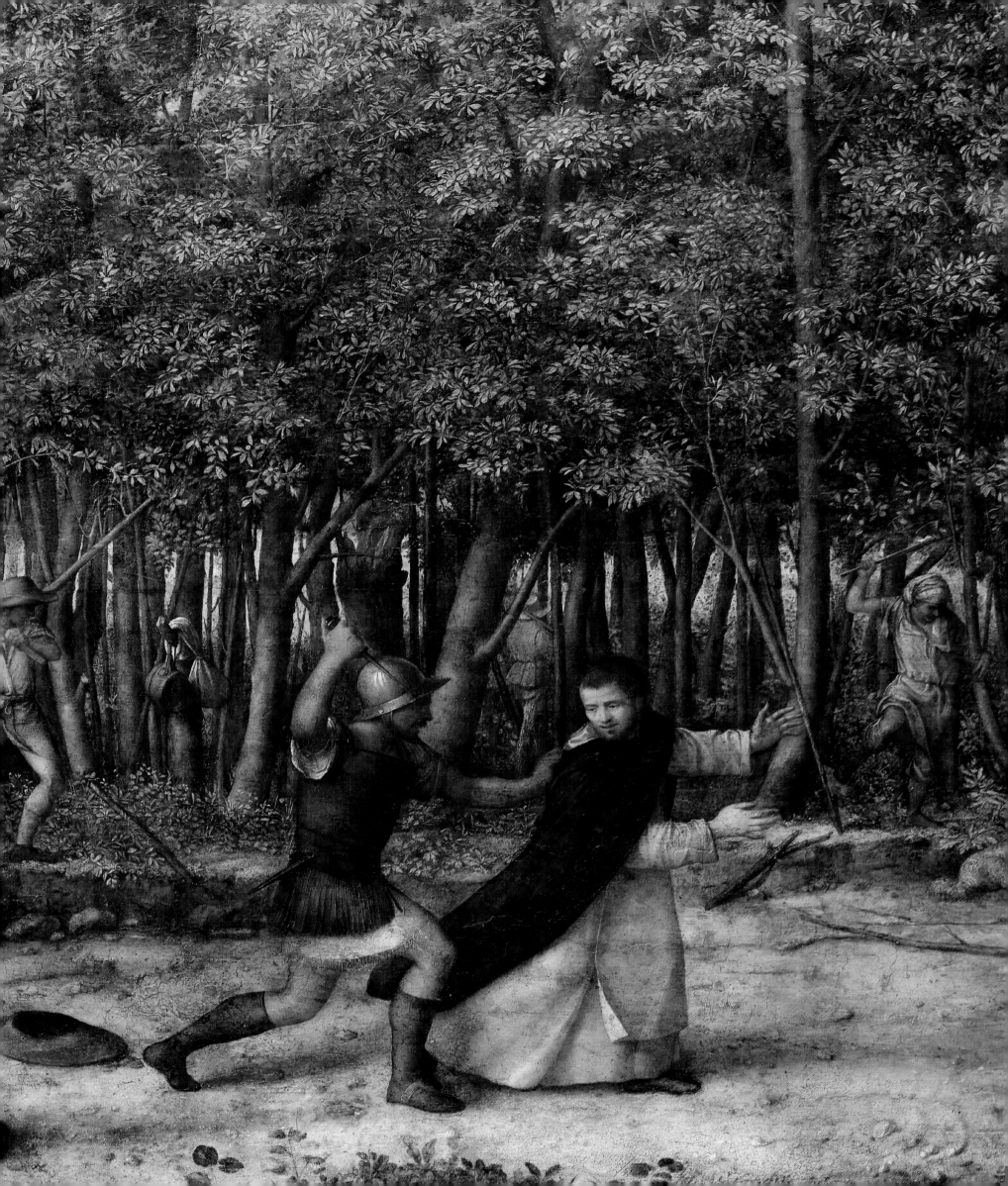

VIRGIN WITH THE BLESSING CHILD

Canvas (transferred from panel), 33½ × 45¼ in. (85 × 115 cm)

Pinacoteca di Brera, Milan, no. 193

Signed and dated IOANNES/BELLINVS/MDX. As Humfrey (1990) indicates, this is probably the *Virgin* that was in the Monti palace in Bologna in 1769. From the gallery of Giacomo Sannazzari it was bequeathed in 1804 to the Ospedale Maggiore of Milan, which sold it to the viceroy government in 1806 for the Accademia of Brera. Crowe and Cavalcaselle (1871) confirmed it as an autograph work by Bellini, an attribution followed by all later scholars with the exception of Ricci (1907), who judged it a workshop product, in large part attributable to the hand of Francesco Bissolo, and L. Venturi (1907), who attributed it to Rocco Marconi. As Goffen (1989) points out, the green silk fabric with a red border hanging behind the group is similar to that behind *The Madonna of the Young Trees* (cat. 65); however, in this painting, which has a horizontal structure and in which the figures are almost full and are directly inserted in the landscape, the hanging also constitutes the only purely symbolic element and alludes to the traditional throne, since in reality we cannot see where Mary is seated, as she holds the child standing on her left knee.

Giovanni must have already made compositions of this type earlier, and a version very similar to the one in the Brera is in the Detroit Institute of Art (panel, 32⅝ × 41 in.; 83 × 104 cm; no. 28.115), signed and dated IOANNES BELLINVS/MDVIIII. The signature and date on this painting, which appear on a book, were brought to light following restoration work performed in 1928, when the painting entered the institute. Crowe and Cavalcaselle saw the painting when it was still completely repainted; Heil (1929) and Valentiner (1929) made it known following the cleaning. The attribution to Giovanni has been accepted by all later scholars with the exception of Dussler (1935), who in his second edition (1949) changes his mind; in Goffen's opinion, it is the fruit of a collaboration with students, and Robertson (1968) sees it as a workshop product, while Huse (1972) attributes to Giovanni only the outline, pointing out that the painting reveals a painting style from the 1480s, justifiable only in a student. We agree in judging this work to be a repetition of an idea provided by the master but made by an assistant, perhaps Rocco Marconi.

The chromatic material in the painting in the Brera is particularly rich and vibrant, and the level of quality is generally very high, the exceptions being the head of Mary, most of all in the white veil, and the figure of the Child, the execution of which seems tired. As has been often seen in earlier works, Giovanni here seems to have dedicated much of his effort to the landscape, which is rendered with highly subtle glazing and with such poetry that it makes us accept the obvious incongruity of the rickety bridge to the right—another memory of folio 58v of the London sketchbook by Jacopo Bellini—seeming to support all the terrain above it, including the tree with its branches smeared with birdlime and its tethered bird decoy, which Robertson identifies as a symbolic *Muscipula Diaboli,* the trap set for the Devil and baited with the flesh of Christ. We cannot agree with Robertson's interpretation of the quadruped crouched at the classical pedestal bearing the signature and date: this is not a little monkey, as he claims, nor is it a spotted cat, as Goffen suggests, but is instead a leopard repeated from folio 89v of the London sketchbook by Jacopo; evidently, three years after inheriting his father's sketches from his brother Gentile, Giovanni had meditated on them in a process of recuperation of his own origins typical of advanced age. Beyond all meanings, the stupendous landscape comes alive in its evocation of an early morning atmosphere, an hour that explains the sleeping shepherd and his flock.

VIRGIN WITH THE
BLESSING CHILD
Pinacoteca di Brera, Milan
(cat. 117)

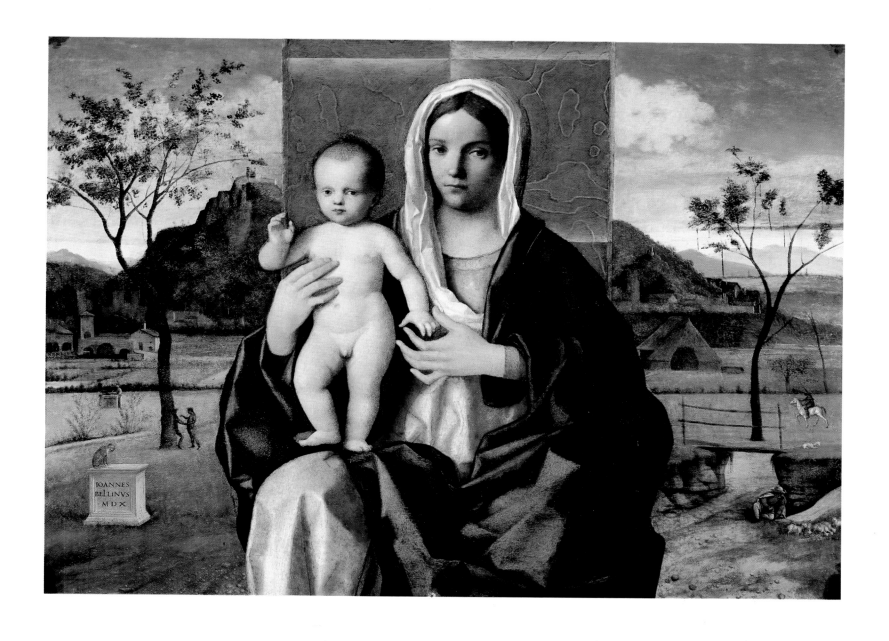

SAN GIOVANNI CRISOSTOMO ALTARPIECE

Panel, 117 × 72⅞ in. (300 × 185 cm)

Church of San Giovanni Crisostomo, Venice

Signed and dated MDXIII/IOANNES/•BELLINVS•P. The work still stands on the altar for which it was painted in the right chapel of the small Greek-cross church.

The altarpiece presents Saints Christopher, Jerome, and Louis of Toulouse. It was commissioned as a result of the will of the merchant Giorgio Diletti, drawn up on June 13, 1494, that provided for the erection of the chapel in the church, which had just been rebuilt following a devastating fire. The principal advocate was the parish priest Ludovico Talenti, who served from 1480 to 1516. Diletti died in 1503, and the financing he left was insured in 1509 by his widow, Ursia, who lived until 1511, to the Scuola Grande di San Marco, owner of the chapel, which, probably only in 1509, commissioned the execution of the altarpiece from its illustrious member Giovanni Bellini.

As a result of an erroneous transcription of the seventeenth-century copy of Diletti's will, as printed by Paoletti (1893), the saint on the left was believed to be John Chrysostom, which would have been in keeping with the wishes expressed by Diletti; he is also the titular saint of the church to whom is dedicated the main altarpiece, made by Sebastiano del Piombo in 1510-11.

In reality, as proven by Lattanzi (1985), the saint is indicated in the will as Christopher, as can be seen in two other versions of the will, an eighteenth-century printed copy today in the holdings of the Scuola Grande di San Marco in the Archivio di Stato of Venice, and a manuscript copy, made in 1516 by the patriarchal secretary, in the parish archives of San Canciano, also in Venice. The figure dressed as a bishop, indicated in the will as Louis of Toulouse, was later transformed into Saint Augustine by writing *De civitate Dei* (The City of God) on the book he holds with his left hand. But he is young, as would be suitable for the son of Charles II of Anjou, and bears on his cope not the lilies of France—although seen by both Ruggeri Augusti (1978) and Coltellacci and Lattanzi (1985)—but rather the image of Saint Francis, that is, the founder of the monastic order to which the French bishop belonged. The title of the book is written upside down and not, as Goffen (1989) thought, on the back of the book, for the location of the book's spine is visible. The saint is indicated as Augustine by Pallucchini (1949 and 1959) and by Berenson (1957), while Robertson (1968) says that at least originally it was Louis, according to the identification accepted by other scholars. The hermit saint in the center is usually taken to be Jerome, but Gamba (1937) and Heinemann (1962) see him as John the Evangelist, while Dussler (1949) opts for Jerome, but with doubts. According to Robertson, it is Saint Jerome, although he also noted that the Greek writing on the inside of the arch, which reproduces the second verse of Psalm 13 (14 in the King James version: "God looked down from Heaven upon the children of men to see if there were any that did understand and seek God"), seems to be an allusion to Saint John Chrysostom, author of homilies on the Psalms. Robertson also held that the altarpiece originally must have had an arched frame and that the painted architecture matched that of the altar, following a practice employed in other works by Giovanni Bellini (cf. cat. 58 and 106).

The central zone of the painting, in which the staff of Christopher, the crosier of Louis, and the figure of Jerome form an arch, was covered over in 1733 when a statue of Saint Anne was set against it and nailed to the panel; it was removed through the efforts of the Scuola Grande di San Marco only to be replaced by a statue of Saint Anthony that was still there at the time of Moschini (1815), as recalls Ruggeri Augusti. The altarpiece was cleaned in 1826 and 1940, and it was restored in 1976. Unfortunately, even today church authorities neglect its care: Goffen is right in seeing potential dangers in the numerous candles lit before a venerated image a few yards away. Despite the opacity of the robes of Saint Christopher, which have lost their original coloring, and the fact that the pilasters have been abraded

SAN GIOVANNI CRISOSTOMO ALTARPIECE
Church of San Giovanni Crisostomo, Venice
(cat. 119)

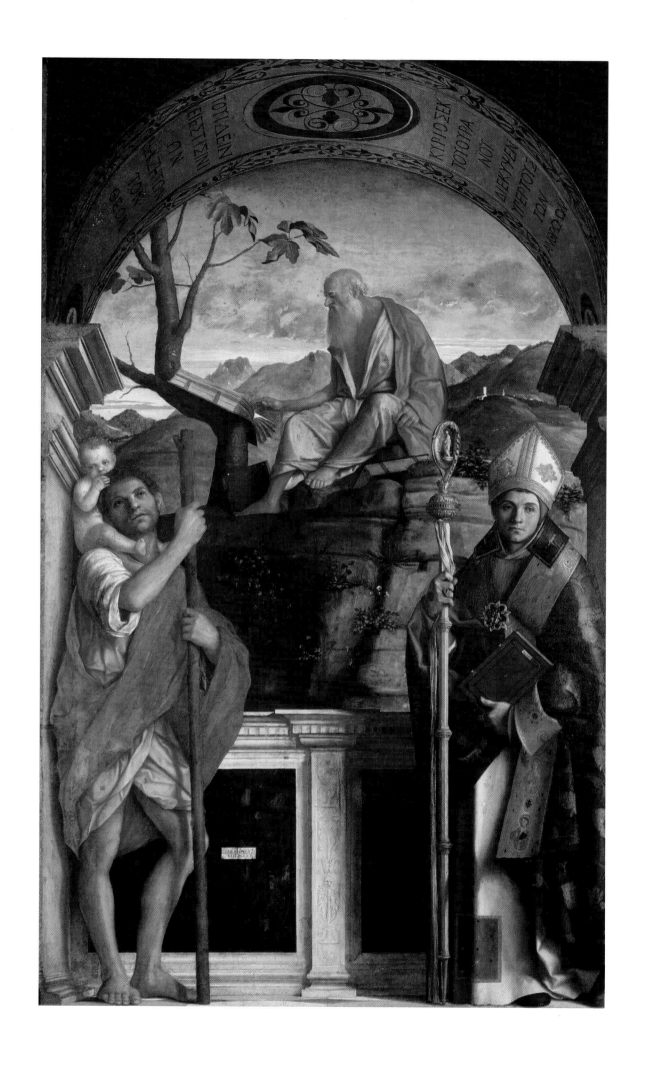

to show the wood both at the base and at the level of the frames, the painting still looks splendid, its colors so rich and warm that van Marle (1935) hypothesized the collaboration of Titian. Particularly fascinating is the damasked cope of Saint Louis, dark green and gold with red borders, which is very similar to one presented in the group of eight saints in the *Immaculate Conception* altarpiece on Murano (cat. 115); his crosier seems to reproduce that of the Primicerius, today in the Tesoro of San Marco, as it appeared before the changes that later partly altered it (Tempestini, 1992, *Oreficeria*); the decoration of the vault recalls the *San Giobbe Altarpiece* (cat. 58). As many scholars indicate, the figure of Saint Jerome closely recalls that of the figure in Washington, D.C. (cat. 107); Coltellacci and Lattanzi claim that the colors of his robes are the same as those of the vestments worn by priests in the celebration of Pentecost, which marks the descent of the Holy Spirit, and would indicate that his ascent marks a route toward resurrection: the two scholars also point out that the Greek writing, aside from relating to the text in the book of Saint John Chrysostom on the church's high altar and also matching the layout of the Greek-cross church, may also be related to the Greek edition of the psalter printed in Venice by Aldo Manuzio between 1496 and 1498.

The arrangement using a central saint presented in profile is perhaps an echo of the altarpiece by Sebastiano del Piombo, but the concept is quite different, since in Giovanni's painting two completely distinct spaces are created, one for the hermit on his rock, near the symbolic fig tree and against the sky, and one for the two saints in the foreground, emblems of an active apostolate in contrast with the contemplative, meditative life; there is probably an allusion to the events of Vincenzo Querini and Tomaso Giustinian, who retired to Camaldoli, and to the need to call the faithful to action following the defeat at Agnadello, which took place in the same 1509 in which the altarpiece was commissioned; in this we agree again with Coltellacci and Lattanzi.

This painting was displayed as no. 125 in the 1949 Venice exhibition.

SAN GIOVANNI
CRISOSTOMO ALTARPIECE
Detail: SAINT CHRISTOPHER
Church of San Giovanni
Crisostomo, Venice
(cat. 119)

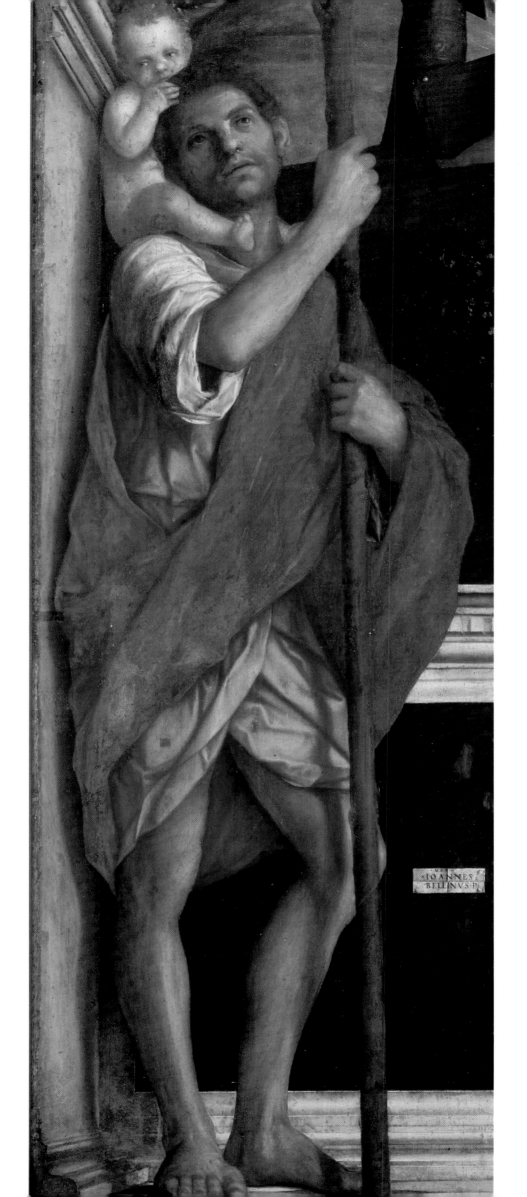

183

THE FEAST OF THE GODS

Canvas, 67 × 74 in. (170.2 × 188 cm)
Widener Collection, National Gallery of Art,
Washington, D.C., no. 597

Signed and dated on the basket at bottom right, "ionnes bellinus venetus/p MDXIIII." This painting was made for the duke of Ferrara, Alfonso I d'Este, who wanted it for his alabaster *camerino* in the Castello Estense. Alfonso sent the final payment of eighty-five gold ducats on November 14, 1514. The painting, together with the *Offering to Venus,* the *Andrii,* the *Bacchus and Ariadne* by Titian, and a *Bacchanal of Men* by Dosso Dossi, of controversial identification, was moved in 1598 to Rome, where it was held in the Aldobrandini collection until 1797; it was then acquired by the painter Vincenzo Camuccini, who held it until his death in 1844. It passed in 1856 to Alnwick Castle, in the collection of the fourth duke of Northumberland. The seventh duke of Northumberland put it on sale in London in 1917; despite encouragement from Bernard and Mary Berenson, Isabella Stewart Gardner, deeply in debt as a result of war taxes, was unable to add it to her Boston collection. In 1922 it was acquired by Joseph Widener, who kept it in Philadelphia and donated it in 1942 to the National Gallery of Art. In 1956 the gallery's director, John Walker, published the results of X-ray examinations that revealed two partial reworkings, the second of which had been performed by Titian and dated to 1529. Scientific restoration began in 1985, and the results were made public by Bull (1990). The painting appeared as no. 19 in the Titian exhibition held in 1990 in Venice and Washington, D.C.

A painting that Giovanni left unfinished and Titian completed: so it had been reported by Vasari (1568) and so it was accepted by art scholarship until Walker, as indicated, published the findings of the X rays, although this version of events still shows up in Dussler (1949). From 1956 on we have known that the landscape in the background originally looked like the landscape in *The Killing of Saint Peter Martyr* in the National Gallery in London (cat. 109). Long-debated problems include the time of Titian's alterations, the identity of the person responsible for the first of the two transformations that the landscape has undergone, the theme presented in the painting, the paternity of the changes made to the figures of the gods, and the original destination of the canvas. Wind (1948) sought to identify the *Feast* as a painting Giovanni made for Isabella d'Este Gonzaga for her camerino in Mantua: in that work the painter, following a program suggested by Pietro Bembo, presented Alfonso I d'Este, his wife, Lucrezia Borgia, his brother Cardinal Ippolito d'Este, Bembo, and even himself. We agree with Robertson (1968) in refuting these identifications along with the hypothesis that the painting documents a capitulation in the face of Isabella's repeated requests for a painting on a mythological theme: aside from everything else, the measurements do not match those of the paintings from the camerino in Mantua, which are 4 inches (10 cm) shorter.

Except for the situation created in 1506 by the death of his brother-in-law, Andrea Mantegna, who had enjoyed a monopoly on mythological themes within the Bellini clan of artists, we do not know precisely what induced Giovanni to agree to make profane compositions that were neither portraits nor historical paintings during the last period of his life. It was clearly a deeply felt and gradual decision, as indicated by the fact that he himself reworked the first version of the *Feast,* changing what must have seemed to the patron too severe an assemblage by adding attributes to the gods, baring the breasts of several female figures, and inserting lascivious allusions, such as the activities of Neptune, who caresses Cybele with his right hand while his left is lost behind Cere's thighs. Recent analyses of the painting clearly indicate that the changes made to the first version were done by Bellini himself, but we do not know who made the first changes to the landscape on the left, where today a woody cliff appears against a blue sky crossed by white summery clouds: all that is the work of Titian, who made these

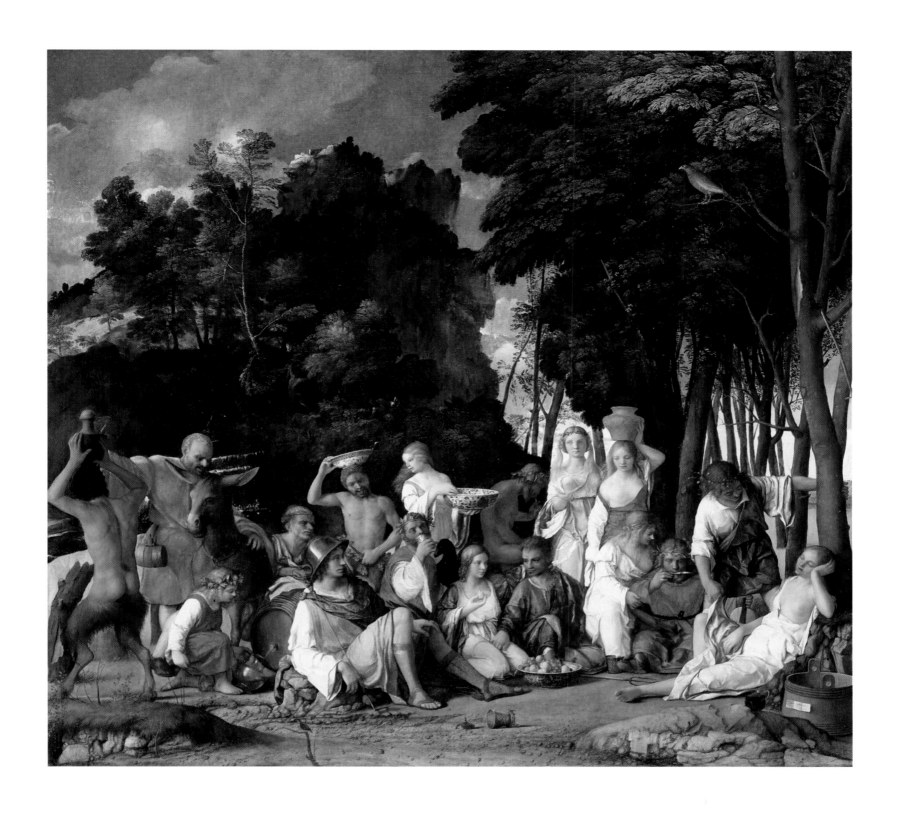

changes during the period when the Este camerino was being set up, also adding the three paintings he provided, two of which were substitutions for works commissioned from Fra Bartolomeo and Raphael. Today we are unable to either confirm or convincingly disprove the recurrent hypothesis according to which Dosso Dossi, author, as already indicated, of the last painting in the group, should be credited with making the first changes to the Bellini landscape. As Bull indicates, the pheasant on the branch at the upper right was part of this first group of changes, but many of the branches in that same area must be ascribed instead to Titian, also author of the figure of Sylvanus, behind the donkey, while Jupiter's white gown, which Huse (1972) assigned to Titian, has been ruined by clumsy restoration, as Bull points out. It seems probable that the first changes should be attributed to Dosso, if only because we find it hard to believe that Titian would have agreed to make two series of changes to a work by Giovanni, thus correcting himself. It seems more likely that he made his improvements following the first variations made by Dosso, court painter in Ferrara.

The subject of the painting is an episode from the myth of Priapus, not as narrated in the poem of that name by Bembo but following Ovid's version in his *Fasti*: Priapus, on the right, lifts the gown of the sleeping Lotos while all around the gods fall prey to the effects of wine; the braying of Silenus's donkey will prevent the Priapus from completing his lewd scheme. The painting seems to be an *unicum* in the catalog of Giovanni—although being a typical example of the exceptional qualitative level of his last works—in the figures, the draper with its Dürer-like sharpness, to use the definition used by Vasari and repeated by Robertson, in the minute details of the ground in the foreground, in the highly realistic objects, in the woods in the background to the right, in which sunlight shines between trunks, a light opposed to the light that illuminates the pagan scene, in keeping with that principle of double illumination that can be found in even the earliest works. Colantuono (1991), in his erudite article, clarifies the time of year—the month of January—in which the mythological episode takes place.

THE FEAST OF THE GODS
Detail
Widener Collection,
National Gallery of Art,
Washington, D.C.
(cat. 120)

NUDE WOMAN WITH A MIRROR

Panel, 24⅜ × 31⅛ in. (62 × 79 cm)
Kunsthistorisches Museum, Vienna, no. 97

Signed "Ioannes bellinus/faciebat M•D•X•V," this painting was in the collection of Grand Duke Leopold William, where it was recorded in 1659.

The attribution to Giovanni was confirmed by Crowe and Cavalcaselle (1871) and has been accepted by all scholars with the exception of Morelli (1897), who assigned it to Francesco Bissolo; van Marle (1935); Dussler (1949), according to whom Giovanni was responsible only for the invention; Heinemann (1962), who attributed the panel to the "Master of the Three Ages of Man," and Huse (1972), who shared Dussler's opinion.

A replica existed in the Contini Bonacossi collection, which, according to von Hadeln (Pallucchini, 1959) followed by Dussler, must have served as the model for the painting in Vienna. In reality, it was a model from Giovanni's workshop, as indicated by the pentimenti revealed by X rays, but its painted surface was not attributable to Giovanni but rather to a student whom Giovanni must have had make the work after designing it, and who can probably be identified as Girolamo da Santacroce, as we wrote in 1993 to the owner; the opinion was shared by Catarina Schmidt and Enrico Maria Dal Pozzolo, who published it (1993). The panel, formerly in the Contini Bonacossi collection, was exhibited by its then owner in the exhibition "Titian/Amor Sacro and Amor Profano" in Rome (1995) with an attribution to the "Workshop of Giovanni Bellini (Vincenzo Catena?)." Bottari (1963) gives the traditional identification of the female figure as the woman sung to by Bembo in his sonnet O *immagine mia celeste e pura*. Robertson (1968) and Pignatti (1969) point out the absolute absence of sensuality in this nude, which Robertson compared with the nymphs in *The Feast of the Gods* (cat. 120); evidently the painter, after his arguments with Isabella d'Este and following the consignment of the painting to Alfonso I, overcame the problem of profane themes, but even so he dealt with them in an extremely chaste way. According to Goffen (1989 and 1991), who provides an evocative reading of the painting, Giovanni presents an allegory of the sense of sight: we agree with her in emphasizing the refined beauty of the work, unfortunately in a bad state of preservation and not well restored in the past. The figure, whose left arm was damaged and poorly redrawn, stands out against the black background of the wall on which a mirror is suspended that reflects the back of her hair, while she studies her face in a smaller mirror that she holds in her right hand. Behind her is a window with a view toward a landscape with blue mountains in the distance, the light of sunset across a sky covered by clouds; on the windowsill is a clear vase half-full of clear water, but it does not contain flowers, as Goffen thought, but rather supports a small plate, perhaps also made of glass, on which rests a small sponge for the woman's ablutions, as reported to me orally by Catarina Schmidt and Petra Schäpers and already believed by Ludwig (1906), who called the object by its Venetian name, *sponzarol*.

The narrow strand of pearls in her hair need not necessarily evoke Venus, as Goffen proposes. The damask cloth wrapped around her hair is only one of several elements that seem to make this painting a precedent for the *Magdalene* by Caravaggio, today in the Galleria Doria Pamphilj in Rome.

NUDE WOMAN
WITH A MIRROR
Kunsthistorisches
Museum, Vienna
(cat. 122)

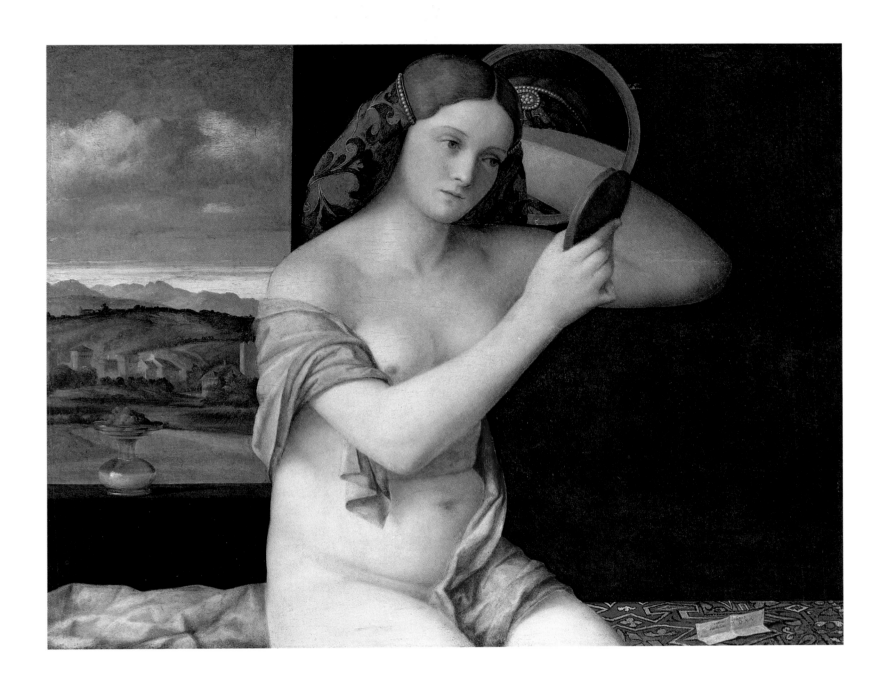

CATALOG OF WORKS

1. SAINT JEROME AND THE LION

Panel, 18¾ × 14 in. (48 × 35.8 cm)
Barber Institute of Fine Arts,
Birmingham, Great Britain

This small panel is signed—unusually, as Robertson (1968) also pointed out—in the cartellino in the middle at the bottom, IHOVANES BELINVS. It was accepted by Crowe and Cavalcaselle (1871) and unanimously by every Italian art historian, as well as by Berenson (1957), Robertson, Huse (1972), and Goffen (1989), as his first work, or among his first works; Gronau (1930) and Dussler (1935 and 1949) said nothing, and Heinemann (1962) attributed this to Lazzaro Bastiani.

Shown as no. 24 at the 1949 Venice exhibition.

See also the introductory essay.

1

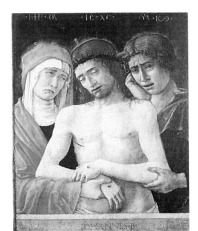

2

2. THE DEAD CHRIST SUPPORTED BY MARY AND SAINT JOHN EVANGELIST (PIETÀ)

Panel, 16 × 12½ in. (42 × 32 cm)
Galleria dell'Accademia Carrara,
Bergamo
No. 502 (formerly no. 174)

Signed IOHANNES · B · on the parapet. Unknown to Gamba (1937), omitted from the catalog of the 1949 Venice exhibition, and unmentioned by Belting (1985). Crowe and Cavalcaselle (1871) assigned it to Giovanni; Gronau (1930), who did not care for it, returned its authorship to him after Morelli (1897) had rejected it; Longhi (1949) confirmed it as being by Bellini with a date between 1450 and 1455; it was dated plausibly by Bottari (1963) to around 1455; Robertson (1968) believed that it immediately followed the Birmingham *Saint Jerome* (cat. 1). According to Berenson (1957), the work was only partly by him, but Pallucchini (1959) accepted it as an autograph work; Heinemann, who dated it to 1455–60; Pignatti (1969); Huse (1972); and Goffen (1989) accepted it; whereas Arslan (1936) considered it to be by Ferrara.

See also the introductory essay.

3

3. VIRGIN WITH THE CHILD IN HER ARMS (KALMAR MADONNA)

Panel, 30 × 21⅞ in. (78 × 56 cm)
Formerly Kalmar Collection,
Paris

Longhi brought this to public attention in 1946, when it was in the Fodor collection, and he dated it to 1465 or shortly after; it was exhibited as no. 4 in the 1949 Venice exhibition and immediately afterward restored by Mauro Pellicioli, who removed the repainted landscape, revealing the original one.

In his review of the exhibition (1949), Longhi moved the date of the panel back to around 1460. Bottari (1963) accepted this date, with reservations, but Pignatti (1969) plausibly placed it at the time of Andrea Mantegna's marriage to Giovanni's sister (1453), or, let's say, immediately after; Conti (1981) dated it to before 1460. Neither Berenson (1957), Robertson (1968), nor Goffen (1989) mentioned it. Heinemann (1962) assigned it to Lazzaro Bastiani. Dussler confirmed this in his second edition (1949) and emphasized the anomalous appearance of this Child within Giovanni's production, but also pointed out that

Mary's hands are in keeping with the works of the painter's youth; the "Donatellian" plasticism of the hands are in fact consistent with the first stages of the artist's activity. It is true that the Child in the *Kalmar Madonna* is unusual, but it is comparable to Jacopo's, while the landscape is very similar to those in Mantegna's style in the other early works.

4. THE VIRGIN ADORING THE SLEEPING CHILD (DAVIS MADONNA)

Panel, 28¼ × 18⅟₁₆ in.
(72.4 × 46.3 cm)
The Metropolitan Museum of Art,
New York
No. 30.95.256

This came into the museum's collection in 1915 with the Davis gift. When it was in the Fol collection in Rome, until 1890, it was assigned to Alvise Vivarini because of its obvious reference to an idea that came out of his circle, and it was borrowed by Quirizio and Andrea da Murano. After Richter (1894) recognized it as a work by Giovanni, all the scholars accepted it

4

as one of the young painter's first half-length Madonnas; Robertson (1968) and Goffen (1989), in fact, believed that it might actually be the first.

Dussler (1949) dated the work to 1460-65, while Heinemann (1962) went as late as 1465-70. Zeri suggested dating it to the early 1460s, or even earlier, an idea with which we agree.

Shown as no. 5 at the 1949 Venice exhibition.

See also the introductory essay.

5. CARITÀ TRIPTYCHS

(1) SAINT SEBASTIAN TRIPTYCH

Saint John the Baptist
Panel, 49½ × 18¾ in. (127 × 48 cm)

*Saint Sebastian;
Saint Anthony Abbot*
Panels, 40¹/₁₆ × 17½ in.
(103 × 45 cm) each

Lunette: *The Annunciation and the Blessing God the Father*
Panel, 23 × 66 in. (59 × 170 cm)

(2) SAINT LAWRENCE TRIPTYCH

*Saint John the Baptist;
Saint Lawrence*
Panels, 40¹/₁₆ × 17½ in.
(103 × 45 cm) each

Saint Anthony of Padua
Panel, 49½ × 18¾ in. (127 × 48)

Lunette: *The Virgin Between Two Flying Angels*
Three panels, 22 × 20 in. (57 × 51 cm);
25¼ × 27⅝ in. (65 × 71 cm);
23¹³/₁₆ × 25¾ in. (61 × 66 cm)

(3) NATIVITY TRIPTYCH

Saint Francis of Assisi
Panel, 49½ × 18¾ in. (127 × 48 cm)

Nativity of Christ and Annunciation to the Shepherds
Panel, 40⅛ × 17½ in. (103 × 45 cm)

Saint Victor
Panel, 49½ × 18¾ in. (127 × 48 cm)

Lunette: *The Trinity Between Saints Augustine and Dominic*
Panel, 23¼ × 64¾ in. (60 × 166 cm)

(4) TRIPTYCH OF THE VIRGIN

*Saint Jerome; The Virgin;
Saint Hubald*
Panels, 49½ × 18¾ in.
(127 × 48 cm) each

Lunette: *The Man of Sorrows Between Two Flying Angels*
Panel, 23¼ × 64¾ in. (60 × 166 cm)
*Gallerie dell'Accademia, Venice
Cat. nos. 621, 621a, b, c*

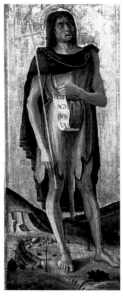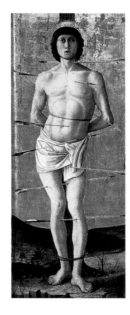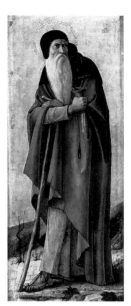

5 (1)

The historical sources tell us nothing about who painted these four triptychs, executed for as many chapels in the church of Santa Maria della Carità in Venice between 1460 and 1471. They were plausibly reconstructed, according to the report drawn up in 1807, when they were removed from their altars. Heinemann (1962) is the only modern scholar who completely disagreed with the present arrangement of the panels, which have lost their original frames.

If we were to work from the dimensions of the main panels, we would certainly be led to look for an alternative reconstruction because, if we consider the triptychs in the usual order, from the *Saint Sebastian* to the *Saint Lawrence*, from the *Nativity* to the *Virgin*, and count the twelve panels from left to right within their individual groups, we see, in fact, that panels 1, 6, 7, 9, 10, 11, and 12 are 49½ × 18¾ in. (127 × 48 cm), whereas numbers 2, 3, 4, 5, and 8 are 40¹/₁₆ × 17½ in. (103 × 45 cm). Hence, only the fourth triptych presents panels of the same size, whereas in the first the largest panel is on the left; in the second triptych, it is on the right; and in the third the smaller panel is between two larger ones. Yet, if we look more closely, we can easily

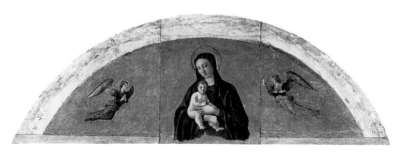

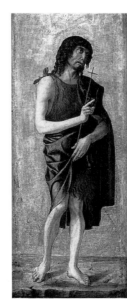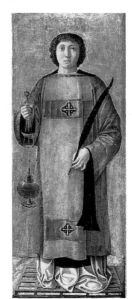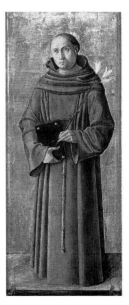

5 (2)

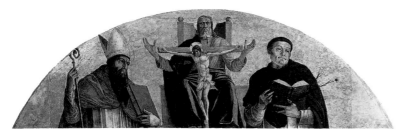

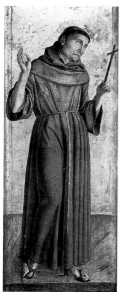

5 (3)

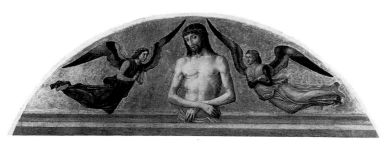

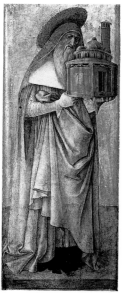
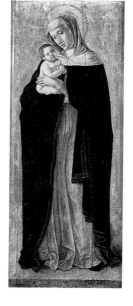
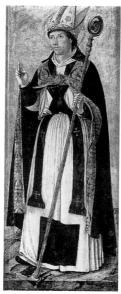

5 (4)

see that the *Saint Sebastian* and *Saint Lawrence* triptychs ought to remain as presently grouped, the former because of the landscape in the background, which extends uninterruptedly behind the three figures, and the latter because of the equally continuous flooring, upon which the three saints stand. One could perhaps exchange the two middle panels of the *Nativity* and *Virgin* triptychs, which is how they appeared in the 1949 Venice exhibition (where the triptychs were exhibited as nos. 6 through 21), since Saint Francis seems to be looking at Mary and the Child more than at the manger. One could also devise a different arrangement for the lunettes, for example placing *The Trinity* over the *Saint Sebastian Triptych* and *The Annunciation and the Blessing God the Father* over the *Nativity Triptych,* but there is not enough to justify such shifts. Thus, we can accept, hypothetically, the now-codified reconstruction as found in the catalog of the Gallerie dell'Accademia (Moschini Marconi, 1955) as well as in the many subsequent publications on Giovanni and Jacopo Bellini. We also refer readers to the catalog mentioned above for the adventures of the individual panels following Napoleon's suppression of the Scuola della Carità.

See also the introductory essay.

6. CHRIST WITH THE CROSS AND AN ANGEL WHO COLLECTS HIS BLOOD (THE BLOOD OF THE REDEEMER)

Panel, 18¼ × 13¼ in. (47 × 34 cm)
National Gallery, London
No. 1233

This panel, which the scholars unanimously consider autograph,

should be dated to the period when Giovanni was working on the *Carità Triptychs* (cat. 5) for the second time, because of the typological similarities and the comparable anatomical structure of Christ and certain saints, especially Saint Sebastian: this places us in the latter half of the 1460s.

Dussler (1935 and 1949), essentially followed by Goffen (1989), proposed 1460, while Heinemann (1962) suggested a date as late as 1470.

See also the introductory essay.

7. THE TRANSFIGURATION

Panel, 52¼ × 26½ in. (134 × 68 cm)
Museo Civico Correr, Venice
No. 27

This former door of the silver altarpiece for the high altar of the church of San Salvatore in Venice was still in that monastery in A. M. Zanetti's time (1733). It had traditionally been assigned to Andrea Mantegna, but Crowe and Cavalcaselle (1871) correctly attributed it to Giovanni Bellini, and their opinion was accepted by all later scholars. Cut off at the top before 1870, it originally had a

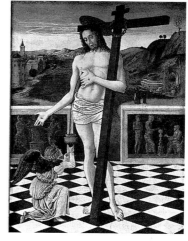

6

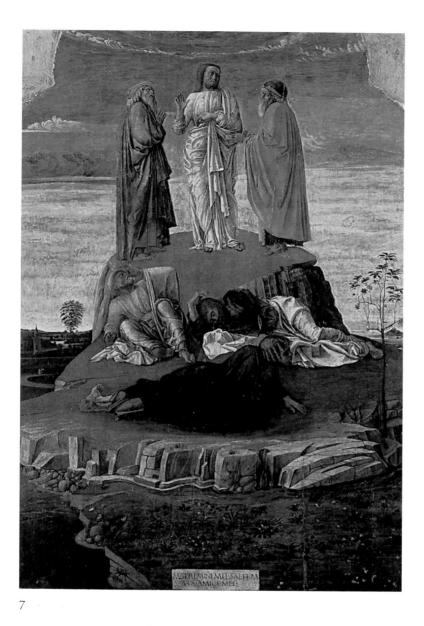

7

Dussler (1935 and 1949) dated it to around 1460; Heinemann to between 1457 and 1460; Bottari (1963) to 1460 or earlier; and Degenhart and Schmitt (1990) to between 1455 and 1460; but the date should be moved to around the mid-1460s, as Lucco (1990) also proposed, because of the similarities with the London *Prayer in the Garden* (cat. 8) and the Brera *Pietà* (cat. 10)—in particular, the ringleted hairstyle of the two prophets and Saint John Evangelist, which occurs in these two paintings. In these and in *The Transfiguration* there is a remarkable assurance and solidity combined with a fury in the folds of the drapery that would seem "Neo-Crivellesque" or "Ferrarese," if the lessons of Donatello, by way of Mantegna, were not obvious: there is nothing captious about the tortured plasticism of the clothing, it is merely and perfectly functional in its expressiveness.

Exhibited as no. 41 at the 1949 Venice exhibition.

See also the introductory essay.

8. THE PRAYER IN THE GARDEN

Panel, 31⅞⁄₁₆ × 49½ in. (81 × 127 cm)
National Gallery, London
No. 726

This painting was attributed to Mantegna when it was in British private collections, including Sir Joshua Reynolds's, but Waagen (1854–57), followed by Crowe and Cavalcaselle (1871) and all later scholars, restored it to Giovanni Bellini.

The date of between 1465 and 1470, proposed by Dussler (1935 and 1949) and endorsed by both Heinemann (1962) and Lucco (1990), seems the most likely. Degenhart and Schmitt (1990), who placed the panel in the early 1460s, correctly pointed out that the painting is derived not only from Mantegna's two compositions in London and Tours but also from Jacopo's drawings (43v and 44r) in the sketchbook that is today in London. It would seem that when Jacopo was still alive, his illegitimate son, Giovanni, had access to his drawing books, which in 1471 Jacopo's widow gave to Gentile, the legitimate son, from whom, in 1507, Giovanni inherited the book now in London.

See also the introductory essay.

cusped arch and displayed God the Father supported by red cherubim, one of whom is still partly visible. Besides the Latin inscription on the bottom, MISEREMINI·MEI· SALTEM / VOS·AMICI·MEI (Job 19:21), it bears a spurious monogram of Andrea Mantegna on the stone on the right. It was restored by Pellicioli in 1950.

At the time, the panel had been generally dated to around 1460, but Pignatti (1969) made it slightly earlier; Heinemann (1962) and Robertson (1968) noted that the Church instituted the Feast of the Transfiguration in 1457, but Heinemann did not rule out that

Giovanni's painting might have already existed at that time, since the devotion already existed.

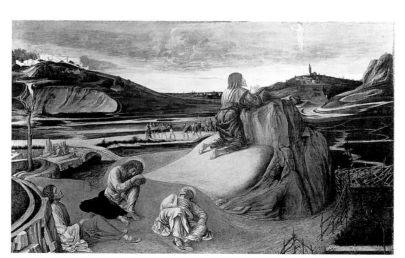

8

 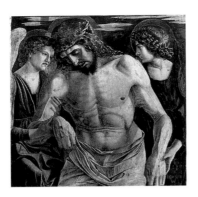 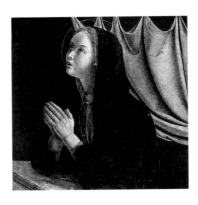

10. THE DEAD CHRIST SUPPORTED BY MARY AND SAINT JOHN EVANGELIST (PIETÀ)
Panel, 33⅞ × 42⅛ in. (86 × 107 cm)
Pinacoteca di Brera, Milan
No. 204

See entry, p. 94.

11. THE DEAD CHRIST IN THE TOMB SUPPORTED BY TWO ANGELS (PIETÀ)
Panel, 28⅞ × 19½ in. (74 × 50 cm)
Museo Civico Correr, Venice
No. 39

Morelli (1897) was the first to attribute to Giovanni Bellini this small panel, which bears Albrecht Dürer's signature and the date 1499, both of which are spurious; Crowe and Cavalcaselle (1871), however, had assigned it to Pier Maria Pennacchi. Morelli's proposed attribution was accepted by all scholars except Dussler, who initially (1935) recognized it as autograph, in particular because of the angels, but who in 1949 said nothing about the painting. The dates suggested by various scholars range within almost two decades: Goffen (1989) dated the painting to the early 1450s, implicitly, though not chronologically, taking up the opinion of Gronau (1930), who considered it the earliest of Giovanni's Pietàs, but later than the *Carità Triptychs* (cat. 5); Degenhart and Schmitt (1990) were of the same opinion, but dated the work to around 1460. Heinemann (1962), on the other hand, suggested placing it at around 1470, even though, like Gronau, he considered the landscape to be very similar to the one in the *Davis Madonna* (cat. 4).

Recently restored and exhibited at the Museo Civico Correr in the spring of 1993.

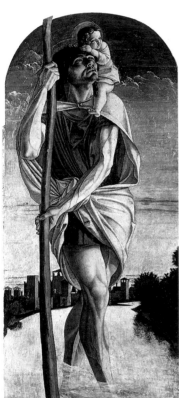 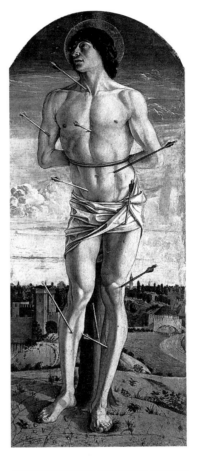

9

9. POLYPTYCH OF SAINT VINCENT FERRER
Church of Santi Giovanni e Paolo (San Zanipolo), Venice

Angel of Annunciation;	*Saint Christopher;*	Predella: *Five Scenes*
The Dead Christ Supported	*Saint Vincent Ferrer in Ecstasy;*	*from the Life of*
by Two Angels; Annunciate Virgin	*Saint Sebastian*	*Saint Vincent Ferrer*
Panels, 28⅜ × 26⅜ in.	*Panels, 65¾ × 26⅜ in.*	*Three panels, 14⅛ × 23⅝ in.*
(72 × 67 cm) each	*(167 × 67 cm) each*	*(36 × 60 cm) each*

See entry, pp. 88–93, and the introductory essay.

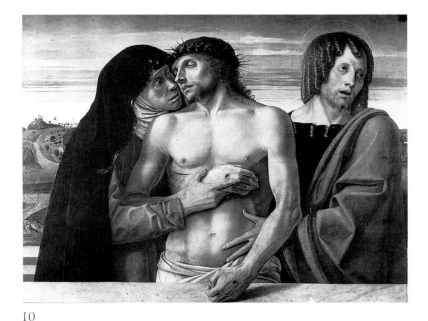

10

Shown as no. 26 at the 1949 Venice exhibition.

See also the introductory essay.

12. CRUCIFIXION WITH THE MOURNERS IN A LANDSCAPE

Panel, 21¼ × 11⅝ in. (54.5 × 30 cm)
Museo Civico Correr, Venice
No. 28

This is reliably datable to Giovanni's Mantegna stage, as evidenced by the squires, which are very similar to those in Padua's Ovetari agli Eremitani Chapel; there is nothing at all Flemish in the brightness and

11

transparency of the dawn-lit landscape, however—they are genuinely Venetian. Pellicioli's restoration of 1946 revealed the cherubim in the sky.

Datable to around 1465.

Recently restored and exhibited at the Museo Civico Correr in the spring of 1993.

See also the introductory essay.

13. THE DEAD CHRIST ON THE GRAVE AND THE TWO MOURNERS (PIETÀ)

Canvas, 44⅞ × 123⅝ in.
(115 × 317 cm)
Doge's Palace, Venice

This work, which A. M. Zanetti (1771) maintained was dated 1472 on the tag where today only the signature IHOANES BELLINVS can be read, is both problematic and controversial. In 1571, it was enlarged with the addition of a landscape by Paolo Farinato, then in 1948 restored to its original dimensions and appearance.

Many scholars—all the Italians as well as Dussler (1935 and 1949) —accepted Giovanni Bellini's sig-

nature, but its too fragile state of conservation prevented Huse (1972) from giving a definitive opinion. Robertson (1968) found it comparable to the *Polyptych of Saint Vincent Ferrer* (cat. 9), and assigned it to an assistant of Giovanni's, perhaps Lauro Padovano. Belting (1985) considered it to be probably the work of Jacopo Bellini and assistants: there is no question that it was derived from Jacopo's drawings, but it cannot be attributed to him; the attribution to Gentile is more plausible, at least for the figures of Saints Mark and Nicholas on the sides, but even Meyer zur Capellen (1985) attributed at least the invention of the middle group, with reservations, to Giovanni, as

did Goffen (1989) and Degenhart and Schmitt (1990).

It is painted in tempera on canvas, that is, a support that was Andrea Mantegna's usual one but which was exceptional for Giovanni before the *Barbarigo Votive Altarpiece* of 1488 (cat. 66). Bottari (1963) and Pignatti (1969) credited Longhi (1949) with attributing the painting to Giovanni, but in reality, Crowe and Cavalcaselle (1871) had already assigned it to him, albeit with some minor reservations, and Gronau (1930) and Gamba (1937) confirmed the attribution.

Restored in 1993 and shown at the exhibition at the Museo Civico Correr.

Shown as no. 50 at the 1949 Venice exhibition.

See also the introductory essay.

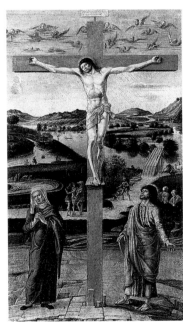

12

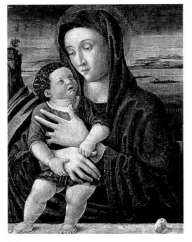

14

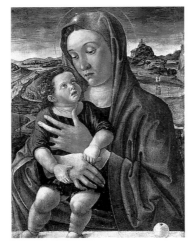

15

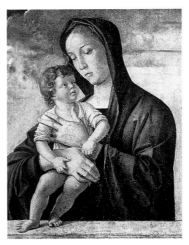

16

14. THE VIRGIN
WITH CHILD STANDING
ON A PARAPET

Panel, 25¾ × 18⅝ in. (66 × 48 cm)
Rijksmuseum, Amsterdam
No. A 3287

See cat. 16.

15. THE VIRGIN
WITH CHILD STANDING
ON A PARAPET

Panel, 26¹/₁₆ × 19¹/₁₆ in. (67 × 49 cm)
Gemäldegalerie, Berlin
No. 1177

See cat. 16.

16. THE VIRGIN
WITH CHILD STANDING
ON A PARAPET

Panel, 30 × 22¼ in. (77 × 57 cm)
Museo di Castelvecchio, Verona
No. 77

The first two small panels, almost exactly the same size, appear to be based upon the same cartoon, according to a procedure that would become customary in Giovanni's workshop; there can be no doubt about the authorship of this composition. A comparison between the Amsterdam and Berlin paintings presents no elements that would justify ranking them, even

to the extent of considering one a replica of the other, as has sometimes happened in the critical history of the two works: for once, Dussler's (1935 and 1949) extremely prudent eye judged them both—correctly—to be autograph. According to Gamba (1937) and Bottari (1963), the Amsterdam painting is original and the one in Berlin a replica and not autograph; Pignatti (1969) also considered the work in the Rijksmuseum, with its fascinating lagoon landscape, to be the prototype, but maintained that the Berlin *Virgin* was also autograph. Berenson (1957) considered both of the panels to be autograph. Robertson (1968) viewed both paintings as products of the workshop, derived from a work that is now lost; in this he seconded Heinemann's (1962) opinion: the British scholar dated them to what he believed to be the period of the *Polyptych of Saint Vincent Ferrer* (cat. 9), that is, the late 1460s and early 1470s.

Goffen (1989) listed both paintings as replicas or variants from the workshop of a composition by Giovanni of c. 1460, whereas Lucco (1990) dated them to between 1460 and 1465, pointing out, and his opinion is entirely acceptable,

Jacopo Bellini's influence. Both are listed by Degenhart and Schmitt (1990), who dated them to around 1455 and compared them to Jacopo Bellini's *Virgin* in Lovere's Accademia Tadini.

Morelli (1897) attributed the Verona painting to Giovanni, and it was accepted as such by all the scholars except Huse (1972), who ignored it, and Goffen (1972), who downgraded it to a product of the workshop. It came from Tiepolo's house in Venice; there is a copy, not ancient, in the Museo Civico in Padua (no. 431), which re-emerged from a 1986 restoration worn but legible (Marinelli, 1987, pp. 64–71).

The Amsterdam painting was shown as no. 25 at the 1949 Venice exhibition; the catalog described it and the Berlin painting as autograph.

The Verona panel was exhibited as no. 77.

See also the introductory essay.

17. BLESSING CHRIST

Panel, 22⅝ × 17⅛ in. (58 × 44 cm)
Musée du Louvre, Paris
No. RF 2039

Fry (1912) attributed this painting—at one time assigned to Lucas

van Leyden—to Giovanni, as did Logan Berenson in the same year. According to Borenius (1912), this is the painting that Ridolfi (1648) mentioned as a gift received from the friars of Santo Stefano in Venice; only Morassi (1958) identified the latter as the painting that is today in the Kimbell Art Museum in Fort Worth (cat. 114) and was in a private collection in Switzerland at the time.

All the scholars have accepted the panel's autography, but the dates suggested for it range from 1460 to 1470; the latter is Heinemann's (1962) proposal: the panel would be datable to around the middle of the decade, like the *Lehman Madonna* (cat. 18), on account of its fresh, refined coloration, the crepuscular melancholy that pervades the composition, and the clear signs, in both works, of an experimental stage that goes beyond his father's prototypes and those of his brother-in-law, Mantegna, to resemble Flemish painting, on the one hand, and on the other, Marco Zoppo's Venetian works, which, as we have earlier pointed out, already interested Giovanni at the time

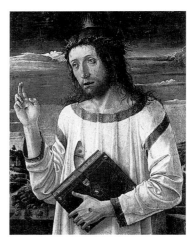

17

of the *Polyptych of Saint Vincent Ferrer* (cat. 9).

See also the introductory essay.

18. VIRGIN WITH THE BLESSING CHILD STANDING ON A PARAPET (LEHMAN MADONNA)

Panel, 21 × 15⅛ in. (54 × 39 cm)
Lehman Collection, The Metropolitan Museum of Art, New York

This painting comes from the collection of the princely Potenziani family of Rieti. Gnoli (1911) published it as autograph by Giovanni, and it is almost unanimously accepted as such. Dussler (1935) expressed reservations that he later (1949) abandoned. Heinemann (1962), who dated it to around 1470 as one of the more mature Madonnas of that period, identified an entire series of changes by other hands, which he scrupulously listed, while Goffen (1989) considered it repainted and deleted it from his catalog of autograph works by the master. Lucco (1990), seeing Jacopo's influence in it, dated it to between 1460 and 1465; Degenhart and Schmitt (1990)

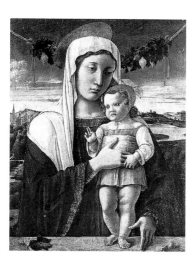

18

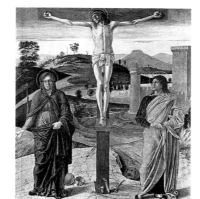

19

agreed, although they dated it to around 1460.

See also the introductory essay.

19. CRUCIFIXION WITH THE TWO MOURNERS

Panel, 27⅝ × 24⅝ in. (71 × 63 cm)
Musée du Louvre, Paris
No. RF 1970.39

This painting comes from the Contini Bonacossi collection in Florence. The attribution to Giovanni Bellini goes back to Crowe and Cavalcaselle (1871), and was adopted by all the Italian scholars, as well as by Gronau (1930) and Berenson (1957), the latter believing it to be largely autograph. Dussler, however, rejected the attribution in 1935, but then in 1949 pointed out that the Saint John in this work, which displays Mantegna's influence, very closely resembles the one in the Brera *Pietà* (cat. 10), leading us to ask ourselves whether Giovanni might not have at least collaborated. Heinemann (1962) believed it to have been composed by Lazzaro Bastiani, under Giovanni's influence, like the Berlin *Pietà* now destroyed. Robertson (1968) assigned it to the painter of the *Polyptych of Saint Vincent Ferrer* (cat. 9), seconded by Huse (1972),

whereas Goffen (1989) said nothing about it.

Shown as no. 42 at the 1949 Venice exhibition.

See also the introductory essay.

20. ENTHRONED VIRGIN ADORING THE SLEEPING CHILD (MADONNA DELLA MILIZIA DI MARE)

Panel, 46¹³⁄₁₆ × 24⁹⁄₁₆ in. (120 × 63 cm)
Gallerie dell'Accademia, Venice
Cat. no. 591

This comes from the Ufficio del Magistrato della Milizia di Mare; it is signed IOANNES BELLINVS P, but is not unanimously believed to be autograph. Berenson (1957) considered it to be from the workshop, whereas Heinemann (1962), while expressing a similar opinion, pointed out a resemblance he saw between Mary's face and that of the Museo Bagatti Valsecchi's *Borromeo Saint Justina,* which we do not believe to be autograph (see the introductory essay).

Dussler (1949), on the other hand, maintained that once the original colors were revealed by the restoration published in 1940, it had to be accepted as Giovanni's work. This was accepted by all the scholars, including Goffen (1989), who believed it to be a fragment of a triptych or polyptych.

Chronologically, it is close to the Louvre's *Crucifixion* (cat. 19), that is, of shortly before 1470. The panel was inserted in an outsize frame and combined at the top with a lunette that forms an awkward addition to the top of the throne.

Shown as no. 57 at the 1949 Venice exhibition.

See also the introductory essay.

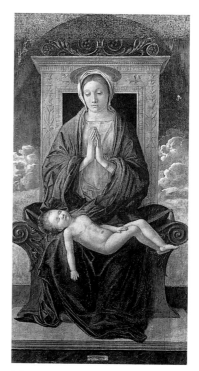

20

21. PRESENTATION OF JESUS IN THE TEMPLE

Panel, 31⅛ × 41 in. (80 × 105 cm)
Pinacoteca Querini Stampalia, Venice

Berenson (1916) attributed this work to Giovanni Bellini, and all the critics agreed except for Dussler (1935 and 1949), Arslan (1962), Huse (1972), and Goffen (1989).

It is datable to the late 1460s; only Robertson dates it to ten years later.

Shown as no. 46 at the 1949 Venice exhibition.

See also the introductory essay.

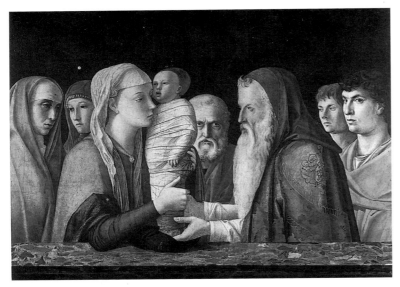

21

22

23

24

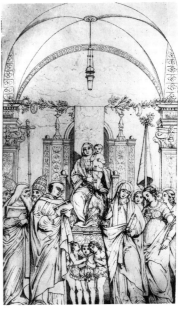

25

22. MADONNA WITH GREEK INSCRIPTION (MADONNA GRECA)

Panel, 32¾ × 24⅛ in. (84 × 62 cm)
Pinacoteca di Brera, Milan
No. 92

From the Ufficio dei Regolatori alla Scrittura in the Doge's Palace in Venice, this Madonna went to the Pinacoteca di Brera in 1808. It was restored in 1883 and 1986–87. According to Pellicioli (see Bottari, 1963), the background was originally gilded and the sky overlaid onto it in the sixteenth century; the most recent restoration, however, revealed the opposite to be true, that is, that the gilding covered the original sky and was almost entirely removed in 1883. The analyses also produced a finished drawing, as in the Pesaro *Coronation* (cat. 27).

Shown as no. 78 at the 1949 Venice exhibition.

See also the introductory essay.

23. THE MADONNA OF THE THUMB

Panel, 30¹³⁄₁₆ × 24⁹⁄₁₆ in. (79 × 63 cm)
Gallerie dell'Accademia, Venice
Cat. no. 583

This panel comes from the Ufficio del Magistrato del Monte Novissimo in the Palazzo dei Camerlenghi in Rialto. Its imperfect state of conservation had led scholars in the past to doubt its autography, which, however, the severe Dussler (1949) accepted, as did Heinemann (1962), Pignatti (1969), and Goffen (1989).

Berenson (1957) considered it to be autograph in part and repainted; it was excluded from the 1949 Venice exhibition.

See also the introductory essay.

24. VIRGIN WITH STANDING CHILD (CRESPI MADONNA)

Panel, 23¼ × 17⁹⁄₁₆ in. (60 × 45 cm)
Fogg Art Museum, Cambridge,
Massachusetts
No. 23.232

This panel was very damaged by fire while traveling in the United States; its previous condition is documented by the photograph that A. Venturi published in 1900, when the work was in the Galleria Crespi in Milan. According to Heinemann (1962), the Child's left eye, the lower left part of his body, his left foot, the Virgin's right forearm and upper left arm, and almost all of the parapet were reworked. Nevertheless, the autograph portions are of extraordinary quality, unlike the contemporary but—we believe—spurious *Frizzoni Madonna* in the Museo Correr in Venice and the *Borromeo Saint Justina,* in the Museo Bagatti Valsecchi in Milan.

See also the introductory essay.

25. VIRGIN ENTHRONED, TEN SAINTS, AND THREE SMALL ANGELS

Panel, approximately 130 × 114⅛ in.
(330 × 290 cm)
Formerly in the church of
Santi Giovanni e Paolo
(San Zanipolo), Venice

Painted for the altar of Saint Catherine of Siena, the first one on the right, it was signed IOHANNES BEL / LINVS P•(P. = "pinxit" in Latin = painted [this]). On the night of August 16, 1867, it and Titian's *Killing of Saint Peter Martyr* were destroyed by the fire that devastated the Rosary Chapel where the large panel had been placed temporarily.

See also the introductory essay.

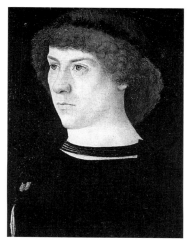

26

26. PORTRAIT OF JÖRG FUGGER

Panel, 10 1/16 × 7 3/4 in. (26 × 19.9 cm)
Norton Simon Foundation,
Pasadena, California

Discovered in the castle of the Fugger princes in Oberkirchberg, near Ulm, Germany, and published by Mayer (1926). All the scholars accepted it as autograph except Beck (1988–89); before him, Dussler had rejected the autography in his first edition (1935), but then accepted it in 1949.

At one time, this small panel was inscribed on the back, JOERG FVGGER A D XX DI ZUGNO MCCCCLXXIIII. The cut of the portrait looked Antonellesque to some critics; so much so that von Hadeln (1927) hypothesized that by the first half of 1474 the portrait style of the artist from Messina was already well known in Venice, a hypothesis that has been adopted by all scholars including Lucco (1990); the theory is well founded, not least because the painting is executed with oils. According to Conti (1987), this is very similar to the predella of the Pesaro altarpiece (cat. 27). On the other hand, Bottari (1963) and Pignatti (1969) preferred to believe that in this small portrait, Giovanni was refer-

ring to Flemish prototypes, the same ones that inspired Antonello; the coincidence would seem to be altogether singular, given that the date of the portrait corresponds to the early period of the Sicilian master's sojourn on the lagoon. Furthermore, we have no reason to doubt the date of the inscription (which today can no longer be seen), since Jörg Fugger, born in 1453, is documented as being in Venice in 1474.

Shown as no. 75 at the 1949 Venice exhibition.

See also the introductory essay.

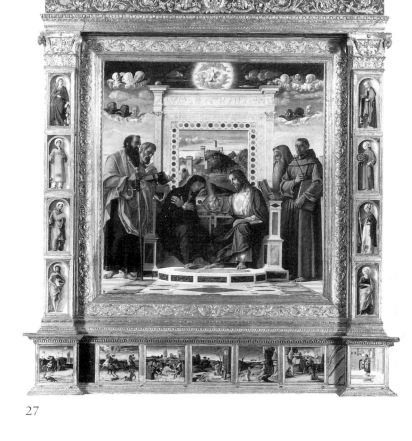

27

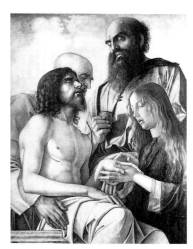

27 (Cyma)

27. CORONATION OF THE VIRGIN BETWEEN SAINTS PAUL, PETER, JEROME, AND FRANCIS

Central panel, 104 1/8 × 94 1/2 in.
(262 × 240 cm)

Pilasters: *Saint Catherine of Alexandria; Saint Lawrence; Saint Anthony of Padua; The Baptist;*

Blessed Michelina of Pesaro; Saint Bernardino of Siena; Saint Louis of Toulouse; Saint Andrew
Panels, 24 × 9 7/8 in. (61 × 25 cm) each

Bases of the pilasters:
Saint George Killing the Dragon; Saint Terentius
Panels, 15 3/4 × 14 1/8 in.
(40 × 36 cm) each

Predella: *The Conversion of Saul; The Crucifixion of Saint Peter; The Nativity of Christ; Saint Jerome in the Desert; Saint Francis Receives the Stigmata*
Panels, 15 3/4 × 16 1/2 in.
(40 × 42 cm) each
Museo Civico, Pesaro
No. 81

Cyma: *Embalming of Christ*
Panel, 42 1/8 × 33 1/8 in. (107 × 84 cm)
Pinacoteca Vaticana, Rome
No. 290

See entry, pp. 96–101.

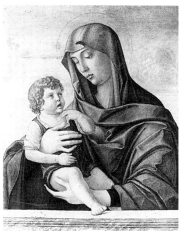

28

28. VIRGIN WITH SEATED CHILD

Panel, 32 1/4 × 24 1/4 in. (83 × 62.5 cm)
Pinacoteca dell'Accademia dei Concordi, Rovigo
No. 141

Signed IOANNES BELLI / NVS P. Restored by Pellicioli in 1949. Crowe and Cavalcaselle (1871) attributed this to Giovanni, and

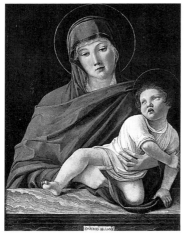

29

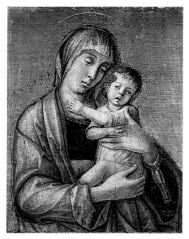

30

Gronau (1930), who was still working with the repainting, confirmed the attribution; Dussler (1935 and 1949) suspended judgment because of the state of conservation, recognizing, however, that it at least derived from an autograph cartoon. Berenson (1957), Pallucchini (1959), Bottari (1963), and Pignatti (1969) dated it to 1475; whereas Heinemann (1962) pushed the date to closer to 1480; Robertson (1968) included it in a group of works that Giovanni composed in his father's workshop at the time of the *Carità Triptychs* (cat. 5); Goffen (1989) didn't mention it. With *The Virgin with Standing Child* of the Museo di Castelvecchio in Verona, this is one of the small paintings that Giovanni made for private

devotions just before the mid-1470s, close in time to the Pesaro *Coronation* (cat. 27).

Shown as no. 54 at the 1949 Venice exhibition.

29. THE LOCHIS MADONNA

Panel, 18½ × 13⅜ in. (47 × 34 cm)
Galleria dell'Accademia Carrara, Bergamo
No. 724 (formerly no. 167)

See entry, p. 104.

30. VIRGIN EMBRACING THE CHILD (CLARK MADONNA)

Panel, 12⅝ × 9¼ in. (32.3 × 24 cm)
Clark Collection, Saltwood Castle, Kent, Great Britain

Gronau (1930) published this small panel, which came from the collection of Count Portalupi of Verona, comparing it to a work that is not autograph, the *Virgin* today in the Yale University Library in New Haven. The latter, based on a lost drawing by Bellini, is a product of the workshop, executed perhaps in part by Giovanni Mansueti.

Dussler (1935 and 1949) accepted the attribution of the *Clark Madonna* to Giovanni at least as a

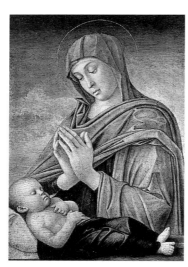

31

composition reflecting an original idea of the master's. Berenson (1957) also cataloged it among the early works; Heinemann (1962) pointed out eighteenth-century restored areas in the gold background and reworked areas of the clothing, correctly identifying references in the composition to Mantegna and Donatello. Bottari (1963) thought very highly of this little painting, whose authenticity he found to be demonstrated also in the replica in the Da Ponte collection in Brescia that Longhi published (1949). Pignatti (1969) cataloged it as well, and dated it to between 1460 and 1464, while Dussler favored a date closer to 1470-75, and Bottari opted for 1475; Goffen did not mention it (1989). The idea is contemporary or only slightly later than the Pesaro *Coronation* (cat. 27) and is wonderful in the way that the two figures are conceived as animated by a profound spirituality, despite the parts concealed by its ruined state. Compare the Child with the Saint Terentius of the Pesaro *Coronation*.

Shown as no. 35 at the 1949 Venice exhibition.

31. VIRGIN ADORING THE CHILD

Panel, 30 × 21⅞ in. (77 × 56 cm)
Formerly in the Contini Bonacossi Collection, Florence

See cat. 32.

32. VIRGIN ADORING THE CHILD

Panel, 32 × 24⅛ in. (81.9 × 62 cm)
National Gallery, London
No. 2901

These two very similar compositions were painted at some small distance in time. The first, which Gamba (1937) published as a replica

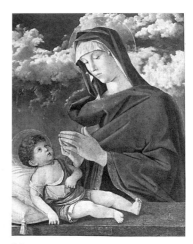

32

of the related work in the Museo di Castelvecchio in Verona, shows the Child sleeping with the lower half of his body wrapped in a kind of blanket that reveals his feet, while his Mother is draped in a mantle that appears to be inspired by those of classical statuary; in the second version (a restoration-laden variant of it exists in the Berenson collection in Fiesole), the Child is awake and seated, with two cushions supporting his back, and his gaze fixed on the face of his adoring mother, whose ample and enveloping mantle reveals a white veil on her forehead, as Giovanni Bellini's Madonnas, with few exceptions, would show from then on.

A related version is in the Fogg Art Museum in Cambridge, Massachusetts (panel, 28½ × 21 in. [73 × 54 cm]; no. 43.103), in which the Child is awake; there is a drawing for it in the British Museum in London. A copy of the Cambridge painting, formerly in the Winthrop collection, New York, is in the Museo Civico in Padua (no. 2294).

The location of the work formerly in the Contini Bonacossi collection is presently unknown; the others all seem to be products of the workshop from drawings by the master. The version with the

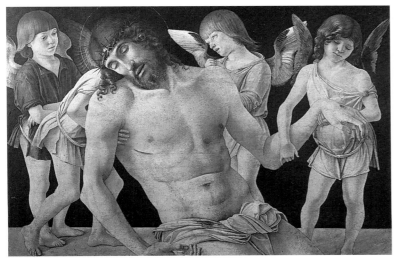

33

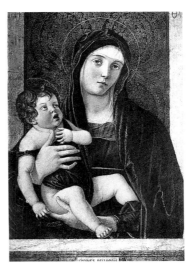

35

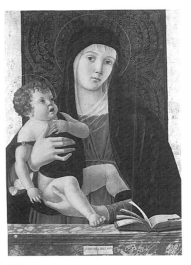

37

sleeping Child must have been conceived in the very early 1470s, shortly before the Cambridge painting, which is chronologically close to the *Dead Christ* in Rimini (cat. 33); the London composition was made a few years later, toward the end of the decade. All these paintings, discussed by the various specialists, from Gronau (1930) to Dussler (1935 and 1949), Berenson (1957) to Pallucchini (1949 and 1959), Heinemann (1962) to Bottari (1963), and Robertson (1968) to Pignatti (1969), are unmentioned by Goffen (1989).

The former Contini Bonacossi

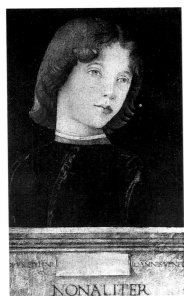

34

Virgin was shown as no. 53 in the 1949 Venice exhibition.

33. THE DEAD CHRIST WITH FOUR ANGELS

Panel, 31¾ × 47¼ in. (80.5 × 120 cm)
Pinacoteca Comunale, Rimini

See entry, p. 106.

34. PORTRAIT OF A BOY

Panel, 14¹³⁄₁₆ × 9 in. (38 × 23 cm)
Barber Institute of Fine Arts,
Birmingham, Great Britain

The inscription on this small panel, OPUS BELLINI IOANNIS VENETI / NONALITER, does not appear to be original, even if evidence seems to support Heinemann's (1962) thesis that it was added in 1520–30. The panel comes from the Holford collection, London, where it was seen by Waagen (1854–57), who noted the influence of Antonello da Messina, an opinion that inclined Crowe and Cavalcaselle (1871) to an attribution to the Sicilian painter. Berenson initially (1901) thought of Niccolò Rondinelli, but later (1957) accepted the attribution to Giovanni proposed by Gronau (1930) and then by all later scholars, except for Dussler (1935 and 1949). Benedicenti (1993) confirmed the date of 1475, as well as

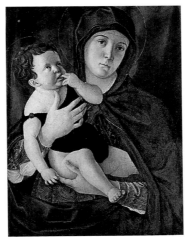

36

the original existence of the inscription NONALITER.

Shown as no. 81 at the 1949 Venice exhibition.

See also the introductory essay.

35. VIRGIN HOLDING THE CHILD

Panel, 29¼ × 19½ in. (75 × 50 cm)
Church of the Madonna dell'Orto,
Venice

See cat. 37.

36. VIRGIN HOLDING THE CHILD

Panel, 29¼ × 20⅝ in. (75.5 × 53 cm)
Gemäldegalerie, Berlin
No. 10 A

See cat. 37.

37. MADONNA AND CHILD

Panel, 29¼ × 20⅝ in. (75.5 × 53 cm)
Kimbell Art Museum,
Fort Worth

Of these three known small panels of the same composition, with few variations and all of high quality, the one that is unquestionably the best and certainly autograph is the one in the Venetian church, on the first altar on the left, signed IOANNES BELLINVS; unfortunately it was stolen on March 1, 1993. Sansovino (1581) had already attributed it to Giovanni, and according to Cicogna (1824–53), Luca Navagero, the Venetian viceregent for Friuli who died in Udine in 1488, had commissioned it for his own tomb, in a different part of the same church. The work, however, had been executed some ten years earlier; perhaps, as Goffen (1989) suggested, Navagero selected it from among several Virgins that were already available for sale in Giovanni's workshop.

The Madonna dell'Orto panel was shown as no. 79 at the 1949 Venice exhibition.

See also the introductory essay.

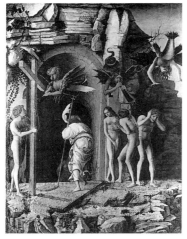

38

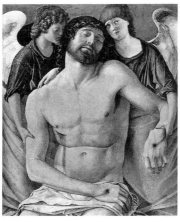

39

38. CHRIST'S DESCENT INTO LIMBO

Parchment, 20³/₁₆ × 14⁹/₁₆ in.
(52 × 37.4 cm)
City Museum and Art Gallery, Bristol
No. K 1654

Andrea Mantegna devised the composition, which is customarily related to a letter of June 28, 1468, written by him to Ludovico Gonzaga, in which the Paduan painter tells Gonzaga that he has begun an *"instoria del limbo,"* "a picture of limbo." Byam Shaw (1952) attributed the Bristol painting, as well as the Paris drawing, to Giovanni Bellini; Berenson (1957), Pallucchini (1959), Heinemann (1962), Bottari (1963), Robertson (1968), who dates it correctly to a little before 1480,

Pignatti (1969), and Goffen (1989) accepted the attribution.

See also the introductory essay.

39. THE DEAD CHRIST SUPPORTED BY TWO ANGELS (PIETÀ)

Panel, 32¼ × 26³/₁₆ in.
(83 × 67.5 cm)
Gemäldegalerie, Berlin
No. 28

In 1879, Morelli congratulated the gallery's administration for their recent attribution of this painting to Giovanni Bellini, which was previously assigned to Mantegna; their opinion remains unquestioned.

Regarding the chronology, Gronau (1930) discussed Berenson's idea, which at the time situated the painting before the Rimini *Pietà* (cat. 33), and the dating to 1465 proposed in the gallery's catalogs up through the definitive one of 1931, arguing that it should be made at least ten years later. At first Dussler (1935) confirmed the date, but later (1949) made it 1480-85, thereby joining Gamba (1937), who saw the Berlin *Dead Christ* as later than the London panel (cat. 40); only Bottari (1963) subsequently adopted this position, with all other scholars dating the work to between 1475 and 1480; Degenhart and Schmitt (1990) dated it to around 1480.

This is surely only slightly later than the Pesaro *Coronation* (cat. 27), based on the serene and sorrowful expression and the solidly constructed forms, which no longer display the harshness of the early works. One of the characteristics of this painting is the absence of any allusion to the tomb: Christ's powerfully built body, covered with a loincloth and deep in mortal sleep, its great heaviness expressed in the

right hand especially, is about to be wrapped in the shroud as two angels support him; the one on the left, dumbfounded, seems to be trying to talk to him, while the one on the right gazes upward, barely holding back tears. Blood is still issuing from the wound in his side, spilling onto the loincloth; according to Goffen (1989), this refers to Christ's being circumcised. Although the composition has a touch of the *Pietà* in the *Polyptych of Saint Vincent Ferrer* (cat. 9), it is precisely a comparison between the two paintings that reveals incontrovertibly how far the painter had come. He would paint the same subject several more times, always with variations, affirming his personal perception of the reality of Christ the Redeemer, who by means of his death on the cross becomes the sacrificial victim who in turn becomes the Venerable God.

40. THE DEAD CHRIST SUPPORTED BY TWO ANGELS (PIETÀ)

Panel, 36¹⁵/₁₆ × 28 in. (94.6 × 71.8 cm)
National Gallery, London
No. 3912

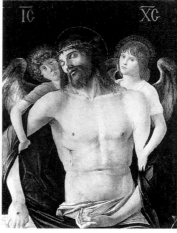

40

This comes from the Mond collection and was attributed to Mantegna, before Morelli (1897), seconded by all later scholars, recognized it as typical of Giovanni's work.

It is not easy to place either this painting or the preceding one securely in chronological order; in this painting in particular, some scholars, such as Gronau (1930) and Dussler (1949), who correctly dated it to the second half of the 1470s, and Heinemann (1962), saw a similarity—which to us appears to be merely typological—between the angel on the left and the Child in the *Madonna with Greek Inscription* (cat. 22). Berenson (1957) also considers it to be an early work; Pignatti (1969) dates it to 1471-74, whereas Robertson (1968) considers the Rimini (cat. 33), Berlin (cat. 39), and London Pietàs to be earlier than the Pesaro altarpiece (cat. 27). Huse (1972) compared the London painting to the pinnacle of the Pesaro altarpiece, today in the Vatican, while Lucco (1990) dated the Berlin and London paintings to immediately before the Pesaro *Coronation;* according to Goffen (1989), the painting was executed with assistants. Only Bottari (1963) switched the order of this painting and the one with a similar composition in Berlin, which he dated to between 1475 and 1480. We have already said that we concur with Dussler on this dating for the London *Pietà,* in which the reference to older works lies especially in the Greek inscription, Christ's monogram. The left-hand angel, who some scholars find resembles the Child in the *Madonna with Greek Inscription,* is actually closer to the Pesaro *Saint Terentius* and the Child of the *Clark Madonna* (cat. 30).

The grief-stricken sadness,

conveyed without dramatic notes, along with a softer, more continuous rendering of the anatomy than in the Berlin work, not to mention the usual extremely effective language of the hands, all make this small painting—which Richter (1910) considered to be part of an altarpiece of the type of the one in Pesaro or of the *Polyptych of Saint Vincent Ferrer* (cat. 9)—an extraordinarily intense *Andachtsbild*.

41. THE RESURRECTION OF CHRIST

Panel, 58¼ × 50⅜ in. (148 × 128 cm)
Gemäldegalerie, Berlin
No. 1177 A

See entry, pp. 108-10.

42. CRUCIFIXION

Panel, 22¼ × 17½ in. (57 × 45 cm)
Galleria Corsini, Florence

This *Crucifixion* comes from the Colonna collection in Rome, as the family's coat of arms, still visible at the lower right, indicates. At times its attribution and dating have been contested, but it remains a small masterpiece, which Robertson (1968) rightly situates close in time to the Berlin *Resurrection* (cat. 41). It was once assigned to a student of Antonello da Messina, to whom A. Venturi assigned it as late as 1915, although he changed his opinion in a footnote in favor of a Venetian inspired by Bellini's early works. Gronau (1930), persuaded by the landscape, was the first to counter the reservations, but Dussler (1935 and 1949) was again very cautious, deeming it to be, if Venetian, of the school of Antonello. Pallucchini (1949) pointed out its dependence on ideas of the master from Messina, as they find expression in the National Gallery

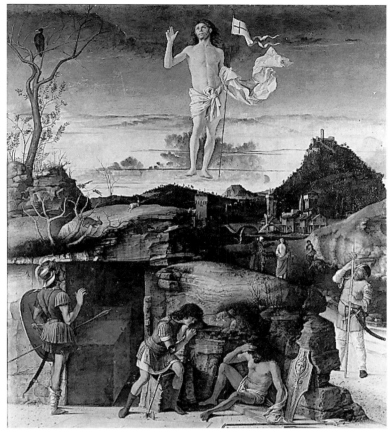

41

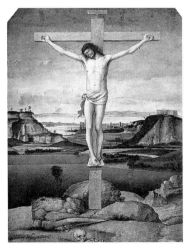

42

of London's *Crucifixion* (no. 1166), dated 1475, and in its contemporary in the Royal Museum of Antwerp (no. 4). Heinemann (1962) considered it later than the *Crucifixion* formerly belonging to the Niccolini di Camugliano, today in Prato (cat. 55), and compared it with the Uffizi's *Sacred Allegory* (cat. 88); he maintained

its autography, observing rightly that it had been doubtful in the past because the painting had been compared with very early works. Bottari (1963) dated it to between 1475 and 1480, whereas Pignatti (1969), like Robertson, made it slightly later than the Berlin *Resurrection*. Goffen (1989) did not even illustrate it, relegating it among the works of uncertain attribution; Lucco (1990) believed it to be close in time to the painting formerly belonging to the Niccolini di Camugliano, between the Frick's *Saint Francis* (cat. 45) and the Capodimonte *Transfiguration* (cat. 57); Degenhart and Schmitt (1990) dated it to around 1480, citing it in the entry concerning Drawing 74 of Jacopo Bellini's sketchbook in the Louvre.

It was shown as no. 84 at the 1949 Venice exhibition.

See also the introductory essay.

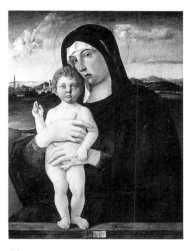

43

43. VIRGIN WITH STANDING BLESSING CHILD

Panel, 30¼ × 22⁹/₁₆ in. (78 × 58 cm)
Gallerie dell'Accademia, Venice
Cat. no. 594

See cat. 44.

44. VIRGIN WITH STANDING BLESSING CHILD

Panel, 21½ × 19 in. (55 × 49 cm)
Rijksmuseum, Amsterdam
No. A 3379

The first panel, signed IOANNES BELLINVS and today in Venice, came from the Contarini collection, from whence it was donated to the gallery in 1838. It is in a poor state of conservation, its relative

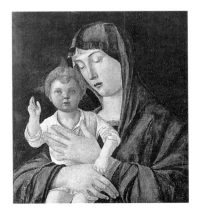

44

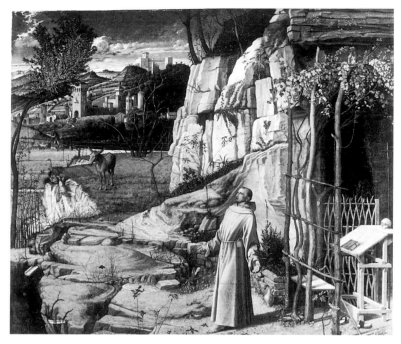

45

opacity perhaps also due to Pellicioli's restoration just before World War II.

It was mentioned by Ridolfi as early as 1648. After Crowe and Cavalcaselle (1871) proposed dating it to immediately after the now-lost San Zanipolo altarpiece (cat. 25), all the critics have been unanimous in dating it to later than the Pesaro altar (cat. 27): Degenhart and Schmitt (1990) placed it between 1475 and 1480, referring to its derivation from Jacopo Bellini's *Virgin* in the Accademia Tadini in Lovere; it is easy to see that Giovanni reflected upon the latter painting, which shares with the small former Contarini panel the standing, blessing Child, which he would employ again in some of his most significant works, from the *Barbarigo Votive Altarpiece* (cat. 66), to *The Frari Triptych* (cat. 67), to the *San Zaccaria Altarpiece* (cat. 106), to the late Pinacoteca di Brera *Virgin* (cat. 117).

Shown as no. 83 at the 1949 Venice exhibition.

See also the introductory essay.

45. SAINT FRANCIS IN ECSTASY

Panel, 47¼ × 54 in. (120 × 137 cm)
The Frick Collection, New York
No. 15.1.3

See entry, pp. 112-14.

46. PORTRAIT OF A YOUNG MAN IN RED WITH DUCAL CAP (MELLON PORTRAIT)

Panel, 12½ × 10³⁄₁₆ in. (32 × 26.5 cm)
Mellon Collection, National Gallery of Art, Washington, D.C.
No. 29

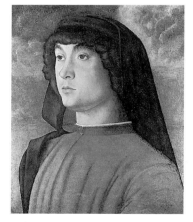

46

Originally from the collection of the Count von Ingenheim in Ober-Rengersdorf, near Dresden, *Portrait of a Young Man* passed from Duveen to New York; in 1930 it came to the Mellon collection in Washington, D.C., and from there to the National Gallery of Art. Mayer (1930) was the first to publish it with an attribution to Giovanni Bellini, which was accepted by Gronau (1930), who specifically stated that he did not know the original. In 1932, Borenius opined that the small panel derived from the one in Andrea Vendramin's collection, which was attributed to Giovanni. Dussler (1935 and 1949) raised the possibility of the work not being by Giovanni Bellini; if it were, he proposed dating it to around 1480. Berenson (1957) considered it autograph. According to Heinemann (1962), it was probably the painting formerly in the Vendramin collection, but he moved the date back because of the marked influence of Antonello. Bottari (1963) placed it at around 1480. Robertson (1968) believed it to be either contemporary with or slightly later than the Pesaro *Coronation* (cat. 27) and related it to the London *Virgin Adoring the Child* (cat. 32), whereas Pignatti (1969) maintained that the dating should be a decade later, in consideration of what she described as "chromatic development." For Goffen (1989), it is a product of the workshop.

See also the introductory essay.

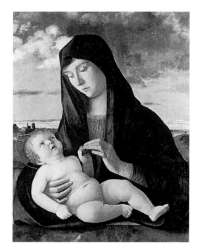

47

47. MADONNA AND CHILD (BOOTH MADONNA)

Panel, 28¹⁄₁₆ × 20¾ in.
(72 × 53.2 cm)
National Gallery of Art, Washington, D.C.
No. 894

This work bears an inscription added onto the parapet: IDEM / Z B. It was first published by Gronau (1930), who recalled that Berenson had noted its presence in Teniers's painting of the picture gallery of Archduke Leopold William of Austria. Although Berenson identified it initially (1916) with the spurious version today in the Accademia Carrara in Bergamo, he later (1932 and 1957) recognized the Booth painting as autograph. Dussler (1935 and 1949) concurred, and dated it to 1480-85, pointing out the work's poor state of conservation but very high quality. Bottari (1963) agreed, considering it one of Giovanni's "most limpid" works; Robertson (1968), too, placed it in the first half of the 1480s, while Pignatti (1969) inclined toward an execution of between 1485 and 1490. Goffen (1989) held it to have been done in collaboration with assistants.

See also the introductory essay.

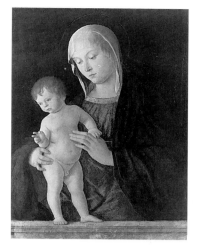

48

48. VIRGIN WITH STANDING BLESSING CHILD

Panel, 23¹³/₁₆ × 18³/₁₆ in.
(61 × 47 cm)
Art Gallery, Glasgow
No. 332

From the Gilbert collection in Glasgow, this panel passed into the Burrell collection in the same city; it was on exhibition at the Art Gallery. It was attributed to Giovanni Bellini by Gronau (1930), who knew a much weaker version (no. 112 of the third Sedelmeyer sale, Paris, 1907); according to Gronau, this painting is closer to the *Madonna of the Pear* in the Stuttgart Staatsgalerie (not autograph; see cat. 56) and the one formerly in the Barberini collection in Rome—today also in the Burrell collection and also exhibited at the Glasgow Art Gallery (cat. 73)—than to the Louvre's *Virgin Between Saints Peter and Sebastian* (cat. 50).

In Dussler's view (1949), this work probably derived from a prototype by the master and reflects compositional and typological motifs that appear in his half-length works of 1485 to 1490; to the German scholar, Berenson's opinion (iterated in 1957) that the painting

was largely autograph was incomprehensible. Heinemann (1962) assigned the Glasgow *Virgin* to Francesco Bissolo on the basis of a bizarre comparison with the two saints in the *Saint Euphemia Altarpiece* in the Duomo of Treviso. He also set up another baseless comparison with the Child in the *Barbarigo Votive Altarpiece* (cat. 66) and in *The Frari Triptych* (cat. 67); it seems as if Heinemann confused the Glasgow *Virgin* with the one in Northampton (cat. 64). According to Bottari (1963), the small panel, especially in the little figure standing on the parapet, recalls the manner of the Rimini *Dead Christ* (cat. 33); he consequently proposed a date close to that for the work he considered the prototype, the derivation of which lacks the subtlety of the original. Neither Robertson (1968), Huse (1972), nor Goffen (1989) mentioned the painting. Pignatti (1969) dated it to 1475, stating his agreement with Bottari and noting a close similarity to Antonello's style in the glancing light and dark background. The dating of the panel, a work of great refinement and sensitivity, though in less than perfect condition, should be moved forward, though not to the extremes, the first half of the 1480s, proposed by Dussler and Heinemann.

49. VIRGIN WITH STANDING CHILD EMBRACING HER (WILLYS MADONNA)

Panel, 19¹⁵/₁₆ × 13⅝ in. (51 × 35 cm)
Museu de Arte, São Paulo

Signed IOANNES BELLINVS on the parapet. This painting passed from the Campbell collection in London, through Duveen, to the Willys collection in Toledo, Ohio,

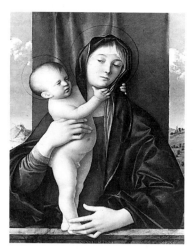

49

then to New York to the Wildenstein collection. Berenson (1916), the first to publish it, dated it to "early in 1488," whereas Gronau (1930) made it the 1490s, pointing out a similarity—which we consider to be merely formal—between Mary's hands in this painting and those of the Virgin in *The Virgin Between Saints Paul and George* in the Accademia in Venice (cat. 85). Dussler (1935 and 1949) also dated it to between 1490 and 1495, admiring especially the type of the Child, which he described as surprising and which he saw as resembling the putti in *Vincenzo Catena's "Restelo"* (cat. 77); in his opinion, the invention and perhaps the execution are assignable to Giovanni. Berenson (1957) and Heinemann (1962) considered it autograph; the latter, finding it truly mature, dated it to around 1490-92. Bottari (1963) seconded Berenson in dating it to 1488, and he listed various versions that derived from the prototype presently in São Paulo, among them the product of the workshop in the Art Institute of Chicago. He also pointed out another trace of Antonello, validated by Antonello da Saliba's replica, no. 13 of the Kaiser-Friedrich-Museum in Berlin, which

was lost in 1945, and mentioned Filippo Mazzola's replica, at one time in the Stroganoff collection, and the version in the Ringling Museum in Sarasota, Florida, which Suida (1949) assigned to Cristoforo Caselli. Neither Robertson (1968), Huse (1972), nor Goffen (1989) mentioned the São Paulo panel. Pignatti (1969) dated it to 1487, as did Lucco (1990). Another derivation of this painting is *The Virgin Between Saint Joseph and the Magdalene,* signed by Bernardino Licinio, its location today unknown. Vertova (1975) dated it to around 1535.

The panel today in São Paulo should be dated to before 1485, since it is clearly less mature than *The Madonna of the Young Trees,* which is dated 1487 (cat. 65).

This was shown as no. 90 at the 1949 Venice exhibition, when it was still in the Wildenstein collection in New York.

50. THE VIRGIN BETWEEN SAINTS PETER AND SEBASTIAN

Panel, 32¾ × 23¹³/₁₆ in. (84 × 61 cm)
Musée du Louvre, Paris
No. M.I. 231

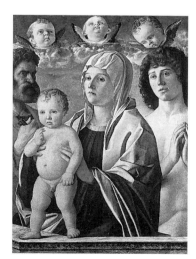

50

Signed IOANNES BELLINVS. It has been in the van Cuyck collection, the collection of the Princes of Orange, and the Brentano and Lord Northwich collections.

Crowe and Cavalcaselle (1871) considered it to have been executed with the collaboration of Marco Basaiti, whereas Morelli (1897) believed it to be the work of Niccolò Rondinelli. Gronau (1930) argued for its autography by comparing it with the *Virgin with Two Saints* in the Accademia in Venice (cat. 71) and the *Virgin with the Baptist* (not autograph) in the Galleria Doria Pamphilj in Rome. He also pointed out the similarities between Saint Peter and the same saint in *The Virgin Between Saints Peter and Clare* in Washington, D.C. (cat. 68). Dussler (1949) considered it to be based upon the Bellini types of the late 1480s but rejected the autography of Mary's head and of the Child. Berenson (1957) considered it to be autograph, while Heinemann (1962) took the discussion backward, maintaining that it was painted in the workshop, from a now lost original of around 1490, with the collaboration of Basaiti and Rondinelli; he correctly emphasized the typological similarity between the Mary here and in the *Virgin with the Standing Blessing Child (Northampton Madonna)* (cat. 64). Bottari (1963) agreed with a dating to around 1490 and admired the painting's luminous coloration, but he confused the nineteenth-century opinions about the proposed collaborators. For Robertson (1968), this is one of the Virgins of the 1490s invented by Giovanni but executed with assistants; he said, rightly, that the excessive crowding of the figures is redeemed by the great beauty of the color, which he

admired in particular in Mary's yellow mantle. Pignatti (1969) pointed out that the compositional scheme of the Child moving along the parapet to the left appears frequently in works of the 1480s and 1490s; he dated the Louvre's painting to 1487. In actuality, this should be put back a few years, since it is stylistically closer to Bellini's painterly production of the early 1480s. According to Goffen (1989), this is a collaborative work. The foreshortened cherub also turns up in the *Barbarigo Votive Altarpiece* (cat. 66).

The Galleria Luzzetti in Florence presented a high-quality replica of this panel at the International Antiques Show at Palazzo Strozzi in Florence in 1987.

This was shown as no. 109 at the 1949 Venice exhibition.

51. THE VIRGIN GIVING A PIECE OF FRUIT TO THE SEATED CHILD (MOND MADONNA)
Panel, 30⅝ × 22¹³/₁₆ in.
(78.7 × 58.4 cm)
National Gallery, London
No. 3913

Signed IOANNES BELLINVS on a tag on the parapet. It belonged to the Lazzari collection in Naples and came into the National Gallery from the Mond collection.

Gronau (1930) dated it to the 1490s, like the *Morelli Madonna* (cat. 63) and the Uffizi's *Sacred Allegory* (cat. 88), whereas Crowe and Cavalcaselle (1871) included it in the group of works executed with the assistance of Marco Basaiti. Berenson (1901) placed it in the first half of the 1480s, an entirely acceptable date; in 1957, he reaffirmed the painting's autography. Dussler (1949) considered it

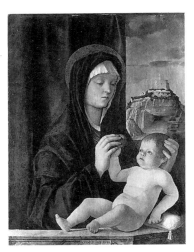

51

derived from a cartoon by Giovanni, a development related to the compositional schema already present in the *Booth Madonna* (cat. 47); he noted the similarity between its landscape and those in the Virgins in the Kansas City Gallery of Art (nos. 61–66) and the Washington, D.C., National Gallery of Art (no. 373), both in the Samuel H. Kress collection and, though not autograph, from a cartoon by Giovanni often copied by students, including several times by Marco Bello. According to Dussler, this type of Madonna appears also in the so-called *Virgin with Red Cherubim* (cat. 72), which in reality is a much more mature work. Heinemann (1962) considered this painting autograph, and in other respects concurred with Dussler's opinions; he pointed out that the parapet forms an angle as in the related *Virgin Between Saints Peter and Sebastian* (cat. 50) and as would recur in the *Northampton Madonna* (cat. 64), in the latter instance, for no compositional reason. Robertson (1968) rightly dates the *Mond Madonna* to the first half of the 1480s. According to Bottari (1963), seconded by Pignatti (1969), this is an autograph work, albeit repainted and damaged in places, and datable

to between 1480 and 1490. Goffen (1989) did not mention it.

See also the introductory essay.

52. THE VIRGIN WITH STANDING CHILD AND DONOR
Panel, 32⅛ × 27³/₁₆ in. (82.5 × 70 cm)
Harewood Collection, Harewood Castle, Yorkshire

Signed IOANNES BELLINVS on the parapet. It formerly belonged to the Langton Douglas collection in London and to Viscount Harcourt.

Arguing that the painting portrays Gerolamo Hollivier's late brother Marin, Gronau (1930) identified it with the painting that Hollivier left as a bequest to the church of the Madonna dell'Orto in Venice in 1528; There are many known replicas of the figure of the Virgin, and Gronau listed some of them, pointing out also that Mary's right hand and the Child with arms crossed over his chest reappear in Vittore Carpaccio's *Virgin Between Saints Jerome and Catherine,* formerly no. 14 in the Kaiser-Friedrich-Museum in Berlin, which was lost in 1945 (see Sgarbi, 1994, p. 220, cat. 31). Dussler (1949) suggested that the Hollivier painting could be the one belonging to the Friedsam Memorial Library in Saint Bona-

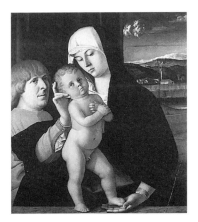

52

venture, New York; according to him the donor's head and the landscape are autograph; he lists the formerly Duveen derivation in New York and Vincenzo Catena's in the Dresden Gemäldegalerie. The Harewood painting is autograph according to Berenson (1957); Bottari (1963), who dated it to c. 1490; and Pignatti (1969), who situated it close in time to *The Madonna of the Young Trees* (cat. 65), that is, to 1487. According to Robertson (1968), we are looking at one of Giovanni's inventions of the 1490s, executed in collaboration with an assistant. In this case, Heinemann (1962) was the most correct when he described the panel as undoubtedly autograph, painted around 1485, and admired its lively coloration. Goffen (1989) judged it to be from the workshop.

Shown as no. 95 at the 1949 Venice exhibition.

See also the introductory essay.

53. SAINT JEROME IN THE DESERT

Panel, 59½ × 44½ in. (151 × 113 cm)
Galleria degli Uffizi, Florence
No. CB 25

See cat. 54.

54. SAINT JEROME IN THE DESERT

Panel, 18³⁄₁₆ × 13⅛ in. (47 × 33.7 cm)
National Gallery, London
No. 281

See entry, pp. 116–18.

55. CRUCIFIXION WITH JEWISH CEMETERY (NICCOLINI DI CAMUGLIANO CRUCIFIXION)

Panel, 31⅞ × 19¼ in. (81 × 49 cm)
Cassa di Risparmio, Prato

See entry, p. 120.

56. THE TWO CRUCIFIED THIEVES

Panels, 31⅛ × 11⁹⁄₁₆ in.
(80 × 29.8 cm) each
Formerly Private Collection, London

These works became famous in Sotheby's London auction of November 20, 1957; the auction catalog described them as lateral panels of the former Niccolini di

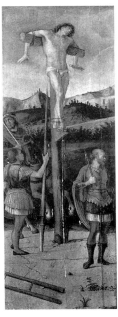
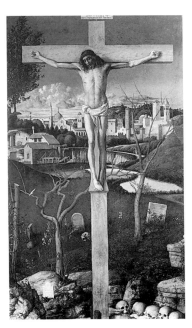
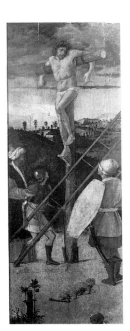

55

56

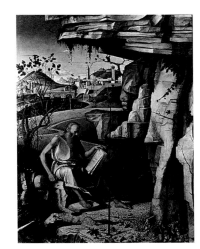

53

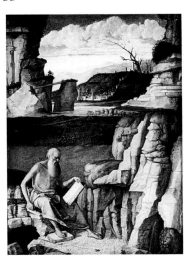

54

Camugliano *Crucifixion* (cat. 55). Berenson (1957) ignored them, but Pallucchini (1959), Heinemann (1962), Bottari (1963), and Pignatti (1969) accepted them as autograph, while Huse (1972), stating that he did not know them in the original, maintained that they could not be related to the painting today in Prato. Pignatti seemed convinced of the relationship, but Bottari, while acknowledging that their measurements make the relationship plausible, held that from a stylistic point of view the two panels are rather to be related to the Berlin *Resurrection* (cat. 41). Goffen (1989) did not mention the two panels.

In fact, these are two autograph fragments of excellent quality, as far as may be judged from photographs, but they are to be dated to a period earlier than the one initiated by the Frick *Saint Francis* (cat. 45), which still recalls the figurative forms that Giovanni expressed between the Pesaro *Coronation* (cat. 27) and the Berlin *Resurrection*. Nor does the landscape relate to that of the Prato *Crucifixion*.

57. THE TRANSFIGURATION

Panel, 45⅝ × 60⅝ in. (116 × 154 cm)
Galleria Nazionale di Capodimonte, Naples
No. 56

See entry, p. 122.

58. SAN GIOBBE ALTARPIECE

Panel, 184 × 101⅝ in. (471 × 258 cm)
Gallerie dell'Accademia, Venice
Cat. no. 38

See entry, pp. 124–26.

59. SAINT PETER MARTYR

Panel, 77⅝ × 32¾ in. (194 × 84 cm)
Pinacoteca Provinciale, Bari
No. 22

Signed on the riser of the step IOANNES BELLINVS. This painting comes from the church of San Domenico in Monopoli, in the province of Bari, confirming the diffusion of Venetian pictorial works executed as commissions along the Adriatic coast.

Frizzoni published it (1914) and

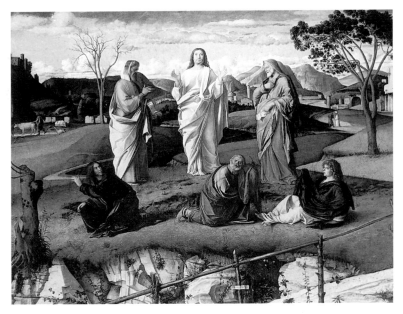

57

dated it to 1490. A. Venturi (1915) pushed the date back to just after the Brera *Pietà* (cat. 10) and before the Pesaro *Coronation* (cat. 27). Berenson (1916) correctly pointed out its stylistic resemblance to the *San Giobbe Altarpiece* (cat. 58), and Gronau (1930), Dussler (1935 and 1949), and Huse (1972) concurred. According to Heinemann (1962), it is contemporary with the Berlin *Resurrection* (cat. 41), closer to 1475 than to 1480, because of the figures' rigidity, and also because the young nude with a horse drawn in charcoal on the back of the panel recalls the saints on the pilaster of the Pesaro altarpiece; Gronau agreed.

Gamba (1937) proposed that the Bari panel was the middle element of a triptych whose lateral panels would have been the two saints in the National Gallery in Zagreb (cat. 60); Pallucchini (1959), Bottari (1963), and Pignatti (1969) rejected this theory because of the discrepancies between the dimensions on the one hand and the orientation of the figures on the other. Robertson (1968) admitted that he was very tempted by Gamba's hypothesis, but dis-

missed it for these same reasons. According to Goffen (1989), *Saint Peter Martyr* is close in time to *The Frari Triptych* (cat. 67), an opinion expressed earlier by Robertson and Pignatti, who dated it to 1487; Pignatti thought that the Bari panel belonged to a triptych or polyptych whose other elements are missing. Both she and Robertson opted for an execution with an assistant, an opinion with which we concur; however, we believe that the date should remain close to that of the *San Giobbe Altarpiece* (cat. 58) rather than to *The Frari Triptych*. We would note that the idea of the saint standing on a kind of plinth in front of a low wall with a background of sky appears in polyptychs by Filippo Mazzola, as well as in the *Saint Catherine of Alexandria* in the Wallace collection in London, the middle part of the dismembered Mestre triptych executed by Giambattista Cima immediately after 1500.

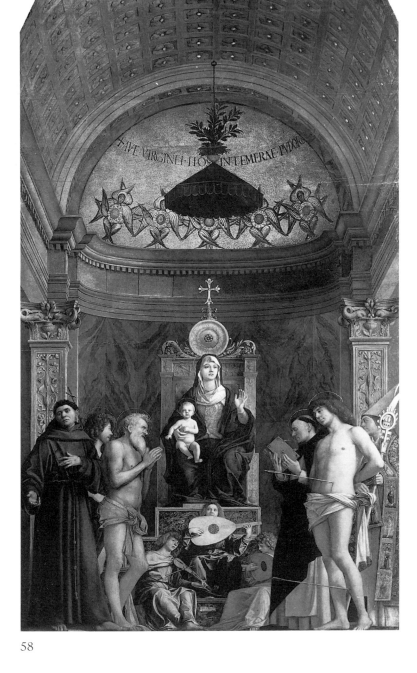

58

60. SAINT AUGUSTINE; SAINT BENEDICT

Panels, 42¼ × 16½ in.
(108.7 × 42.3 cm) each
National Gallery, Zagreb
Nos. 81 and 243

Gronau (1930) attributed these to Giovanni, considering them stylistically very similar to the Bari *Saint Peter Martyr* (cat. 59), although not part of a single entity because the dimensions do not jibe; this opinion is shared by all later scholars, except for Gamba (1937), who

held that it came from a single triptych. Several scholars have situated it chronologically close to the *San Giobbe Altarpiece* (cat. 58), but we maintain that they should be dated later than the Bari panel. The identification of the *Saint Augustine* is not unanimous: the National Gallery catalog (1967) adopted Berenson's (1957) opinion that it is Saint Nicholas, although he lacks that saint's usual attribute of the three golden balls. According to Dussler (1935 and 1949),

both panels were executed by the workshop, while Robertson (1968) and Goffen (1989) posited the participation of an assistant; Heinemann (1962) specified this in the right sleeve, gloves, and lower part of the *Saint Augustine*. The painting's background was repainted, according to Bottari (1963). Aside from its fragile state of conservation and the retouching in nonessential areas, the two figures appear very effective, especially the heads, which are true portraits characterized by the same expressive intensity and spirituality of the lateral saints in *The Frari Triptych* (cat. 67); nevertheless, we must acknowledge the collaboration of the workshop because details such as the two crosiers are of poor quality and not taken from life, as would have been done by Giovanni.

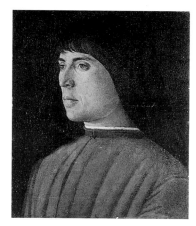

61

60

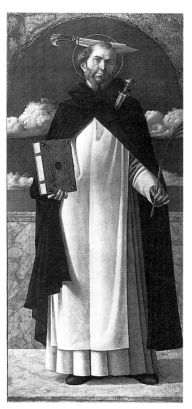

59

61. PORTRAIT OF A YOUNG MAN

Panel, 12½ × 10¹/₁₆ in. (32 × 26 cm)
Gemäldegalerie, Berlin
No. S. 12

This work came to the museum in 1904 as a gift of J. Simon. Published by Gronau (1922), it was accepted with reservations by Dussler (1935 and 1949); confirmed by Gamba (1937); listed by Berenson (1957); and considered autograph by Heinemann (1962), who emphasized its abysmal state of conservation and believed it to probably have been cropped. Pallucchini (1959), Bottari (1963), and Pignatti (1969), who dated it to the 1480s, and Goffen (1989) concurred with the attribution. Neither Robertson (1968) nor Huse (1972) mentioned

it. In the gallery's catalogs it was entered with a question mark in 1931, but definitively assigned to Giovanni in 1986.

Pignatti pointed out the difficulty of dating it because of its approach, which still recalls Antonello; in contrast with this are a more mature technique and softer and richer painting; nonetheless, she proposed the early 1480s, which is perfectly acceptable for a portrait that, despite its poor condition in areas, is powerfully evocative in the rendering of the absorbed expression and intense gaze of the sitter. These make it one of Giovanni's greatest achievements in this genre before *Portrait of Doge Leonardo Loredan* (cat. 93); the coloration is extremely effective, characterized

by the blue of the background, which sets off the line of the young man's tan face and the red of his doublet, whereas the area around his head covering looks rather opaque. Bottari's dating, to between the *Portrait of Jörg Fugger* (cat. 26) and the *Madonna with Greek Inscription* (cat. 22), is not acceptable.

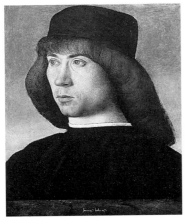

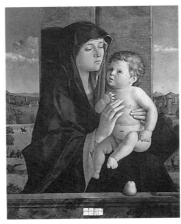

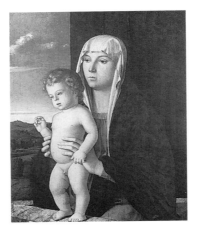

62

63

64

62. PORTRAIT OF A
YOUNG MAN

Panel, 12¹/₁₆ × 9¾ in. (31 × 25 cm)
Samuel H. Kress Collection, National
Gallery of Art, Washington, D.C.
No. 293

Signed *Ioannes·bellinus·* in lower-case letters on the parapet, an unusual practice that Giovanni would follow increasingly in the late works. It comes from the collection of Barthold Georg Niebuhr, who was the Prussian ambassador to the Papal court from 1816 to 1823, and who may have bought it in Italy. It passed through several hands before entering the Contini Bonacossi collection in 1935; from there, it passed in 1939 to the Samuel H. Kress collection, most of which is in the National Gallery of Art in Washington, D.C. Von Hadeln (1931) published it as by Giovanni Bellini, with a date of c. 1500. Dussler (1935 and 1949), Berenson (1957), Pallucchini (1959), Heinemann (1962), Bottari (1963), and Pignatti (1969) accepted the attribution; Huse (1972) did not mention it, and Goffen (1989) listed it as a painting done by the workshop. Robertson (1968) proposed a date in the 1480s or 1490s; the gallery's catalog (1979) cites Longhi's manuscript opinion, which situated it in 1480-85. The latter

seems to us to be the most likely date for this portrait of a young man with an absorbed and almost timorous air, in which the youthful tension of the gaze and features express a remarkable psychological concentration shot through with apprehension. This was a period when Giovanni was particularly interested in the work of his brother Gentile and when Giambellino was beginning his decoration of the Sala del Maggior Consiglio in the Doge's Palace, that is, after 1479; but we cannot push the dating of this panel too far, because the pictorial technique is still rather dry, without the rich glazing that characterizes the works of the artist's more advanced periods.

63. MADONNA OF
THE PEAR
(MORELLI MADONNA)

Panel, 33¼ × 25¾ in. (84.3 × 65.5 cm)
Gallerie dell'Accademia Carrara,
Bergamo
No. 958

See entry, p. 128.

64. VIRGIN WITH
THE STANDING
BLESSING CHILD
(NORTHAMPTON
MADONNA)

Panel, 28⅞ × 22⁹/₁₆ in. (74 × 58 cm)
Northampton Collection, Ashby
Castle, Northamptonshire

Signed IOANNES BELL / INVS·P· on a small card attached to the oblique parapet, a motif found also in the *Mond Madonna* (cat. 51) and the *Virgin Between Saints Peter and Sebastian* (cat. 50). The panel comes from the collection of Lady Ashburton and was shown with an attribution to Niccolò Rondinelli in the Venetian painting exhibition of 1894–95 in London; Fry (1925) returned it to Giovanni. Gronau (1930) accepted this, pointing out the similarities, especially in the figure of the Child, with *The Frari Triptych* (cat. 67) and the *Barbarigo Votive Altarpiece* (cat. 66). This opinion was seconded by Dussler (1935 and 1949), who saw in the Mary a variation of the figure in the Louvre and the one between two saints in the Accademia in Venice (cat. 71); he disagreed with the attribution to Rondinelli but was unable to take a position on the painting's autography. Berenson (1957) listed it, but Heinemann (1962) considered it a product of

the workshop with some participation on the master's part and derived in part from the *Barbarigo Votive Altarpiece;* strangely, this scholar advanced the hypothesis that Giovanni's assistant on this painting could be identified as the mediocre Francesco Tacconi. Bottari (1963) dated it to before 1485, which seems too early, since the similarities to the works of 1488 are unarguable, even if this one still seems somewhat immature; Robertson (1968) pushed the dating into the 1490s, seeing an invention by Giovanni in a painting executed in collaboration with assistants. Pignatti (1969) dated it to the 1480s, but Goffen (1989) ignored it.

The upper part of the Child is identical to the one in *The Frari Triptych* and the *Barbarigo Votive Altarpiece;* his legs suggest a movement that allows us to call him *gradiens;* the invention of his Mother holding him with both hands without embracing him, as in the *Frari* and in Murano, is very beautiful. The painting should be dated to 1486–87 and considered fundamentally autograph, probably with the hand of an assistant in Mary's face and in the clothing over her chest, which reveals some weaknesses of execution.

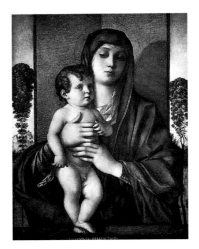

65

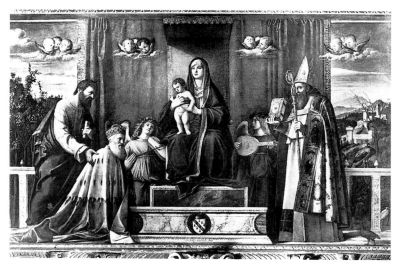

66

65. THE MADONNA OF
THE YOUNG TREES
Panel, 28¹⁵⁄₁₆ × 22⁹⁄₁₆ in.
(74 × 58 cm)
Gallerie dell'Accademia, Venice
Cat. no. 596

Signed ·IOANNES·BELLINVS·P· /
1487. It came to the gallery as part
of the Contarini gift in 1838. After
the *Portrait of Jörg Fugger* (cat. 26)
this is the oldest work by Giovanni
bearing a date. Morelli (1886), fol-
lowed by L. Venturi (1907), consid-
ered the signature spurious for no
reason. The state of conservation is
fragile, especially in the area of
Mary's mantle. It underwent a very
controversial restoration in 1902,
which, according to some scholars,
including Pallucchini (1959), seri-
ously damaged the painting surface;
this may be why he excluded the
work from the 1949 Venice exhibi-
tion. Robertson (1968) and Pignatti
(1969), minimizing the conse-
quences of the procedure, disagreed.
We may infer an idea of the original
colors from notes accompanying a
drawing by Cavalcaselle, which
Fogolari (1939-40) published.

This is without question a work
that seems to presage the pictorial
effects that the artist would achieve

in the first decade of the 1500s, as
Robertson pointed out. Today, a
date of 1487 is unanimously ac-
cepted. The problem of the two
trees has not been addressed beyond
their possible meaning, which
Robertson gives as the Old and
New Testaments; Heinemann
(1962) considered them at least
retouched. Stylistically as well, this
motif appears already to refer to
inserts typical of Perugino's future
work, inserts that entered Raphael's
earliest works and the Emilian
school, although somewhat later:
let us not forget that Perugino was
in Venice for the first time in 1494;
these might be echoes of Flemish
compositions such as Hans Mem-
ling's. The overall composition re-
peats the one Giovanni had used
earlier in devotional paintings of
this kind, as far back as the *Madonna
with Greek Inscription* (cat. 22), and
we find the Child and Mary's
hands again in *The Virgin Between
Saints Paul and George* (cat. 85), also
in the gallery, as Gronau (1930),
Heinemann, and Schmidt (1990)
pointed out. I disagree with
Pignatti, however, when she sees
in the hanging that leaves space
on either side an element typical

of the artist in this period; in fact,
it is a theme that appears as early as
the *Madonna with Greek Inscription,*
in the *Crespi Madonna* (cat. 24), and
in the Madonna in the Venetian
church of the Madonna dell'Orto
(cat. 35). Goffen (1989) emphasized
the position of the Child's little
feet, which overlap as in the Cru-
cifixion; the tender, yet apprehen-
sive way Mary looks at her Son;
and the frontal light that picks
them out, bringing them into the
viewer's space.

This is one of Giovanni's most
beautiful creations in this genre for
a private commission: here, Mary's
formal comeliness, seen frontally
in a pose that is both spontaneous
and hieratic, is emphasized by the
refinement of the drawing: every-
thing in this little painting is natu-
ral, as if, despite its respect for the
tradition of the Quattrocento, we
had already experienced the tonal
revolution and early-sixteenth-
century painting—not only Vene-
tian. Yet it would not make sense
to move the date forward, because
we would run the risk of situating
it in a period later than the conclu-
sion of Bellini's biography. There is
a replica of this panel that measures
29 × 22³⁄₈ in. (74.6 × 57.3 cm);
it is of good quality, but not auto-
graph, and was formerly in the von
Thyssen collection in Lugano, then
in the collection of former presi-
dent Marcos of the Philippines,
which was sold at Christie's in
New York in January 1991.

66. BARBARIGO VOTIVE
ALTARPIECE
Canvas, 78¾ × 126 in.
(200 × 320 cm)
Church of San Pietro Martire,
Murano

See entry, pp. 130-34.

67. THE FRARI
TRIPTYCH
*Enthroned Virgin with the Child
and Two Small Musical Angels*
Central panel, 72½ × 31⅛ in.
(184 × 79 cm)

*Saints Nicholas of Bari and Peter;
Saints Mark and Benedict*
Side panels, 45¼ × 18⅛ in.
(115 × 46 cm) each
*Sacristy, Church of Santa Maria
Gloriosa dei Frari, Venice*

See entry, pp. 136–38.

68. THE VIRGIN
BETWEEN SAINTS PETER
AND CLARE
*Canvas (transferred from panel),
29¼ × 19¹⁵⁄₁₆ in. (76 × 51 cm)*
*Samuel H. Kress Collection, National
Gallery of Art, Washington, D.C.
No. 538*

Signed IOANNES BELLINVS P. For-
merly in the Wysard collection,
Pangbourne, Buckinghamshire,
then in the Thompson collection
in Lake Forest, Illinois; from there
it went to Duveen in New York
and was sold in 1940 to Samuel H.
Kress, most of whose collection
passed to the National Gallery of
Art in 1943.

Valentiner (1926) published
it as an autograph work by Gio-
vanni. Gronau (1930), who was
unacquainted with the original,
pointed out the similarity between
its middle group and that of *The
Frari Triptych* (cat. 67), and between
its Saint Peter and the head of an
old man behind Christ's head in
the Uffizi's *Lamentation over the
Dead Christ* (cat. 74). Gamba (1937)
and later Dussler (1949), Pallucchini
(1959), and Pignatti (1969) con-
curred with the first comparison.
According to Heinemann (1962),
who considered it an autograph
work damaged in the transfer from

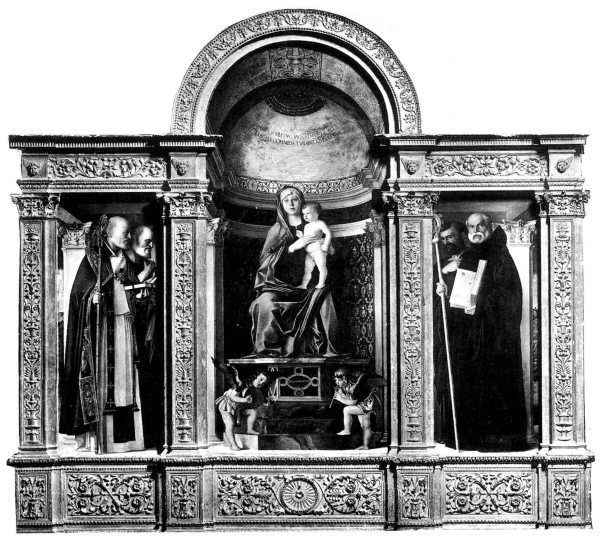

67

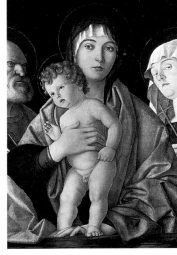

68

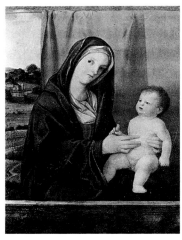

69

70

panel to canvas, the Washington, D.C., painting would be an earlier precedent than the Venetian triptych. In Berenson's (1957) opinion, it is attributable in part to Bellini, whereas Bottari (1962) considered it a collaboration or a product of the workshop. Robertson (1968), Huse (1972), and Goffen (1989) said nothing about it. According to the gallery's catalog (1941), the female saint would be Margaret, while Berenson hesitated between Helen and Clare. The painting was definitely cut off at the sides, as Heinemann had already pointed out. The gallery's most recent catalog (1979) cites Zeri's (1969) opinion that the painting is the replica of an original known to

him and in a private collection but not publishable. Absent the possibility of a comparison, the Washington painting is still the only record of a composition undoubtedly conceived by Giovanni very close in time to the *Barbarigo Votive Altarpiece* (cat. 66) and *The Frari Triptych* and to be added to his extensive series of paintings done for private devotions.

69. ROGERS MADONNA
Panel, 34⅝ × 27¾ in.
(88.9 × 71.1 cm)
The Metropolitan Museum of Art,
New York
No. 08.183.1

See cat. 70.

70. COOK MADONNA
Panel, 35½ × 26½ in. (91 × 68 cm)
Private Collection, Switzerland

Signed IOANNES BELLINVS, the former panel (cat. 69) came into the museum's collection in 1908 (in 1906, according to Pallucchini, 1959) and Fry assigned it to Giovanni that same year, dating it to c. 1480. Berenson (1957) proposed 1483, Gronau (1930) made it close to 1490, and Dussler (1935) went back to 1485, later (1949) accepting Gronau's date, as did Bottari (1963). Heinemann (1962) disagreed, because he did not see in the panel the greatness that the artist had already achieved in works created between 1475 and 1480. Robertson (1968) considered the

New York painting the finest of Bellini's Madonnas of the 1490s, all of which, with the exception precisely of the *Rogers Madonna,* he believed to have been done in collaboration with students; Pignatti (1969) believed it to have been executed in the decade between 1480 and 1490. This composition should be situated shortly after *The Frari Triptych* (cat. 67) and before the *Virgin with Red Cherubim* (cat. 72), on the evidence of the ample but not yet completely fluid drapery. Goffen (1989) considered it a product of the workshop, while Huse (1972) did not mention it.

Nearly all the scholars, except for the latter two, also accepted as autograph the following work, signed IOANNES BELLINVS and formerly in the Cook Collection, Richmond, Surrey, which differs from the *Rogers Madonna* in Mary's hands; the Child, who holds Mary's right thumb; and the landscape. In the New York landscape, for reasons unknown, Bottari thought he recognized a not otherwise identified village in Friuli.

Gronau believed the version formerly in the Cook collection, which Borenius (1912) attributed to Rocco Marconi, to be a variant from the workshop, and not entirely autograph; Dussler, Bottari, and Zeri (1973) agreed. The latter considered autograph another variant, in the Harrach collection in Vienna. Gamba (1937), however, maintained that it is autograph, seconded by Berenson (1957); Pallucchini, citing Morassi's (1958) concurrence; and Pignatti. Both these versions were undoubtedly painted by the master, who left to an assistant in the workshop the task of completing the less important parts, as was customarily the case when great heads of

schools were dealing with works made for sale.

71. VIRGIN WITH TWO SAINTS

Panel, 42⅛ × 61¾ in. (107 × 157 cm)
Gallerie dell'Accademia, Venice
Cat. no. 613

See entry, p. 140.

72. VIRGIN WITH RED CHERUBIM

Panel, 30 × 23¹³⁄₁₆ in. (77 × 61 cm)
Gallerie dell'Accademia, Venice
Cat. no. 612

Formerly in the Scuola della Carità, *Virgin with Red Cherubim* was attributed to Giovanni by Moschini (1815) and the suggestion was unanimously accepted. The controversy lies rather in the dating.

Crowe and Cavalcaselle (1871) dated it to the same period as the *Barbarigo Votive Altarpiece* (cat. 66) and *The Frari Triptych* (cat. 67). Fry (1899) agreed, but pointed out a resemblance he saw with the *Morelli Madonna* (cat. 63); Berenson (1916), who agreed with this, made the date of the panel earlier. Gronau (1930), on the basis of a hypothesis of L. Venturi (1907), pushed the date to close to the end of the century, an opinion that Longhi (1949) shared. Gamba (1937), Dussler (1935 and 1949), Pallucchini (1949 and 1959), Heinemann (1962), who approached it in time to both the Morelli and Rogers Madonnas and believed that Mary's hands revealed the participation of a student, and Pignatti (1969) essentially agreed that the painting was executed around 1490. Robertson (1968) maintained that it was earlier than *The Madonna of the Young Trees* (cat. 65), emphasized the reference to the Pesaro *Coronation*

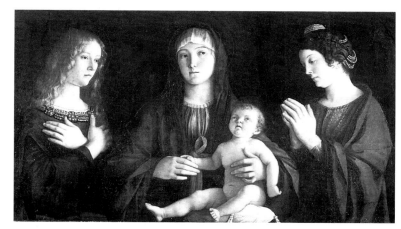

71

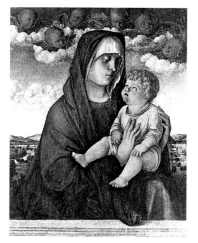

72

(cat. 27) in the red cherubim—although the motif would recur as late as in the Murano *Meditation* (cat. 115)—and dated the painting to the mid-1480s. Goffen (1989) saw the *Virgin with Red Cherubim* as an intermediate point between the Madonna formerly in the Contarini collection (cat. 43) and the one with young trees, rightly noting an iconographic precedent in Jacopo Bellini's *Virgin and Child* in the same galleries, its background entirely teeming with cherubim; the American scholar emphasized the beauty of the lenticular landscape, pointed out earlier by Bottari (1963) and Gamba, according to whom "the waters and houses are already whitening in the pale glints of dawn."

There exists in a private collection in Fiesole a mediocre replica of the painting, with a window in the background and a spurious signature, that came from a 1956 sale in Brussels.

See also the introductory essay.

73. THE VIRGIN WITH STANDING CHILD WHO HOLDS A FLOWERING TWIG HANGING FROM A THREAD

Panel, 24⅛ × 18⁹⁄₁₆ in. (62 × 47.6 cm)
Burrell Collection, Art Gallery, Glasgow

Formerly in the Barberini collection in Rome, in 1936 it passed into the Burrell collection in the Art Gallery, Glasgow. Assigned to Pasqualino Veneto by Crowe and Cavalcaselle (1871) and to Niccolò Rondinelli when it was in Palazzo Barberini, it was restored to Giovanni by Gronau (1930), and later by Berenson (1957), Heinemann (1962), and Pignatti (1969). Dussler (1949) believed it to be from a cartoon by the master; Pallucchini (1959) and Bottari (1963) considered it autograph in part; and Robertson (1968) considered it executed with a collaborator, a view with which Goffen (1989) concurred.

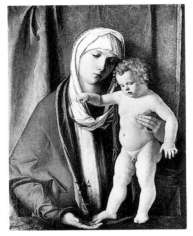

73

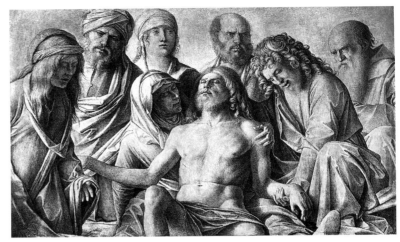

74

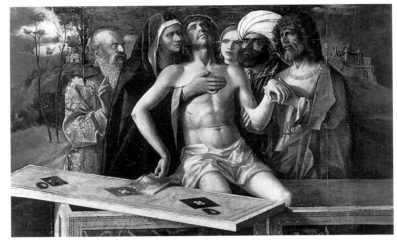

75

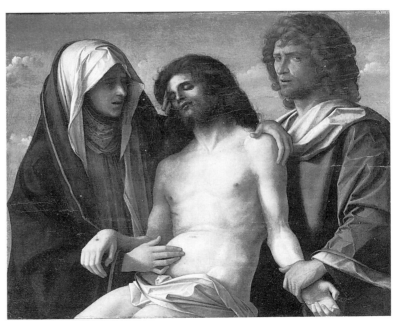

76

74. THE LAMENTATION OVER THE DEAD CHRIST (PIETÀ)

Panel, 29⅛ × 46½ in. (74 × 118 cm)
Galleria degli Uffizi, Florence
No. 943

See entry, pp. 142–44.

75. THE DEPOSITION INTO THE TOMB

Panel, 26 1/16 × 33½ in. (67 × 86 cm)
Sacristy, Cathedral, Toledo, Spain

See cat. 76.

76. THE LAMENTATION

Panel, 26½ × 33½ in. (68 × 86 cm)
Gemäldegalerie, Berlin
No. 4

The Toledo panel is signed IOANNES BELLINI at the edge of the sarcophagus on the left and *Joannes Bellinus* in Gothic script on the front of the sarcophagus on the right; the latter inscription was without doubt added later. The provenance of the painting is unknown; the work reprises the theme of the Lamentation, this time situating it with clear indications of the place of burial. The middle group, certainly conceived by Giovanni, is extremely effective; he also painted the Christ frontally, seated on the edge of the sarcophagus, his body abandoned and, as it were, supple in death; the grieving Mother, her little finger typically separate from the other fingers; a Saint John so rapt in sorrow that his gaze appears transformed into prophetic vision. I have written on another occasion (1986) that the other three figures, however, should be considered inserts added by a collaborator of Cima da Conegliano, into whose workshop the painting may have passed at a later date; all the scholars specified that the two panels with the land-

The dating varies between Dussler's 1485–88, Pignatti's 1488, Heinemann's "not later than 1489," and the 1490s, in which Robertson situated it. After the last restoration, its autography appeared plausible; the remarkable number of derivations confirms that there must have existed a cartoon in Giovanni's workshop that various students—among them certainly Pietro Duia—used.

Pallucchini referred to a replica dated 1489 in the collection of the Contessa Brentano in Bergamo, while an undistinguished copy exists in the Museo Borgogna in Vercelli. According to Pignatti, the Glasgow panel is the prototype for a *Madonna of the Pear,* which is not autograph, in the Stuttgart Staatsgalerie (see cat. 48 and 63); in fact, the Child in the latter painting is closer to the one in *The Frari Triptych* (cat. 67).

scapes on the sides were added, as were parts of the two outer figures.

Related to the Toledo painting are two derivations that may be considered copies, in the Hermitage in St. Petersburg and the Museo Civico in Padua, respectively; a Stuttgart painting; and one in the National Museum in Warsaw with the identical composition but with a donor added and bearing a dubious signature of Giovanni Mansueti.

The Stuttgart panel, which has the inscription IOANNES BELLINVS, was in the Contarini collection, then in the Barbini-Breganze collection in Venice. Gronau (1930), Gamba (1937), and Berenson (1957) considered it autograph; Heinemann (1962) attributed to Giovanni at least the figure of Christ, which actually is quite flawed, especially in the face; all the other scholars believed it to be a product of the workshop, and Robertson (1968) attributed even the preparatory drawing to students.

Compared with the Uffizi *Lamentation* (cat. 74), all those under consideration seem lesser, aside from the conception and execution of the principal figures in the Toledo painting, which are attributable to the master. In the Stuttgart and Warsaw versions, the Saint John is once more very much in Cima's style, as evidenced by the fact that he reappears transformed into Saint James the Great in the polyptych in the parish church of Ornica, in Bergamo province, a painting that came from the workshop of the master from Conegliano. The types of Mary and Saint John that we see in Toledo recur in the Berlin panel, which the German critics unanimously considered to be autograph or at least conceived by Giovanni, after Gronau attributed it to him, a

change of mind after his earlier (1928) inclusion of the panel in his catalog of the pseudo-Basaiti. We may mention that Huse (1972), too, pointed out that the Toledo and Stuttgart paintings appear to have at least interested Cima. Goffen (1989) said nothing about this entire series. The dating would be to around the mid-1490s.

77. FOUR ALLEGORIES (VINCENZO CATENA'S "RESTELO")

(1) FORTUNE/MELANCHOLY
Panel, 13⅜ × 8⅝ in. (34 × 22 cm)

(2) VAINGLORY
Panel, 13⅜ × 8⅝ in. (34 × 22 cm)

(3) PERSEVERANCE
Panel, 12½ × 8⅝ in. (32 × 22 cm)

(4) ENVY/SLOTH
Panel, 13⅜ × 8⅝ in. (34 × 22 cm)
Gallerie dell'Accademia, Venice
Cat. no. 595

See entry, pp. 146–47.

78. THE PRESENTATION OF JESUS IN THE TEMPLE
Panel, 24¾ × 31¹³⁄₁₆ in.
(63.5 × 81.5 cm)
Kunsthistorisches Museum, Vienna
No. 117

This work comes from the castle of Bratislava. The museum's old catalog (1907) attributed it to Francesco Bissolo but also cited Frimmel's suggestion of Vincenzo Catena's authorship; it was considered autograph in the next catalog (1928), and Berenson (1932 and 1957) and Gamba (1937) concurred. It was cut down to give it its oval shape. It is generally held to be the best of several replicas, all of them derived from a lost prototype by Giovanni

77 (2)

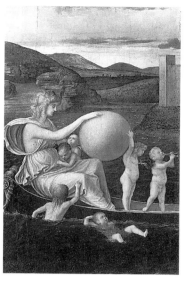

77 (1)

77 (4)

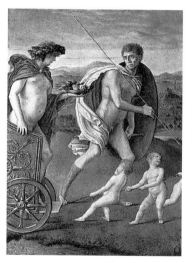

77 (3)

Bellini. But Dussler (1949) and Goffen (1989) preferred the work signed IOANNES BELLINVS • in the Borchard collection, which passed to the Metropolitan Museum of Art in 1968 (panel, 29 × 38¾ in. [74.3 × 99.4 cm], no. 68.192), in which the sky sets off the figures. Robertson (1968) and Huse (1972), on the other hand, referred to the version belonging to the Museo di Castelvecchio in Verona (panel, 29⅝ × 42⅛ in. [76 × 108 cm], no. 18). This one is also signed, and the left-hand figure—which in the Vienna and New York paintings is the prophet Anna, repeating, as does the Saint Joseph, an

idea expressed earlier in the Uffizi *Lamentation* (cat. 74), as Lucco (1990) had already pointed out—is replaced with a woman carrying a basket with two doves, modeled after the Saint Catherine of the *San Zaccaria Altarpiece* (cat. 106)

See also the introductory essay.

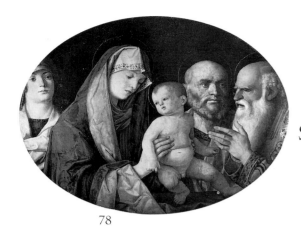

78

79. PORTRAIT OF A YOUNG MAN WITH LONG HAIR

Panel, 12½ × 10¹/₁₆ in. (32 × 26 cm)
Musée du Louvre, Paris
No. 1158a

Berenson (1932 and 1957); Dussler (1949), who dated it to 1490–95; Fiocco (1960); Heinemann (1962); Bottari (1963); Robertson (1968); and Pignatti (1969) all argued for the authenticity of the Louvre panel. Robertson placed it in the 1480s or '90s, identifying the one with red hair in the Uffizi (no. 1863) as not autograph, whereas Pignatti made the point that the group to which this portrait belongs ought not be confused with the series of about ten years later to which the Padua *Portrait of a Young Senator* (cat. 92), the London *Leonardo Loredan* (cat. 93), and the so-called "*Pietro Bembo*" at Hampton Court (cat. 96) belong. Dal Pozzolo (1993) suggested an alternative attribution of this small portrait to Andrea Previtali, a tempting opinion, although it is based solely upon stylistic comparisons. No final decision on the panel's autography can be made before it is restored.

See also the introductory essay.

80. PORTRAIT OF A BLOND YOUNG MAN

Panel, 13¼ × 10 ³/₁₆ in.
(34 × 26.5 cm)
Pinacoteca Capitolina, Rome
No. 47

Signed IOANNES BELLINVS / P•. According to seventeenth- and eighteenth-century inventories of the gallery, this is a self-portrait, an identification that Crowe and Cavalcaselle (1871) and Morelli (1897) rejected, the latter assigning it to Niccolò Rondinelli. Gronau (1930) accepted it as autograph, as did all later scholars, with the single exception of Goffen (1989), who judged it done in collaboration with an assistant.

Dussler's (1935 and 1949) proposed date of c. 1500, which seems reasonable to us, was accepted by Pallucchini (1949 and 1959), Heinemann (1962), and Pignatti (1969); Berenson (1932), followed by Robertson (1968), placed it in the twenty years between 1480 and 1500. Bottari (1963) dated it close to the paintings in the Louvre (cat. 79) and in Padua (cat. 92), both datable to a little before 1485. Only Gamba (1937) pushed the date to 1515, while Huse (1972) established a comparison between the sitter and the Saint Sebastian of the *San Giobbe Altarpiece* (cat. 58), pointing out a similar dignity in the portrait but less idealization; we may infer that he considers the two works contemporary.

Shown as no. 108 at the 1949 Venice exhibition.

See also the introductory essay.

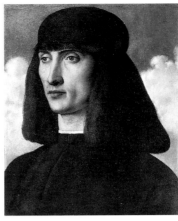

79

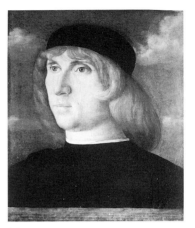

80

81. PORTRAIT OF A YOUNG MAN WITH CURLS

Panel, 11⅝ × 7 ¹³/₁₆ in. (30 × 20 cm)
Samuel H. Kress Collection, National Gallery of Art, Washington, D.C.
No. 365

Signed •IOANNES•BELLINVS•. From the Carvendon collection in London, then the Harding collection in New York, this painting was recognized as autograph, with a date of around 1500, by Gronau (1930), Berenson (1932), Dussler (1949), Heinemann (1962), Bottari (1963), Robertson (1968), and Pignatti (1969); only Goffen (1989) considered it a product of the workshop.

This is one of Giovanni's most successful works in this genre: the personage, set off by the sky, communicates to us the young man's strong-willed serenity; his black clothing, along with the little white collar and cap, identify him as belonging to the same social, and probably bureaucratic, category whose representatives, in a compact group, attend Saint Mark's sermon in the painting that Giovanni completed after Gentile's death and that is now in the Pinacoteca di Brera (cat. 113).

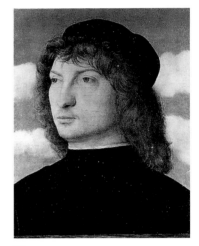

81

82. TWO FRAGMENTS OF "THE TRANSFIGURATION"

(1) HEAD OF CHRIST
Panel, 12¹⁵/₁₆ × 8⁹/₁₆ in. (33 × 22 cm)

(2) SIGNATURE IOANNES BELLI / NVS MEPINXIT•
Panel, 12¹/₁₆ × 8⁹/₁₆ in. (31 × 22 cm)
Gallerie dell'Accademia, Venice
Cat. no. 87

These panels come from the Contarini collection in Venice. Cantalamessa (see Moschini Marconi, 1955) identified them as the only surviving fragments of *The Transfiguration*, which A. M. Zanetti (1733) remembered as being in the Venetian church of San Salvador and which is usually identified as the one in the Museo Civico Correr

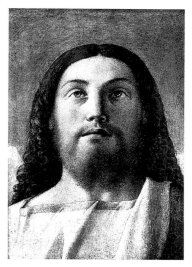

82 (1)

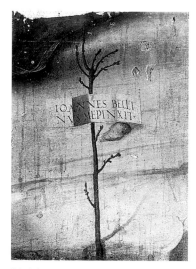

82 (2)

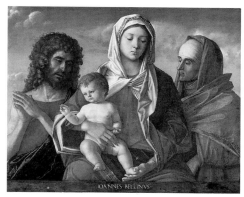

83

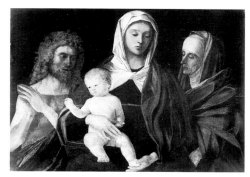

84

84. VIRGIN AND CHILD BETWEEN THE BAPTIST AND SAINT ELIZABETH

Panel, 27 3/16 × 34 15/16 in.
(70 × 89.5 cm)
Galleria Nazionale delle
Marche, Urbino
No. 643

The Frankfurt work is signed
•IOANNES BELLINVS•. It was pur-
chased in 1833 from the Baranow-
sky Gallery in Vienna. Gronau
(1930), followed by Berenson (1932
and 1957), Pallucchini (1959),
Bottari (1963), and Pignatti (1969),
attributed it to Giovanni, while
Dussler (1949) considered the
composition to represent a juxta-
position of individual figures and
accepted a connection only with
Bellini's works of the 1490s. Heine-
mann (1962) found the Urbino
panel to be of better quality than
the one in Frankfurt, albeit in a
terrible state of conservation, and
proposed that they were both deri-
vations from a single original, now
lost. Schmidt (1990), too, consid-
ered them to be high-quality
works executed in the workshop.
The Urbino painting was attrib-
uted to Giovanni by Zampetti
(1950), who rejected the autogra-
phy of the one in Frankfurt. Nei-
ther Robertson (1968), Huse
(1972), nor Goffen (1989) men-
tioned the composition. The
middle group recurs in works by
Niccolò Rondinelli, Vincenzo
Catena, and Lattanzio da Rimini,
as well as in other versions that
cannot be specifically attributed.
We cannot swear to the absolute
autography of the Urbino panel,
which was restored in 1968; never-
theless, it appears that, despite the
loss of all the glazing, it gives us a
much better idea of Giovanni's
conception, a more mature para-
phrase of the ideas expressed in the

Louvre and Washington, D.C.,
paintings (cat. 50 and 68), only a
few years after the Uffizi *Lamenta-
tion* (cat. 74). We don't have to see
Rondinelli's hand in the Frankfurt
painting—as Heinemann hypothe-
sized—to see the touch of Vittore
Belliniano, who worked with Gio-
vanni in the Doge's Palace after 1507
and who completed the monu-
mental canvas *The Martyrdom of
Saint Mark* for the Scuola Grande di
San Marco (cat. 126) following the
death of the head of the school.

(cat. 7). Later, all the scholars
acknowledged the panels as authen-
tic, almost unanimously considering
them parts of *The Transfiguration*
because of the white robe and
Christ's transcendent gaze. Only
Berenson initially (1916) thought
that they might belong to the
Supper in Emmaus of 1490, which
we know only from copies, the
most important of which is in the
same church in Venice. Bottari
(1963) generically assigned the
works to an altarpiece, while Huse
(1972) spoke of a head of Christ,
which he compared with those of
Saints Francis, John the Baptist,
and Sebastian in the *San Giobbe
Altarpiece* (cat. 58); this one differs
in its hieratic quality. He evidently
considered the two works to be
contemporary, as Goffen (1989)
did later, also holding the altar-
piece from which these two panels
survive to be coeval with the
Naples *Transfiguration* (cat. 57).
Robertson (1968) dated them to
ten years later, Dussler (1949)
tended toward 1495–1500, and
Heinemann (1962) placed them at
around 1500 or later, while Bottari
and Pignatti (1969) saw them as
close to the Vicenza *Baptism of
Christ* (cat. 100), that is, executed

in the first years of the new cen-
tury. It is not easy to express a con-
fident judgment about two such
small pieces, yet, just as the still
somewhat lenticular way in which
all the natural elements in the frag-
ment with the signature are exe-
cuted and the very blended paint
with its light glazing on the divine
figure persuade us that we are
looking at the relics of a master-
piece, so do they lead us to opt
for a fairly late date, but not later
than the early 1490s.

83. VIRGIN AND CHILD BETWEEN SAINTS JOHN THE BAPTIST AND ELIZABETH

Panel, 28 1/8 × 35 1/8 in.
(72.3 × 90.2 cm)
Städelsches Kunstinstitut, Frankfurt
No. 853

See cat. 84.

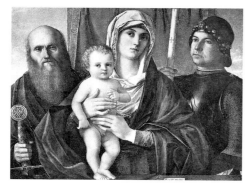

85

86

85. THE VIRGIN BETWEEN SAINTS PAUL AND GEORGE

Panel, 25¾ × 34³⁄₁₆ in. (66 × 88 cm)
Gallerie dell'Accademia, Venice
Cat. no. 610

Signed IOANNES BELLINVS. This painting comes from the Venier collection in Venice. Crowe and Cavalcaselle (1871) dated it to between 1483 and 1487, seeing it as a prototype of *The Madonna of the Young Trees,* also in the Gallerie dell'Accademia (cat. 65), from which it obviously derives; witness the more ample shapes, as Moschini Marconi (1955), Pallucchini (1959), Bottari (1963), and Pignatti (1969) emphasized, but especially in the middle group, a very banal version of the one in the model, which, as we have seen, constitutes one of Giovanni's greatest achievements among the Madonnas he painted for private devotion.

In the present case, we have a painting of remarkable quality in the treatment of the two saints, especially the strong-willed Saint George, in which Pignatti believed, probably correctly, she could see the client's portrait. The middle group, however, was assigned to a student, perhaps Francesco di Simone da Santacroce, who was active in Giovanni's workshop after 1492 (see cat. 87). The participation of assistants in this painting was hypothesized or proved by Pallucchini, Robertson (1968), and Goffen (1989), who actually reversed the situation, proposing the master's mere participation. Besides the scholars already mentioned, Gronau (1930)—the first to refer to the replica, then in the Pallfry collection, today in the Fine Arts Museum in Budapest (no. 4243), in which Saint Catherine replaces Saint George—Dussler (1935 and 1949), Berenson (1957), and Heinemann (1962) also argued for the painting's autography, while Huse (1972) said nothing. Schmidt (1990) pointed out the absence of dialogue between the figures, who are seated frontally, although none of them really look at us.

We are probably looking at one of those paintings that the master oversaw but left in part to students during the period of his most intense activity in the Doge's Palace, according to the late Gibbons's (1965) interpretation of the division of tasks in Giovanni's workshop. In this case, Giovanni felt obligated to execute the saints himself, leaving space for a student to paint the Virgin and especially the Child.

86. THE CIRCUMCISION OF THE CHRIST CHILD

Panel, 29⅛ × 39⅞ in.
(74.9 × 102.2 cm)
National Gallery, London
No. 1455

Signed IOANNES / BELLINVS. Heinemann (1962), it derives from a prototype by Gentile Bellini, recalled by Ridolfi (1648) and Lanzi (1789) in the Palazzo Barbarigo della Terrazza in Venice, whereas Moschini Marconi (1815) cites another work, also signed by Gentile, in Palazzo Grimani, near Santa Maria Formosa.

Crowe and Cavalcaselle (1871) considered the version today in London as autograph by Giovanni, as did Berenson (1916), who dated it to around 1500; Gronau (1928 and 1930), who believed it to have been executed in 1502–3; and Gamba (1937). Other scholars have generally held it to be the most faithful copy, executed in the workshop, of the lost original. This is probably the painting that in Ridolfi's time was in the Muselli collection in Verona; it is certain that it then passed into the collection of the duke of Orléans; it came to the National Gallery from the collection of the earl of Carlisle at Castle Howard.

See also the introductory essay.

87. VIRGIN AND CHILD WITH SAINTS PAUL AND GEORGE, TWO FEMALE SAINTS, AND DONOR (POURTALÈS SACRA CONVERSAZIONE)

Panel, 29¼ × 42⁹⁄₁₆ in.
(75 × 109.2 cm)
Pierpont Morgan Library, New York

A bequest of Cardinal Rezzonico of Venice to Antonio Canova, this painting then passed to the artist's bishop brother, from whom it passed into the Pourtalès collection in Paris. It was sold in Paris in 1865, when Gaillard engraved it; it successively entered the Salamanca collection, and that of the marquis de la Ganay. It was exhibited at the Royal Academy in London in 1912.

Crowe and Cavalcaselle (1871) were cautious about its autography; Berenson initially (1916) considered it to be just a product of the workshop, but later (1957) cataloged it as a late work and partly autograph.

The *Pourtalès Sacra Conversazione* was considered autograph by Gronau (1930) and Gamba (1937), largely so by Pallucchini (1959), and was accepted by Pignatti (1969); according to Dussler (1949); Heinemann (1962), who dated it to shortly before the *Portrait of Doge Leonardo Loredan* (cat. 93); Goffen (1989); and Schmidt (1990), it is a product of the workshop, based upon models by the master. Schmidt rightly pointed out how the composition belongs to a group in which Giovanni and his students were attempting a more articulated arrangement of the figures. Here in particular the proposed solution is asymmetrical, as in the earlier style of Andrea Mantegna and in the *Barbarigo Votive Altarpiece* (see cat. 66); we are at the beginning of the evolutionary process that reached its most confident developments with Titian and Palma Vecchio. The dating of the painting in question to around 1500, as proposed by Heinemann and Schmidt, seems acceptable, also in light of the chronology of the followers who were inspired by this invention of the master's.

See also the introductory essay.

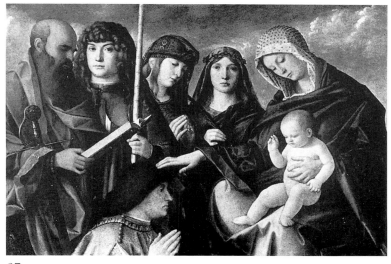

87

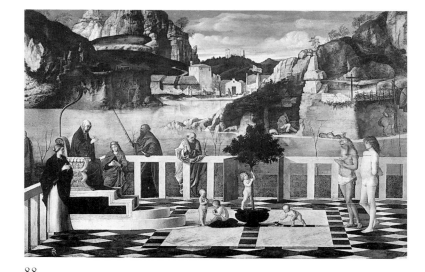

88

88. SACRED ALLEGORY

Panel, 28¾ × 46⅞ in. (73 × 119 cm)
Galleria degli Uffizi, Florence
No. 903

See entry, pp. 152-56.

89. THE PRIULI
TRIPTYCH

Panels, middle: 50³/₁₆ × 25 in.
(129 × 64 cm), lateral: 50½ × 20⅞ in.
(129.5 × 53.5 cm) each
Kunstsammlungen der Stadt,
Düsseldorf
No. 1110

Signed IOANNES / BELLINVS / F• in
the middle panel (F = "faciebat"
in Latin = made [this]). This trip-
tych comes from the Chapel of
the Cross in the church of San
Michele in Isola, Venice, built by
Pietro Priuli and still under con-
struction in 1495. The donor is
represented on the right lateral
panel, on the opposite side of the
figure addressed by the Child's
blessing gesture; according to
Goffen, this was the choice of the
client, a very humble man, who
did not demand a completely auto-
graph work and who selected an
extremely simple marker for him-
self, without a coat of arms; this is

an endorsable thesis. The triptych
passed from the antiques market to
Düsseldorf's public art collections
in 1831.

It was considered a work pro-
duced by the workshop; only
Gamba (1937) maintained that at
least the middle part is autograph.
Pallucchini (1959) and Bottari
(1963) didn't even mention it.
In actual fact, the commission is
confirmed by Priuli's will, drawn
up in 1491. All the scholars agreed
that the work was not completed
until after 1500: in 1503–5, accord-
ing to Berenson (1957); Robertson
(1968) held it to be contemporary
with the Brera *Virgin with the
Blessing Child,* dated 1510 (cat. 117);
Pignatti (1969) dated it to 1505–10;
and Goffen to 1506–7. It is not
easy to establish a precise chronol-
ogy; we are certain it was made in
the early years of the new century
and that the execution was entirely
by the workshop.

The middle panel is based on a
drawing invented by the master;
the lateral panels—for which
Heinemann (1962) constructed a
"Master," assigning him, not
without reason, the problematic
Dominican Saint in the Stuttgart

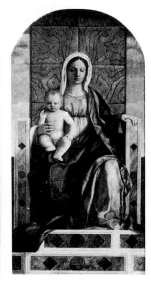

89

Staatsgalerie (no. 2210)—and the
conception of the figures are
assignable to a follower not rigidly
in Bellini's mold, but sensitive to
echoes of the Tusco-Umbrian
figurative culture, perhaps the one
that emerged from the work of
Bartolomeo della Gatta, from the
Veneto, who also painted the
Virgin Enthroned with Saints that
replaced Giovanni Bellini's de-
stroyed altarpiece (see cat. 25) on
the first altar on the right in the
Venetian church of Santi Giovanni
e Paolo. There is some likelihood
that the painter can be identified
with the young Benedetto Diana,

even if Lucco (orally) suggested
Marco Basaiti.

90. CHRIST BEARING
THE CROSS

Panel, 18⅝ × 14⁹/₁₆ in. (48 × 37.5 cm)
Toledo Museum of Art, Ohio
No. 40.41

See cat. 91.

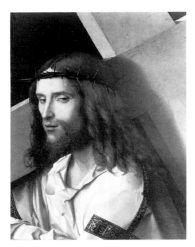

90

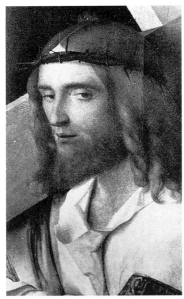

91

91. CHRIST BEARING
THE CROSS
Panel, 18¹⁵⁄₁₆ × 10½ in.
(48.5 × 27 cm)
Pinacoteca dell'Accademia del
Concordi, Rovigo
No. 142

This compositional idea by Giovanni Bellini has come down to us in several very similar versions; over time, critics have selected as the prototype in the master's hand either the one today in the Toledo (Ohio) Museum of Arts or the one in Rovigo. We should add as noteworthy the one in the Gardner Museum in Boston, which most of the scholars reasonably identify as

by Giorgione, in one of his earliest efforts, from an idea outlined by the old Venetian head of his school. Other replicas of Giovanni's original are the former no. 34 in the Kaiser-Friedrich-Museum in Berlin, assigned to Girolamo da Santacroce in the 1931 catalog; no. 4220 in the Fine Arts Museum in Budapest, which we attributed to Marco Bello (1984) and which was also cited by Goffen (1989); as well as certain copies, among which we include only the one formerly in the Lanckoronski collection in Vienna and no. 177 of the Staatsgalerie in Stuttgart.

The problem debated by the critics centers on the identification of the painting mentioned by Michiel (1521–43) as being in the home of Taddeo Contarini in Venice. Gronau (1930) and Huse (1972) did not address the dilemma; Dussler (1949) referred to the Rovigo and Boston works but did not propose a solution; Heinemann (1962) cataloged fifty-five copies or derivations of the original, which he believed to be lost, that he thought to have been created during Leonardo's period in Venice; while Berenson (1957) and Pallucchini (1959) accepted the Toledo panel as autograph, recalling that Richter (1939), then Tietze (1940), had assigned it to Giovanni. Bottari (1963) did not take a position, but referred to Valcanover's (1962) opinion that the Rovigo painting is one of Giovanni's masterpieces. Robertson (1968) maintained that the Toledo painting is the only autograph work of the series, recalling the Uffizi *Lamentation* (cat. 74) and referring forward to the Besançon *Drunkenness of Noah* (cat. 125); Pignatti, on the other hand, opted once more for the painting in

Rovigo, and Goffen considered the original to be lost. Judging from the crumpled drapery, we are certainly in the very early 1500s. The Boston painting—attributable, as we have said, to Giorgione—is characterized by the absorbed and very lively expression on Christ's face, which instead, in both the Toledo and Rovigo paintings, presents a clouded, suffering gaze; in every version, he wears a kind of dalmatic reminiscent of the robe in the Louvre's *Blessing Christ* (cat. 17). It is hard to affirm the absolute autography of a painting that one has only infrequently seen, but the Rovigo and Toledo panels were surely executed in Giovanni's workshop with the master's direct participation. The Rovigo painting, as well as a replica then in the Rosenberg collection in New York, was shown in the exhibition *Giorgione e i giorgioneschi* in Verona (1955).

92. PORTRAIT OF A
YOUNG SENATOR
Panel, 13⁹⁄₁₆ × 10³⁄₁₆ in.
(35 × 26.4 cm)
Fondo Emo Capodilista,
Museo Civico, Padua
No. 43

Berenson initially (1907) assigned this work to Niccolò Rondinelli but later (1957) cataloged it as a work of Giovanni's. A. Venturi (1915) assigned it to Antonello da Messina, but Gronau (1922) returned it to Bellini, and von Hadeln (1927) seconded his opinion, as did all succeeding scholars except Robertson (1968), who considered it "perhaps never more than the work of a follower," and Huse (1972), who did not mention it. The proposed dating is less unanimous: we believe it to be datable to the early 1500s on the

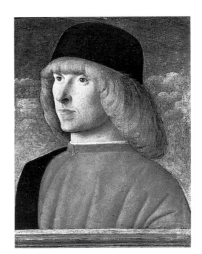

92

basis of the rich pigments and blended style, which by that time was different from the portraits assignable to the last decade of the previous century (see cat. 79–81); we agree here with Dussler (1949), who considered it one of the best of Giovanni's portraits that have come down to us; Goffen (1989) was perhaps of the same opinion, since she discusses this painting immediately before *Portrait of Doge Leonardo Loredan* (cat. 93). The apparent similarity—a merely chromatic one—with the *Mellon Portrait* in Washington, D.C. (cat. 46), threw off both Robertson and Bottari (1963), the latter opting for 1480-85; Pignatti (1969), who proposed 1485–90; and evidently also Banzato (1988), who dated it to the 1480s; whereas Berenson (1907) remained cautiously between 1480 and 1500; and Heinemann (1962) went as late as shortly after 1495.

This is a delightful portrait, displaying Hans Memling's influence more than Antonello's, as Pallucchini (1949) rightly observed.

Shown as no. 106 in the 1949 Venice exhibition.

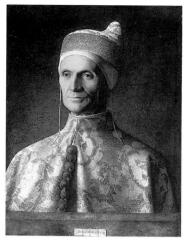

93

93. PORTRAIT OF DOGE LEONARDO LOREDAN

Panel, 24¼ × 17¾ in. (61.5 × 45 cm)
National Gallery, London
No. 189

See entry, p. 158.

94. PORTRAIT OF DOGE LEONARDO LOREDAN WITH FOUR MAGISTRATES

Panel (from canvas), 53⁹⁄₁₆ ×
82³⁄₁₆ in. (137.5 × 211 cm)
Staatliche Museen, Berlin
No. B 79

See cat. 93.

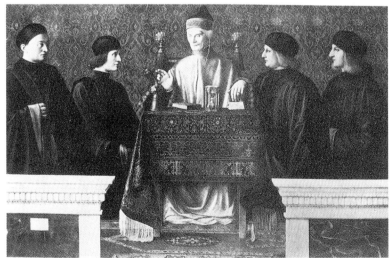

94

95. SAINT DOMINIC

Panel, 16¾ × 10¹⁵⁄₁₆ in. (43 × 28 cm)
Formerly in the Hickox Collection,
New York

Signed IOANNES BELLINVS. Gronau (1930), Heinemann (1962), and Goffen (1989) identified it with the painting executed in 1501 for Alfonso d'Este, the future Duke Alfonso I; Dussler (1949), Robertson (1968), and Pignatti (1969) expressed the same opinion, but with reservations. A. Venturi (1926) confirmed the attribution, and all the later scholars accepted it, except for Pallucchini (1959),

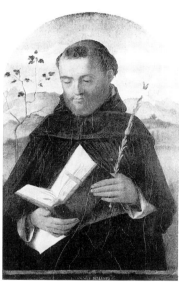

95

Bottari (1963), and Huse (1972), who did not mention the work. The date is not unanimously agreed to be 1501: Dussler placed the painting at around 1500-1510, and Robertson considered it very close in time to the Vicenza *Baptism* (cat. 100). The painting's stylistic features suggest a date slightly later than the very first years of the century; the uncertainty of the drawing on the left-hand side could support Goffen's opinion that it was executed with the participation of an assistant. In all the recent literature, it has appeared as being in the Hickox collection in New York, except that Goffen had it as belonging to Frederick R. and Jan Mayer, but gave no location.

96. PORTRAIT OF A MAN ("PIETRO BEMBO")

Panel, 16⁹⁄₁₆ × 13³⁄₁₆ in.
(42.6 × 34.1 cm)
Royal Collections, Hampton Court (on loan to the National Gallery, London)
No. 277

Signed *Joannes bellinus.* This panel was in the collection of Charles I Stuart, and before then perhaps in the collections of the marchesi of Mantua.

This is considered to be the portrait executed before Pietro Bembo became cardinal and was recalled by Ridolfi (1648). Pallucchini (1949 and 1959), Bottari (1963), and Pignatti (1969) agreed. Although they did not reject the identification, neither did Robertson (1968) and Goffen (1989) definitely confirm it, which in fact seems reasonable. Huse (1972) ignored the painting about which Crowe and Cavalcaselle (1871) had remained uncertain; Berenson (1894) had proposed it as a work by Francesco Bissolo but subse-

quently (1957) cataloged it as a late work by Giovanni Bellini. The other scholars accepted it as autograph, except for Dussler (1935 and 1949). Everyone was also unanimous in dating it to the first years of the new century: Pallucchini, Bottari, and Pignatti placed it at around 1505; Robertson saw similarities between its landscape and the one in the *Dolfin Sacra Conversazione* (cat. 112), thus opting for 1507; Heinemann thought around 1510, and Goffen indicated 1505-10.

It is a portrait that must be dated to a fairly late period, around 1505, because of the complete blending of form and color and the relationship between figure and landscape, their lines harmonizing with great fullness, as Goffen also noted.

97. HEAD OF CHRIST

Panel, 16¾ × 12½ in. (43 × 32 cm)
Academia de San Fernando, Madrid
No. 450

In a note, Crowe and Cavalcaselle (1871) mentioned this head of Christ, signed *Joannes Bellinus,* as similar in typology and character to the one in the Naples *Transfiguration* (cat. 57); the two scholars hypothesized that it could be identified with the one recalled by

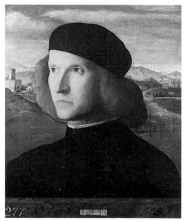

96

97

Boschini (1674) as being in the Scuola della Carità in Venice. Gronau (1930) accepted it and cataloged other similar paintings, on which the sources give information, as did Gamba (1937), who believed it to be contemporary with *The Virgin Between Saints Paul and George* (cat. 85); Berenson (1957); Heinemann (1962); Bottari (1963), who cites Rocco Marconi's replica in the sacristy of the Salute in Venice; Robertson (1968), who considered it the best version of all those derived from the lost *Supper in Emmaus;* and Pignatti (1969), who dated it to 1502. Neither Dussler (1935 and 1949), Huse (1972), Goffen (1989), nor Tempestini (1992, catalog) mentioned it. It is a painting of extremely high quality, datable to the first years of the new century.

98. BLESSING CHRIST, FULL LENGTH

Canvas (from panel), 62 × 34⅝ in. (159 × 89 cm)
National Gallery of Canada, Ottawa, No. 328

There is no certainty that this panel, transferred to canvas, is an autograph by Giovanni Bellini. It must, however, be cited as a record of the existence of a similar com-

positional idea conceived by the painter and documented by other versions, such as the replica in the Gemäldegalerie in Berlin (no. 3) and Cima da Conegliano's variant in the Gemäldegalerie in Dresden (no. 61), which bears a false signature of Giovanni Bellini's, and which, according to Humfrey (1983) is the protoype for the derivations from Giovanni's workshop, among them this one in Ottawa, which Berenson (1932 and 1957) and Pallucchini (1959) considered autograph, while Heinemann (1962) believed it to be the best replica of a lost original, and Bottari (1963) cataloged it as an attributed work. Robertson (1968), Huse (1972), Goffen (1989), and Tempestini (1992, catalog) ignored it.

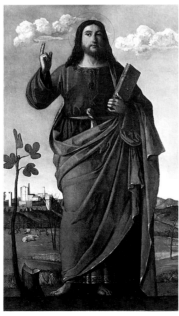

98

99

99. BLESSING CHRIST, HALF LENGTH

Panel, 20³⁄₁₆ × 15⅞ in. (52 × 40.6 cm)
National Gallery of Canada, Ottawa No. 4421

Gronau (1930) assigned this to Giovanni; Berenson (1957) held it to be largely autograph; Heinemann (1962) considered it a copy; Bottari (1963) accepted it and dated it, correctly, to the period of the Vicenza *Baptism* (cat. 100); Pignatti (1969) saw it as "Giorgionesque" and accepted it with reservations, placing it later than 1510. Robertson (1968), Huse (1972), Goffen (1989), and Tempestini (1992, catalog) ignored it.

Bellini's students, including Francesco Bissolo, liked this composition.

100. THE BAPTISM OF CHRIST

Canvas, 156 × 103⅝ in. (400 × 263 cm)
Church of Santa Corona, Vicenza
See entry, p. 160.

101. GOD THE FATHER

Panel, 39¹³⁄₁₆ × 51½ in. (102 × 132 cm)
Museo Civico, Pesaro No. 87

Berenson (1894) published the Pesaro panel, assigning it to Gio-

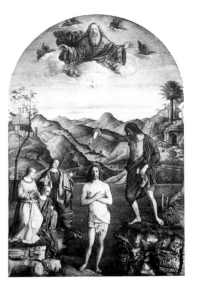

100

101

vanni Bellini, and he was seconded by all later critics except Dussler (1935 and 1949), who considered it a product of the workshop. Huse (1972) thought it a copy and Goffen (1989) did not mention it. A compositional similarity with the figure at the top of the Vicenza *Baptism* has been generally pointed out, and Gronau (1930), Pallucchini (1949), who recalled Pellicioli's restoration of that same year, and Bottari (1963) believed the two to be contemporary. Heinemann (1962), Robertson (1968), and Pignatti (1969) rightly indicated the stylistic features, which denote a further maturing, in the greater blending of color and the softer shape, and proposed this as a fragment of the upper part of a painting the rest of which is lost, perhaps another *Baptism,* but which cannot be, as Robertson noted, the one

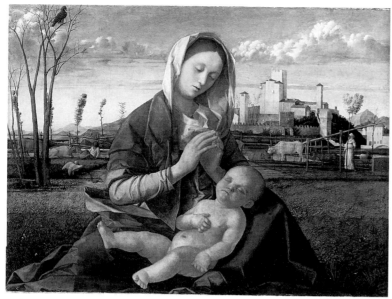

102

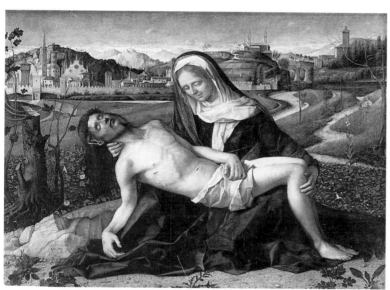

103

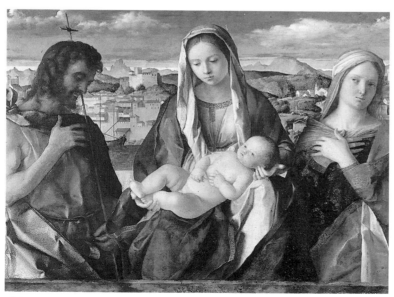

104

in San Giovanni dei Cavalieri. Gibbons (1965) suggested that we should see the Pesaro panel as a likeness from which the students would have executed the Vicenza God the Father, the figure who surveys Francesco Bissolo's *Christ Crowning Saint Catherine with Thorns* in the Accademia in Venice, and, as Lucco (1990) proposed, and we agree, the figure the painter himself added to the upper part of the *Virgin Enthroned Adoring the Child,* signed by Fra Antonio da Negroponte, in the church of San Francesco della Vigna in Venice. Gibbons's opinion must be qualified, however, because the painting today in Pesaro presents features in the finish, the sky, and the clouds that surround the figure which identify it as an altarpiece, as said earlier, later than that in the church of Santa Corona.

Shown as no. 112 at the 1949 Venice exhibition.

102. THE MADONNA OF THE MEADOW

Canvas (transferred from panel), 26½ × 34 in. (67.3 × 86.4 cm)
National Gallery, London
No. 599

See entry, pp. 162–64.

103. DONÀ DALLE ROSE PIETÀ

Panel, 25⅝ × 34¼ in. (65 × 87 cm)
Gallerie dell'Accademia, Venice
Cat. no. 883

See entry, pp. 166–68.

104. GIOVANELLI SACRA CONVERSAZIONE

Panel, 21¹/₁₆ × 29⁹/₁₆ in. (54 × 76 cm)
Gallerie dell'Accademia, Venice
Cat. no. 881

Signed IOANNES BELLINVS. Panel 104 comes from the collection of Principe Giovanelli in Venice. Crowe and Cavalcaselle (1871) attributed it to Andrea Previtali on the basis of the figure of the Baptist, the prototype of the one that the painter from Bergamo placed in a very similar attitude in *The Mystical Marriage of Saint Catherine,* dated 1504 (National Gallery, London, no. 1409). Following Longhi's (1927) argument in favor of Giovanni Bellini as author, Gronau (1928–29 and 1930) changed his mind about his earlier position (1911) favoring Vincenzo Catena, which he had based upon Morelli's (1891) view and which Berenson (1894) also initially took up. All later scholarship recognized Bellini's authorship of the painting, except for Dussler (1935 and 1949), who assigned only the idea to Giovanni; Huse (1972) agreed with him, while Goffen (1989) posited the collaboration of assistants. As for its chronology, 1504 is unanimously accepted, for the reason given above, as the *terminus ante quem.* Gamba (1937) dated it to as early as 1498–99, while Robertson (1968), confirming the general dating, rightly pointed out that it was tempting to push the date to the end of Giovanni's career, given the extreme blending of color both in the figures and the landscape. This scholar went so far as to establish a comparison between the Mary and the female saint in this painting, on the one hand, and the nymphs of *The Feast of the Gods* (cat. 120) on the other. The similarity between the drawing of Mary's left hand

here and in the *San Zaccaria Altarpiece* of 1505 (cat. 106) has been brought up several times as proof of the generally accepted date.

Shown as no. 113 at the 1949 Venice exhibition.

105. SAN CRISTOFORO DELLA PACE TRIPTYCH

Isaiah; Saint John the Baptist; Saint Francis
Panels, 36 3/16 × 14 1/4 in.
(93 × 37 cm) each
<hr>
Lunette: The Virgin and Child Between Saints Helen and Veronica
Panel, 18 1/4 × 64 in. (47 × 164 cm)
Formerly in the Kaiser-Friedrich-Museum, Berlin
No. 20 (until 1945)

The triptych comes from the church of San Cristoforo della Pace in

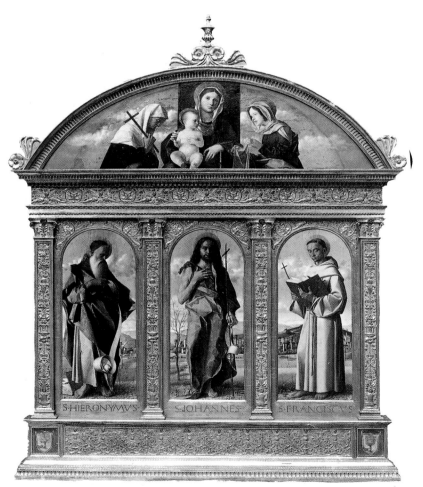

105

Venice, formerly on an island near the island of San Michele, which is today occupied by the municipal cemetery. It passed into the Berlin museum in 1821 with the Solly collection. Martinioni, in his edition of Sansovino (1663), listed the triptych as a work in the "manner of the Santacroce family," whereas Boschini (1664) assigned it to Cima da Conegliano. Waagen (1832) and Crowe and Cavalcaselle (1871) assigned it to Marco Basaiti, so that it entered the catalog of the pseudo-Basaiti, but Gronau (1928–29 and 1930) later attributed it to Giovanni; Dussler (1935 and 1949) rejected the attribution, but dated it correctly to 1500–1505. Neither Pallucchini (1959), Bottari (1963), Huse (1972), nor Goffen (1989) mentioned it. The catalog of the Kaiser-Friedrich-Museum (1931)

accepted it as largely autograph, as did Berenson (1957), Heinemann (1962), Robertson (1968), and Pignatti (1969). Lucco (1990) saw it as a product of the workshop, perhaps corrected by the master, in the second half of the 1480s, on the basis of a comparison with the triptych by Alvise Vivarini, dated 1485, today in the Galleria di Capodimonte in Naples (no. 53). This is an important product of Giovanni's atelier; the three full-length figures —but not the hands of Saint John the Baptist—were certainly conceived and largely executed by the head of his school, while the lunette above, as Robertson already suspected, comes from another group and is not autograph. We may find indirect proof of this by comparing the triptych formerly in Berlin with Francesco Bissolo's, which in the past was sometimes attributed to Pietro degli Ingannati, in the Pinacoteca di Brera in Milan (no. 82), in which the saint on the right is an exact copy of the prototype and the figure on the left presents a certain similarity in its presentation with that of Isaiah, who has sometimes been identified in the literature as Saint Jerome, probably because of the transformation from prophet to saint that the figure had undergone in the very many copies made by Giovanni Bellini's students.

See also the introductory essay.

106. SAN ZACCARIA ALTARPIECE

Canvas (transferred from panel),
195 × 91 1/2 in. (500 × 235 cm)
Church of San Zaccaria, Venice

See entry, pp. 170–72.

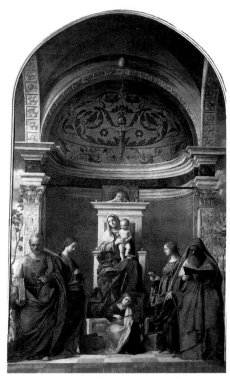

106

107. SAINT JEROME IN THE DESERT

Panel, 19 1/8 × 15 1/8 in. (49 × 39 cm)
Samuel H. Kress Collection, National Gallery of Art, Washington, D.C.
No. 328

Inscribed [. . .]s · MCCCCCV. It passed through several English collections, including the Benson collection in London, in whose catalog (1914) it was listed as the work of Giovanni Bellini and Marco Basaiti, an opinion seconded by Berenson (1916),

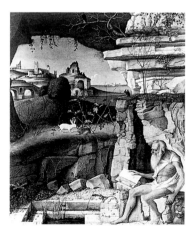

107

who had previously (1894) assigned it entirely to the student. In 1939, it entered the Samuel H. Kress collection in New York; the collection has been in the National Gallery of Art since 1941. Gronau (1930) was the first to publish it as autograph by Giovanni, and he was substantially followed by later scholars: Dussler (1949) saw an assistant's hand in the landscape, an opinion that Bottari (1963) shared, while Berenson in the end considered it autograph in part, as did Goffen (1989), who raised doubts about the date, in the tradition of Hendy and Goldscheider (1945), according to whom it should be read MCCCCCX. Heinemann (1962) proposed the hypothesis, shared by Robertson (1968), that Giovanni began the painting around 1480, or at the time of the Frick's *Saint Francis* (cat. 45) or the other Saint Jerome paintings (cat. 53 and 54), executing much of the landscape, but did not complete it until 1505, when he added the figure of the saint and the ruins in the background. Gamba (1937), Pallucchini (1959), Bonicatti (1964), and Pignatti (1969) accepted it unconditionally, while Huse did not mention it. Bottari cited the *Saint Jerome* in the

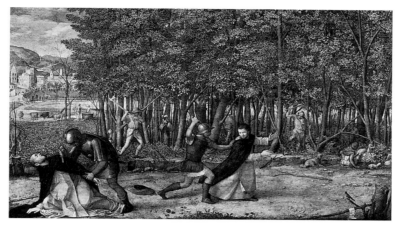

109

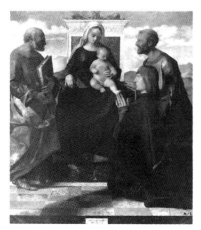

108

Ashmolean Museum at Oxford (no. 302), which Berenson also attributed to Giovanni, but which is not in fact autograph. The Washington, D.C., panel documents the theme's popularity with private clients, and is a painting of extremely high quality, its composition recalling the works that Giovanni executed in the 1470s and '80s, such as the two listed above and the Bristol *Christ's Descent into Limbo* (cat. 38), but it is to be situated in the period indicated by its date because of both the figure and the distant landscape in the left background.

See also the introductory essay.

108. VERNON SACRA CONVERSAZIONE (MADONNA AND CHILD WITH SAINTS AND DONOR)

Panel, 35 15/16 × 31 1/8 in. (92 × 80 cm)
City Museum and Art Gallery,
Birmingham, Great Britain

Signed and dated IOANNES / BELLINVS MCCCCCV. Mentioned by Ridolfi (1648), who saw it completed by panels depicting Saints Francis and Vincent Ferrer, now dispersed; it was still whole when it appeared in the inventory of the Muselli collection in Ferrara (MS., 1662), published by Campori

(1870), whereas Bartolomeo dal Pozzo (1718) described it, now without its lateral panels, as being in the collection of the conti Serego Alighieri in Verona. Around 1840, when it was in the collection of the banker Dawson Turner, it was reproduced in a watercolor by Elizabeth Turner. In 1895, the fifth earl of Ashburnham lent it for a show at the Royal Academy in London; in 1899, it was purchased by Oliver Vernon Watney, who placed it in his home, Cornbury Park, in Charlbury, Oxfordshire, where it remained until it was given to the museum where it is today. Over the course of the nineteenth century, it was sold at auction many times, always in England; from 1899 to 1967, it could for all practical purposes not be studied. Gronau (1930) considered it autograph, as did Berenson (1932 and 1957), Gamba (1937), Pallucchini (1959), Bottari (1963), Robertson (1968), Pignatti (1969), and Cannon-Brookes (1977). Heinemann (1962) withheld judgment because he did not know the original. Dussler (1949) classified it as a product of the workshop, and Huse (1972) and Goffen (1989) concurred. As for its autography, aside from the head of the donor, executed from life by a Veronese painter, we think

there may have been a collaboration with a student in the main group, while the two saints are certainly by the head of the school. See also the introductory essay.

109. THE KILLING OF SAINT PETER MARTYR

Panel, 39 3/8 × 65 in. (100 × 165 cm)
National Gallery, London
No. 812

See entry, pp. 174–76.

110. THE CONTINENCE OF SCIPIO

Canvas, 29 1/8 × 138 15/16 in.
(74.8 × 356.2 cm)
Samuel H. Kress Collection, Nationa
Gallery of Art, Washington, D.C.
No. 1090

When the abbreviated epigraph on the marble panel in the middle is deciphered, it reads as follows: TVRPIVS / IMPER[ARE] / VENERE[M] - Q[VAM] - A[LIENA] • / MIS[ERICORDIA] A[DIVAR]I: the subject of the painting, at one time generically identified as *Triumph of a Roman General,* is the episode in which Scipio Africanus, as Livy and Valerius Maximus tell it, returned to his betrothed, a girl Scipio was offered in Cartagena as a spoil of war. The painting was in the Cook collection in Richmond, Surrey, after 1873; it then passed into the Contini Bonacossi collection in Florence, and from there, in 1949, into the Samuel H. Kress collection in New York; it has been in the National Gallery of Art in Washington, D.C., since 1952.

Longhi (op. ms., 1951) recognized that this panel is the second of two friezes depicting stories of the gens Cornelia, progenitors, according to legend, of the Venetian family. The friezes were

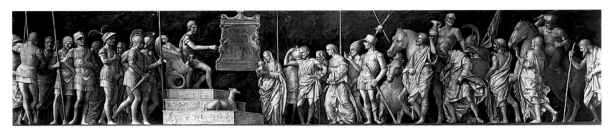

110

Panel, 35 1/16 × 56½ in. (90 × 145 cm)
Church of San Francesco della
Vigna, Venice

Signed and dated IOANNES
BELLINVS· / MDVII·. Ordered by
Giacomo Dolfin for his chapel in
the Venetian church; the client's
will, of February 7, 1506, revealed
it to be still under way. The donor's
portrait, perhaps due to a case of
damnatio memoriae, was replaced
by one in the style of Bassano or, in
Huse's (1972) view, Tintoretto, that
Heinemann (1962) believed could
be attributed to Francesco Becca-
ruzzi. It portrays the Virgin and
Child with the donor and Saints
John the Baptist, Francis, Jerome,
and Sebastian, all behind a low wall
on which are the signature and
date, in a hilly landscape that, for
the first time in a painting of this
kind in Bellini's body of work,
contains the figures. Even if we
accept the opinion of many schol-
ars that the panel was abbreviated
at the top, the format is unusual,
as the horizontal layout is for an
altarpiece; one, moreover, intended
for a family chapel and not one of
the church's main altars.

Pallucchini (1949 and 1959)
identified this painting with the
one that replaced Giovanni's *The
Dead Christ Seated in a Landscape*
(cat. 111) in the same church, but,
as Robertson (1968) stated, Vasari
(1550 and 1568) specified that the
painting given to the king of France
was replaced with a work on the
same subject; that would make this
a second commission that Giovanni
received for the same church. The
almost full-length Virgin repeats
the compositional schema of the
one in the *Barbarigo Votive Altar-
piece* (cat. 66), as Heinemann,
Robertson, Huse, and Schmidt

commissioned from Andrea Man-
tegna by Francesco Corner for his
San Polo palazzo; the first of the
two paintings, *Scipio Receives the
Image of the Goddess Cybele,* exe-
cuted by the Paduan head of his
school, is in the National Gallery
in London. Giovanni agreed to
finish it only after the death of
his illustrious brother-in-law, not
wanting to compete with him in
a historical theme, as emerged
in a letter of June 25, 1501, from
Michele Vianello to Isabella d'Este,
which Goffen published (1989).
Bellini, assisted by the workshop,
executed the frieze during the
period when he was engaged in
making the canvases on the history
of Venice for the Sala del Maggior
Consiglio in the Doge's Palace, as
Huse (1972) also pointed out.

As for the question of the
autography of this painting, done
in imitation of a marble relief,
Borenius (1912) had already iden-
tified it as a work by the school;
Berenson (1932 and 1957) attrib-
uted it to Giovanni, but Gronau
(1930) had ignored it, while Duss-
ler (1949), Heinemann (1962), and
Huse (1972) deleted it from the
Bellini catalog. Pallucchini (1959),
Bottari (1963), and Pignatti (1969)
considered it autograph, while
Robertson (1968) saw it as exe-
cuted in the workshop from a
drawing by the master. For Goffen,
it is the result of a collaboration
between the head of the school
and his students. The fascination of

the work lies in the way the false
relief is created on the right-hand
side, where the figures present
stylistic features characteristic of
Bellini's late production, anticipat-
ing *The Feast of the Gods* (cat. 120),
as Goffen also pointed out. We
concur with Robertson's observa-
tion concerning a remarkable simi-
larity between the girl and one of
the angels in the Vicenza *Baptism*
(cat. 100). On the other hand, in
the section on the left, the group
of warriors directly behind Scipio's
throne has a banal look, indicating
the workshop's contribution. Over-
all, the work was incontrovertibly
substantially conceived and in part
executed by Giovanni Bellini.

111. THE DEAD CHRIST
SEATED IN A LANDSCAPE

Panel, 41 5/8 × 27 3/16 in. (107 × 70 cm)
Nationalmuseum, Stockholm
No. 1726

Sirén (1933) attributed this panel to
Giovanni Bellini; it had previously
been assigned to Marco Basaiti by
Berenson (1932), an opinion that
van Marle shared (1935), whereas
Richter (1934) attributed it to
Rocco Marconi. Heinemann (1962)
concurred, considering it a copy
of the painting that Giovanni exe-
cuted for the church of San Fran-
cesco della Vigna in Venice and
that, according to Vasari (1550 and
1568), was given to the king of
France, Louis XII. Gamba (1937)
identified the work with the one
that left Venice, an identification
accepted by all the scholars that
consider the work to be autograph,
that is, Pallucchini (1949 and 1959),
Berenson (1957), Bottari (1963),
Robertson (1968), and Pignatti
(1969). Goffen (1989) did not iden-
tify the panel with the one given
to the king of France, maintaining
that the document in question
mentions mourners near Christ.
Dussler (1949) and Huse (1972)
did not mention it.

It was shown as no. 111 at the
1949 Venice exhibition and was
restored in 1991.

See also the introductory essay.

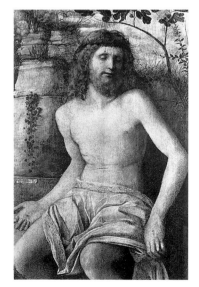

111

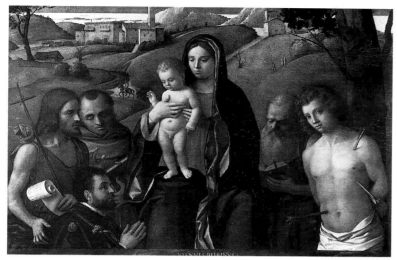

112

(1990) pointed out; according to Huse, this precludes the work's autography. Fiocco (1916) assigned the painting to Girolamo da Santacroce; in fact, Giovanni's student from Bergamo executed a faithful replica, today in the Pinacoteca dell'Accademia dei Concordi in Rovigo. Even in the imperfect condition in which this piece came down to us, the Dolfin altarpiece constitutes an important example of Giovanni's poetic evolution with respect to the *San Zaccaria Altarpiece* (cat. 106) and even to Giorgione's altarpiece in Castelfranco, and it opens the way to the motif of the Sacra Conversazione of the Venetian high sixteenth century. Its autography must be asserted, even with the participation of assistants. In fact, virtually all the scholars agreed on this, except for Dussler (1949), who, however, accepted the middle group, and Huse, as above. We might hypothesize Andrea Previtali's hand in the saints on the left, whereas the warm, blended pigment of the other figures and the silent countryside should be attributed to the master.

Shown as no. 118 at the 1949 Venice exhibition. Restored in 1982.

See also the introductory essay.

113. SAINT MARK'S SERMON IN ALEXANDRIA

*Canvas, 135 3/16 × 300 3/16 in.
(347 × 770 cm)
Pinacoteca di Brera, Milan
No. 67*

The documents concerning this canvas, which was executed for the Scuola Grande di San Marco in Venice, were published by Molmenti (1888) and Paoletti (1894): on May 1, 1504, the Scuola accepted Gentile Bellini's offer of this painting, which on March 9, 1505, was reported to be largely completed. In his will, dated February 18, 1507, Gentile charged his brother Giovanni with finishing the work; on March 7, following Gentile's death, Giovanni agreed. The great

canvas was restored in 1590 and 1768. It came to the Brera on February 13, 1809. After its transfer to Milan, which damaged it somewhat—to this day it retains the marks of being folded—it was repainted by Antonio de Antoni in 1826. After World War II, it underwent a conservation treatment by Pellicioli. From 1984 to 1988, Pinin Brambilla Barcilon transferred the painting to a new canvas, relined it, and restored it. Vasari (1550), Sansovino (1581), and Ridolfi (1648) all remembered it, and Ridolfi referred to the church in the background as Sant'Eufemia, as did A. M. Zanetti (1771). Carotti (1892) believed that the magistrate in yellow on the right, wearing a gold necklace, was a self-portrait by Gentile, while on the left, behind the podium on which the saint is preaching, the gentleman in red, also wearing a gold necklace, would be a portrait of Giovanni by Gentile. According to Paoletti, Gentile would be the figure in red, and Giovanni the one in yellow; Gronau (1930), Fiocco (1938), Robertson (1968), Collins (1970), and Williams Lehmann (1977) also identified Gentile's self-portrait as the personage in red on the left. The latter pointed out that the face is identical with the one on Vittore Camelio's medal portraying the

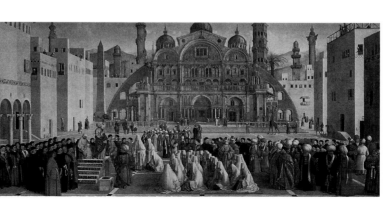

113

painter, who in the painting would be showing off the necklace he was given by Muhammad II. Opinions are divided concerning the extent of Giovanni's participation: Crowe and Cavalcaselle (1871), who believed the canvas to be significantly repainted, limited themselves to attributing to him the harmonizing of the whole and the painting's completion; Paoletti maintained that Girolamo da Santacroce, Ventura Trevisano, and Vittore Belliniano collaborated with Giovanni; Fiocco, and later (1949) Dussler, credited Giambellino with softening the sharp edges, giving the painting its already tonal luminosity and adding the clouds in the sky and the chain of mountains in the background. Fiocco also pointed out, correctly, that what the canvas depicts is Saint Mark's last sermon, since an executioner with a scimitar is stationed at the foot of the platform, while next to him the block for the saint's decapitation stands ready. Modigliani (1950) identified Giovanni's hand in the figure of the title saint, an opinion shared by Meyer zur Capellen (1985), who, like Pallucchini (1959), Arslan (1962), and Bottari (1963), also attributed some of the bystanders on the left. Personally, we believe that Giovanni's poetics are recognizable in the luminosity that distinguishes the composition, in the figures of Saint Mark and the scrivener, in a few of the listeners, and particularly, as Arslan also believed, in the magistrate in yellow on the right, as well as in the glazing on the drapery of the Muslim women in the middle. When he completed this painting, Giovanni was beginning to fulfill the commitment he and his brother had made in 1492 to the Scuola Grande di San Marco, to replace

the canvases executed by himself, Jacopo, and Gentile that had been destroyed in the fire of 1485.

114. THE RISEN BLESSING CHRIST

Panel, 23 × 18³⁄₁₆ in. (59 × 47 cm)
Kimbell Art Museum,
Fort Worth

It is not easy to date this panel, which presents a figure in a posture similar to that of the Baptist in the *San Cristoforo della Pace Triptych* (cat. 105) and the motif of the two rabbits that appears in the Washington, D.C., *Saint Jerome* (cat. 107), but which also displays similarities with the figures of saints in the painting cataloged here as no. 115. According to Morassi (1958), *The Risen Blessing Christ* would be the painting executed for the church of Santo Stefano in Venice and is usually identified with the one today in the Louvre (cat. 17). Pallucchini (1959), Heinemann (1962), and Bottari (1963) accepted it as autograph and dated it to 1490-95; Pignatti (1969) placed it in 1500. Robertson (1968), Huse (1972), Goffen (1989), and Tempestini (1992, catalog) ignored it. It is probably a fragment that looks like an *Andachtsbild,* that is, a nonnarrative painting representing the

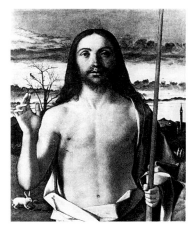

114

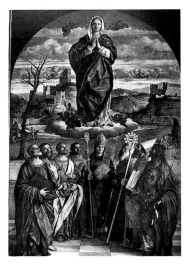

115

risen Christ but not his Resurrection; it might originally have been part of a Noli Me Tangere.

115. MEDITATION OF EIGHT SAINTS ON THE MARIAN MYSTERY

Panel, 136½ × 74¹⁄₁₆ in.
(350 × 190 cm)
Church of San Pietro Martire,
Murano

The painting, which represents Mary levitating, like an apparition, on a cloud with cherubim, observed with astonishment by Saints Peter, John the Evangelist, Mark, Francis of Assisi, Louis de Toulouse, Anthony Abbot, Augustine, and John the Baptist, is usually interpreted as an Assunta, or Assumption. In fact, as Robertson (1968) and Goffen (1989) maintained, it is an *Andachtsbild,* that is, a nonnarrative painting, which they called *Immaculate Conception,* but which, in our opinion, represents a series of saints, including only three apostles, in the act of meditating on the Marian mystery, which involves, in an indivisible theological nexus, her birth without sin, her virginal conception of her Son, and her admission into the

Empyrean alongside the Trinity. The panel cannot be depicting the Assumption, because those present would have to be the apostles around Mary's blossoming tomb; in this case, we have the successor to Jesus; the disciple to whose care Mary was entrusted by her crucified Son; the patron apostle of Venice; the monk that was almost another Christ; the French bishop who, with him, asserted the mystery of Mary's immaculate birth; the prototype of the monastic life; the theologian and Father of the Church; and the precursor of the Messiah. The painting came from the high altar of the church of Santa Maria degli Angeli in Murano, and was commissioned in 1501 by the doge Agostino Barbarigo. However, like many other works of the late period, it took a long time to execute, and must not have been finished until toward the end of the first decade, a few years after the *San Zaccaria Altarpiece* (cat. 106), although the basic composition may have been worked out early enough for Lorenzo Lotto to have borrowed it for his so-called *Assunta* of 1506, in Asolo. Ridolfi (1648), who assigned it to Giovanni, very much admired the Murano altarpiece, but already Boschini (1674), followed by A. M. Zanetti (1771) as well as Crowe and Cavalcaselle (1871) and Berenson (1894), attributed it to Marco Basaiti; over the course of the nineteenth century, only V. Zanetti (1863) maintained that the work was autograph by Bellini. Morelli (1897) suggested Francesco Bissolo under the master's direction, while Gronau, who in 1909 had considered it a product of the school, in 1911 entered it in the catalog of the pseudo-Basaiti created by Ludwig (1903). Cantalamessa (1914) attributed the entire

group to Giovanni, but A. Venturi (1915) moved the painting to under Rocco Marconi's name. In the end, it was Gronau (1928-29 and 1930) who definitively restored it to Bellini, dating the painting to before 1505; he was seconded by Gamba (1937), Heinemann (1962), Bottari (1963), and Robertson (1968). Berenson (1932 and 1957); van Marle (1935); Dussler (1935 and 1949), who considered it predominantly a collaborative work; Pallucchini (1959); Pignatti (1969), who dated it as late as 1513; Huse (1972), who agreed with Gibbons (1965) in assigning it to Rocco Marconi; and Goffen (1989) all moved the date earlier, referring to the compositional and stylistic similarities it shares with works executed between the end of the first and beginning of the second decades. Pallucchini considered necessary to this painting the organ panels in the church of San Bartolomeo in Rialto, executed by Sebastiano del Piombo between 1508 and 1509. We concur with those scholars who hold that the work was conceived by Giovanni but was executed more or less exclusively by collaborators. We believe that the dating ought to be pushed to the end of the first decade but not beyond; the execution of the Murano panel cannot be dated too much earlier, because of the similarities between the Saint Louis of Toulouse in this painting and the one in the *San Giovanni Crisostomo Altarpiece* (cat. 119), which we know to have been executed between 1509 and 1513. In the *Meditation,* although the drapery is rich and full, the style is not what Robertson considered influenced by Dürer, but rather one that characterizes many works by Giovanni in his more Giorgionesque

phase, from the Vicenza *Baptism* (cat. 100) to the *San Giovanni Crisostomo Altarpiece*. The Murano painting was restored in the early 1990s under the auspices of Venice's Soprintendenza ai Beni Artistici e Storici; we are grateful to Ettore Merkel for giving us the opportunity to examine it up close in the San Gregorio conservation workshop.

It was shown as no. 124 in the 1949 Venice exhibition.

116. VIRGIN AND CHILD

Panel, 19½ × 16 in. (50 × 41 cm)
Galleria Borghese, Rome
No. 176

Signed *Joannes bellinus / faciebat* in lowercase letters, as is often the case in Giovanni's late production. Although Crowe and Cavalcaselle (1871) argued for the work's autography, their proposal was not immediately accepted, since A. Venturi (1893) and Morelli (1897) thought of Francesco Bissolo, Bernardini (1910) assigned it to Vincenzo Catena, and Gronau (1911) to the pseudo-Basaiti. Cantalamessa (1914) revived the attribution to Bellini, followed by Longhi (1927), Gronau (1928–29 and 1930), Gamba (1937), Pallucchini (1949 and 1959), Della Pergola (1955), Berenson (1957),

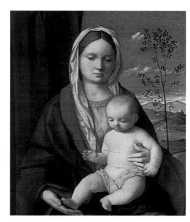

116

Bottari (1963), and Pignatti (1969). A. Venturi in his last writings (1915) cast the work into anonymity, while Dussler (1935 and 1949) and Heinemann (1962) considered it a workshop pastiche of the master's ideas, the type expressed in the Baltimore Sacra Conversazione (cat. 118). Robertson (1968) also considered it to be the work of students; Huse (1972) and Goffen (1989) did not mention it at all. It is the latest example that Giovanni Bellini left us of a half-length Virgin and Child in a vertical format for private devotion, and there is no reason to doubt its autography: there are verifiable compositional similarities with the Birmingham painting (cat. 108) and with the Baltimore painting cited above; arguments in favor of the latter's attribution to the master himself are far more tenuous, as we shall see. The date is around 1510.

117. VIRGIN WITH THE BLESSING CHILD

Canvas (transferred from panel), 33⅛ × 44⅞ in. (85 × 115 cm)
Pinacoteca di Brera, Milan
No. 193

See entry, p. 178.

118. VIRGIN ENTHRONED, SAINTS PETER AND PAUL, AND THREE VENETIAN PROCURATORS

Canvas mounted on panel, 35¹³⁄₁₆ × 58½ in. (91.8 × 150 cm)
Walters Art Gallery, Baltimore
No. 37.446

Ridolfi (1648) and Boschini (1664) described this piece as being in the Procuratia de Ultra in the Doge's Palace in Venice. It bore a cartellino with signature and date, 1510,

visible in an engraving of the painting published by Gronau (1928–29); Robertson (1968) raised questions about the authenticity of the cartellino, believing the area in which it had been placed to have been renovated before the engraving was made in the early nineteenth century. Except for Berenson (1957), who saw it as largely autograph, all the other scholars considered this work—a public commission—as undoubtedly from Giovanni's workshop but executed almost entirely by his students. The procurators that the two saints introduce are Tommaso Mocenigo, Luca Zeno, and Domenico Trevisan. The left-hand side is of especially poor quality, with its very weak Saint Peter, but the overall drawing of the painting is certainly Giovanni's work; here, as Lucco (1983) pointed out, Giovanni echoed the compositional idea behind the *Judgment of Solomon* that Giorgione had begun but that was left unfinished, in a second pass, by Sebastiano del Piombo and today belongs to the National Trust in London. We will only register Gibbons's (1962) view that the work is assignable to Rocco Marconi, even though the most obvious students would seem to be rather Vittore Belliniano and Vincenza Catena. A drawing of two mantled male figures, formerly in the Lugt collection, today in the Dutch Institute in Paris, should be dated close to the period in which this painting was being worked out.

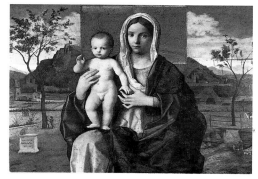

117

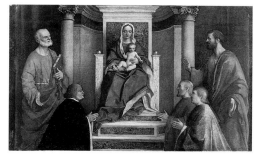

118

119. SAN GIOVANNI CRISOSTOMO ALTARPIECE

Panel, 117 × 72⅞ in. (300 × 185 cm)
Church of San Giovanni Crisostomo, Venice

See entry, pp. 180–82.

120. THE FEAST OF THE GODS

Canvas, 67 × 74 in. (170.2 × 188 cm)
Widener Collection, National Gallery of Art, Washington, D.C.
No. 597

See entry, pp. 184–86.

121. THE INFANT BACCHUS

Panel, 18⅝ × 14³⁄₁₆ in. (48 × 36.8 cm)
Samuel H. Kress Collection, National Gallery of Art, Washington, D.C.
No. 1362

The Infant Bacchus is somewhat related to *The Feast of the Gods* in the same gallery (cat. 120); it again presents the theme of the god of

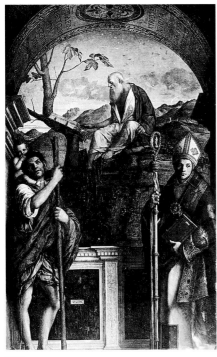

119

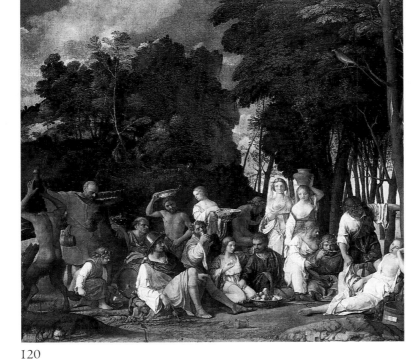

120

the Dominican monastery of Santi
Giovanni e Paolo in Venice, docu-
mented in 1514, as Paoletti (1929)
reported. This circumstance renders
improbable Heinemann's (1962)
hypothesis, according to which the
use of canvas would indicate that
the work was begun by Gentile but
finished by Giovanni. *Saint Dominic*
is of a kind with the last works of
the master's catalog, the period of
The Drunkenness of Noah (cat. 125),
as Pignatti (1969) also maintained.

wine as an infant, but varies it with
respect to the above painting. The
attribution to Giovanni goes back
to Gronau (1930), who suggested
identifying it with the small paint-
ing assigned to Giorgione, which
Ridolfi (1648) mentioned being
in the home of Bartolo Dafino in
Venice. The painting was accepted
by all the later scholars except
Dussler (1949), who considered it
a product of the workshop. Nei-
ther Robertson (1968) nor Huse
(1972) mentioned it; Goffen (1989)
listed it among works executed in
collaboration with assistants or

121

whose attribution was uncertain.
The Washington, D.C., National
Gallery of Art *Orpheus* (no. 598),
however, should be deleted from
the painter's catalog.

122. NUDE WOMAN WITH A MIRROR

Panel, 24⅜ × 31⅛ in. (62 × 79 cm)
Kunsthistorisches Museum, Vienna
No. 97

See entry, p. 188.

123. SAINT DOMINIC

Canvas, 24½ × 19³⁄₁₆ in.
(62.9 × 49.5 cm)
National Gallery, London
No. 1440

Signed IOA[N]NIS BELLIN[US] OP•
on a tag, and on the parapet may
be read the date M • D • XV and the
inscription, partly covered by the
cartellino, IMAGO FRATRIS THEO-
DORI URBINATIS. This work was
traditionally attributed to Gentile
Bellini, but Gronau's (1930) claim
for Giovanni was accepted by most

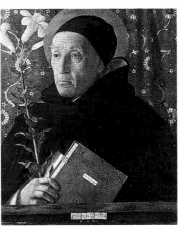

122

of the scholars, including Davies
(1951 and 1961). Dussler (1949)
found it not unworthy of the
master, and in any case more like
his work than his brother's, while
Huse (1972) did not mention it.
Von Hadeln (1907) thought that
Saint Dominic's attributes had
been added, but tests done on the
painting at the gallery proved
otherwise. The panel is generally
held to have come from the Pesaro
collection in Venice; in the early
nineteenth century it passed into
the Soulages collection in Tou-
louse. The person portrayed as
Saint Dominic—this cannot be
considered a true portrait, since
besides the lily and the book, he
also has a halo—is a monk from

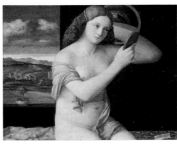

123

124. THE DEAD CHRIST

Canvas, 21¼ × 31⁹⁄₁₆ in. (55 × 81 cm)
Scuola Grande di San Rocco, Venice

Goffen (1989) considered the
Stockholm painting (cat. 111)
Giovanni Bellini's farewell to a
devotional theme dear to him; in
actuality, we think Lucco (1983)
is right to attribute to the painter
the *Dead Christ* with Greek mono-
grams in the Scuola Grande di San
Rocco in Venice, usually attributed
to Giorgione or his circle—Coletti
(1955) and Heinemann (1962) even
assigned it to Titian. It seems to us
in keeping with Giovanni's latest

style, also because of the slender anatomy that we find in the Besançon *Drunkenness of Noah* (cat. 125) as well.

125. THE DRUNKENNESS OF NOAH

Canvas, 40⅛ × 61⅛ in. (103 × 157 cm)
Musée des Beaux-Arts, Besançon
No. 896.1.13

Longhi (1927) attributed it to Giovanni, and Pallucchini (1949 and 1959), Berenson (1957), Bottari (1963), Robertson (1968), Pignatti (1969), and Goffen (1989) confirmed the attribution. Gronau (1930) ignored it, Dussler (1949) assigned it to the painter of *The Three Ages of Man* in the Palazzo Pitti, Gilbert (1956) and Huse (1972) attributed it to Lorenzo Lotto, and Heinemann (1962) attributed it to Titian. Berenson initially (1932) had opted for Giovanni Cariani. It is an extremely original painting, but it cannot be separated from *The Feast of the Gods* (cat. 120), having in common with it the drapery, the empty cup in the foreground, and the vine leaves in the background, which also reminded Robertson of the surroundings of *The Killing of Saint Peter Martyr* (cat. 109). The mantle with which the drunken patriarch is being covered is very similar in design and color to the drapery in the Vienna *Nude Woman with a Mirror* (cat. 122). Compared

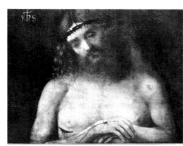

124

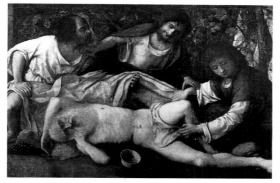

125

126

with the latter, the shapes here are looser, as is true of the protagonists of the *Feast*. Noah's slender figure, which reminded Goffen of *The Barberini Faun,* seems to be taken from one of the large sculpted gullies of the basilica of San Marco in Venice; Robertson thought of a plastic prototype as well, one on the exterior of the Doge's Palace. One is tempted to speak of "pre-Caravaggism" because of the naturalistic force with which the four figures—who barely fit into the space—are constructed; perhaps because of the small size of the canvas, the work constitutes, in a way, the painter's spiritual will and testament, come from afar and completely transforming the traditional schemata within which his training had taken place.

126. THE MARTYRDOM OF SAINT MARK

Canvas, 141⅛ × 300⅝ in.
(362 × 771 cm)
Library of the Ospedale Civile (Scuola Grande di San Marco), Venice

Signed MDXXVI / VICTOR BELLINIA[N]VS. It was commissioned from Giovanni on July 4, 1515; the next day, the painter gave a receipt for ten ducats on account. We do not know how far advanced the work was when the painter died on November 29, 1516, nor to what

extent he had already employed Vittore Belliniano, who ought to be considered responsible for most of the execution of the crowd of figures on the right, where the scene of the martyrdom is taking place. The overall conception, however, should be attributed to Giovanni, as all the critics believed, in Gamba's (1937) wake, with the sole exceptions of Dussler (1949), who considered the master's participation to have been minimal, and Huse (1972), who assigned the work to his student. We concur with Robertson (1968) that it seems unlikely that Vittore on his own could have imaginatively constructed a whole so articulated and difficult, because of the door in the middle; also in this regard, the small figures that appear to be moving around above the architectural frame seem very unusual. We should remember that in 1506 Gentile had provided a drawing for the *Martyrdom,* which Giovanni may have referred to in order to bring this composition into line with the Brera *Saint Mark's Sermon* (cat. 113), as the buildings serving as the wing of a stage set would seem to demonstrate. In the background, Giovanni introduced the church of San Siriaco of Ancona and the Venetian campanile of Santa Fosca, which can also be seen in the city in the background of the *Crucifix-*

ion with Jewish Cemetery (cat. 55) formerly in the Niccolini di Camugliano collection, further proving how he studied certain buildings over time; in fact, their treatment and the point of view change in each instance, so that we cannot see here a student repeating a motif in a repertory. The large canvas, like the one that went to the Brera, suffered damage due to environmental conditions and historical vicissitudes: Ridolfi (1648) and Boschini (1664) remembered it in the Doge's Palace, from whence it was transferred to the Scuola Grande di San Marco, where it stayed during the Napoleonic era; it was then taken to Vienna, where it remained in the gallery of the Academy until 1919. When it was returned to Venice, Pellicioli restored it (see Fogolari, 1940) and it was re-placed on the doorway wall of the former Sala del Albergo of the Scuola Grande di San Marco, now the library of the Ospedale Civile, from where it was removed a few years ago to be restored by Ottorino Nonfarmale.

233

BIBLIOGRAPHY

1502
M. A. Sabellico. *De venetae Urbis Situ, Venezia.* Repr. Ed. G. Meneghetti. Venice, 1957.

1521–43
M. A. Michiel. *Notizia d'Opere di Disegno.* MS. Biblioteca Marciana, Venice. Ed. J. Lermolieff (G. Morelli) Bassano, 1800; ed. G. Frizzoni. Bologna, 1884.

1548
P. Pino. *Dialogo di Pittura.* Venice.

1550
G. Vasari. *Le Vite de' più eccellenti Architetti, Pittori et Scultori italiani da Cimabue insino ai Tempi nostri.* Florence. Repr. Eds. L. Bellosi and A. Rossi. Turin, 1986.

1568
G. Vasari. *Le Vite de' più eccellenti Pittori, Scultori ed Architetti.* Florence. Repr. 7 vols. Ed. G. Milanesi. Florence, 1873-81.

1581
F. Sansovino. *Venetia Città nobilissima et singolare.* Venice.

1648
C. Ridolfi. *Le Maraviglie dell'Arte.* Venice.

1660
M. Boschini. *La Carta del Navegar pittoresco.* Venice.

1663
F. Sansovino. *Venetia Città nobilissima et singolare descritta in XIIII Libri . . . con Aggiunta di tutte le Cose notabili . . . dall'Anno 1580 al presente 1663 da D. G. Martinioni.* 2 vols. Venice.

1664
M. Boschini. *Le Miniere della Pittura.* Venice.

1674
M. Boschini. *Le ricche Miniere della Pittura Veneziana.* Venice.

1676
M. Boschini. *I Gioielli pittoreschi.* Venice.

1718
B. dal Pozzo. *Vite de' Pittori, degli Scultori e Architetti veronesi.* Verona.

1733
A. M. Zanetti. *Descrizione di tutte le pubbliche Pitture della Città di Venezia e Isole circonvicine.* Venice.

1771
A. M. Zanetti. *Della Pittura veneziana e delle Opere pubbliche de' veneziani Maestri.* Venice.

1789
L. Lanzi. *Storia pittorica della Italia.* Bassano.

1795
Descrizione italiana e francese al tutto ciò che si contiene nella Galleria del Sig. Marchese Senatore Luigi Sampieri. Bologna.

1815
G. A. Moschini. *Guida per la Città di Venezia.* Venice.

1824–53
E. A. Cicogna. *Delle Inscrizioni veneziane raccolte ed Illustrate.* 6 vols. Venice.

1832
G. F. Waagen. *Verzeichnis der Gemälde-Sammlung des königlichen Museums zu Berlin.* Berlin.

1834
G. Moschini. *Giovanni Bellini e pittori contemporanei.* Venice.

1840
D. Turner. *Outlines in Lithography from a Small Collection of Pictures.* Yarmouth, Norfolk, England.

1854–57
G. F. Waagen. *Treasures of Art in Great Britain.* 4 vols. London.

1863
V. Zanetti. *Del Monastero e della Chiesa di S. Maria degli Angeli a Murano. Memorie storiche.* Venice.

1869
V. Zanetti. "Un quadro di Giovanni Bellino esistente a Murano. . . ." *La Voce di Murano,* no. 22.

1870
G. Campori. *Raccolta di Cataloghi ed Inventarii inediti.* Modena.

1871
J. A. Crowe and G. B. Cavalcaselle. *A History of Painting in North Italy.* 2 vols. London.

1879
G. Frizzoni. "L'Arte italiana nella Galleria Nazionale di Londra." *Archivio Storico Italiano,* 4th ser., 4, pp. 246-81, 394-428.

1879–1903
I Diarii di Marino Sanuto (MCCCCXCVI–MDXXXIII). 58 vols. Venice.

1883
J. P. Richter. *Italian Art in the National Gallery.* London.

1884
W. von Bode. In J. Burckhardt. *Der Cicerone. Eine Anleitung zum Genuss der Kunstwerke Italiens. Unter Mitwirkung verschiedener Fachgenossen bearb. von W. von Bode.* 5th ed. Leipzig.

1886
G. Morelli. *Le Opere dei Maestri italiani nelle Gallerie di Monaco, Dresda e Berlino.* Bologna.

1888
P. Molmenti. "I Pittori Bellini. Documenti e Ricerche." *Archivio Veneto* 36, no. 1, pp. 219-34.

1891
G. Frizzoni. *Arte italiana del Rinascimento.* Milan.
J. Lermolieff (G. Morelli). *Kunstkritische Studien über italienische Malerei. Die Galerien zu München und Dresden.* Leipzig.

1892
Catalogo delle R. Pinacoteca di Milano (Palazzo Brera). Intro. by G. Carotti. Milan.

1893
P. Paoletti. *L'Architettura e la Scultura del Rinascimento in Venezia.* Venice.
A. Venturi. *Il Museo e la Galleria Borghese.* Rome.

1894
B. Berenson. *The Venetian Painters of the Renaissance.* New York and London.
P. Paoletti. *Raccolta di Documenti inediti per servire alla Storia della Pittura veneziana nei Secoli XV e XVI.* Fasc. 1, no. 1. Padua.
J. P. Richter. "Die Winterausstellungen der Royal Academy und der New Gallery in London." *Zeitschrift für bildende Kunst.* n.s., 5, pp. 145-50.

1894–95
Venetian Art. Exhib. cat. London.

1895
B. Berenson. *The Venetian Painters of the Renaissance.* 2nd ed. New York and London.

1897
B. Berenson. *The Venetian Painters of the Renaissance with an Index of Their Works.* 3rd ed. New York and London.
G. Morelli. *Della Pittura italiana.* Milan.

1899
R. Fry. *Giovanni Bellini.* London.

1900
A. Venturi. *La Galleria Crespi in Milano. Note e Raffronti.* Milan.

1901
B. Berenson. *The Study and Criticism of Italian Art.* 1st ser. London.

1863

E. Jacobsen. "Italienischen Gemälde in der Nationalgalerie zu London." *Repertorium für Kunstwissenschaft.* 24, pp. 339-75.

1902
G. Ludwig. "Giovanni Bellinis sogenannte *Madonna am See* in den Uffizien, eine religiöse Allegorie." *Jahrbuch der königlich preussischen Kunstsammlungen* 23, pp. 163-86.

1903
G. Cantalamessa. "*La Resurezione di Cristo,* quadro di Giovanni Bellini." *Arte e Storia* 22, p. 51.
G. Ludwig and W. von Bode. "Die Altarbilder der Kirche S. Michele di Murano und das Auferstehungsbild des Giovanni Bellini in der Berliner Galerie." *Jahrbuch der königlich preussischen Kunstsammlungen* 24, supplement, pp. 131-46.

1905
G. Ludwig. "Archivalische Beiträge zur Geschichte der venezianischen Malerei." *Jahrbuch der königlich preussischen Kunstsammlungen* 26, supplement, pp. 1-159.

1906
G. Ludwig. Restelo, Spiegel und Toilettenutensilien in Venedig zur Zeit der Renaissance." In *Italienischen Forschungen.* Vol. 1, pp. 185-361. Berlin.

1907
G. Biadego. *Variazioni e divagazioni a proposito di due sonetti di Giorgio Sommariva in onore di Gentile e Giovanni Bellini.* Verona.
D. von Hadeln. "Zu Gentile Bellini in der National Gallery in London." *Repertorium für Kunstwissenschaft* 30, pp. 536-37.
Kunsthistorische Sammlungen der allerhöchsten Kaiserhauses. Die Gemäldegalerie. Alte Meister. Vienna.
C. Ricci. *La Pinacoteca di Brera.* Bergamo.
L. Venturi. *Le Origini della Pittura veneziana.* Venice.

1908
R. E. F. "A Madonna and Child by Giovanni Bellini." *Bulletin of the Metropolitan Museum of Art* 3, pp. 180-82.

1909
G. Gronau. *Die Künstlerfamilie Bellini.* Bielefeld and Leipzig.
G. Vaccaj. *Pesaro.* Bergamo.

1910
G. Bernardini. "Alcuni Dipinti della Galleria Borghese." *Rassegna d'Arte* 10, pp. 142-44.
J. P. Richter. *The Mond Collection.* 2 vols. London.

1911
D. Gnoli. "Una Tavola sconosciuta di Giovanni Bellini." *Rassegna d'Arte* 11, p. 177.
G. Gronau. "Vincenzo Catena o Vincenzo dalle Destre." *Rassegna d'Arte* 11, pp. 95-98.

1912
T. Borenius. *Notes on J. A. Crowe & G. B. Cavalcaselle: A History of Painting in North Italy.* 3 vols. London.
Burlington Fine Arts Club: Early Venetian Pictures and Other Works of Art. London.
R. Fry. "*The Redeemer* by Giovanni Bellini." *Burlington Magazine* 21, pp. 10-15.
M. Logan Berenson. "Le Nouveau tableau de Bellini au Louvre." *Gazette des Beaux-Arts* 54, nos. 4, 7, pp. 371-76.

1913
G. Frizzoni. "Per la Reintegrazione della grande Pala di Giovanni Bellini a Pesaro." *Emporium* 37, pp. 105-14.

1914
G. Cantalamessa. "La Madonna di Giovanni Bellini nella Galleria Borghese." *Bollettino d'Arte* 8.
Catalogue of Italian Pictures at 16, South Street, Park Lane, London, and Buckhurst in Sussex Collected by Robert and Evelyn Benson. London.
G. Frizzoni. "Opere di Pittura veneta lungo la Costa meridionale dell'Adriatico." *Bollettino d'Arte* 8, pp. 23-40.
R. Longhi. "Piero della Francesca e lo Sviluppo della Pittura veneziana." *L'Arte* 17, pp. 198-221, 241-56. Repr. in *Edizione delle Opere complete di Roberto Longhi.* Vol. 1, bk. 1, pp. 61-106, *Scritti giovanili, 1912–1922.* Florence, 1961.
A. Venturi. *Storia dell'Arte Italiana.* Vol. 7. Milan.
———. *La Pittura del Quattrocento.* Vol. 3. Milan.

1915
A. Venturi. *Storia dell'Arte Italiana.* Vol. 7. Milan.
———. *La Pittura del Quattrocento.* Vol. 4. Milan.

1916
B. Berenson. *The Study and Criticism of Italian Art.* 3rd ser. London.
———. *Venetian Paintings in America. The Fifteenth Century.* London.

1919
G. Fiocco. "I Pittori di Santacroce." *L'Arte* 19, pp. 179-206.

1921
G. Fogolari. *Giovanni Bellini.* Florence.
G. Gronau. Lauro Padovano, ein Gehilfe des Giovanni Bellini. In *Collectanea variae doctrinae Leoni S. Olschki . . . obtulerunt,* pp. 100-112. Munich.

1922
G. Gronau. "Über Bildnisse von Giovanni Bellini," *Jahrbuch der königlich preussischen Kunstsammlungen* 43, pp. 97-105.
D. von Hadeln. "Zwei unbeachtete Originale des Giovanni Bellini." *Zeitschrift für bildende Kunst,* n.s., 33, pp. 112-15.

1923
T. Borenius. *A Catalogue of the Pictures Collected by Viscount and Viscountess Lee of Fareham.* Oxford.

1925
R. Fry. "Giovanni Bellini's Madonna and Child." *Burlington Magazine* 47, pp. 64-65.

1926
G. Fiocco. "Felice Feliciano Amico degli Artisti." *Archivio Veneto-Tridentino* 9, pp. 188-201.
G. Gronau. "Una Pietà di Giovanni Bellini." *Cronache d'Arte* 3, pp. 274-77.
A. L. Mayer. "A Portrait of Jörg Fugger Ascribed to Giovanni Bellini." *Burlington Magazine* 48, pp. 218-19.
W. R. Valentiner. *Catalogue of Early Italian Painting Exhibited at the Duveen's Galleries, New York, April to May 1924.* New York.
A. Venturi. "Tre ignorati Quadri di Gian Bellino." *L'Arte,* 29, pp. 68-72.

1927
D. von Hadeln. "Two Portraits by Giovanni Bellini." *Burlington Magazine* 51, pp. 4-7.
R. Longhi. "Un Chiaroscuro e un Disegno di Giovanni Bellini." *Vita Artistica* 2, pp. 133-38. Repr. in *Edizione delle Opere complete di Roberto Longhi.* Vol. 2, bk. 1, pp. 179-88, *Saggi e Ricerche 1925–1928.* Florence, 1967, 1.

1928
Kunsthistorisches Museum. *Katalog der Gemäldegalerie.* Foreword by G. Glück. Vienna.
W. R. Valentiner. "Giovanni Bellini's Madonna and Child." *Bulletin of the Detroit Institute of Arts* 10, pp. 18-22.

1928–29
G. Gronau. *Spätwerke des Giovanni Bellini.* Strasbourg. Italian edition in *Pinacoteca* 1, pp. 57-70, 115-31, 171-77.

1929

W. Heil. "Eine Bellini-Madonna im Museum zu Detroit." *Pantheon*, 3, pp. 140-41.

P. Paoletti. *La Scuola Grande di S. Marco.* Venice.

E. Tietze-Conrat. "Giovanni Bellinis Gruppenbild von 1507." *Belvedere* 8, pp. 106-8.

J. Wilde. "Die Pala di S. Cassiano von Antonello da Messina." *Jahrbuch der Kunsthistorischen Sammlungen in Wien*, n.s., 3, pp. 57-72.

1930

G. Gronau. *Giovanni Bellini.* Stuttgart-Berlin.

A. L. Mayer. "Zu den Bildnissen des Gentile Bellini." *Pantheon* 5, pp. 17-22.

1931

D. von Hadeln. "An Unknown Portrait by Giovanni Bellini." *Burlington Magazine* 58, pp. 218-19.

E. Sandberg-Vavalà. "Lazzaro Bastiani's Madonnas." *Burlington Magazine* 59, pp. 124-40.

Staatliches Museen zu Berlin. *Beschreibendes Verzeichnis der Gemälde im Kaiser-Friedrich-Museum und Deutschen Museum.* Berlin.

1932

B. Berenson. *Italian Pictures of the Renaissance.* Oxford.

T. Borenius. "More about the Andrea Vendramin Collection." *Burlington Magazine* 60, pp. 140-45.

G. Fogolari. "Disegni per Gioco e Incunaboli del Giambellino." *Dedalo* 12, pp. 360-89.

1933

O. Sirén. *Italianska Tavlor och Techningar i National Museum.* Stockholm.

1934

G. M. Richter. "Italian Pictures in Scandinavian Collections." *Apollo* 19, pp. 128-32.

1935

L. Dussler. *Giovanni Bellini.* Frankfurt am Main.

R. van Marle. *The Development of the Italian Schools of Painting.* Vol. 17. The Hague.

1936

W. Arslan. "Recensione a L. Dussler, *Giovanni Bellini.*" *Archivio Veneto* 5, no. 19, pp. 281-88.

1937

C. Gamba. *Giovanni Bellini.* Milan.

1938

G. Fiocco. "Visto da vicino. *La Predica di San Marco* di Gentile e Giovanni Bellini." *Emporium* 88, pp. 7-16.

1939

G. M. Richter. "*Christ Carrying the Cross* by Giovanni Bellini." *Burlington Magazine* 75, pp. 94-97.

1940

G. Fogolari. "I Restauri del Giambellino delle Gallerie dell'Accademia di Venezia." *Le Arti* 2, pp. 251-55.

H. Tietze. *Four Centuries of Venetian Painting.* Toledo, Ohio.

1941

G. Weise. "Das Transzendente als Darstellungsvorwurf der Kunst des Abendlandes." In *Deutschland-Italien. Festschrift für Wilhelm Waetzoldt*, pp. 65-80. Berlin.

1942

G. F. Hartlaub. "Die Spiegel-Bilder des Giovanni Bellini." *Pantheon* 30, pp. 235-41.

1943

V. Moschini. *Giambellino.* Bergamo.

1944

H. Tietze and E. Tietze-Conrat. *The Drawings of the Venetian Painters in the 15th and 16th Centuries.* New York.

1945

L. Grassi. "Seconda Mostra a Palazzo Venezia." *Arti figurative* 1, pp. 55-64.

Ph. Hendy and L. Goldscheider. *Giovanni Bellini.* Oxford and London.

R. Pallucchini. *Cinque Secoli di Pittura Veneta.* Exhib. cat. Venice.

F. R. Shapley. "Giovanni Bellini and Cornaro's Gazelle." *Gazette des Beaux-Arts* 28, pp. 27-30.

1946

G. Fogolari. *Scritti d'Arte.* Milan.

R. Longhi. *Viatico per Cinque Secoli di Pittura Veneziana.* Florence. Repr. in *Edizione delle Opere complete di Roberto Longhi.* Vol. 10, pp. 3-63, *Ricerche sulla Pittura Veneta.* Florence, 1978.

C. L. Ragghianti. *Miscellanea minore di Critica d'Arte.* Bari.

N. Rasmo. "La Sacra Conversazione belliniana degli Uffizi e il Problema della sua Comprensione." *Carro minore* 5, 6, pp. 229-40.

E. Tietze-Conrat. "Again: Giovanni Bellini and Cornaro's Gazelle." *Gazette des Beaux-Arts* 29, pp. 187-90.

————. "Again: Giovanni Bellini and Cornaro's Gazelle." *Gazette des Beaux-Arts* 30, p. 185.

1947

G. Fiocco. "Pitture veneziane ignote del Museo di Varsavia." *Arte Veneta* 1, pp. 276-83.

H. Friedmann. "Cornaro's Gazelle and Bellini's *Orpheus.*" *Gazette des Beaux-Arts* 32, pp. 15-22.

R. Longhi. "Calepino Veneziano. I Due Pannelli di Giambellino giovane." *Arte Veneta* 1, pp. 79-90. Repr. in *Edizione delle Opere complete di Roberto Longhi.* Vol. 10, pp. 73-74, *Ricerche sulla Pittura Veneta.* Florence, 1978.

H. Tietze. "Giovanni Bellini's *Portrait of Giacomo Marcello.*" *Gazette des Beaux-Arts* 31, pp. 145-50.

1948

E. Tietze-Conrat. "An Unpublished *Madonna* by Giovanni Bellini and the Problem of Replicas in His Shop." *Gazette des Beaux-Arts* 33, pp. 379-82.

E. Wind. *Bellini's "Feast of the Gods": A Study in Venetian Humanism.* Cambridge, Mass.

1949

A. M. Brizio. "Considerazioni su Giovanni Bellini." *Arte Veneta* 3, pp. 23-39.

L. Coletti. "Revisione della Storiografia belliniana." *Vernice* 4, nos. 33-34, pp. 10-14.

M. Dazzi. "La *Presentazione* della Querini-Stampalia." *Arte Veneta* 3, pp. 153-58.

R. K. Donin. "Die Bellini-Ausstellung in Venedig." *Mitteilungen der Gesellschaft für vergleichende Kunstforschung in Wien* 2, no. 2, pp. 48-49.

L. Dussler. *Giovanni Bellini.* 2nd ed. Vienna.

G. Fiocco. "I disegni del Giambellino." *Arte Veneta* 3, pp. 40-54.

R. Gallo. "I polittici delle cappelle del coro già nella chiesa di Santa Maria della Carità." *Arte Veneta* 3, pp. 136-40.

R. Longhi "The Giovanni Bellini Exhibition." *Burlington Magazine* 91, pp. 274-83. Repr. in *Edizione delle Opere complete di Roberto Longhi.* Vol. 10, pp. 99-109, *Ricerche sulla Pittura Veneta.* Florence, 1978.

V. Moschini. "Nuovi aspetti di opere famose." *Bollettino d'Arte* 4, no. 34, pp. 162-70.

————. "Postilla sui restauri belliniani." *Arte Veneta* 3, p. 176.

R. Pallucchini. "A proposito di Giambellino e di altri argomenti." *Arte Veneta* 3, pp. 175-76.

————. *Giovanni Bellini.* Exhib. cat. Venice.

————. "La presentazione della mostra del Bellini." *Bollettino d'Arte* 4, no. 34, pp. 375-78.

W. Suida. *A Catalogue of Paintings in the John & Mable Ringling Museum of Art.* Sarasota, Fla.

H. Tietze and E. Tietze-Conrat. "L'*Orfeo* attribuito al Bellini della National Gallery di Washington." *Arte Veneta* 3, pp. 90-95.

G. Urbani. "Alcuni disegni di Giovanni Bellini." *Arte Veneta* 3, pp. 87-89.

L. Vertova. *Giovanni Bellini.* Florence.

L. Zanini. "Dopo la mostra del Giambellino." *La Panarie* 17, no. 97, pp. 129-31.

1949-50

M. Minio. "Iconografia della flora spontanea in Giovanni Bellini: suo interesse di fonte cronologica e come tipo di intuizione biologica."

Atti dell'Istituto Veneto di Scienze, Lettere ed Arti 108, pp. 155-76.

1950

T. Bertelè. "Iconografia di Bartolomeo Colleoni." *Bergomum* 24, pp. 3-36.

M. Davies. "Un dipinto belliniano radiografato a Londra." *Arte Veneta* 4, p. 169.

B. Degenhart. "Nach der Bellini-Ausstellung." *Zeitschrift für Kunst* 4, pp. 3-34.

N. Maclaren and A. Werner. "Some Factual Observations about Varnishes and Glazes." *Burlington Magazine* 92, pp. 189-92.

E. Modigliani. *Catalogo della Pinacoteca di Brera.* Milan.

R. Pallucchini. "Commento alla Mostra di Ancona." *Arte Veneta* 4, pp. 7-32.

W. E. Suida. "Giovanni Bellini's Portrait of the Condottiere Bartolomeo d'Alviano." *Art Quarterly*, pp. 49-58.

E. Wind. "The Eloquence of Symbols." *Burlington Magazine* 92, pp. 349-50.

P. Zampetti. "La Mostra della Pittura Veneta nelle Marche." *Bollettino d'Arte* 35, pp. 372-75.

1950-51

C. Norris. "Exhibition of Giovanni Bellini's Paintings." *Phoebus* 3, pp. 36-41.

1951

E. Arslan. "I Trittici della Carità." *Bollettino d'Arte* 36, pp. 305-23.

M. Davies. *National Gallery Catalogues: The Earlier Italian Schools.* London.

R. Fastnedge. "Two Cleaned Pictures from the Roscoe Collection." *Liverpool Bulletin* 1, no. 1, pp. 15-23.

F. M. Godfrey. "The Birth of Venetian Genre and Giorgione." *Connoisseur* 523, pp. 75-82.

A. Pallucchini. "Giovanni Bellini e l'umanesimo veneziano." *Arte Veneta* 5, pp. 187-88.

1952

E. Arslan. "Il Polittico di San Zanipolo." *Bollettino d'Arte* 37, pp. 127-46.

J. Byam Shaw. "A Giovanni Bellini at Bristol." *Burlington Magazine* 94, pp. 157-59.

————. "A Further Note on the Bristol Bellini." *Burlington Magazine* 94, p. 237.

F. M. Godfrey. "Masterpieces of European Painting from the Kaiser-Friedrich-Museum." *Connoisseur* 527, pp. 33-38.

G. Mariacher. "Dipinti restaurati al Museo Correr di Venezia." *Bollettino d'Arte* 37, pp. 261-65.

1952-53

P. Verdier. "L'Allegoria della Misericordia e della Giustizia di Giambellino." *Atti dell'Istituto Veneto di Scienze, Lettere ed Arti* 111, pp. 97-116.

1954

G. Fiocco. "Notes sur les dessins de Marco Zoppo." *Gazette des Beaux-Arts* 43, pp. 221-30.

C. Sterling. "Notes brèves sur quelques tableaux inconnus à Dallas." *Arte Veneta* 8, pp. 265-71.

1955

L. Baldass. "Die Tat des Giorgione." *Jahrbuch der Kunsthistorischen Sammlungen in Wien* 51, pp. 103-44.

L. Coletti. *Tutta la Pittura di Giorgione.* Milan.

P. Della Pergola. *Galleria Borghese. I Dipinti.* 2 vols. Rome.

S. Moschini Marconi. *Gallerie dell'Accademia di Venezia. Opere d'Arte dei Secoli XIV e XV.* Rome.

P. Zampetti. *Giorgione e i Giorgioneschi.* Exhib. cat. Venice.

1956

E. Arslan. *Vicenza. Le Chiese.* Catalogo delle cose d'arte e d'antichità d'Italia. Rome.

W. Braunfels. "Giovanni Bellinis Paradiesgärtlein." *Das Münster* 9, pp. 1-13.

A. Dürer. *Schriftlicher Nachlass.* Vol. 1, pp. 43-45. Ed. H. Rupprich. Berlin.

C. Gilbert. "Alvise e Compagni." In *Scritti di storia dell'arte in onore di Lionello Venturi*, pp. 277-308. Rome.

M. Laclotte. "Peintures italiennes des XIVe et XVe siècles à l'Orangerie." *Arte Veneta* 10, pp. 225-32.

J. Walker. *Bellini and Titian at Ferrara: A Study of Styles and Taste.* London.

1957

B. Berenson. *Italian Pictures of the Renaissance: Venetian School.* 2 vols. London.

T. Hetzer. *Aufsätze und Vorträge (1929).* Pp. 7-41. Leipzig.

Sotheby's. *Important Drawings and Paintings*, 20.11, n. 7. London.

G. Mariacher. *Il Museo Correr di Venezia. Dipinti dal XIV al XVI secolo.* Venice.

M. Meiss. *Andrea Mantegna as Illuminator.* New York.

V. Moschini. "Il lascito Fornoni alla Scuola di S. Rocco." *Arte Veneta* 11, pp. 249-50.

R. Pallucchini. "Bellini e Tiziano a Ferrara." *Arte Veneta* 11, pp. 237-38.

E. Waterhouse. "The Manchester Exhibition 1957." *Burlington Magazine* 99, pp. 412-15.

1957-59

D. Redig de Campos. "Monumenti, musei e gallerie pontificie nel quinquennio 1954-58. Il Relazione dei laboratori di restauro." *Atti della pontificia Accademia Romana di Archeologia. Rendiconti.*" Vols. 30-31, pp. 273-306.

1958

G. Fiocco. "Segnalazioni venete nel Museo di Kieff. Una predella di Jacobello del Fiore; una *Madonna* di Giovanni Bellini; due busti di Danese Cattaneo." *Arte Veneta* 12, pp. 31-37.

————. "Notes sur les dessins de Marco Zoppo." In *Essays in Honor of Hans Tietze*, pp. 223-32. Paris.

F. Klauner. "Venezianische Landschaftsdarstellung von Jacopo Bellini bis Tizian." *Jahrbuch der Kunsthistorischen Sammlungen in Wien* 54, pp. 121-50.

G. Marioni and G. Mutinelli. *Guida storicoartistica di Cividale.* Udine.

A. Morassi. "Scoperta d'un Cristo benedicente del Giambellino." *Arte Veneta* 12, pp. 45-52.

1959

J. Byam Shaw. "Two Drawings by Domenico Tiepolo." *Festschrift Friedrich Winkler*, pp. 340-45. Berlin.

R. Pallucchini. *Giovanni Bellini.* Milan.

1960

G. Fiocco. *Giovanni Bellini.* Milan.

G. Mandel. "Giovanni Bellini." *Rinnovamento* 1, no. 2, pp. 7-8.

G. Robertson. "The Earlier Work of Giovanni Bellini." *Journal of the Warburg and Courtauld Institutes* 23, pp. 45-59.

D. Sutton. "Quattro secoli di connoisseurship." *Arte figurativa* 8, no. 43, pp. 2-31.

1960-61

M. Compton. "William Roscoe and Early Collectors of Italian Primitives." *Liverpool Bulletin* 9, no. 3, pp. 27-51.

1961

M. Davies. *National Gallery Catalogues: The Earlier Italian Schools.* 2nd ed., rev. London.

M. Levey. "Minor Aspects of Dürer's Interest in Venetian Art." *Burlington Magazine* 103, pp. 511-13.

1962

E. Arslan. "Studi belliniani." *Bollettino d'Arte* 47, pp. 40-58.

A. Campana. "Notizie sulla Pietà riminese di Giovanni Bellini." In *Scritti di storia dell'arte in onore di Mario Salmi.* Vol. 2, pp. 405-27. Rome.

F. Gibbons. "Giovanni Bellini and Rocco Marconi." *Art Bulletin* 44, pp. 127-31.

————. "The Bellinesque Painter Marco Bello." *Arte Veneta* 16, pp. 42-48.

F. Heinemann. *Giovanni Bellini e i Belliniani.* 2 vols. Venice.

R. Longhi. "Crivelli e Mantegna. Due mostre interferenti e la cultura artistica del 1961." *Paragone* 13, no. 145, pp. 3-21.

F. Valcanover. *La Pinacoteca dell'Accademia dei Concordi*. Venice.

1963

S. Bottari. *Tutta la Pittura di Giovanni Bellini*. 2 vols. Milan.

F. Gibbons. "New Evidence for the Birth-Date of Gentile and Giovanni Bellini." *Art Bulletin* 45, pp. 54–58.

M. Meiss. "Giovanni Bellini's St. Francis." *Saggi e memorie di storia dell'arte* 3, pp. 9–30.

M. Prijatelj. "Dobrotska bogorodica Giovanija Bellinija." *Bulletin Instituta za Likovne Umjetnosti* 11, nos. 1, 2, pp. 135–40, 164–65.

M. G. Rutteri. "Musei e Pinacoteche. L'Accademia Carrara di Bergamo." *Acropoli* 3, no. 2, pp. 144–62.

P. Serracino Inglott. "La *Trasfigurazione* del Bellini." *Arte Cristiana* 51, pp. 221–36.

E. Ybl. "Una madonna veneziana del 1500 circa." *Acta historiae artium Academiae Scientiarum Hungaricae* 9, pp. 163–70.

1964

M. Bonicatti. *Aspetti dell'Umanesimo nella Pittura Veneta dal 1455 al 1515*. Rome.

E. Fahy. "New Evidence for Dating Giovanni Bellini's *Coronation of the Virgin*." *Art Bulletin* 46, pp. 216–18.

A. Lipinsky. "Mostra dell'arte in Puglia." *Arte Cristiana* 52, pp. 336–46.

M. Meiss. *Giovanni Bellini's "St. Francis" in the Frick Collection*. Princeton.

A. Morassi. "Giovanni Bellini e i belliniani in un libro di F. Heinemann." *Arte Veneta* 18, pp. 201–3.

R. Pallucchini. "Una nuova opera di Giovanni Bellini." *Arte Veneta* 18, pp. 13–18.

L. Puppi. "L'Umanesimo e la pittura veneta dal 1455 al 1555." *Arte Veneta* 18, pp. 204–7.

Z. Wazbinski. "Autour d'une oeuvre perdue de Giovanni Bellini." *Bulletin du Musée National de Varsovie* 5, no. 2, pp. 39–45.

1965

R. Chiarelli. "Il Castelvecchio riacquistato." *Antichità Viva* 4, no. 1, pp. 33–44.

F. Gibbons. "Practices in Giovanni Bellini's Workshop." *Pantheon* 23, pp. 146–55.

A. Parronchi. "Chi sono 'I tre filosofi'?" *Arte lombarda* 10, pp. 91–98.

———. "Di un 'memento mori' di Giovanni Bellini." *Arte Veneta* 19, pp. 148–50.

A. Pertusi. "Quedam regalia insignia. Ricerche sulle insegne del potere ducale a Venezia durante il Medioevo." *Studi veneziani* 7, pp. 3–123.

1966

M. Meiss. "Letter: Giovanni Bellini's *St. Francis*," *Burlington Magazine* 108, p. 27.

A. Paolucci. "Benedetto Diana." *Paragone* 17, no. 199, pp. 3–20.

E. Ruhmer. *Marco Zoppo*. Vicenza.

C. Semenzato. *Giovanni Bellini*. Florence.

1967

X. de Salas. "Un tableau d'Antonello de Messine au Musée du Prado." *Gazette des Beaux-Arts* 70, pp. 125–38.

M. Salmi. "La donazione Contini Bonacossi." *Bollettino d'Arte*, 5th ser., vol. 52, pp. 222–32.

V. Zlamalik. *Strossmayerova Galerija. Starih Majstora Jugoslavense Akademije Znanosti i Umjetnosti*. Zagreb.

1968

A. Ballarin. "Pittura veneziana nei Musei di Budapest, Dresda, Praga e Varsavia." *Arte Veneta* 22, pp. 237–55.

H. Menz. "Die Ausstellung Venezianische Malerei im Albertinum." *Dresdener Kunstblätter* 12, pp. 98–102.

Mostra di Opere d'Arte restaurate. XIª Settimana dei Musei. Urbino.

G. Robertson. *Giovanni Bellini*. Oxford. Repr. New York, 1981.

1969

C. Brown. "'Una testa de Platone antica con la punta dil naso di cera.' Unpublished Negotiations Between Isabella d'Este and Niccolò and Giovanni Bellini." *Art Bulletin* 51, pp. 372–77.

———. "New Documents Concerning Andrea Mantegna and a Note Regarding 'Jeronimus de Conradis pictor.'" *Burlington Magazine* 111, pp. 538–44.

D. Cast. "The Stork and the Serpent: A New Interpretation of the *Madonna of the Meadow* by Bellini." *Art Quarterly* 32, pp. 247–57.

E. Hubala. *Giovanni Bellini. Madonna mit Kind. Die Pala di San Giobbe*. Stuttgart.

E. Panofsky. *Problems in Titian, Mostly Iconographic*. New York.

T. Pignatti. *L'Opera completa di Giovanni Bellini*. Milan.

L. Puppi. "La pala votiva Mocenigo della National Gallery di Londra." *Antichità Viva* 8, no. 3, pp. 3–18.

A. Rizzi. "Un polittico inedito di Lazzaro Bastiani." *Arte Veneta* 23, pp. 21–30.

A. Schiavo. "I ritratti di Girolamo e Caterina Riario nella Pinacoteca Capitolina." *Studi romani* 17, pp. 315–18.

F. Zeri. "The Second Volume of the Kress Catalogue." *Burlington Magazine* 111, pp. 455–58.

1970

H. Collins. "Gentile Bellini." Ph.D. diss., University of Pittsburgh. Ann Arbor, Mich.: University Microfilm, 1976.

1970–71

E. C. G. Packard. "A Bellini Painting from the Procuratia di Ultra, Venice: An Exploration of the History and Technique." *Journal of the Walters Art Gallery*, 33–34, pp. 64–84.

1971

M. Bonicatti. "Dürer nella storia delle idee umanistiche fra Quattrocento e Cinquecento." *Journal of Medieval and Renaissance Studies* 1, pp. 131–282.

J. M. Fletcher. "Isabella d'Este and Giovanni Bellini's *Presepio*." *Burlington Magazine* 113, pp. 703–12.

C. Hope. "The *Camerino d'Alabastro* of Alfonso d'Este." *Burlington Magazine* 113, pp. 641–50, 712–21.

A. Wilhelm. "Ein neuaufgefundenes Werk des 'Italienisch geschulten Meisters.'" *Das Münster* 24, no. 4, pp. 231–33.

1972

C. Brown and M. A. Lorenzoni. "Luca Fancelli in Mantua: A Checklist of His 185 Letters to the Gonzaga. With an Appendix on the Dating of Letters Regarding Luca Fancelli and Giovanni Bellini." *Mitteilungen des Kunsthistorischen Institutes in Florenz* 16, pp. 153–66.

J. M. Fletcher. "The Provenance of Bellini's Frick St. Francis," *Burlington Magazine* 114, pp. 206–14.

N. Huse. *Studien zu Giovanni Bellini*. Berlin and New York.

A. Smith. "Dürer and Bellini, Apelles and Protogenes." *Burlington Magazine* 14, pp. 326–29.

1973

E. Billanovich. "Note per la storia della pittura nel Veneto." *Italia medievale e umanistica* 16, pp. 359–89.

A. Braham. "A Reappraisal of *The Introduction of the Cult of Cybele at Rome* by Mantegna." *Burlington Magazine* 115, pp. 457–63.

J. Fletcher. "Marcantonio Michiel's Collection." *Journal of the Warburg and Courtauld Institutes* 36.

A. Ian Fraser. "A Catalogue of the Clowes Collection." *Bulletin, Indianapolis Museum of Art*, n.s., nos. 1–2, pp. 195–96.

G. Pochat. "Giovanni Bellini. Gedanken zum Werk anlässlich Norbert Huses *Studien zu Giovanni Bellini*." *Konsthistorisk Tidskrift* 42, nos. 1–2, pp. 48–59.

A. Smart. "The Speculum Perfectionism and Bellini's Frick *St. Francis*." *Apollo* 97, pp. 470–76.

F. Zeri, with the assistance of E. E. Gardner. *Italian Paintings. A Catalogue of the Collection of the Metropolitan Museum of Art. Venetian School*. Vicenza.

1974

C. Brown. "Andrea Mantegna and the Cornaro of Venice." *Burlington Magazine* 116.

R. Goffen. "Icon to Vision: The Half-Length *Madonnas* of Giovanni Bellini." Ph.D. diss., Columbia University.

A.-M. Lecoq. "L'art de la signature." *Revue de l'art* 26, pp. 15–26.

M. L. Shapiro. "The Widener Orpheus." *Studies in the History of Art, National Gallery of Art, Washington, D.C.* 6, pp. 23–36.

1974–76

A. Gentili. "La musica di Orfeo. Elogio e critica dell'armonia nella cultura giorgionesca." In *Annuario dell'Istituto di storia dell'arte, Università degli studi di Roma*, pp. 145–66.

1975

N. Bertos Rigas. "Some Remarks on Titian and Bellini at Ferrara." *Racar* 2, no. 2, pp. 49–54.

R. Goffen. "Icon to Vision: Giovanni Bellini's Half-Length *Madonnas*." *Art Bulletin* 57, pp. 487–518.

L. Vertova. "Bernardino Licinio." In *I Pittori Bergamaschi dal XIII al XIX Secolo. Il Cinquecento*. Vol. 1, pp. 371–425. Bergamo.

1977

J. Bialostocki. "Man and Mirror in Painting. Reality and Transience." In *Studies in Medieval and Renaissance Painting in Honor of Millard Meiss*, pp. 61–72. New York.

P. Cannon-Brookes. *The Cornbury Park Bellini. A Contribution Towards the Study of the Late Paintings of Giovanni Bellini*. Birmingham.

A. Chastel. "Sur deux rameaux de figuier." In *Studies in Medieval and Renaissance Painting in Honor of Millard Meiss*, pp. 83–87. New York.

S. J. Delaney. "The Iconography of Giovanni Bellini's *Sacred Allegory*." *Art Bulletin* 59, pp. 331–35.

C. Del Bravo. "La dolcezza dell'immaginazione." *Annali della Scuola Normale di Pisa. Classe di Lettere e Filosofia* 7, pp. 759–99.

F. Gibbons. "Giovanni Bellini's Topographical Landscapes." In *Studies in Medieval and Renaissance Painting in Honor of Millard Meiss*, pp. 174–84. New York.

P. Humfrey. "A Non-Bellini from the Carità in Venice." *Burlington Magazine* 119, pp. 36–39.

A. Parronchi. "La prospettiva a Venezia tra Quattro e Cinquecento." *Prospettiva* 9, pp. 7–16.

C. L. Ragghianti. "Bonnatiana, 2." *Critica d'arte* 42, nos. 154–56, pp. 55–70.

G. Robertson. "The Architectural Setting of Antonello da Messina's San Cassiano Altarpiece." In *Studies in Medieval and Renaissance Painting in Honor of Millard Meiss*, pp. 368–72. New York.

C. Seymour Jr. "A Note on Early Titian: The *Circumcision* Panel at Yale." In *Studies in Medieval and Renaissance Painting in Honor of Millard Meiss*, pp. 392–98. New York.

Ph. Williams Lehmann. *Cyriacus of Ancona's Egyptian Visit and Its Reflections in Gentile Bellini and Hieronymus Bosch*. New York.

C. C. Wilson. "Bellini's Pesaro Altarpiece: A Study in Context and Meaning." Ph.D. diss., New York University.

1977–78

C. C. Wilson. "Bellini's Pesaro Altarpiece: A Study in Context and Meaning." *Marsyas* 19, pp. 71–72.

1978

D. Goodgal. "The *Camerino* of Alfonso I d'Este." *Art History* 1, pp. 162–90.

G. Knox. "The Camerino of Francesco Corner." *Arte Veneta* 32, pp. 79–84.

M. Lucco. "Contributo alla ricostruzione di un trittico belliniano." *Paragone* 29, no. 335, pp. 79–86.

T. Pignatti. "Giorgione e Tiziano." In *Tiziano e il Manierismo europeo*. Vol. 24, pp. 29–41, *Civiltà veneziana. Saggi*. Florence.

W. Pinardi. "Conservare anche la Madonna di Alzano." *Arte Cristiana* 66, pp. 333–36.

P. Ramade. "Dessins de la Renaissance: Collection du Musée des Beaux-Arts de Rennes." *Bulletin des amis du Musée de Rennes* 1, pp. 25–42.

A. Ruggeri Augusti. "Giovanni Bellini, Vanitas." In *Giorgione a Venezia*. Exhib. cat., pp. 34–37. Venice and Milan.

———. "Santi Gerolamo, Cristoforo e Ludovico." In *Giorgione a Venezia*. Exhib. cat., pp. 196–202. Venice and Milan.

E. Ruhmer. "Paduaner Quattrocento Plastiken als Quellen der Hochrenaissance." *Arte Veneta* 32, pp. 61–67.

L. Russenberger. "Bellini and Titian: The Legacy of a Venetian Tradition." *Apollo* 108, pp. 112–17.

W. S. Sheard. "The Widener *Orpheus*: Attribution, Type, Invention." In *Collaboration in Italian Renaissance Art: In Memoriam Charles Seymour, Jr.*, pp. 189–231. New Haven and London.

F. Valcanover. "Il classicismo cromatico di Tiziano." In *Tiziano e il Manierismo europeo*. Vol. 24, pp. 43–69, *Civiltà veneziana. Saggi*. Florence.

C. Volpe. "Per gli inizi di Giovanni Bellini." *Arte Veneta* 32, pp. 56–60.

P. F. Watson. "Titian and Michelangelo: The Danae of 1545–1546." In *Collaboration in Italian Renaissance Art: In Memoriam Charles Seymour, Jr.*, pp. 245–60. New Haven and London.

A. Braham, M. Wyld, and J. Plesters. "Bellini's *Blood of the Redeemer*." *National Gallery Technical Bulletin* 2, pp. 11–24.

H. W. van Os, J. R. J. van Asperen de Boer, C. E. de Jong-Jansen, and C. Wiethoff. *The Early Venetian Paintings in Holland*. Exhib. cat. Maarssen, The Netherlands.

1978–79

L. Ciriello and F. de Vecchi. "Considerazioni sul cosiddetto *Vesperbild* del museo di Trieste con riferimento ad altri tipi nella regione." *Atti dei civici musei di storia ed arte, Trieste* 10, pp. 50–71.

1979

A. Chastel. "Le arti nel Rinascimento." In *Il Rinascimento. Interpretazioni e problemi*, pp. 273–322. Bari.

A. Conti. "Vedere fino in fondo." *Prospettiva* 16, pp. 79–80.

P. Humfrey. "Cima's Altarpiece in the *Madonna dell'Orto* in Venice." *Arte Veneta* 33, pp. 122–25.

———. "Letter: A Non-Bellini from the Carità in Venice." *Burlington Magazine* 121, p. 253.

C. L. Joost-Gaugier. "A Pair of Miniatures by a Panel Painter: The Earliest Work of Giovanni Bellini?" *Paragone* 30, no. 357, pp. 48–71.

A. Paolucci. In *Gli Uffizi. Catalogo generale*, p. 161. Florence.

M. Robertson. "A Possible Classical Echo in Bellini." *Burlington Magazine* 121, pp. 650–53.

F. R. Shapley. *Catalogue of the Italian Paintings. National Gallery of Washington*. 2 vols. Washington, D.C.

C. H. Smyth. "Venice and the Emergence of the High Renaissance in Florence: Observations and Questions." In *Florence and Venice: Comparisons and Relations. Acts of Two Conferences at Villa I Tatti in 1976–77*. Vol. 1, pp. 209–49. Florence.

1979–80

M. G. Paolini. "La Dimensione rinascimentale di Antonello da Messina." *Atti e Memorie della Accademia Petrarca di Lettere, Arti e Scienze* 43, pp. 65–96.

1980

M. Daly Davis. "Carpaccio and the Perspective of Regular Bodies." In *La Prospettiva rinascimentale. Codificazioni e trasgressioni*. Vol. 1. Florence.

C. Hope. "Titian's Role as Official Painter to the Venetian Republic." In *Tiziano e Venezia. Convegno internazionale di Studi* (Venice, 1976), pp. 301–5. Vicenza.

N. E. Land. "Two Panels by Michele Giambono and Some Observations on St.

Francis and the Man of Sorrows in Fifteenth-Century Venetian Painting." *Studies in Iconography* 6, pp. 29-41.

A. Markham Schulz. "A Portrait of Giovanni Emo in the National Gallery of Art." *Studies in the History of Art* 9, pp. 7-11.

J. Meyer zur Capellen. "Beobachtungen zu Jacopo Pesaros Exvoto in Antwerpen." *Pantheon* 38, pp. 144-52.

A. Perrig. "Leonardo: Die Anatomie der Erde." *Jahrbuch der Hamburger Kunstsammlungen* 25, pp. 51-80.

G. Previtali. "Da Antonello da Messina a Jacopo di Antonello: 2. Il *Cristo deposto* del Museo del Prado." *Prospettiva* 21, pp. 45-57.

1981

C. Cieri Via. "Allegorie morali nella Bottega Belliniana." In *Giorgione e la Cultura Veneta tra 400 e 500. Mito, Allegoria, Analisi iconologica. Atti del Convegno* (Rome, 1978), pp. 126-45. Rome.

S. Coltellacci and M. Lattanzi. "Studi belliniani. Proposte iconologiche per la *Sacra Allegoria* degli Uffizi." In *Giorgione e la Cultura Veneta tra 400 e 500. Mito, Allegoria, Analisi iconologica. Atti del Convegno* (Rome, 1978), pp. 59-79. Rome.

M. Lattanzi. "La pala di *San Giovanni Crisostomo* di Giovanni Bellini. Il soggetto, la committenza, il significato." *Artibus et historiae* 4, pp. 29-38.

R. Linnenkamp. "Über Originalität und ihre Grenzen." *Pantheon* 39, pp. 202-3.

G. Marchini. *La Galleria di Palazzo degli Alberti. Opere d'Arte della Cassa di Risparmi e Depositi di Prato*. Milan.

B. W. Meijer. "Titian Sketches on Canvas and Panel." *Master Drawings* 19, pp. 276-89.

U. Ruggeri. "I disegni veneti della collezione Lugt." *Arte Veneta* 35, pp. 268-71.

G. Schweikhart. "Giorgione e Bellini." In *Giorgione e l'Umanesimo veneziano*. Vol. 2, pp. 465-84. Florence.

F. R. Shapley. "On Bellini's *Orpheus*." *Gazette des Beaux-Arts* 97, p. 130.

A. Tempestini. "*L'Incredulità di San Tommaso* nella Chiesa di San Nicolò a Treviso e il suo enigmatico autore." In *Lorenzo Lotto. Atti del Convegno internazionale di Studi per il V Centenario della Nascita* (Asolo, 1980), pp. 111-13. Eds. P. Zampetti and V. Sgarbi. Venice.

F. Trevisani. "Osservazioni sulla mostra 'Lorenzo Lotto nelle Marche.' Il suo tempo, il suo influsso." *Arte Veneta* 35, pp. 275-88.

E. Waterhouse. "Holman Hunt's *Giovanni Bellini* and the Pre-Raphaelites' Own Early Italian Pictures." *Burlington Magazine* 123, pp. 473-77.

1982

H. F. Collins. "Major Narrative Paintings by Jacopo Bellini." *Art Bulletin* 44, pp. 466-72.

———. "The Cyclopean Vision of Jacopo Bellini." *Pantheon* 40, pp. 300-304.

J. V. Fleming. *From Bonaventure to Bellini: An Essay in Franciscan Exegesis*. Princeton.

1983

C. Del Bravo. "Giovanni Bellini in relazione al Valla." *Annali della Scuola Normale Superiore di Pisa* 13, no. 3, pp. 691-704. Repr. in C. Del Bravo, *Le Risposte dell'Arte*, pp. 91-107. Florence, 1985.

M. Lucco. "Venezia fra Quattro e Cinquecento." In *Storia dell'Arte Italiana*. Vol. 2, bk. 1, pp. 445-77. Turin.

F. Valcanover, E. Merkel, G. Nepi Scirè, L. Lazzarini, P. Spezzani, and O. Nonfarmale. "La pala *Barbarigo* di Giovanni Bellini." In *Quaderni della Soprintendenza ai Beni Artistici e Storici di Venezia*. Vol. 3. Venice.

1984

R. De Simone. "La *Pietà* del Collegio Nazareno. Un problema belliniano." *Notizie da Palazzo Albani* 13, no. 2, pp. 24-29.

H. T. Goldfarb. "An Early Masterpiece by Titian Rediscovered, and Its Stylistic Implications." *Burlington Magazine* 126, pp. 419-23.

N. E. Land. "On the Poetry of Giovanni

Bellini's *Sacred Allegory*." *Artibus et historiae* 10, pp. 61-66.

S. Ringbom. *Icon to Narrative: The Rise of the Dramatic Close-Up in Fifteenth-Century Devotional Painting*. 2nd ed. Doornspijk.

V. Sgarbi. "Dal Vangelo secondo Giovanni: La *Deposizione* di Giovanni Bellini." In *Scritti di storia dell'arte in onore di Federico Zeri*. Vol. 1, pp. 312-14. Milan.

W. S. Sheard. "The Birth of Monumental Classicizing Relief in Venice on the Façade of the Scuola di San Marco." In *Interpretazioni veneziane. Studi di storia dell'arte in onore di Michelangelo Muraro*, pp. 149-74. Venice.

A. Tempestini. "Marco Bello tra Giovanni Bellini e Vincenzo Catena." In *Scritti di storia dell'arte in onore di Federico Zeri*. Vol. 1, pp. 315-22. Milan.

1984-86

T. Thomas. "The Pagan Reliefs in Giovanni Bellini's *Blood of the Redeemer*." *Studies in Iconography* 10, pp. 67-78.

1985

H. Belting. *Pietà, Ikone und Bilderzählung in der Venezianischen Malerei*. Frankfurt am Main.

C. Eisler. "*Saints Anthony Abbot and Bernardino of Siena* Designed by Jacopo and Painted by Gentile Bellini." *Arte Veneta* 39, pp. 32-40.

R. W. Gaston. "Attention and Inattention in Religious Painting of the Renaissance: Some Preliminary Observations." In *Renaissance Studies in Honor of Craig Hugh Smyth*. Vol. 2, pp. 253-68. Florence.

A. Gentili and F. Torella. *Giovanni Bellini. Il Polittico di San Vincenzo Ferrer*. Venice.

R. Goffen. "Giovanni Bellini and the Altarpiece of St. Vincent Ferrer." In *Renaissance Studies in Honor of Craig Hugh Smyth*. Vol. 2, pp. 277-85. Florence.

———. "Bellini's Altarpieces, Inside and Out." *Source: Notes in the History of Art* 5, no. 1, pp. 23-28.

T. Hetzer. *Venezianische Malerei von ihren Anfängen bis zum Tode Tintorettos*. Stuttgart.

M. Lattanzi and S. Coltellacci. *Giovanni Bellini. Pala dei Santi Girolamo, Ludovico e Cristoforo*. Venice.

G. Marchini. *La Galleria di Palazzo degli Alberti. 100 Opere d'arte*. Prato. (See 1981.)

J. Meyer zur Capellen. *Gentile Bellini*. Stuttgart.

G. Mulazzani. "Raphael and Venice: Giovanni Bellini, Dürer and Bosch." *Studies in the History of Art* 17, pp. 149-53.

D. Sutton. "Aspects of British Collecting, Part IV; XIV: From Ottley to Eastlake; XVI: Crowe and Cavalcaselle; XVII: Discoveries." *Apollo* 122, no. 282, pp. 84-95, 111-17, 118-29.

1986

G. Agosti. "Sui teleri perduti del Maggior Consiglio nel Palazzo Ducale di Venezia." *Ricerche di storia dell'arte* 30, pp. 61-87.

A. Angelini. *Disegni Italiani del tempo di Donatello*. Intro. by L. Bellosi. Exhib. cat., pp. 7-11. Florence.

H. Belting. *L'Arte e il suo pubblico. Funzione e forme delle antiche immagini della passione*. Bologna.

M. Bergstein. "*La Fede*: Titian's Votive Painting for Antonio Grimani." *Arte Veneta* 40, pp. 29-37.

M. Boskovits. "Giovanni Bellini. Quelques suggestions sur ses débuts." *Revue du Louvre et des Musées de France* 36, pp. 386-93.

I. Chiappini di Sorio. *Giovanni Bellini. Incoronazione della Vergine (Pala di Pesaro)*. Venice.

Gemäldegalerie Berlin. Gesamtverzeichnis der Gemälde. Complete Catalogue of the Paintings. London.

R. Goffen. "Bellini, S. Giobbe and Altar Egos." *Artibus et historiae* 14, pp. 57-70.

P. Humfrey. "Some Additions to the Cima Catalogue." *Arte Veneta* 40, pp. 154-56.

———. "The Venetian Altarpieces of the Early Renaissance in the Light of Contemporary Business Practice." *Saggi e memorie di storia dell'arte* 15, pp. 63-82.

L. Iseppi. "Una proposta per gli esordi di Lazzaro Bastiani." *Paragone* 37, nos. 431-33, pp. 36-40.

A. Tempestini. "Recensione a P. Humfrey, *Cima da Conegliano*." *Antichità Viva* 25, no. 1, pp. 47-51.

1987

G. Agosti, V. Farinella, and S. Settis. "Passione e gusto per l'antico nei pittori italiani del Quattrocento." *Annali della Scuola Normale Superiore di Pisa* 17, no. 4, pp. 1061-1070.

J. Benci and S. Stucky. "Indagini sulla pala della *Lamentazione*. Bonaventura da Forlì e i Servi di Maria a Venezia." *Artibus et historiae* 15, pp. 47-65.

B. L. Brown. "On the *Camerino*." In *Bacchanals by Titian and Rubens. Papers given at a Symposium in the Nationalmuseum Stockholm*, pp. 43-56. Stockholm.

D. Bull. "The Restoration of Bellini's-Titian's *Feast of the Gods*." In *Bacchanals by Titian and Rubens. Papers Given at a Symposium in the Nationalmuseum Stockholm*, pp. 9-16. Stockholm.

A. Conti. "Giovanni Bellini fra Marco Zoppo ed Antonello da Messina." In *Antonello da Messina. Atti del Convegno di Studi* (Messina, 1981), pp. 274-303. Messina.

D. Goodgal. "Titian Repairs Bellini." In *Bacchanals by Titian and Rubens. Papers Given at a Symposium in the Nationalmuseum Stockholm*, pp. 17-24. Stockholm.

P. Holberton. "The Choice of Texts for the *Camerino* Pictures." In *Bacchanals by Titian and Rubens. Papers Given at a Symposium in the Nationalmuseum Stockholm*, pp. 57-66. Stockholm.

C. Hope. "The *Camerino d'Alabastro*. A Reconsideration of the Evidence." In *Bacchanals by Titian and Rubens. Papers Given at a Symposium in the Nationalmuseum Stockholm*, pp. 25-42. Stockholm.

S. Marinelli. *Proposte e Restauri. I Musei d'Arte negli anni Ottanta*. Verona.

J. Snow-Smith. "Leonardo's *Virgin of the Rocks* (Musée du Louvre): A Franciscan Interpretation." *Studies in Iconography* 11, pp. 35-94.

S. Sponza. "Osservazioni sulle pale di San Giobbe e di San Zaccaria di Giovanni Bellini." *Arte Veneta* 41, pp. 168-75.

1988

D. Banzato. *La Quadreria Emo Capodilista. 543 Dipinti dal '400 al '700 (Padua)*. Exhib. cat. Rome.

P. Humfrey. "Competitive Devotions: The Venetian Scuole Piccole as Donors of Altarpieces in the Years around 1500." *Art Bulletin* 70, pp. 401-23.

R. G. Kecks. *Madonna und Kind. Das häusliche Andachtsbild im Florenz des 15. Jahrhunderts*. Berlin.

S. Marinelli. "L'Amico del Sublime." In F. Feliciano. *Epistole e Versi agli Amici artisti*. Verona.

R. Tardito. "Milano, Pinacoteca di Brera. Il restauro della *Predica di San Marco in Alessandria d'Egitto* di Gentile e Giovanni Bellini." *Arte Veneta* 42, pp. 258-66.

B. Treffers. "Il Francesco Hartford del Caravaggio e la spiritualità francescana alla fine del XVI secolo." *Mitteilungen des Kunsthistorischen Institutes in Florenz* 32, pp. 145-72.

M. R. Valazzi. *La Pala ricostituita. L'Incoronazione della Vergine e la Cimasa vaticana di Giovanni Bellini. Indagini e Restauri (Pesaro)*. Exhib. cat. Milan.

1988-89

J. Beck. "A Crucial Painting for Giambellino Studies." *Prospettiva* 53-56 (Scritti in ricordo di Giovanni Previtali), 1, pp. 278-80.

G. Schizzerotto. "Iter postumo del ciclo belliniano di S. Giovanni Evangelista." *Labyrinthos* 7-8, pp. 81-94.

1989

U. Bauer-Eberhardt. "Lauro Padouano und Leonardo Bellini als Maler, Miniatoren und Zeichner." *Pantheon* 47, pp. 49-82.

R. Carvalho de Magalhaes. "Il saper vedere di Matteo Marangoni, 2. Contributo alla critica dello stile." *Critica d'arte* 54, no. 20, pp. 56-64.

C. Eisler. *The Genius of Jacopo Bellini. The Complete Paintings and Drawings*. New York.

R. Goffen. *Giovanni Bellini*. London.

J. M. Greenstein. "'How Glorious the Second Coming of Christ': Michelangelo's *Last Judgment* and the *Transfiguration*." *Artibus et historiae* 20, pp. 33-57.

F. Polignano. "Ritratto e biografia: due insiemi a confronto, dalla parte dell'iconologia." In *Il ritratto e la memoria. Materiali 1*, pp. 211-25. Rome.

C. C. Wilson. "Early Citations of Giovanni Bellini's Pesaro Altar-Piece." *Burlington Magazine* 131, pp. 847-49.

1990

F. Ames Lewis. "Il Disegno nella pratica di bottega del Quattrocento." In *La Pittura nel Veneto. Il Quattrocento*. Vol. 2, pp. 657-85. Milan.

J. Anderson. "Collezioni e collezionisti della pittura veneta del Quattrocento. Storia, Sfortuna e Fortuna." In *La Pittura nel Veneto. Il Quattrocento*. Vol. 1, pp. 271-94. Milan.

A. Ballarin. In *Collecciòn Cambo*. Exhib. cat., p. 305. Madrid.

D. A. Brown. "Bellini e Tiziano." In *Tiziano*. Exhib. cat. (Venice and Washington, D.C.), pp. 57-67. Venice.

———. "Festino degli dei." In *Tiziano*. Exhib. cat. (Venice and Washington, D.C.), pp. 98-201. Venice.

D. Bull and J. Plester. "*The Feast of the Gods*": Conservation, Examination and Interpretation. Washington, D.C.

A. Chastel. "Fra Bartolomeo's Carondelet Altarpiece and the Theme of the Virgo in Nubibus in the High Renaissance." In *The Altarpiece in the Renaissance, Atti del Convegno* (London, 1987), pp. 129-42. Eds. P. Humfrey and M. Kemp. Cambridge.

E. M. Dal Pozzolo. "Lorenzo Lotto 1506. La Pala di Assolo." *Artibus et historiae* 21, pp. 85-110.

B. Degenhart, A. Schmitt, and H. J. Eberhardt. *Corpus der italienischen Zeichnungen 1300-1450*. Vol. 2, pp. 5-8. Venice.

J. Fletcher. "Harpies, Venus and Giovanni Bellini's Classical Mirror: Some Fifteenth Century Venetian Painters' Responses to the Antique." In *Venezia e l'archeologia*, pp. 173-74. Rome.

P. Hills. "The Renaissance Altarpiece: A Valid Category?" In *The Altarpiece in the Renaissance, Atti del Convegno* (London, 1987), pp. 340-48. Eds. P. Humfrey and M. Kemp. Cambridge.

P. Humfrey. "Co-ordinated Altarpieces in Renaissance Venice: The Progress of an Ideal." In *The Altarpiece in the Renaissance, Atti del Convegno* (London, 1987), pp. 190-211. Eds. P. Humfrey and M. Kemp. Cambridge.

———. *Musei e Gallerie di Milano. Pinacoteca di Brera. Scuola veneta*, pp. 42-58. Milan.

———. *La Pittura veneta del Rinascimento a Brera*. Florence.

M. Lucco. "Venezia." In *La Pittura nel Veneto. Il Quattrocento*. Vol. 2, pp. 395-480. Milan.

C. Schmidt. "La Sacra Conversazione nella pittura veneta." In *La Pittura nel Veneto. Il Quattrocento*. Vol. 2, pp. 703-26. Milan.

M. Simonetti. "Tecniche della pittura veneta." In *La Pittura nel Veneto. Il Quattrocento*. Vol. 1, pp. 247-70. Milan.

M. Tanzi. "Vicenza." In *La Pittura nel Veneto. Il Quattrocento*. Vol. 2, pp. 599-621. Milan.

1991

D. Arasse and O. S. Barberis. "Giovanni Bellini et la mythologie de Noé." *Venezia Cinquecento* 1, no. 2, pp. 157-83.

E. Battisti. "Le origini religiose del paesaggio veneto." *Venezia Cinquecento* 1, no. 2, pp. 9-25.

D. Bull. "*Christ Crowned with Thorns* by Giovanni Bellini." *Nationalmuseum Bulletin* 15, no. 2, pp. 112–24.

Christie's. *Important Old Master Paintings,* 11.1, no. 2. New York.

S. Ciofetta. "Il *Battesimo di Cristo* di Giovanni Bellini. Patronato e devozione privata." *Venezia Cinquecento* 1, no. 2, pp. 61–88.

A. Colantuono. "*Dies Alcyoniae:* The Invention of Bellini's *Feast of the Gods.*" *Art Bulletin* 73, no. 2, pp. 237–56.

S. Coltellacci. "'Oboedite praepositis vestris, et subiacete illis.' Fonti letterarie e contesto storico della *Derisione di Noè* di Giovanni Bellini." *Venezia Cinquecento* 1, no. 2, pp. 119–56.

D. Ferrara. "Il ritratto del doge Leonardo Loredan. Strategie dell'abito tra politica e religione." *Venezia Cinquecento* 1, no. 2, pp. 89–108.

———. "Il doge Leonardo Loredan e una veduta di Venezia." *Osservatore delle arti* 6, pp. 24–33.

J. Fletcher. "The Painter and the Poet: Giovanni Bellini's Portrait of Raffaele Zovenzoni Rediscovered." *Apollo* 134, no. 355, pp. 153–58.

J. Fletcher and D. Skipsey. "Death in Venice: Giovanni Bellini and the *Assassination of St. Peter Martyr.*" *Apollo* 133, no. 347, pp. 4–9.

A. Gentili. "Giovanni Bellini, la bottega, i quadri di devozione." *Venezia Cinquecento* 1, no. 2, pp. 27–60.

R. Goffen. "Bellini's *Nude with Mirror.*" *Venezia Cinquecento* 1, no. 2, pp. 185–99.

———. "Bellini's *Christ Crowned with Thorns:* The Artist's Epitaph." *Nationalmuseum Bulletin* 15, no. 2, pp. 137–50.

F. Heinemann. *Giovanni Bellini e i Belliniani.* Vol. 3, *Supplemento e Ampliamenti.* Hildesheim, Zurich, and New York.

M. Hochmann. "Tra Venezia e Roma: il cardinale Francesco Corner." *Saggi e memorie di storia dell'arte* 18, pp. 97–110, 203–6.

C. Hope. "Titian 500: Washington, D.C., National Gallery of Art, 25–27.10.1990." *Kunstchronik* 5, pp. 249–53.

P. Humfrey. *Carpaccio. Catalogo completo dei dipinti.* Florence.

———. "Two lost *St. Jerome* Altarpieces by Giovanni Bellini." *Venezia Cinquecento* 1, no. 2, pp. 109–17.

B. Roeck. *Arte per l'anima, arte per lo Stato. Un doge del tardo Quattrocento ed i segni delle immagini.* Venice.

F. Torella. "La *Cena in Emmaus* di San Salvador, I. Documenti per la committenza e la cronologia." *Venezia Cinquecento* 1, no. 2, pp. 203–13.

1992

G. Benedicenti. "Per Giovanni Bellini. Una nuova lettura del ritratto di Birmingham." *Paragone* 513, pp. 3–9.

I. Botti. "Tra Venezia e Alessandria. I teleri belliniani per la Scuola Grande di San Marco." *Venezia Cinquecento* 2, no. 3, pp. 33–73.

D. A. Brown. "Divino baccanale." *FMR* 92, pp. 26–33.

A. Conti. *Restauro.* Milan.

E. M. Dal Pozzolo. "Anatomia di un S. Gerolamo (e una postilla)." *Il Santo* 32, pp. 63–82.

J. Paris. "Triomphe de l'énigme, vel quasi speculum in aenigmate." *Colóquio, artes* 93, pp. 22–29.

A. Ronen. "Iscrizioni ebraiche nell'arte italiana del Quattrocento." In *Studi di storia dell'arte sul Medioevo e il Rinascimento nel centenario della nascita di Mario Salmi. Atti del Convegno internazionale* (Arezzo-Florence, 1989), vol. 2, pp. 601–24. Florence.

W. S. Sheard. "Titian's Paduan Frescoes and the Issue of Decorum." In *Decorum in Renaissance Narrative Art. Papers Delivered at the Annual Conference of the Association of Art*

Historians (London, April 1991), pp. 89–102. London.

J. Shearman. "Only Connect . . ." In *Art and the Spectator in the Italian Renaissance.* Princeton.

S. Simi. "Considerazioni attorno a un busto di Leonardo Loredan." *Antichità Viva* 31, nos. 5–6, pp. 25–36.

O. Stefani. "Una sublime metafora dell'esistenza. Note su la *Flagellazione di Cristo* di Piero della Francesca." *Arte Documento* 6, pp. 77–82.

R. Stefaniak. "Replicating Mysteries of the Passion: Rosso's *Dead Christ with Angels.*" *Renaissance Quarterly* 45, pp. 677–738.

A. Tempestini. *Giovanni Bellini. Catalogo completo dei dipinti.* Florence.

———. "Giovanni Bellini e l'oreficeria. I Pastorali dei Vescovi e degli Abati nei suoi dipinti." In *Ori e Tesori d'Europa. Atti del Convegno internazionale di Studi* (Udine, 1991), pp. 269–78. Udine, 1992.

———. "Giovanni Bellini e Marco Palmezzano." *Antichità Viva* 31, nos. 5–6, pp. 5–12.

W. Tresidder. "A Borrowing from the Antique in Giovanni Bellini's *Continence of Scipio.*" *Burlington Magazine* 134, pp. 660–62.

M. Trionfi Honorati. "Ipotesi di attribuzione della cornice della pala di Giovanni Bellini a Pesaro." *Antichità Viva* 31, 4, pp. 38–44.

1993

G. Agosti. "Su Mantegna, 1 (All'ingresso della mostra del 1992, a Londra)." *Prospettiva* 71, pp. 42–52.

———. "Su Mantegna, 2 (All'ingresso della 'maniera moderna')." *Prospettiva* 72, pp. 66–82.

A. Ballarin. In *Le siècle de Titien.* Exhib. cat. Paris.

E. Borea. "Le stampe dai primitivi e l'avvento della storiografia artistica illustrata, 2." *Prospettiva* 70, pp. 50–74.

M. Calvesi. "La cosiddetta Allegoria di Giovanni Bellini." In *Studi in onore di Giulio Carlo Argan,* pp. 130–39. Florence.

A. Conti. "Echi di Marco Zoppo nel Polittico di San Zanipolo." In *Marco Zoppo. Cento 1433–1478 Venezia. Atti del convegno internazionale di studi sulla pittura del Quattrocento padano* (Cento, 1993), pp. 97–106. Bologna, 1993.

E. M. Dal Pozzolo. "Da Giovanni Bellini ad Andrea Previtali." *Paragone* n.s. 37–38, 44, nos. 515–17, pp. 88–91.

M. Ewel. "Bildlandschaft in der venezianischen Renaissancemalerei und ihre Bedeutung für die Bildarchitektur." *Städel-Jahrbuch* 14, pp. 113–32.

R. Goffen, in Attilia Dorigato, ed. *Carpaccio, Bellini, Tura, Antonello e altri restauri quattrocenteschi della Pinacoteca del Museo Correr* (Venice, 1993). Exhib. cat. Milan.

W. Gundersheimer. "Clarity and Ambiguity in Renaissance Gesture: The Case of Borso d'Este." *Journal of Medieval and Renaissance Studies* 23, no. 1, pp. 1–17.

P. Humfrey. *The Altarpiece in Renaissance Venice.* New Haven and London.

M. Laclotte. "Giovanni Bellini et la 'maniera moderna.'" In *Le siècle de Titien.* Exhib. cat., pp. 263–78. Paris.

M. Lucco. "A l'occasion de la redécouverte d'un tableau du Musée des Beaux-Arts, nouveau regard sur l'oeuvre de Marco Basaiti." *Bulletin des Musées et Monuments Lyonnais* 1, pp. 2–37.

C. Sciolla. "Due epigrammi inediti di Girolamo Bologni da Treviso per Giovanni Bellini." *Arte Veneta* 44, pp. 62–64.

J. Simane. "Grabmonumente der Dogen. Venezianische Sepulkralkunst im Cinquecento." In *Studi. Centro Tedesco di Studi Veneziani.* Vol. 11. Sigmaringen, pp. 38–40.

A. Tempestini. *Giovanni Bellini. Catalogue complet des peintures.* Paris.

———. "Schede di Giovanni Bellini, Pala dell'*Incoronazione di Maria;* Giovanni Bellini, Padre Eterno; Jacopo Bellini (bottega), *Crocifisso.*" In C. Giardini, E. Negro, and M. Pirondini. *Dipinti e disegni della Pinacoteca Civica di Pesaro,* pp. 28–35. Modena.

F. Valcanover. "La Pala *Barbarigo* di Giovanni Bellini." In *Il Classicismo. Medioevo, Rinascimento, Barocco, Atti del Colloquio Cesare Gnudi* (Bologna, 1986), pp. 129–38. Bologna.

P. Zampetti. "Il mito di Ancona. Bellini, Carpaccio, Vittore Belliniano." In *Via Saffi dov'era com'era.* Exhib. cat., pp. 55–59. Ancona.

S. Zuffi. *Giovanni Bellini.* Milan.

K. Kabayana, S. Kimura, and S. Takashina, eds. *Journey into the Masterpiece: The Rite of Spring* (Early Renaissance II). Tokyo.

1994

G. Agosti. "Su Mantegna, 3 (Ancora all'ingresso della 'maniera moderna')." *Prospettiva* 73–74, pp. 131–43.

A. Conti. "Giovanni nella bottega di Jacopo Bellini." In *Hommage à Michel Laclotte. Etudes sur la peinture du Moyen Age et de la Renaissance.* Milan and Paris.

R. Goffen. "The Problematic Patronage of Titian's Venus of Urbino." *Journal of Medieval and Renaissance Studies* 24, no. 2, pp. 301–21.

P. Humfrey. "The Bellini, the Vivarini and the Beginning of the Renaissance Altarpiece in Venice. In *Italian Altarpieces 1250–1550: Function and Design,* pp. 139–74. Oxford.

C. L. Joost-Gaugier. "La prospettiva rinascimentale nella Venezia del Quattrocento." In *I tempi di Giorgione,* pp. 55–63. Rome.

K. Künzi. "Titians verschollenes Capolavoro." In *Georges-Bloch-Jahrbuch des kunstgeschichtlichen Seminars der Universität Zürich* 1, pp. 134–58.

A. J. Martin. "Cima da Conegliano. Conegliano, Pal. Sarcinelli, 1.–2.10.93." *Kunstchronik* 6, pp. 310–25.

E. Merkel. "I mosaici del Cinquecento veneziano (1ª parte)." *Saggi e memorie di storia dell'arte* 19, pp. 73–140.

R. Piva. "Miracoli dipinti. I diavoli e Circe incantatrice." In *I tempi di Giorgione,* pp. 270–77. Rome.

W. R. Rearick. "La Pittura veneta ai tempi di Giorgione." In *I tempi di Giorgione,* pp. 9–15. Rome.

V. Sgarbi and G. Pinna. *Carpaccio.* Milan.

Anchise Tempestini. "I fratelli Busati e il Maestro veneto dell'*Incredulità di San Tommaso.*" *Studi di storia dell'arte* 4, pp. 27–68.

———. "L'approccio alla civiltà classica in Cima da Conegliano e Giovanni Bellini." In *Venezia Cinquecento* 4, no. 7, pp. 35–60.

A. Tempestini and E. Kasten. "Bellini, Giovanni (Giambellino)." *SAUR. Allgemeines Künstler-Lexikon* 8, pp. 489–93.

A. Gentili and C. Cieri Via. "Mito e allegoria nelle immagini del primo '500 a Venezia." In *I tempi di Giorgione,* pp. 259–69. Rome.

1995

G. Agosti. "Su Mantegna, 4 (A Mantova nel Cinquecento)." *Prospettiva* 77, pp. 58–83.

———. "Su Mantegna, 5 (Intorno a Vasari)." *Prospettiva* 80, pp. 61–89.

M. G. Bernardini. "Bottega di Giovanni Bellini (Vincenzo Catena?), *Nuda allo specchio.*" In *Tiziano. Amor Sacro e Amor Profano* (Rome, 1995). Exhib. cat., pp. 242–43. Milan.

A. Dillon Bussi. "Due ritratti di Raffaele Zovenzoni." *Libri & Documenti* 21, no. 1, pp. 25–42.

B. Gopnik. "Contradictory Lightings and the Repainting of Bellini's *Feast of the Gods.*" *Gazette des Beaux-Arts* 125, no. 1514, pp. 201–8.

J. Paris and C. Point. *L'Atelier Bellini.* Paris.

1996

G. Agosti. "Un amore di Giovanni Bellini." In *Ad Alessandro Conti (1946–1994). Quaderni del seminario di storia della critica d'arte.* Vol. 6, pp. 45–83. Scuola Normale Superiore di Pisa.

G. Agostini. "Dipinti veneti nella Pinacoteca Nazionale di Ferrara." In *La pittura veneta negli stati estensi* (various authors), pp. 57–63. Modena.

G. Agostini and A. Stanzani. "Pittori veneti e commissioni estensi a Ferrara." In *La pittura veneta negli stati estensi* (various authors), pp. 19–56. Modena.

Hans H. Aurenhammer. "Das Christuskind als tragischer Held? Eine antike Pathosformel in Giovanni Bellinis *Lochis-Madonna.*" In *Fremde Zeiten. Festschrift für Jürgen Borchhardt zum sechzigsten Geburtstag.* Vol. 2, pp. 377–94. Vienna.

H. Belting. *Giovanni Bellini. La Pietà.* Modena.

J. Bentini. "Pittura veneta nelle raccolte estensi di Modena." In *La pittura veneta negli stati estensi* (various authors), pp. 259–315. Modena.

M. Douglas-Scott. "Giovanni Bellini's *Madonna and Child with Two Saints and a Donor* at Birmingham: A Proposal." *Venezia Cinquecento* 6, no. 11, pp. 5–21.

F. Haskell. "La vendita dei dipinti estensi di Modena nel 1746 e i suoi antefatti." In *La pittura veneta negli stati estensi* (various authors), pp. 1–17. Modena.

S. Marinelli. "Ferrara, tra Venezia e Modena." In *La pittura veneta negli stati estensi* (various authors), pp. 65–94. Modena.

A. Roesler-Friedenthal. "Ein Portrait Andrea Mantegnas als 'Alter Orpheus' im Kontext seiner Selbstdarstellungen." *Römisches Jahrbuch der Bibliotheca Hertziana* 31, pp. 165–67.

C. Schmidt Arcangeli. "Cima da Conegliano e Vincenzo Catena pittori veneti a Carpi." In *La pittura veneta negli stati estensi* (various authors), pp. 95–116. Modena.

———. "'Un tempio aperto.' I Bellini e il loro ruolo nel progetto della facciata della Scuola Grande di San Marco." *Studi di storia dell'arte* 7, pp. 65–98.

1997

D. Banzato. "Vicenza 1500–1540." In *La pittura nel Veneto. Il Cinquecento.* Vol. 1. Milan.

P. Burke. "Il ritratto veneziano nel Cinquecento." In *La pittura nel Veneto. Il Cinquecento.* Vol. 3. Milan.

E. M. Dal Pozzolo. "Padova 1500–1540." In *La pittura nel Veneto. Il Cinquecento.* Vol. 1. Milan.

M. Hochman. "Marcantonio Michiel e la nascita della critica d'arte veneziana." In *La pittura nel Veneto. Il Cinquecento.* Vol. 3. Milan.

P. Humfrey, "La pala d'altare veneta nell'età delle Riforme." In *La pittura nel Veneto. Il Cinquecento.* Vol. 3. Milan.

P. Joannides. "Classicità e classicismo nella pittura veneta del '500." In *La pittura nel Veneto. Il Cinquecento.* Vol. 3. Milan.

M. Lucco. "Venezia 1500–1540." In *La pittura nel Veneto. Il Cinquecento.* Vol. 1. Milan.

C. Schmidt Arcangeli. "'Un tempio aperto': Die Bellini in ihrer Bedeutung für den Fassadenentwurf der Scuola Grande di San Marco." In *Colloquia Augustana,* Vol. 5, *Kunst und ihre Auftraggeber im 16. Jahrhundert: Venedig und Augsburg im Vergleich.* Eds. K. Bergdolt and J. Brüning, pp. 43–82, 246–55, Berlin.

E. Simon. *Das "Goetterfest" des Giovanni Bellini und die osmanische Tuerkei,* in KOMOS (Festschrift Celebrating the 65th Birthday of Thuri Lorenz), edited by G. Erath, M. Lehner, and G. Schwarz, pp. 305–12. Vienna.

A. Tempestini. "La 'Sacra Conversazione' nella pittura veneta dal 1500 al 1516." In *La pittura nel Veneto. Il Cinquecento.* Vol. 3. Milan.

INDEX OF WORKS

PHOTOGRAPHY CREDITS